**AIGA
GRAPHIC
DESIGN
USA: 1**

**AIGA
GRAPHIC
DESIGN
USA: 1**

The
Annual
of the

**American
Institute
of Graphic
Arts**

Written by
C. Ray Smith
Designed by
Miho

WATSON-GUPTILL
PUBLICATIONS/
NEW YORK

First published 1980 in New York by Watson-Guptill Publications,
a division of Billboard Publications, Inc.,
1515 Broadway, New York, N.Y. 10036

ISBN 0-8230-2148-3
Manufactured in U.S.A.

First Printing, 1980

Distributed outside the U.S.A. and Canada by
Fleetbooks, S.A.
c/o Feffer & Simons, Inc.
100 Park Avenue
New York, New York 10017

Edited by Sharon Lee Ryder and Susan Davis

Contents

Acknowledgments

The AIGA was founded in 1914 as a "source of pleasure and intellectual profit" for its members. The publication of this volume marks an important step in this pursuit. It will also bring the excitement of contemporary graphic design in America to a wide audience both here and abroad. This is a gratifying undertaking, and we are in debt to a number of people for its completion.

First, to our membership, whose continued support makes our program possible, as well as the more than 1,500 individuals from over 40 states and Canada who entered our competitions. Also to be thanked are the chairmen and juries for the competitions who had the difficult task of selection, as well as the firms and individuals whose generous contribution of time and materials made it possible to disseminate our calls for entry.

In addition, there are a number of individuals whose expertise, good spirits, and patience have brought this project to its happy conclusion: The Publications Committee, under the chairmanship of Robert O. Bach and Martin S. Moskof–Martin Fox, Ellen McNeilly, and R.D. Scudellari; James K. Fogleman, president of the AIGA, and Richard Danne, president at the book's inception; C. Ray Smith, author; James Miho and Thomas Geismar, designers of the book and jacket, respectively; Jules Perel, Executive Vice President, Watson-Guptill, and editors Sharon Lee Ryder and Susan Davis; AIGA staff members Deborah Trainer and Nathan Gluck. To all, our thanks for helping us to publish the first volume in a series that will stand as the most significant record of the broad spectrum of graphic design in America today.

Caroline Hightower
Executive Director

The American Institute of Graphic Arts

The American Institute of Graphic Arts is a national, nonprofit organization, founded in 1914. It conducts an interrelated program of competitions, exhibitions, publications, educational activities, and projects in the public interest to promote the advancement of graphic design.

Members of the Institute are involved in the design and production of books, magazines, and periodicals as well as corporate, environmental, and promotional graphics. Their contribution of specialized skills and expertise provides the foundation for the Institute's program. Through the Institute, members form an effective, informal network of professional assistance that is a resource to the profession and to the public.

Founders include publisher William B. Howland; printer and typeface designer Frederic W. Goudy; Alexander W. Drake, art editor of *Century Magazine*; Major George H. Putnam, publisher; artists Will Bradley and Hal Marchbanks, founder of the Marchbanks Press.

Initially, AIGA exhibitions focused on lithography, etching, and design. The Fifty Books of the Year exhibition, for which the AIGA became well known, was established in the early 1920s. Later the exhibition schedule was broadened to include a wide spectrum of printed matter. The exhibition schedule at the Institute's Gallery now includes five annual competitive exhibitions. Of these, the Book Show and a Communication Graphics exhibition, which incorporates Advertising, are held each year. Three other exhibitions may include Illustration, Photography, Covers (book jackets, magazines, periodicals, record albums), Insides (design of the printed page), Signage, and Packaging.

The exhibitions travel nationally and internationally. Each year, the Book Show is donated to the Rare Book and Manuscript Library of Columbia University, which houses the AIGA collection of award-winning books dating back to the 1920s. Other exhibitions are sent to the Popular and Applied Graphic Arts Department of the Library of Congress.

Special exhibitions, mounted each year, have recently included the Caricatures of David Levine, MASSCOM/MASSTRANS (international solutions to subway and bus maps), the Record Album Covers of John Berg, the Typographic Experiments of Alvin Lustig, Bias-free Illustration, Laser Photographs by Erich Hartmann, and Researches in Offset Lithography by Eugene Feldman.

A program of special projects has included a multi-phased Symbol Signs project for the U.S. Department of Transportation, the development of a manual of graphics for nonprofit institutions for the National Endowment for the Arts, and an education survey that has resulted in the publication of an Education Directory, which provides basic information about schools throughout the United States and Canada offering courses in graphic design.

Lectures and seminars are held at the AIGA on a variety of subjects; they have included semiotics, subway map debates (co-sponsored with The Architectural League), nonprofit graphics (sponsored by the New York State Council on the Arts), and a forum on typeface copyright.

Board of Directors 1979–1980

President
James K. Fogleman

Executive Director
Caroline Hightower

Executive Committee
Robert O. Bach
Martin Fox
Howard Glener
Martin S. Moskof
Robert D. Scudellari

Donald Ackland
Wilburn Bonnell III
David Brown
Bill Caldwell
Jacqueline S. Casey

Seymour Chwast
Richard Danne
John Follis
Stephan Geissbuhler
Joseph Hutchcroft

A.E. Jeffcoat
Marjorie Katz
Andrew Kner
Harris Lewine
Ellen McNeilly

Tomoko Miho
Jack W. Odette
Anthony Parisi
Elton Robinson
Norman Sanders

Bernard Sendor
Lorna Shanks
James Stockton
Thomas Suzuki
Massimo Vignelli

Robert Vogele
Constance von Collande

Staff
Deborah Trainer, Assistant Director
Nathan Gluck, Competition Coordinator
Victoria Bartlett, Membership and Special Programs
Glenngo King, Travelling Exhibition Coordinator
Shelley Bance, Editorial Assistant

is often speculated, the resulting selections would almost always be different. Even within juries themselves, of course, few agree unanimously, and the greater number of selections is approved only by majority. One AIGA jury this year found that the few entries it approved unanimously were often "not the innovative images," but rather designs that had a great appeal to a wide audience–evidently including the judges.

The second aspect of the jury process, the actual physical procedure, has a significant influence on the final selection. This encompasses the method by which the jurors familiarize themselves with all the submissions, the decision whether or not to separate into subcategories and subjuries, and the method of voting.

Third, the criteria of each jury ultimately determine the representative nature of the exhibitions. Sometimes, the selection of entries is determined by a standard of excellence concurred upon in the minds of the jurors–"concept, quality of design, invention, and intelligence," as one AIGA juror stated. Another juror laughingly compared himself with a judge at a dog show "who must assume a flawless ideal and decide how closely the beasts at hand approach it." Other juries strive to choose an exhibition that is more broadly representative of the overall field–wanting all categories of work to be represented, like a retrospective of all known work within the eligible period.

Both approaches are considered valid. Yet if a jury selects only the submitted designs of outstanding quality in relation to a preconceived ideal, it may eliminate representative design activity in certain less refined or sophisticated marketing areas. The design of paperback covers for a mass market is the example generally offered. However, if a jury aims for a representative selection–"a balanced show"–it may fall short of exhibiting the highest excellence in graphic design. Ideally, a balance is attained.

In AIGA awards programs, there is no best-of-show award, nor one or more entries singled out as better than others. Because of a crossover of entries in several competition categories, in some instances different juries separately and autonomously selected the same piece for award. Such pieces appear in this volume twice, so that they may be seen within the category in which they were selected.

The AIGA Medal

For sixty years the medal of the American Institute of Graphic Arts has been awarded to individuals in recognition of their distinguished achievements, services, or other contributions within the field of the graphic arts. Medalists are chosen, subject to approval by the Board of Directors, by a committee from nominations submitted by the membership. Past recipients have been:

Norman T. A. Munder, 1920
Daniel Berkeley Updike, 1922
John C. Agar, 1924
Stephen H. Horgan, 1924
Bruce Rogers, 1925
Burton Emmett, 1926
Timothy Cole, 1927
Frederic W. Goudy, 1927
William A. Dwiggins, 1929
Henry Watson Kent, 1930
Dard Hunter, 1931
Porter Garnett, 1932
Henry Lewis Bullen, 1934
J. Thompson Willing, 1935
Rudolph Ruzicka, 1936
William A. Kittredge, 1939
Thomas M. Cleland, 1940
Carl Purington Rollins, 1941
Edwin and Robert Grabhorn, 1942
Edward Epstean, 1944
Frederic G. Melcher, 1945
Stanley Morison, 1946
Elmer Adler, 1947
Lawrence C. Wroth, 1948
Earnest Elmo Calkins, 1950
Alfred A. Knopf, 1950
Harry L. Gage, 1951
Joseph Blumenthal, 1952
George Macy, 1953
Will Bradley, 1954
Jan Tschichold, 1954
P. J. Conkwright, 1955
Ray Nash, 1956
Dr. M. F. Agha, 1957
Ben Shahn, 1958
May Massee, 1959
Walter Paepcke, 1960
Paul A. Bennett, 1961
Willem Sandberg, 1962
Saul Steinberg, 1963
Josef Albers, 1964
Leonard Baskin, 1965
Paul Rand, 1966
Romana Javitz, 1967
Dr. Giovanni Mardersteig, 1968
Dr. Robert L. Leslie, 1969
Herbert Bayer, 1970
Will Burtin, 1971
Milton Glaser, 1972
Richard Avedon, 1973
Allen Hurlburt, 1973
Philip Johnson, 1973
Robert Rauschenberg, 1974
Bradbury Thompson, 1975
Henry Wolf, 1976
Jerome Snyder, 1976
Charles and Ray Eames, 1977
Lou Dorfsman, 1978
Ivan Chermayeff and Thomas Geismar, 1979

AIGA Medalists, 1979:
Ivan Chermayeff and
Thomas Geismar

Committee chairman Edward Russell, Jr., in commenting on the award selection, stated: "Ivan Chermayeff and Thomas Geismar are a superb team whose work consistently reflects excellence. As our committee reviewed the individual medalist nominations, we unanimously selected not one but both as a team to receive the AIGA's highest accolade while they are in their prime."

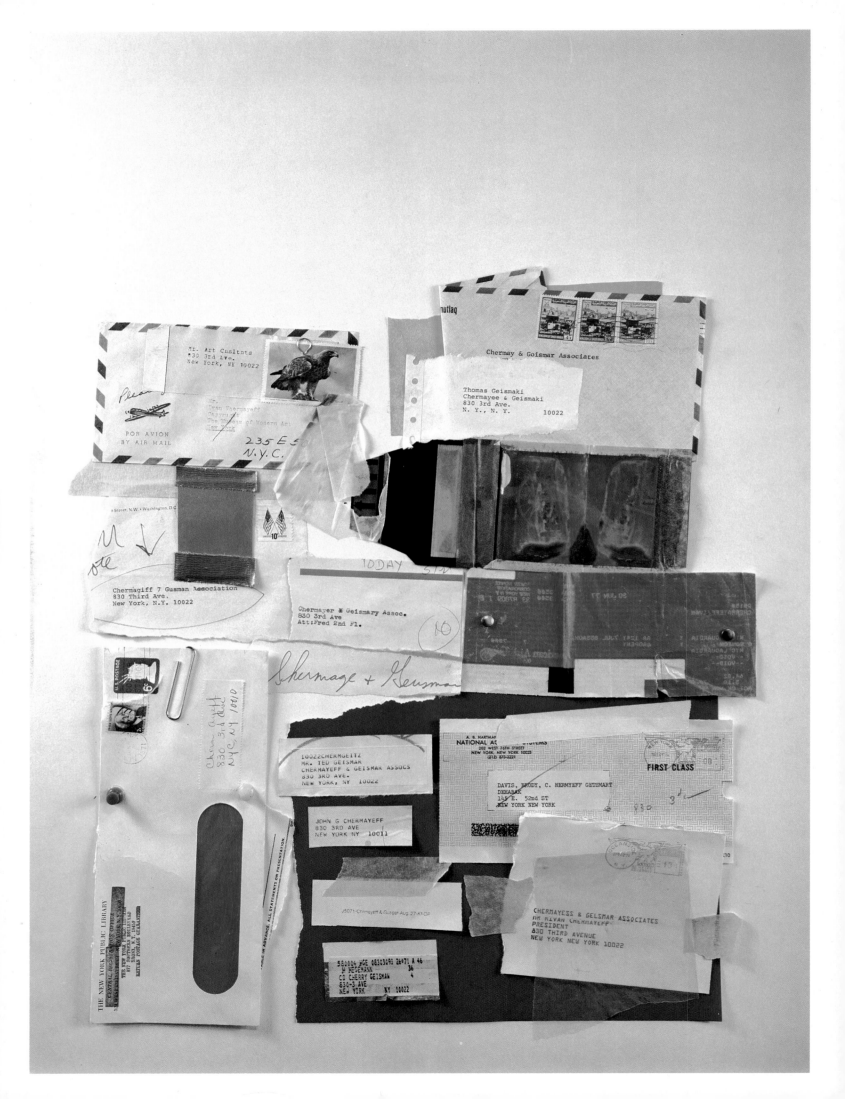

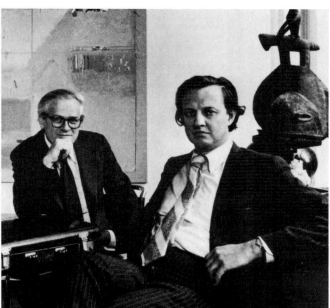

Thomas Geismar (left) and Ivan Chermayeff.

Finding relationships, as Ivan Chermayeff has said, is what graphic design is all about. It is also what poetry is about–analogy, simile, metaphor, meanings beyond meanings, images beyond images. In the work of Chermayeff and Geismar, images are words, have meanings, communicate. They make visual images that are graphic poetry.

Chermayeff and Geismar combine their special kind of poetic communication with efficient practicality. Throughout their career they have shown two interests and directions: first, an emphasis on process or–to use the designers' by-now 20-year-old slogan–"problem solving"; and second, an exploration of a remarkably wide variety of aesthetic approaches to make their images. Their success at problem solving over the years has permitted them to plan, design, and supervise an impressive number of corporate graphics programs across the broadest international framework. They are acclaimed for their methodology–for the clarity and organization of their graphics systems, for their pursuit of consistent details that work at every size and scale to solve the problems of multilingual programs. As a consequence they have collected commissions for corporate programs the way other designers collect book jacket commissions–Burlington Industries, Chase Manhattan Bank, Dictaphone, Mobil Corporation, Pan Am, and Xerox, to name a few. Their work includes logos, symbols, letterheads, signs, annual reports, posters, bags and boxes and banners, trucks and airplanes, tank cars and tote bags, T-shirts and ties, television titles and credits.

Designer Rudolph de Harak recalled in his presentation of the AIGA Medal that as early as 1959, when Chermayeff and Geismar were having an exhibition of their work in New York City, a news release stated that their design office "operated on the principle that design is a solution to problems, incorporating ideas in relation to the given problem, rather than a stylistic or modish solution." Twenty years later, de Harak observed, "Their philosophy is still the same."

"Our work starts out from the information to be conveyed," Ivan Chermayeff explains, "and only then goes on to make the structure subservient to that information or make the structure a way to help express the idea."

Chermayeff and Geismar met at Yale in the mid-1950s when so many ideas that are now a part of our lives were germinating. Chermayeff was born in London, the son of the distinguished architect-teacher Serge Chermayeff. He studied at Harvard, the Institute of Design in Chicago, and received a BFA at Yale. Geismar was born in Glen Ridge, New Jersey, and studied concurrently at Brown University and the Rhode Island School of Design, then received an MFA at Yale. There, both designers discovered a common interest in the design of alphabets or typefaces; they met doing research on papers about typeface design.

Their degrees completed, Geismar went into the Army where he worked as a designer of exhibitions and graphics. Chermayeff went to work in New York, first for Alvin Lustig, then for CBS designing record covers. In 1957, they opened their own practice in New York.

As designer de Harak recalled: "Their work burst forth in the late 50s and early 60s smack in the middle of what is considered to be the time of the graphics revolution in this country. The mid-50s in New York was an exciting time, charged with creative electricity, the sparks flying from all the arts. In architecture, the United Nations building and Lever House had just gone up, and the way was paved for New York's first building by Mies van der

Chairman
Edward Russell, Jr.
The vice-president of Marketing Services for Champion International Corporation since 1960, Edward Russell, Jr. now serves as creative consultant to Champion International. He was responsible for the initial concept of the "Imagination" series. He served on the board of the AIGA for 20 years.

The Committee
Tomoko Miho
Principal of the graphic design firm Miho Inc. since 1974, Tomoko Miho was design manager of the New York office of the Center for Advanced Research in Design and the graphics supervisor for the same agency in Chicago. She has served as a designer and director of the graphics department for George Nelson & Company and as a designer for Harley Earl Associates. Born in Los Angeles, she graduated from the Minneapolis College of Design and also studied in California.

George Tscherny
The principal of his own graphic design firm since 1956, George Tscherny started his professional career in 1950 with Donald Deskey & Associates and then worked as a graphic designer and associate with George Nelson & Company. In addition to his graphics practice he has taught at Pratt Institute, the School of Visual Arts, and Cooper Union. He was born in Budapest, Hungary, and received his education in the United States.

Henry Wolf
The principal of Henry Wolf Productions Inc., which specializes in photography, film, and design, Henry Wolf was born in Vienna and came to the United States in 1941. He spent the next three years in the Army. Six years later he began a series of art directorships with *Esquire, Harper's Bazaar, Show* magazine, Jack Tinker & Partners, and the Center for Advanced Practice. In 1966 he became creative director of Trahey/Wolf Advertising and in 1971 formed his present organization. He was awarded the AIGA Medal in 1976.

Rohe in the late 50s. In the arts, Abstract Expressionism was being nudged aside by Pop painting and sculpture, to be followed by Op works. In the theater, Jerome Robbins had just done "West Side Story." The jazz world was stunned by the passing of Charley Parker and razzle-dazzled by the cacophony of Ornette Coleman, Erick Dolphy, and John Coletrane.

"In graphics, the establishment designers were Will Burtin, Alvin Lustig, Paul Rand, Lester Beall, and Saul Bass, to name just a few. Art Kane was seriously contemplating leaving the drawing board for his cameras, and Jay Maisel had just started on his career as a photographer. Henry Wolf was turning the magazine industry on its ear with his fresh approach to design at *Esquire*, and Lou Dorfsman was already almost legendary at CBS. It was in this climate that Chermayeff and Geismar found themselves as partners, eager to incorporate their talents and skills.

"It is one thing to open a design shop today," de Harak pointed out, "and to solicit work from an already generally alert design-oriented management. It was quite another issue in the late 1950s."

Yet around 1960, Chermayeff and Geismar started the craze for abstract corporate symbols with the one they designed for the Chase Manhattan Bank. They have produced over 100 such corporate symbols in the years since, including those for Manufacturers Hanover Trust, Screen Gems, and the Bicentennial celebration.

Logo:
Xerox Corp., 1968

"We try to do something that is memorable for a symbol," Tom Geismar notes, "something that has some barb to it that will make it stick in your mind, make it different from the others, perhaps unique. And we want to make it attractive, pleasant, and appropriate. The challenge is to combine all those things into something simple."

In meeting that challenge, Chermayeff and Geismar have explored as varied and different a collection of approaches and techniques as any designers now working.

"We do not have an office style," Ivan Chermayeff has said, "like some designers who concentrate on graphics systems, such as grids. And we don't have a special style of illustration like those who are collectors of historical style motifs—Art Deco or 19th-century typography. We are not involved in style and fashion in that way."

Logo:
Design Media, 1966

Programmers of Collections
Instead, Ivan Chermayeff and Thomas Geismar are anthologists, assemblers, and compilers who reduplicate the things they put together, multiply them tenfold—or more. It is the technique of repetition—what they call "collection." In the process, they transform whatever they collect, give it a new turn, and imbue it with new meaning. This technique of repetition, reduplication, or multiplication—starting with a single item and reiterating throughout a corporate program—is a unifying element in their work.

Chermayeff and Geismar collect samples of old typefaces and street signs because such things communicate directly. They are especially addicted to old art of anonymous printers and sign painters that shows unconventional, nontraditional inventiveness of an improvisational nature—accidents, laissez faire, spontaneity, and whimsy. It is the 1960s addiction for happenings. In fact, Chermayeff and Geismar's work often has the air of a graphics happening—casual, but hardly accidental.

Logo:
Best Products Co., Inc.,
1979

Sometimes they make collections of different things of

the same generic nature. In the logo for a shop in Cambridge, Massachusetts, for example, the name of the firm is formed by letters, each taken from a different typeface; in their logo for Brentano's bookstores, a collection of uppercase letters of several typefaces is interspersed in a randomlike quality. They scramble these found objects–it is a Pop/Dada approach–into new visions of the old, the old becoming new and the new gaining distinction from the old. For them, it is "rediscovery as a form of discovery."

For Yale's Garvan Collection of American Furniture, a group of Windsor chairs and benches is hung on a white wall, with Shaker-like simplicity one above the other as well as side by side, so that the display looks like an illustration of silhouetted chair styles as well as a collection of furniture. Again, the arrangement has a random quality like the old typefaces.

Their technique of repeating collections is also seen in clustered corporate logos and symbols that read like overall watermark patterns on stationery, bank checks, and shopping bags. And they have repeated a single rubber stamp all over a poster in a scatter-fire, crazy-quilt kind of imagery. For a Pepsi-Cola annual report, they collected used bottle caps and stacked them up like a bar chart of rising sales. For an Aspen Design Conference poster, they assembled luggage tags from airports all over the world and created an overall quilt pattern to show the international influence of the conference.

The technique permeates their work. Stars are repeated to form a crown on a poster for "Queen of the Stardust Ballroom." Short rectangular brush strokes are reiterated in grids to form lighted windows on a poster for "New York Nights." One of their posters has a cluster of souvenir models of the Statue of Liberty–a found object, Pop item–as an illustration for the National Park Service's Museum of Immigration. At Montreal's Expo 67, they clustered several hundred hats on hatmakers' forms to exhibit the great variety of occupations, professions, and services–the police, firefighters, welders, nurses, motorcyclists–who make up this country. The message–variety–could not be embodied or demonstrated by a single object, but the repetition technique made it loud and clear.

In the U.S. pavilion at Osaka for Expo 70, Chermayeff and Geismar collected masses of weathervanes as one exhibit. In an exhibition on "Productivity" for the Department of Labor at the Smithsonian Institution, they assembled all the protective gloves and helmets that American workers wear; it was a means of calling attention to safety and to improved working conditions.

They call this technique "the supermarket principle." As in supermarkets, the display of relatively unrefined package designs in mass often produces a cumulative effect far beyond the quality of the individual package. It makes an overall pattern that becomes something more than the sum of the individual parts. Even with patently undesigned or ugly things–air-conditioning outlets, crumpled car parts, worn-out gloves–the massing of them can diffuse the ugliness of the single item and create a transcendingly effective overall pattern and rhythm.

As perhaps their ultimate gesture in this direction, Chermayeff and Geismar have collected multiples of the same shell from an American beach and have filled a transparent plastic box with them; then next to that box, they have filled another box with shells from an Italian beach, then a box of shells from an Australian beach, and so on. The boxes are then ganged like a display

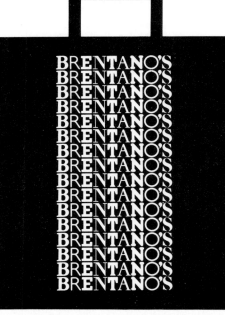

Shopping Bag:
Brentano's, 1978

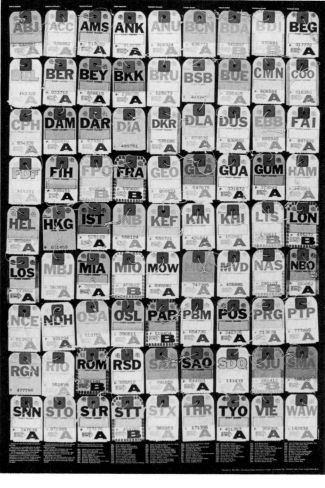

Poster:
International Design Conference in Aspen, 1973

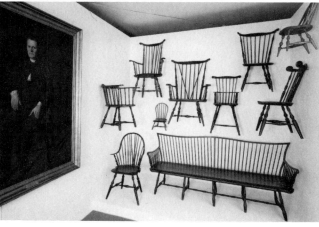

Exhibit:
Yale University/Mabel Brady Garran Galleries of American Arts, 1973

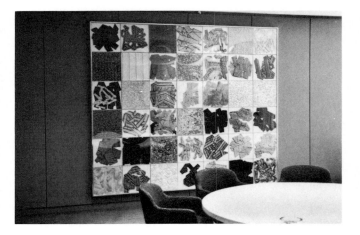

cabinet. In another cabinet, there are boxes of pasta from around the world; another has a collection of sands from around the world; another has ribbons. These modest items not only build up decorative textures, but also form an appropriate art-assemblage program for IBM's World Trade-Far East Headquarters: international stored information.

A Variety of Techniques

To most Americans, the idea that images can be words with meanings is new and unfamiliar. But in the Orient, where words are pictures—pictograms and ideograms—it does not come as a surprise. There, scrolls of calligraphy have been hung on walls like pictures for centuries. Chermayeff and Geismar's pictures are similarly artful words in a Western language.

They deal with meanings of several kinds, such as the various meanings of colors. Culturally, we are taught that red means stop and green means go. Physically, according to nature's properties, we directly associate red with hot and blue with cold. Chermayeff and Geismar work with these accepted axioms, with the givens of common knowledge, with simple knowns—things from childhood, nature symbols, universal standards.

With these unmistakable givens, they often go on to make juxtapositions that express incongruities, that are often revealing combinations of reversal, surprise, or discordant harmony. They create images that are two things at the same time, both good and bad, both what they say and not what they say: visual puns, visual sarcasm, visual comments on the statement. Visual poetry.

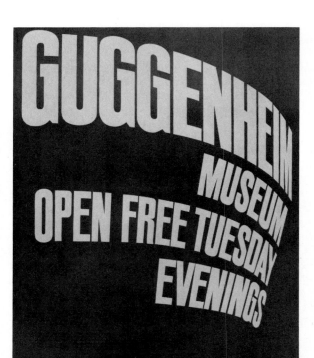

There is always an element of surprise in their work, which is the hallmark of art—to present us with something new that illuminates the subject, its emotional content, or the process of communication. Their logo for Mobil, in a typeface they designed for the corporation, is based on the circle and cylinder motif of filling stations and other architectural elements of the corporate program that were established by the late architect Eliot Noyes. Chermayeff and Geismar have reinforced that motif by singling out the circle in the corporate name and coloring it red. It is a surprising element, but one fundamentally consistent with the overall design program of circles.

Among their techniques of surprise is a device they call "expressive typography" in which type is placed to show—literally—the message or the form of the subject. They have printed the word "dead" with the final "d" turned at a 90° angle, fallen down to reinforce the meaning of the word. This is repetition in two languages, both words and pictures.

On their posters for free Tuesday evenings at the Guggenheim Museum and at the Whitney Museum, the type is placed in the shape of those buildings. The Guggenheim poster has the words in the spiral form of the Frank Lloyd Wright building; the Whitney poster outlines the overhanging ziggurat form designed by Marcel Breuer. It is pictorial typography.

The designers like to say the same thing two ways at the same time. They have printed the word "No" with an X through it, for example. And when they designed the layouts for the magazine *Innovation,* they printed the page numbers in both numerals and letters—"2wo."

They also make use of a primitive quality in calligraphy and illustrations. In their poster for a television production of *War and Peace,* a childlike painting of a bird with an olive branch sits on a pyramid of cannonballs. That says it not only in two ways, but with the simplest, almost naive, pictorial technique. And it creates a very grown-up irony.

With all these approaches and techniques, Chermayeff and Geismar communicate in flashes of illuminating insight. The designers have become not only collectors of programs, but programmers of collections. It is for this graphic poetry that Ivan Chermayeff and Thomas Geismar were awarded the AIGA Medal for 1979.

A dramatization of the Tolstoy novel presented on PBS-TV

Beginning November 20 Made possible by matching grants from

National Endowment for the Humanities & Mobil Oil Corporation

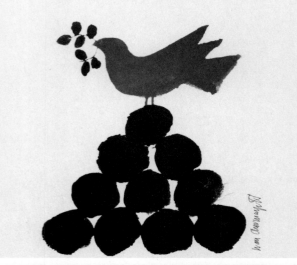

WAR AND PEACE

Poster:
War and Peace, 1973

Masterpiece Radio Theatre

Beginning May 5 on National Public Radio
Saturdays at noon; Sundays 6-7 pm
WNYC am830 fm94 Host: Julie Harris

Mobil

Poster:
Masterpiece Radio Theatre, 1979

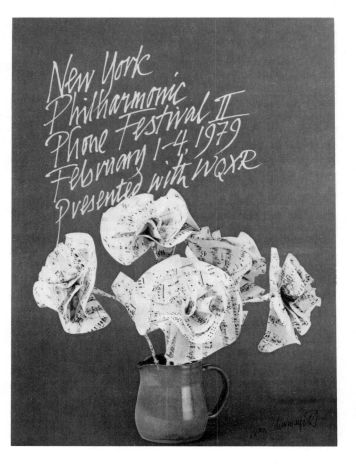

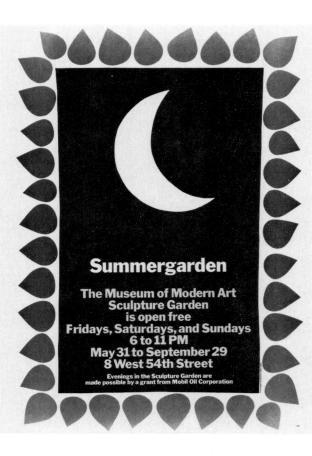

Mobil Showcase presents

Minstrel Man

March 2 CBS channel 2 9pm

Mobil

Poster:
Designer's Saturday, 1978

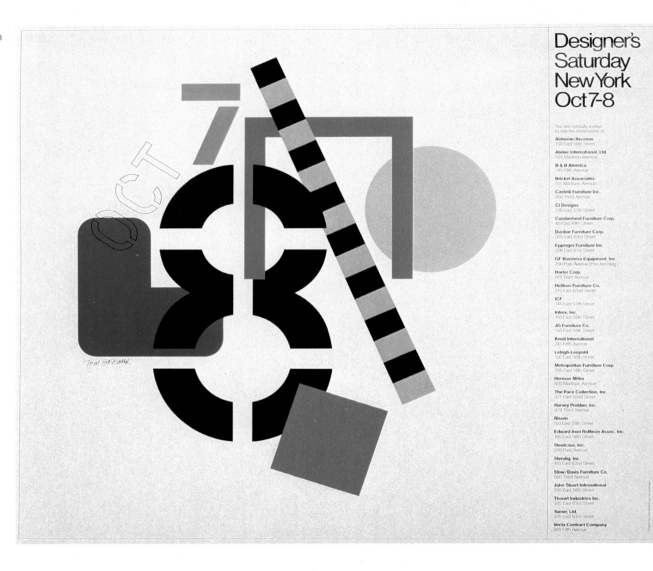

Poster:
Thomas Edison/National
Park Service, 1978

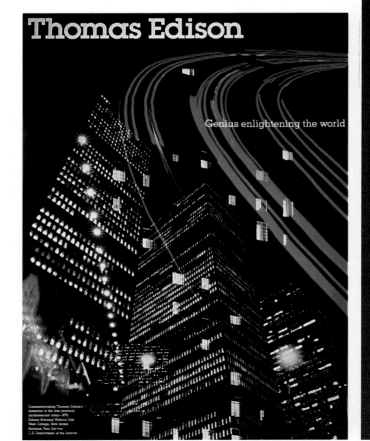

Poster:
Designer's Saturday, 1978

Poster:
Thomas Edison/National
Park Service, 1978

Poster:
American Bicentennial
Theater, 1976

Introduction

AIGA Graphic Design USA: 1 is the first annual volume that documents the exhibitions of the American Institute of Graphic Arts. For the past 65 years, the Institute has conducted an interrelated program of competitions, exhibitions, publications, and educational activities to record, acknowledge, and encourage excellence in graphic design. In the past, each AIGA exhibition, judged by an invited jury of peers, has been recorded in an accompanying catalog. Traditionally, there have been four to five exhibitions each year, as well as the award of the Institute's Medal to an individual who has made an outstanding contribution to the graphic arts. This year, for the first time, these activities are recorded in a single volume so that the work in the Institute's exhibitions can be disseminated to a broad national and international audience.

AIGA Graphic Design USA: 1 is a record of the state of graphic design in America today. Exhibitions are open to all graphic designers and calls for entry are sent to a variety of professional lists. Entries, to be eligible, must have been designed and originated in the United States or Canada within a given period of time.

Numerous considerations affect the representative nature of AIGA exhibitions and, consequently, viewers' comprehension of the state of American graphic design at the time. After a profession has held itself up to this examination process, with all its variations, four or five times annually, it is bound to have developed a representative view of its current state. The exhibitions presented in this volume then, as well as Medalists selected by committee procedure, indicate the vitality of the graphic design profession.

Perhaps even more important historically, AIGA *Graphic Design USA: 1* indicates what the future may bring. New graphic directions and new graphic talents are there to be discovered. This is not an easy task. And most juries have a difficult time in verbalizing observations of this kind. Innovations are not immediately apparent. Yet often they are there—changes that may be beginnings of new styles, new stylistic movements. These turn out to be new directions only five or so years later, by which time more designers have adopted the techniques or approaches and have developed them into apparent new trends.

Such new directions in the past hundred years have produced epochal movements—like Art Nouveau, Art Deco, and the Bauhaus. But they have only been recognized as such long after they first emerged—in the beginning, they were barely discernable. As one juror noted: '"Most things happen by evolution and not revolution. The only really major movement in my 30 years in the graphics field has been the advent of the Swiss method. And that was already 20 or 30 years old when it hit here." Can the first piece of Swiss graphics submitted to an AIGA exhibition have gone unrecognized? Could the jury have eliminated it because it was too idiosyncratic or far out—or because it was not a well-designed piece?

Furthermore, judges often cannot make pronouncements on the relationship between a new approach and the rest of mainstream creative activity because they are too closely involved in their own creative activities to have critical distance or perspective. Today, for example, graphic design judges see a great deal of "eclectic" work. They say: '"There is so much Bauhaus, so much Art Deco, so much Art Nouveau, so much Fiorucci." But they do not say—although they may know it—that together these comprise the decade's main current, which is historicism. Surely, it is the inclusion of all periods of history into a new mix that makes this century's battle of historical styles far more complex than the battle of styles in the 19th century.

Yet who could have known or foreseen a decade or so ago that the preservation movement—in architecture, interior design, music, dance, painting, sculpture, fashion, and film—could have permeated our culture as it has today? In the midst of any age—in the '"too obdurate presence of things," as poet-critic Max Eastman has written—it is difficult enough to distinguish one development from another. But in the decades of the 1970s and 1980s, the explosion of communication and styles—and of responses to both—makes such vision all the more difficult.

Through the words of the AIGA juries, we can see a history of style: fifteen years ago the jury chairman wrote that there was to be seen '"a strong trend . . . recalling the visual world of the gay twenties, reflecting the weakness for accepted values of the past rather than facing today's reality." In those words we recognize the lingering antihistorical taboo of the High Modern movement. Yet by 1978 a juror could say: '"The work submitted indicates that we can kiss the Bauhaus goodbye."

Both statements tell a tale of stylistic movement away from the tenets of modernism and toward our own inclusively eclectic historicism. Now we can have the Bauhaus and the 1940s, Picasso and Rockwell Kent, Punk Rock and High Helvetica—and now "Punk Helvetica." As the selections in this volume immediately demonstrate, we want it all, and we can have it.

Whether AIGA *Graphic Design USA: 1* also defines and demonstrates "an AIGA aesthetic," as some observers suggest, will probably only become truly clear—like the history of a profession or of a style—as subsequent AIGA annuals are published and compared in the mature, vital, graphic arts age of the 1980s.

The Judging Procedure

As in most design awards programs, the final selection by judges is preceded by the preliminary selection of those who enter. Designers contribute to a representative national selection by determining which of their own works that they consider to be best. Sometimes they do not submit the works that many—including the judges—remember and consider to be their best. Other designers choose not to enter at all, though their work may also be among the finest of the period.

Foremost, then, the graphic design profession at large—by both fault and default, as well as by thoughtful selection and active involvement—determines the representative nature of AIGA exhibitions: their breadth or restrictiveness, their diversity or consistency, their presentation of all categories of design projects, their demonstration of all current techniques and approaches.

The jury process itself affects the representative nature of the exhibited materials in three ways. The most critical to that process is the selection of the jurors by committee chairmen. This is virtually the only direct influence that the AIGA exercises on the exhibitions that are finally mounted. And, in any jury procedure, the personal leadership or persuasiveness of one juror over others often plays an important part. If the same group of entries at most awards programs were judged by a different jury, it

The AIGA is indebted to the following organizations and individuals whose support has made our program possible.

Sponsors

American Cancer Society
American Heritage Publishers
Andrews/Nelson/Whitehead
Atlantic Richfield Co.
Avon Books
N.W. Ayer & Son
Baldwin Paper Co.
The Book Press, Inc.
CBS Broadcast Group
Carnegie-Mellon University
Carpenter Paper Co.
Champion International Corp.
Chermayeff & Geismar Assoc.
Connecticut Printers
Container Corporation of America
Corporate Graphics
Crafton Graphic Co., Inc.
Dandelion Press
Davis-Delaney-Arrow, Inc.
R.R. Donnelley & Sons
Doubleday & Co.
Dow Jones & Co.
Dundalk Community College
E.P. Dutton & Co.
Exxon Corp.
General Foods Corp.
Ginn & Co.
Grosset & Dunlap
Harcourt Brace Jovanovich
Harvard University Press
Hobart McIntosh Paper
Holt, Rinehart & Winston
Jack Hough Assoc.
Houghton Mifflin Co.
IBM
Innovative Graphics International
International Typeface Corp.
Joanna Western Mills
Kaeser + Wilson Design
Lake County Community College
Largene Press
Lehigh Press
The Library of Congress
McGraw Hill, Inc.
Macmillan Publishing Co.
Maple Press
Mead Paper Corp.
Mergenthaler Linotype Co.
Metropolitan Museum of Art
Mohawk Paper Mills
Mohawk Valley Community College
W.W. Norton & Co.
Parsons School of Design
J.C. Penney Co.
Pennsylvania State University
Perkins & Squier Co.
Prentice-Hall, Inc.
RCA Corp.
Random House
Rapoport Printing Co.
Raychem Corp.
St. Martin's Press
Sanders Printing Corp.
Sender Bindery
Simon and Schuster, Inc.
The Sloves Organization
Smith Kline & French Laboratories
Sports Illustrated
Takeo Paper Co.
J. Walter Thompson Co.
Time, Inc.
Time-Life Books
Tri-Arts Press, Inc.
Typographic Innovations, Inc.
USV Pharmaceutical Corp.
University Graphics
Vignelli Assoc.
Viking Press
Western Publishing Co.
Wilbar Photo Engraving
John Wiley and Sons
William Paper Co.
Worth Publishers

Contributors

American Printers and Lithographers
Bill Caldwell
CBM Type
Champion International Corp.
Stephen Chapman
Chermayeff & Geismar Assoc.
Composition System
Container Corporation of America
Crafton Graphic Co., Inc.
Otto Daeppen
Design Typographers
John Drummond
Eagle Envelope Co.
Nicholas Fasciano
Franklin Photolettering
B.J. Galbraith
Garret Buchanan Co.
General Foods
Gips + Balkind + Assoc.
Diana Graham
Great Lakes Press
Haber Typographers, Inc.
The Hennegan Co.
Jack Hough Assoc.
Innovative Graphics International
Jashio
Dave Jordano
Kenner Printing Co.
Lindenmeyr Paper Corp.
Lettick Typografic
Dick Lopez, Inc.
Anne McCormick
William McDowell
Gene Mayer
Mobil Oil Corp.
Potlach Corp.
Printers Bindery Inc.
RVI Corp.
Sanders Printing Corp.
Sender Bindery
Smith Lithograph
Mikio Togashi
Tandem Press
Tri-Arts Press
Derek Ungless

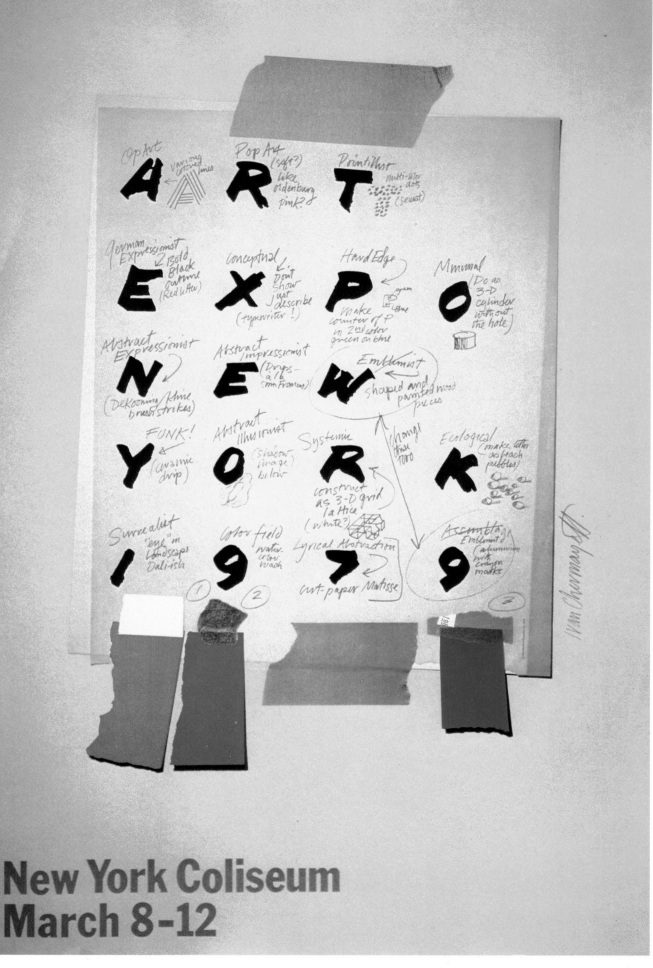

**New York Coliseum
March 8-12**

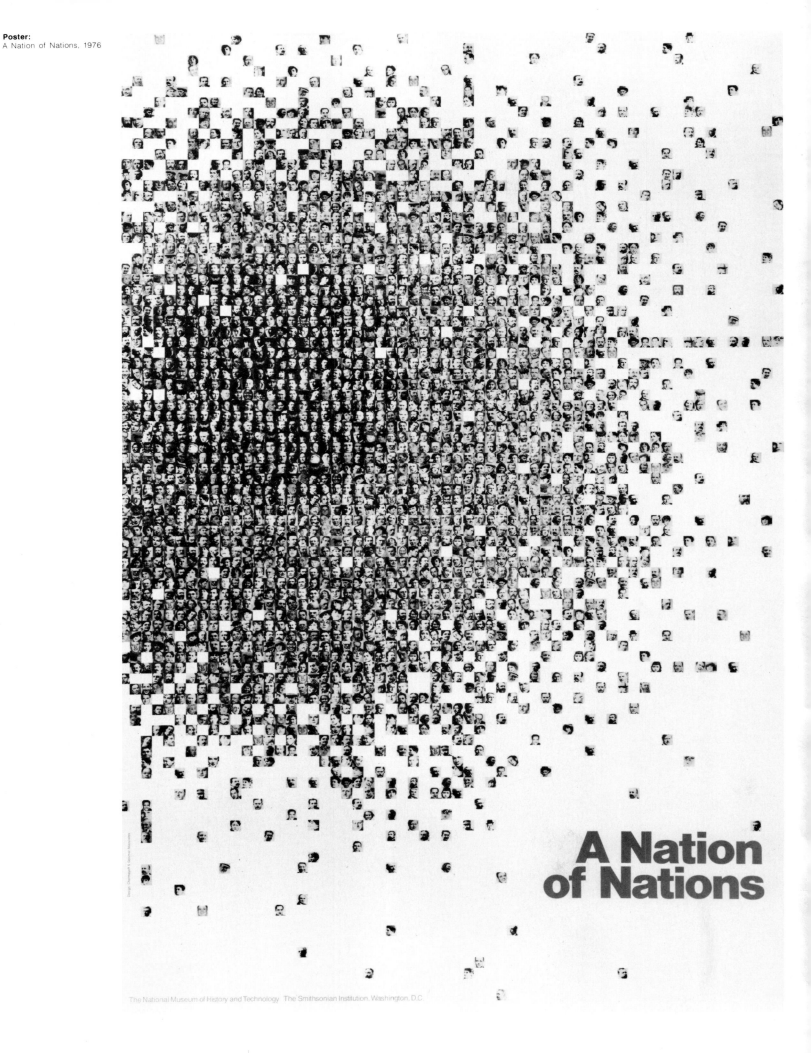

A Nation
of Nations

The National Museum of History and Technology The Smithsonian Institution, Washington, D.C.

DARLING DAUGHTERS
SWEET MOTHERS DANCE
BLACKLIGHT DYNAMITE
ACROBATS ASTROLOGERS
JUGGLERS FREAKS CLOWNS
ESCAPE ARTISTS VIOLINISTS
GROK GRAPES GRASS
UPS DOWNS SIDEWAYS
AIR-CONDITIONED
IN MORE WAYS THAN ONE
THE ULTIMATE LEGAL
ENTERTAINMENT EXPERIENCE

THE ELECTRIC CIRCUS
OPENS JUNE 28, 1967
23 ST. MARK'S PLACE, N.Y.C.
EAST VILLAGE
THINK ABOUT IT.

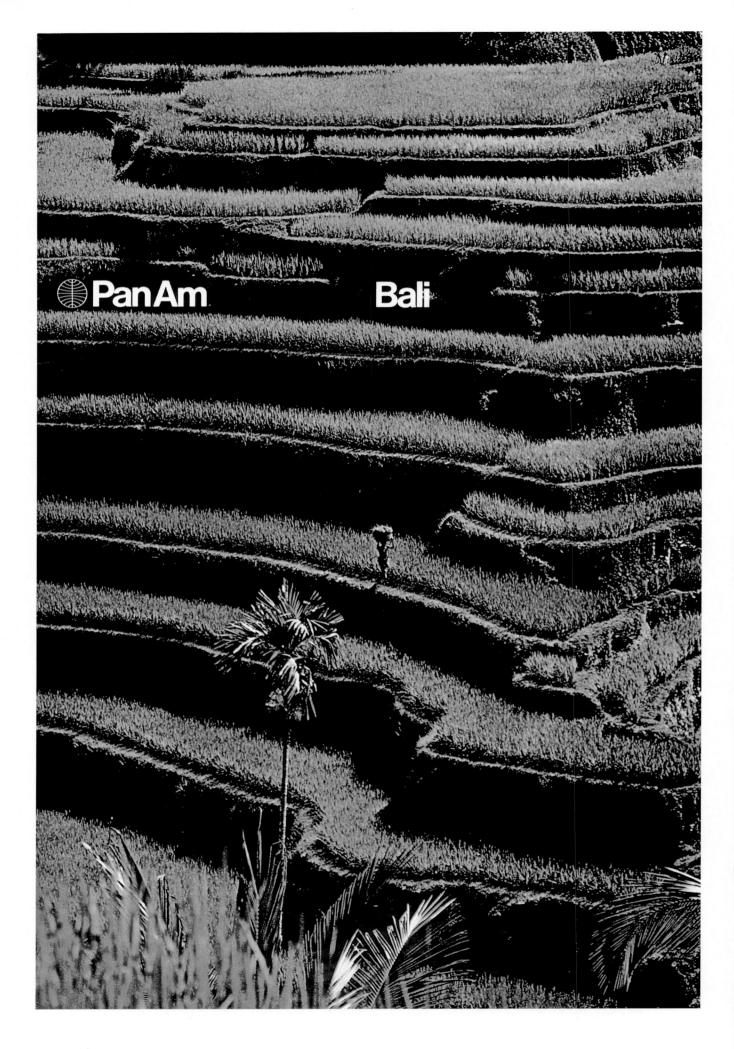

Visit The New York Botanical Garden Conservatory. MTA gets you there.

Subway: (D)(4) to Bedford Park Blvd then take Bx17 bus eastbound
(2) to Allerton Ave-White Plains Road then take Bx17 bus westbound
Bus: Bx17 Bx31 Bx41 Bx55
Transit Information: (212) 330-1234

Conrail: Harlem Line from Grand Central or 125th St to Botanical Garden
Conrail Information: (212) 532-4900

 Metropolitan Transportation Authority

Provided as a public service by Mobil

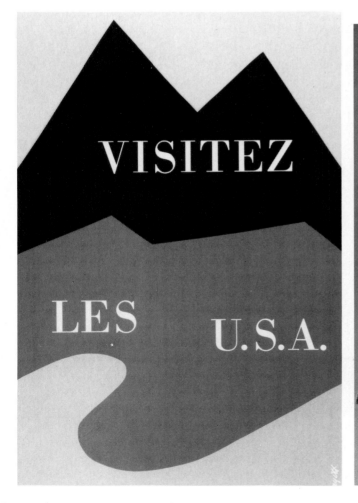

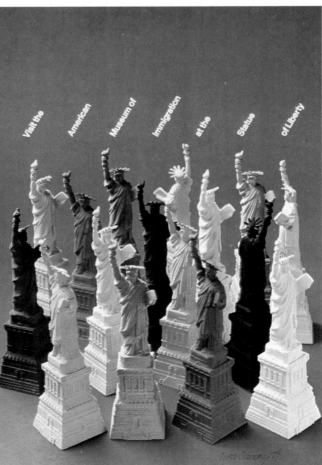

Poster:
New York Botanical
Garden/MTA, 1978

Poster:
Visitez les USA, 1967

Poster:
American Museum of
Immigration at the
Statue of Liberty, 1974

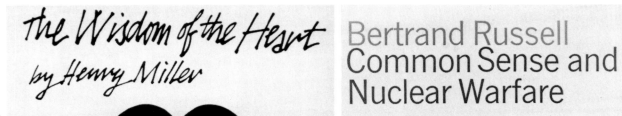

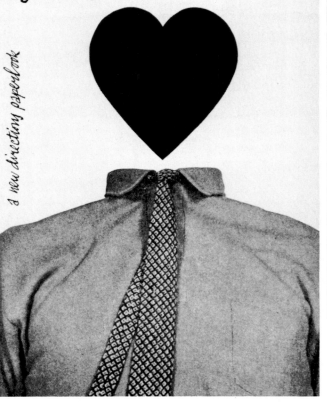

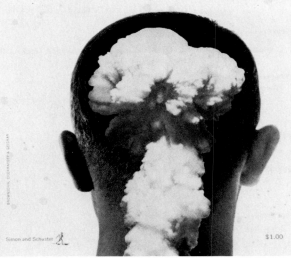

Book Jacket:
Common Sense and
Nuclear Warfare, 1959

Magazine Cover:
Architectural and
Engineering News,
August 1965

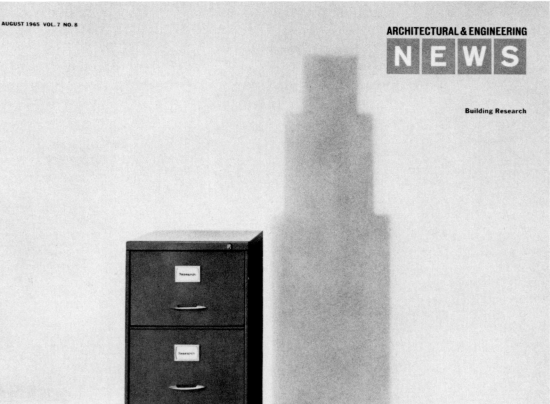

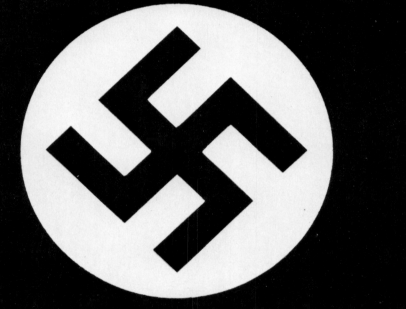

The Rise and Fall
of the Third Reich
A History of Nazi Germany
by William L. Shirer

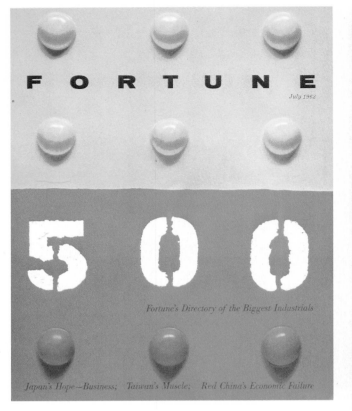

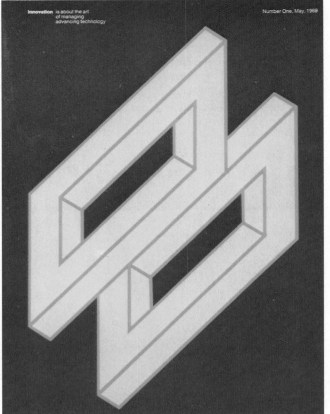

Book Jacket:
Art of Assemblage, 1961

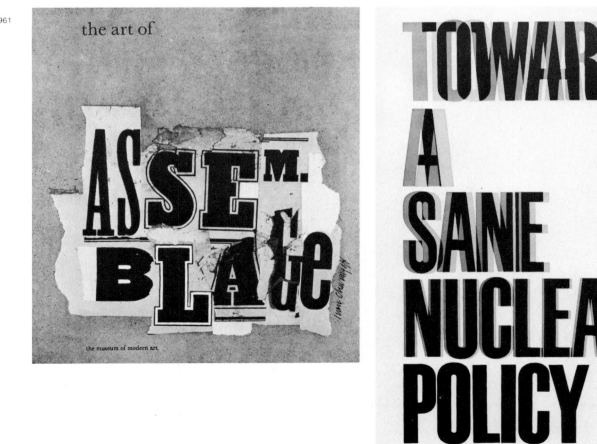

Book Jacket:
Toward a Sane Nuclear
Policy, 1960

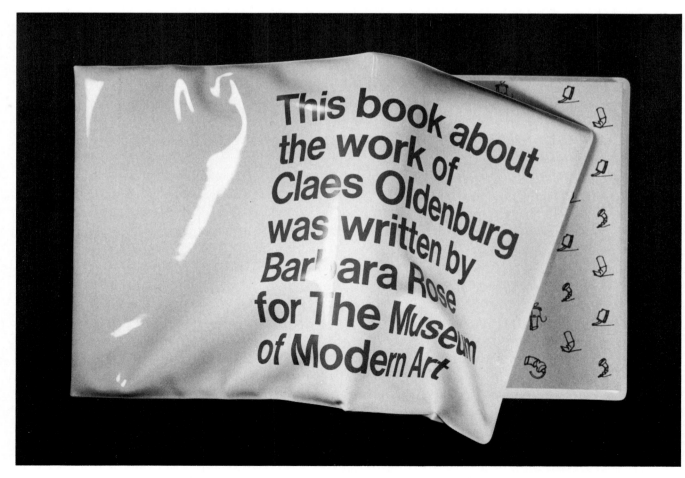

Announcement:
Howard Wise Gallery, 1960

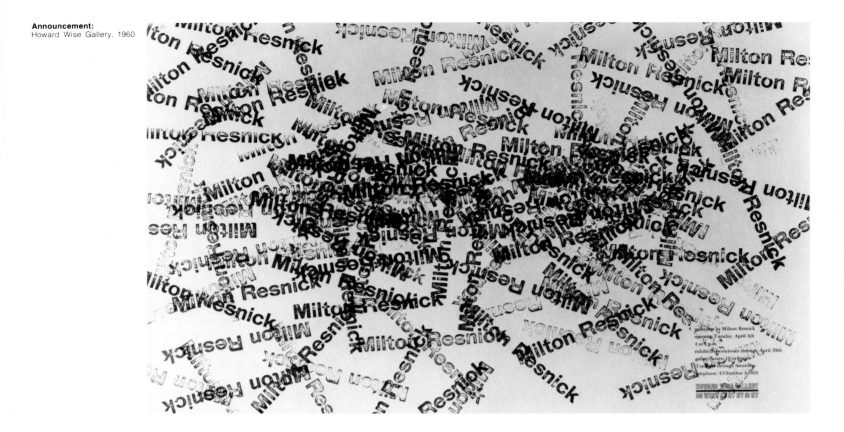

paintings by Milton Resnick
opening Tuesday, April 4th
4 to 7 p.m.
exhibition continues through April 29th
gallery hours: 10 to 6 p.m.
Tuesdays through Saturdays
telephone: COlumbus 5-0465

HOWARD WISE GALLERY
50 WEST 57 ST NY 19 NY

Announcement:
Howard Wise Gallery, 1960

paintings by John Grillo
opening Tuesday, February 7th
4 to 7 p.m.
exhibition continues through March 4th
gallery hours: 10 to 6 p.m.
Tuesdays through Saturdays
telephone: COlumbus 5-0465

HOWARD WISE GALLERY
50 WEST 57 ST NY 19 NY

GRILLO

AT WW ORRKK

Booklet:
About U.S. (one of a series
on experimental typography),
1960

Visit **New York** for the first time;

walk in any direction

until you're thirsty.

Drop anchor at any *Bar and Grill;*

talk to the bartender; tell him you're **a stranger,**

never saw the city before.

If that will be says

You should have seen it in the **old days.**

Take this neighborhood.

None of these big apartment houses then.

Or take the Bronx.

It was a wilderness;

walk a mile to the el.

Mouquin's, Villepegue's, Shanley's, the old Claremont Inn and Broadway—

Give my regards to Broadway.

They don't come like that any more.

I was a kid selling papers outside of **Luchow's** on Fourteenth Street.

Every night,

this guy with a fur collar on his coat

gives me a dollar for the **Globe**

and lets me keep the change.

They don't come like that any more.

Beneath the chimney pots

of The Village,

They lived for a while,

or tried to.

1ne
2wo
3hree
4our
5ive
6ix
7even
8ight
9ine
10n
11even

Catalog Cover:
Graphic Arts USA,
USIA Exhibit, 1963

АМЕРИКАНСКАЯ ГРАФИКА

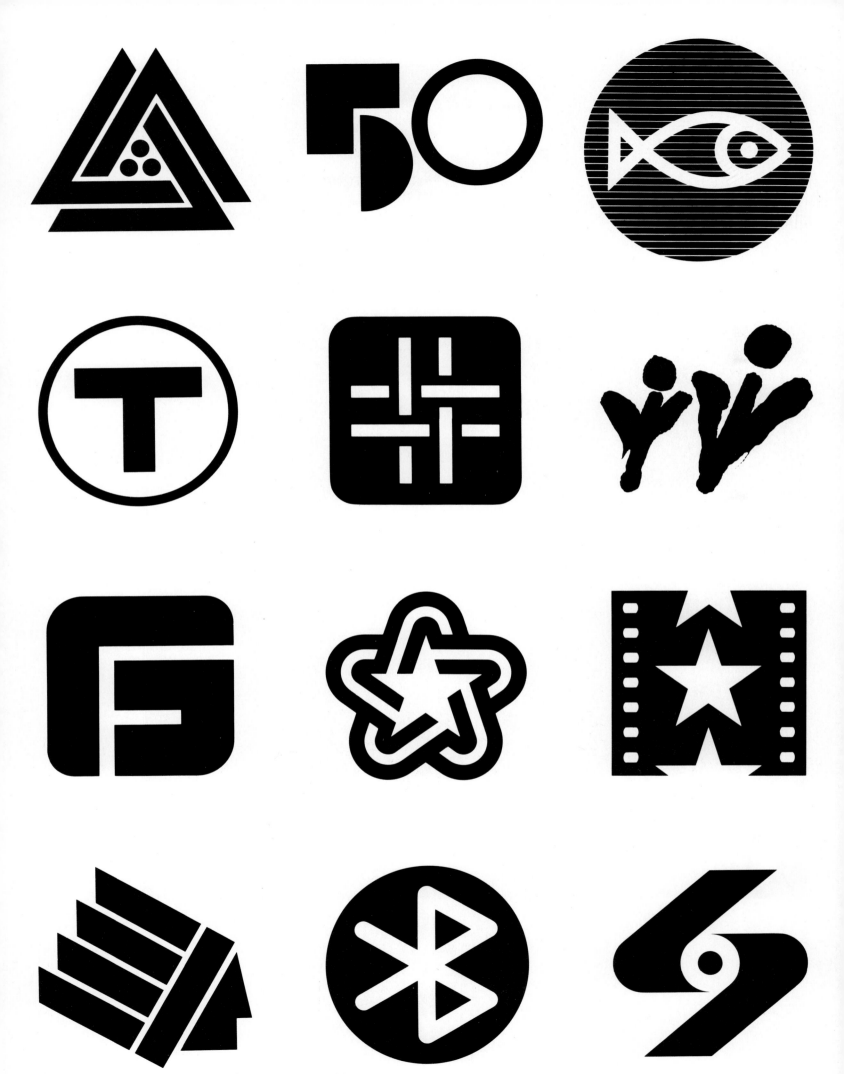

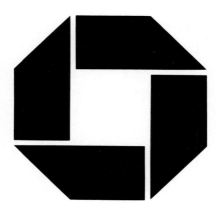 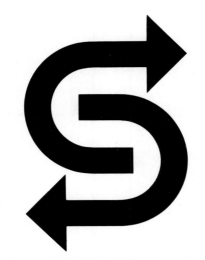

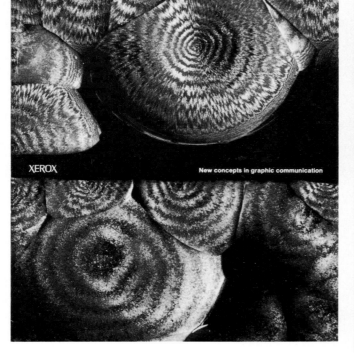

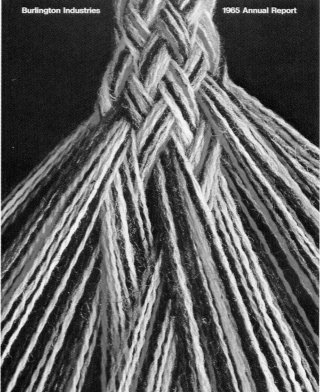

Annual Report:
Burlington Industries, 1965

Annual Report:
Torin Corp., 1973

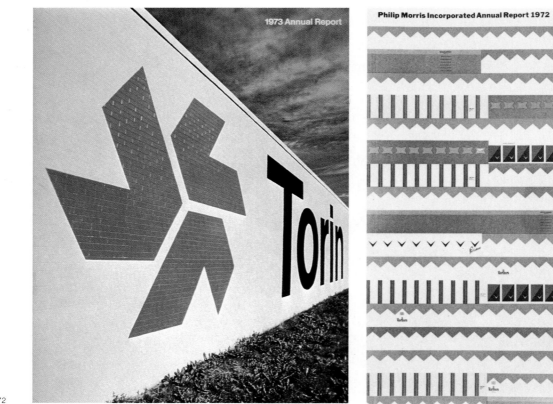

Annual Report:
Philip Morris, Inc., 1972

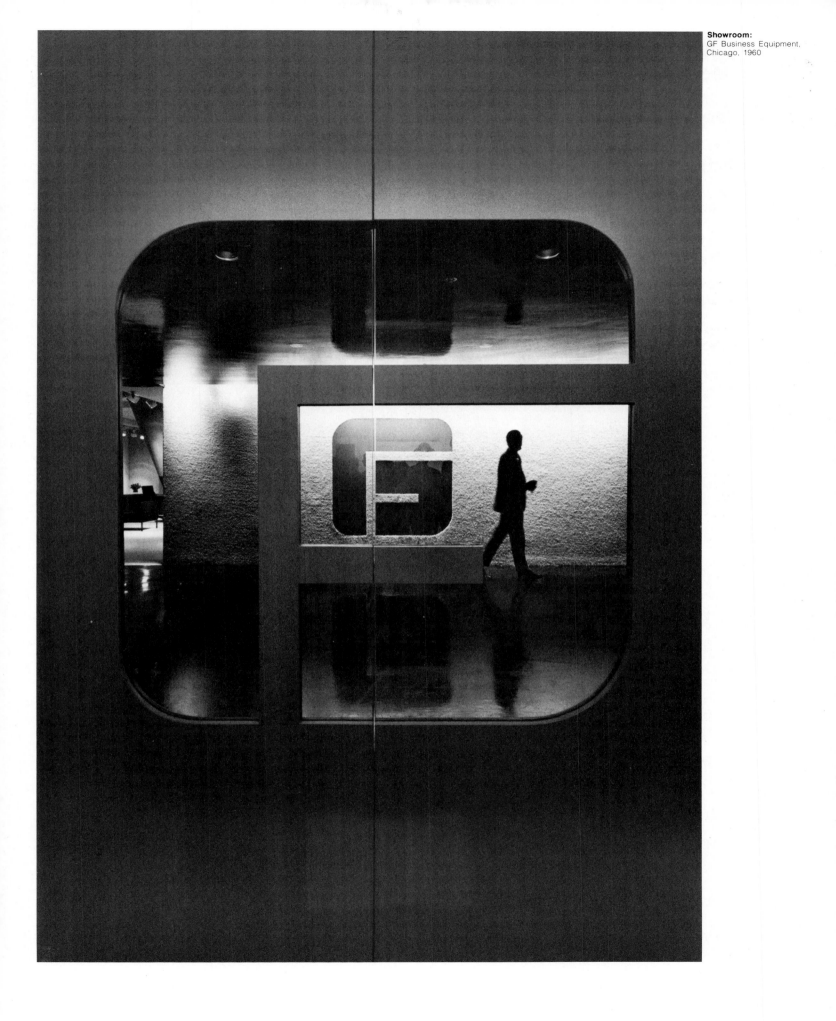

Showroom:
GF Business Equipment,
Chicago, 1960

Package:
May D & F, 1977

Logo:
Seatrain Lines, 1965

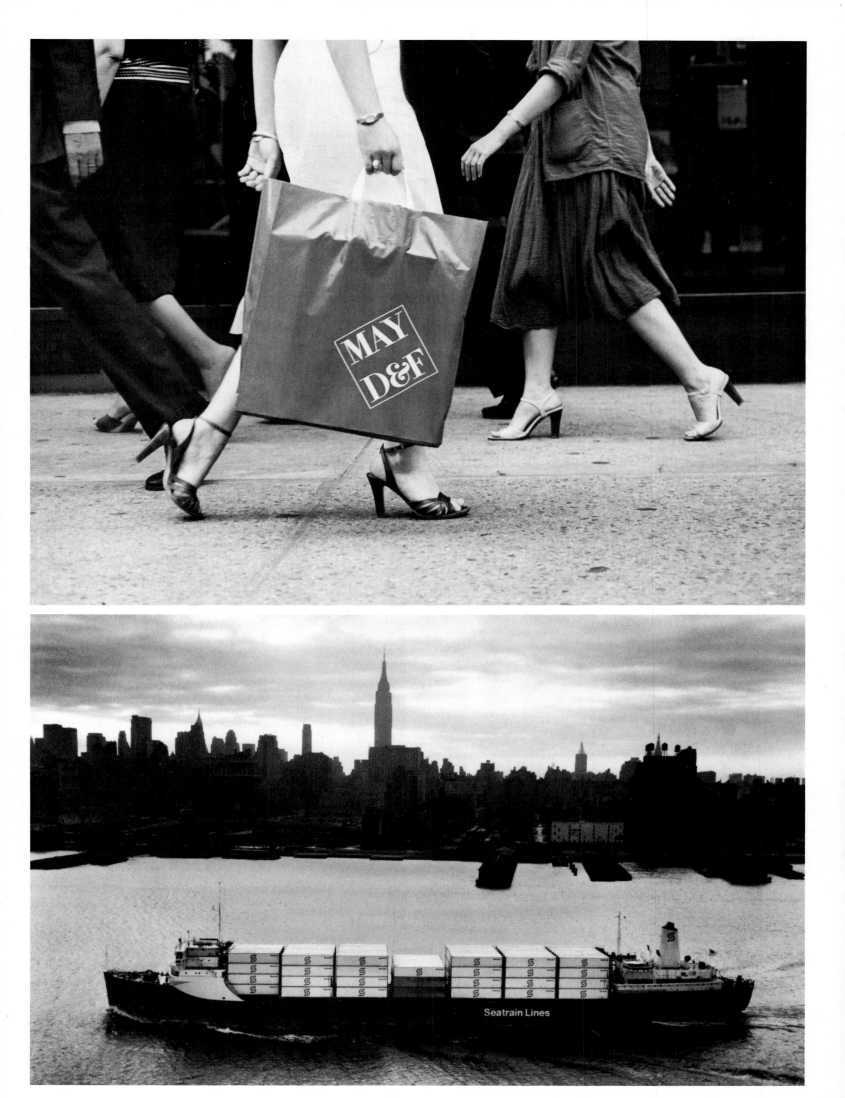

Mobil Graphics 2

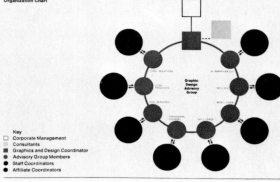

Graphic Design Advisory Group

How is Mobil's Identity Program organized?

What is the role of the Graphic Design Advisory Group?

What is the role of a graphics coordinator at the corporate, staff and affiliate levels?

These were three of the questions raised by readers of the first issue of Mobil Graphics. The purpose of this article is to answer these questions.

Early in 1967, Mobil Oil Corporation's management established the organization for the Identity Program, and distributed a memorandum outlining coordinating relationships.

In summary, Mobil Oil Corporation's Design and Graphics Development Coordinator, working with consultants, was given the responsibility for coordinating the use of graphics throughout the Mobil group of companies, for developing standards for all graphics of these companies and for monitoring graphics quality and consistency.

At the same time, a Graphic Design Advisory Group was established within the corporation. This group, shown in the accompanying chart, represented principal graphics areas in both the petroleum and chemical fields, such as

merchandising, advertising, forms design, etc. The group's duties include:

—Responsibility for the quality and consistency of Mobil's design image.

—Periodic review of graphics and design work done throughout the Mobil organization.

—Maintenance of graphics standards by advising Mobil's and its affiliates' personnel involved with graphics on ways of observing the guidelines, and by bringing to the attention of the responsible department any work that fails to meet Mobil's graphics standards.

The Advisory Group meets periodically, and with the guidance of the corporation's coordinator and outside consul-

(Article continued on back page)

Organization Chart

Key
☐ Corporate Management
☐ Consultants
■ Graphics and Design Coordinator
● Advisory Group Members
● Staff Coordinators
● Affiliate Coordinators

Indian Head Annual Report 1971

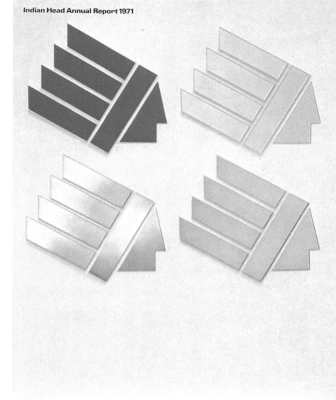

Brochure:
Mobil Graphics 2, 1971

Annual Report:
Indian Head, Inc., 1971

Brochure:
Mobil Oil Corp., 1976

Brochure:
Xerox Corp., 1973

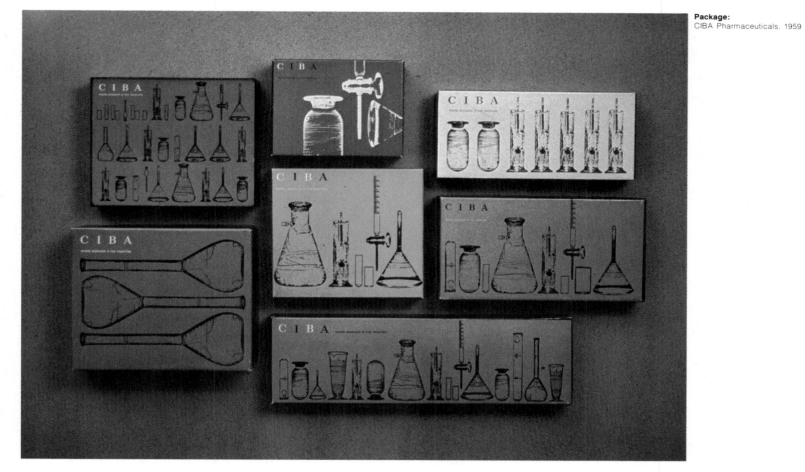

Package:
CIBA Pharmaceuticals, 1959

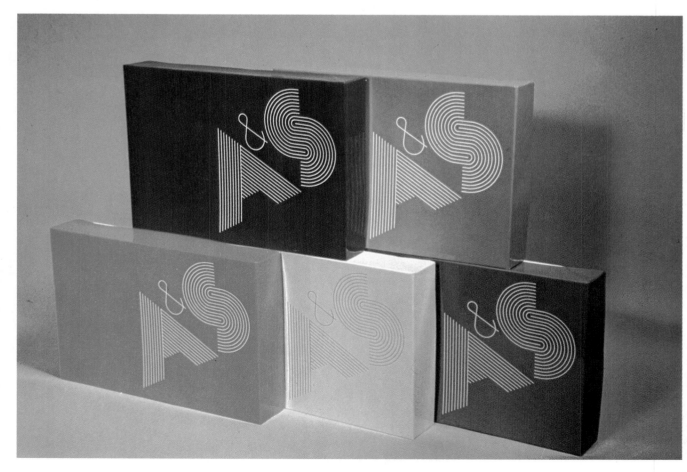

Package:
Abraham & Straus, 1976

Package:
Brentano's, 1978

Package:
Saks Fifth Avenue, 1976

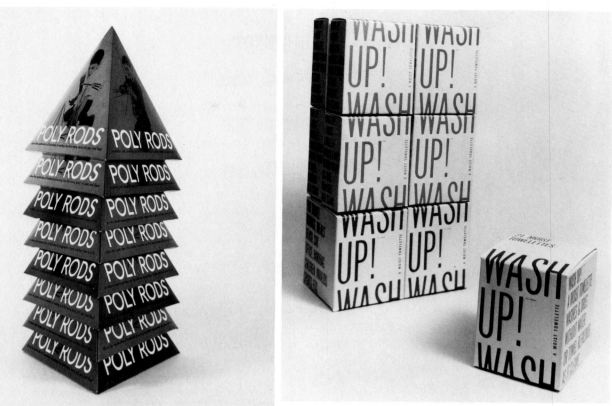

Package:
Poly-Rods, 1958

Package:
Wash Up!, 1959

Package:
Mobil, 1965

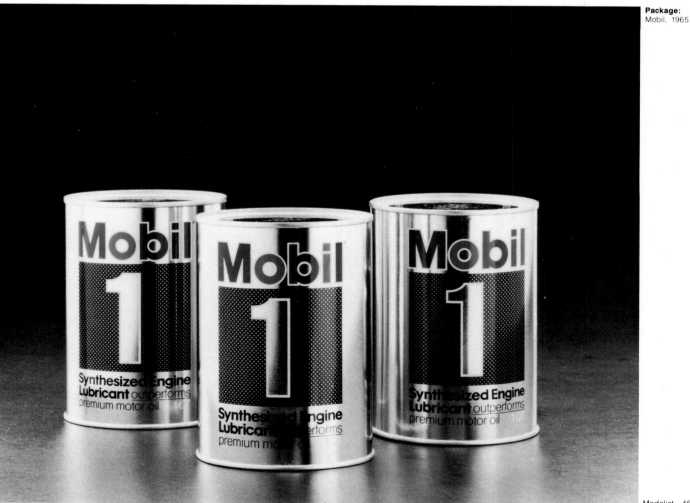

Sign:
Best Products Co., Inc.,
1979

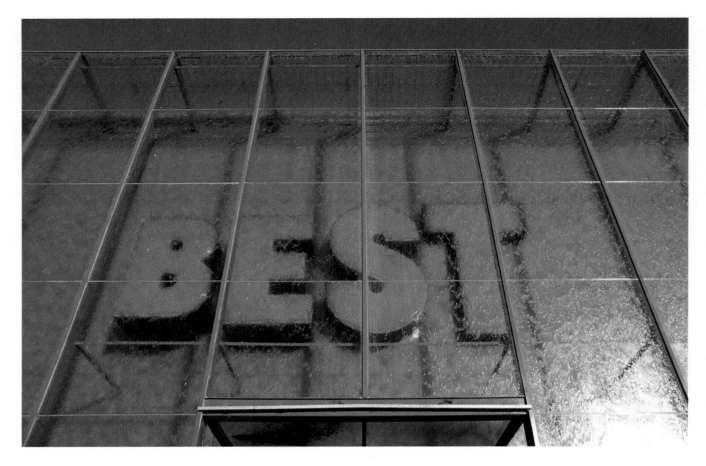

Water Fountain:
St. Louis
Children's Zoo, 1969

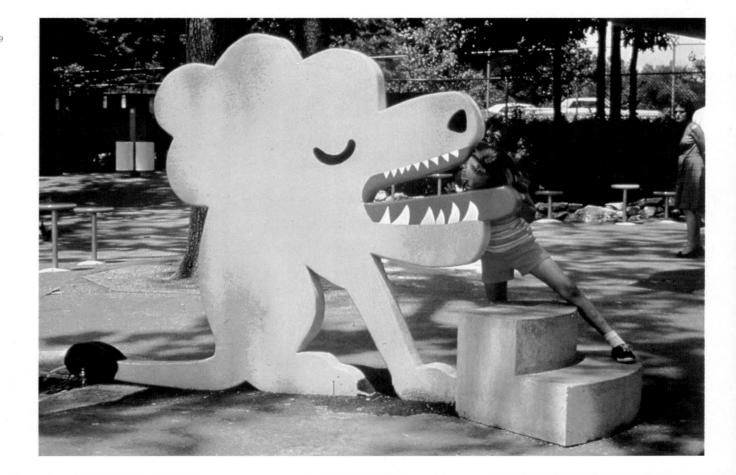

Banners:
The Museum of
Modern Art, 1964

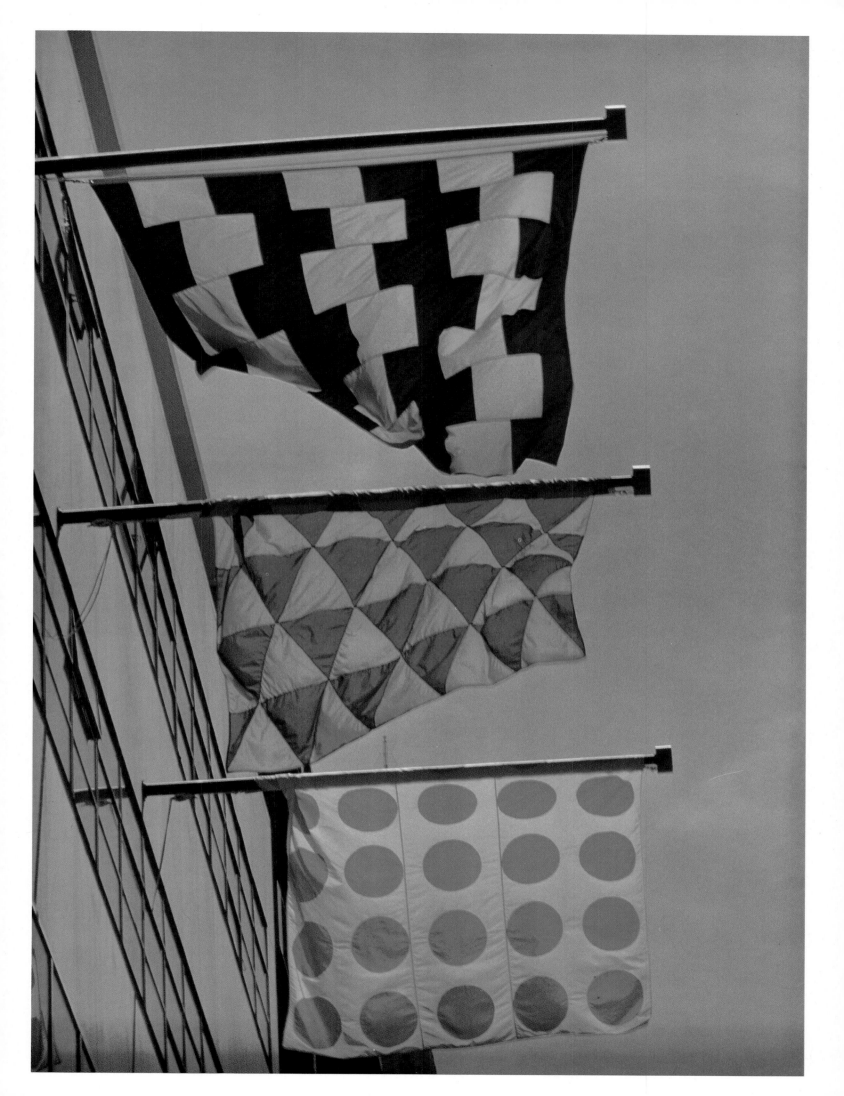

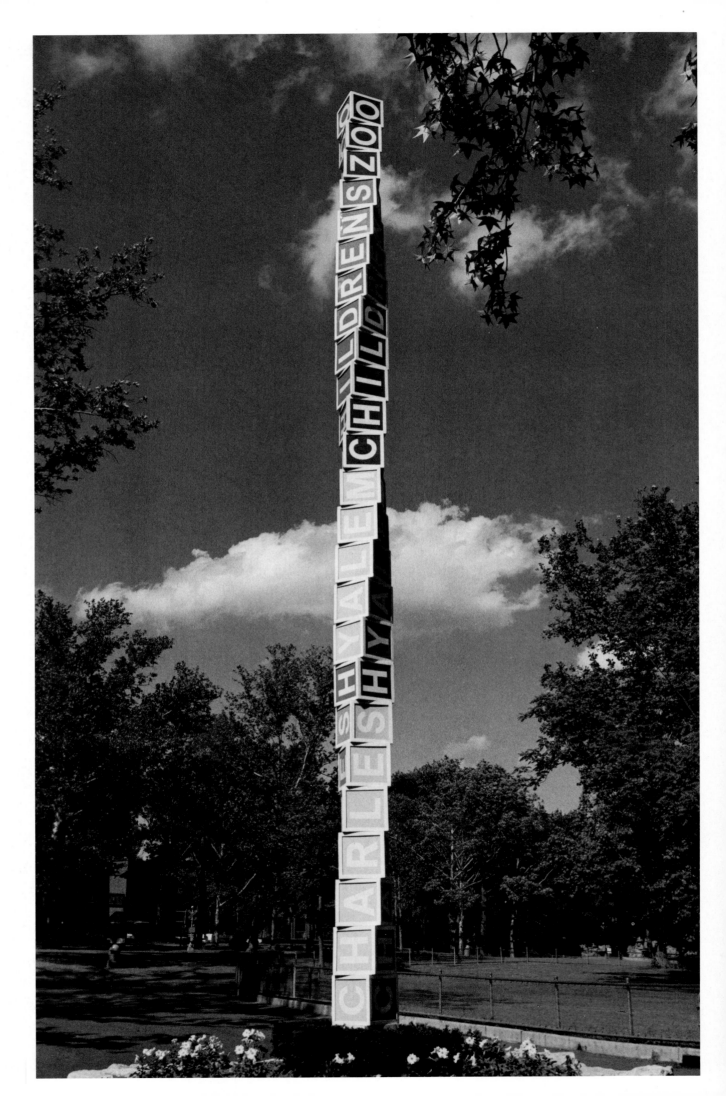

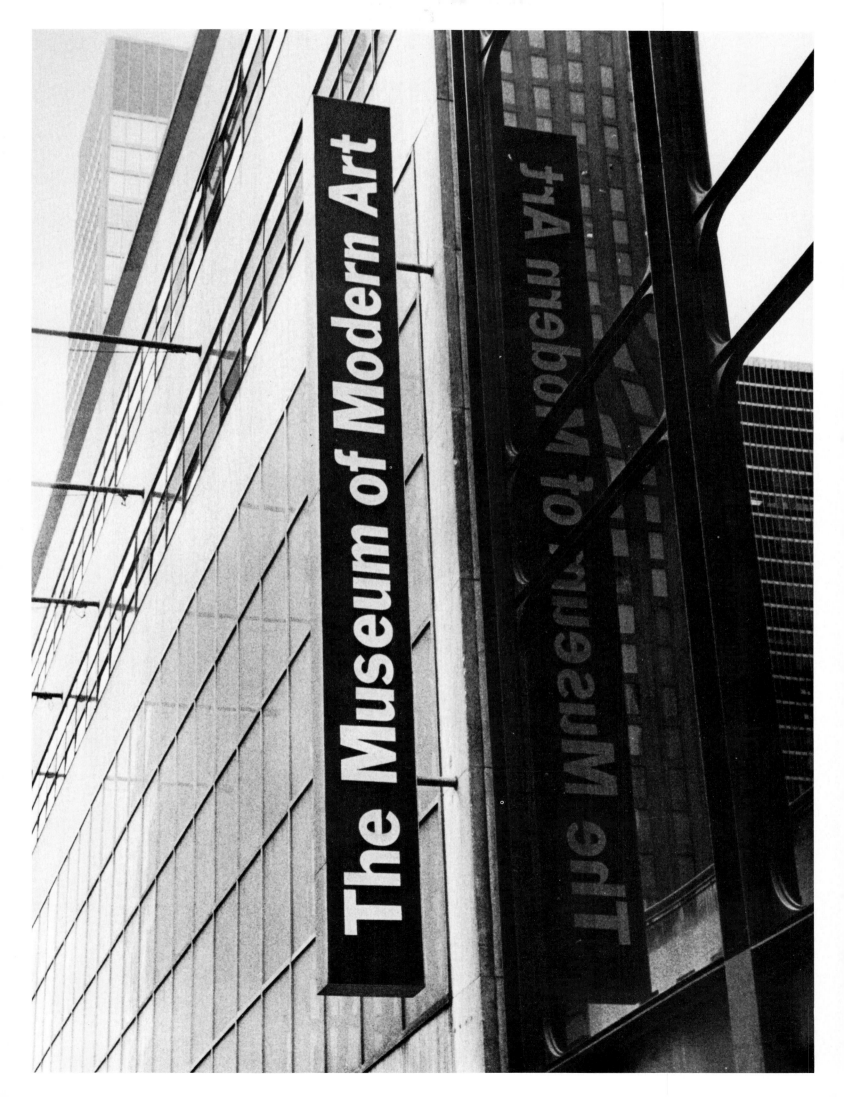

Identification Tower:
Philip Morris, 1972

Sign:
"9" West 57th St., N.Y.
Solow Building Co., 1972

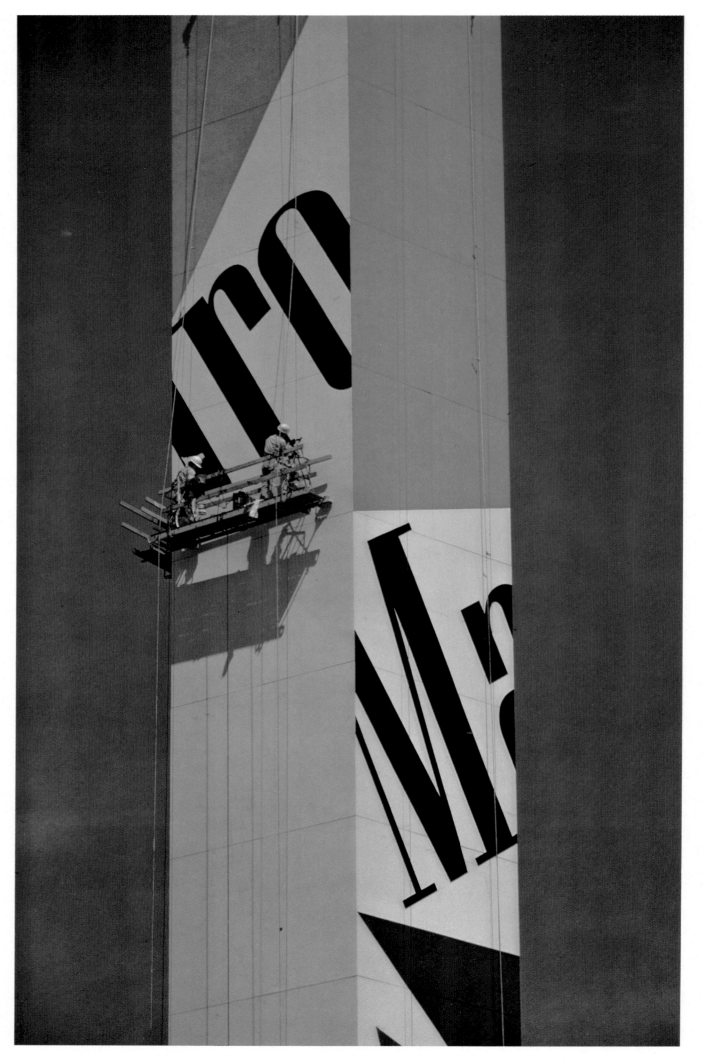

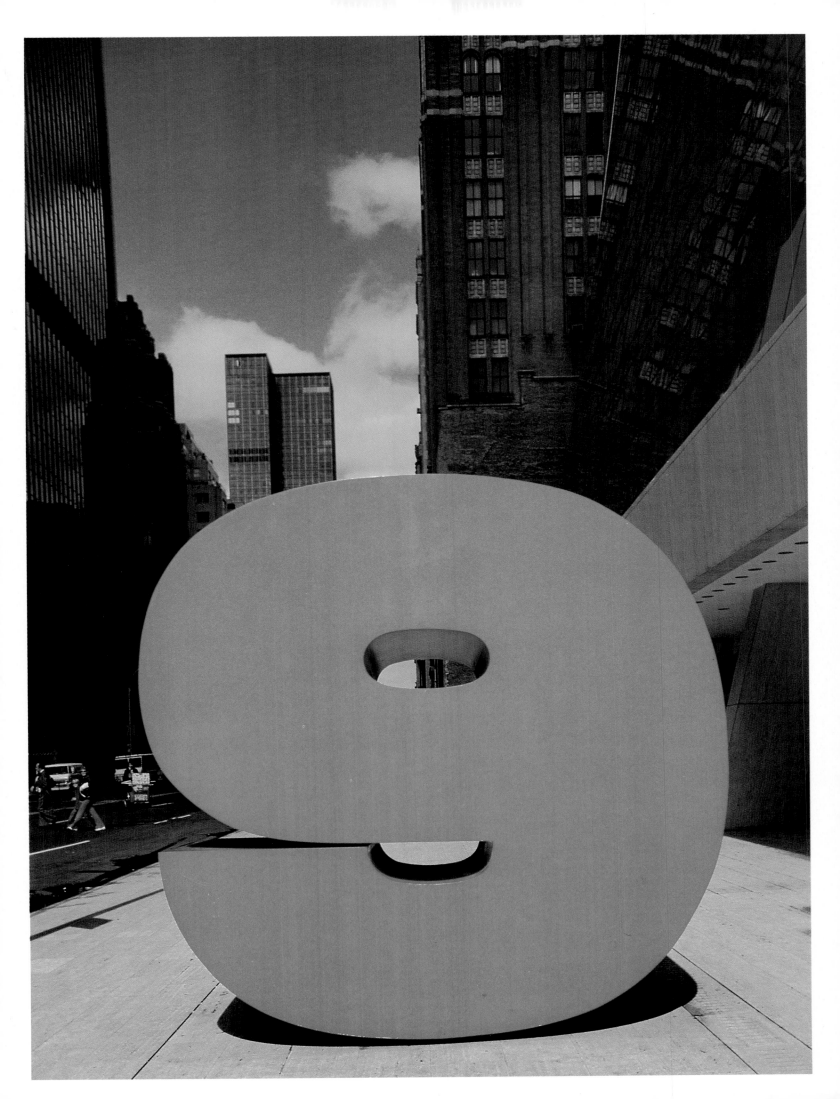

Construction Fence:
9 West 57th St., N.Y.,
Solow Building Co., 1971–72

Mural:
Candy (detail),
IBM World Trade Americas,
Far East Corp.,
North Tarrytown, N.Y., 1976

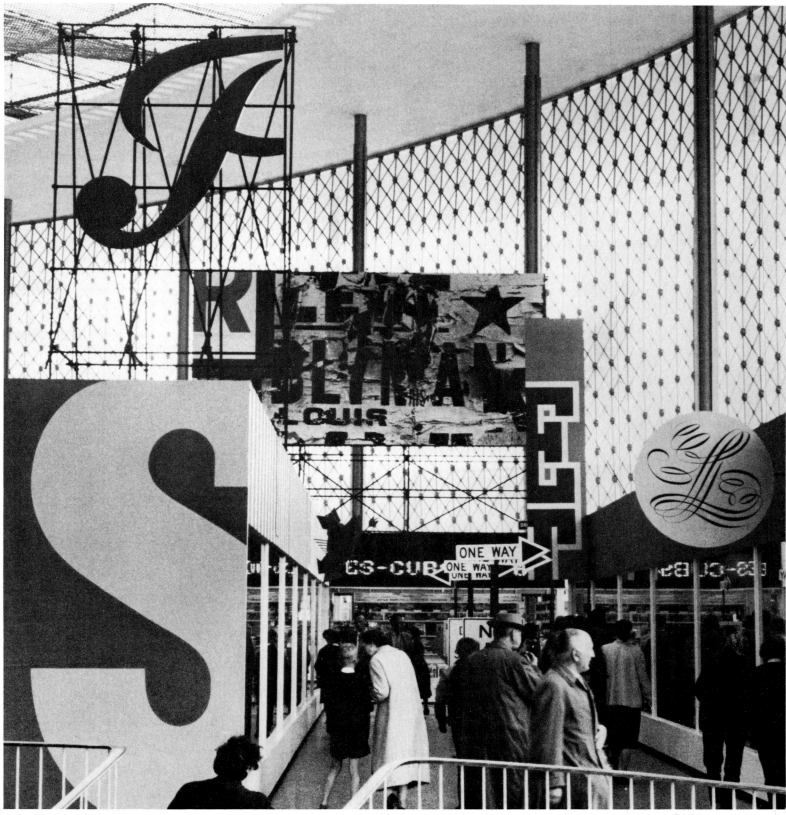

Exhibit:
"Streetscape,"
U.S. Pavilion,
Brussels World's Fair, 1958

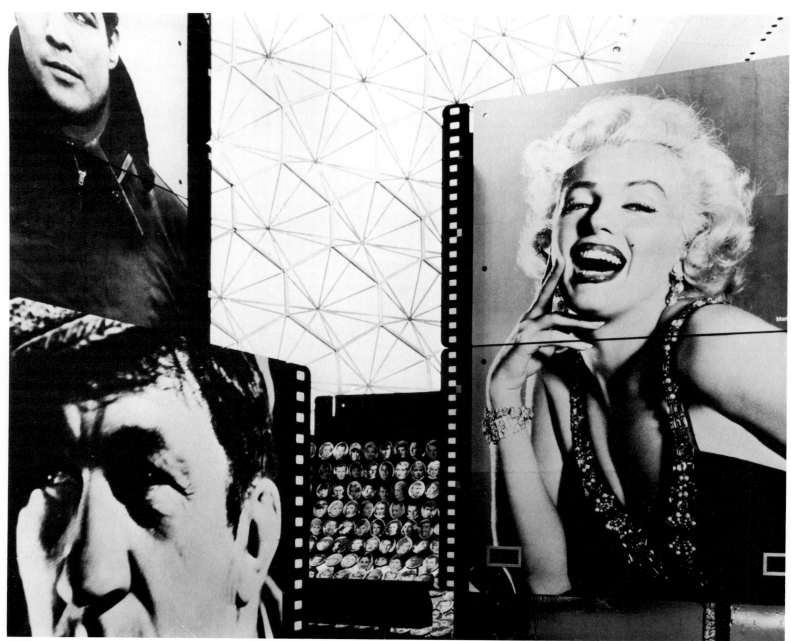

Exhibit:
U.S. Information Agency
U.S. Pavilion, Expo '67,
Montreal

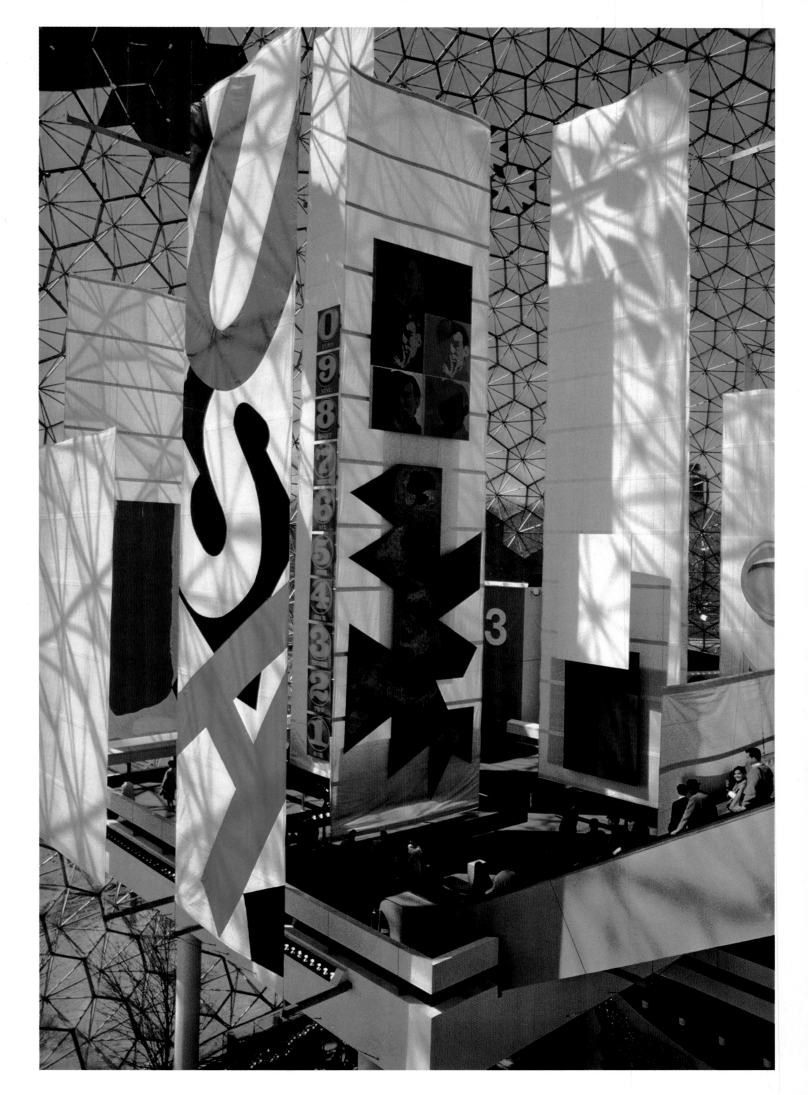

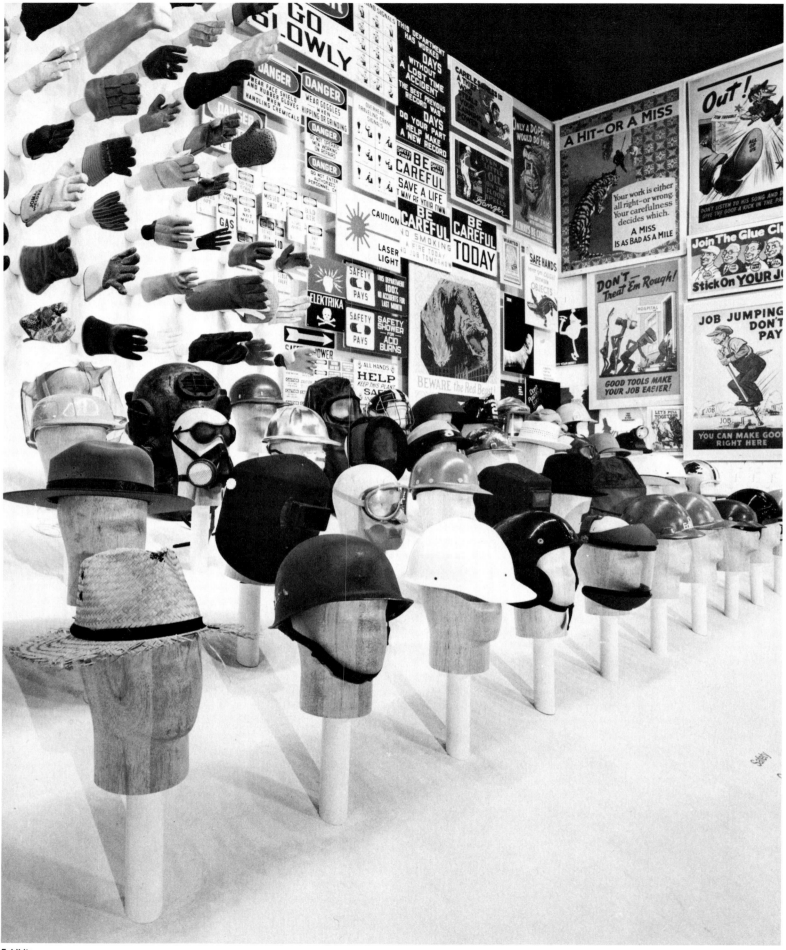

Exhibit:
Smithsonian Institution,
Museum of History and
Technology.
"If we're so good,
why aren't we better?" 1970

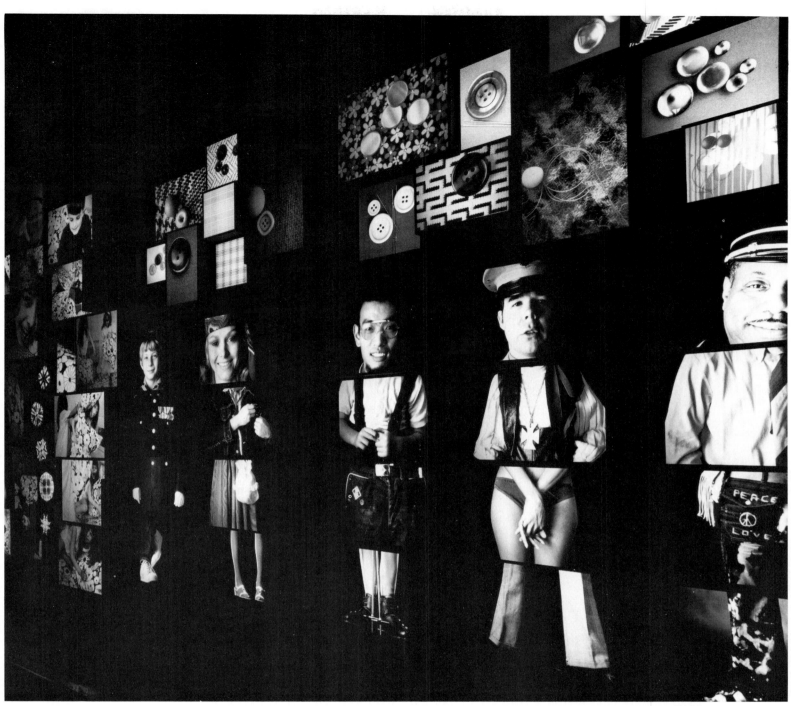

Exhibit:
Burlington Industries
"The Mill," 1970

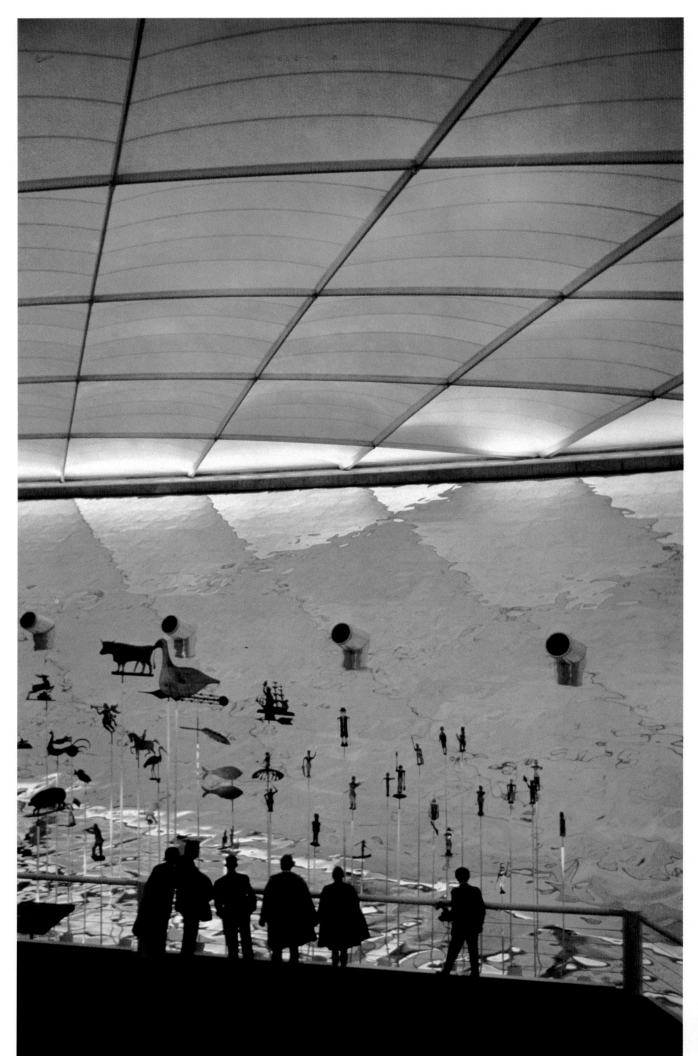

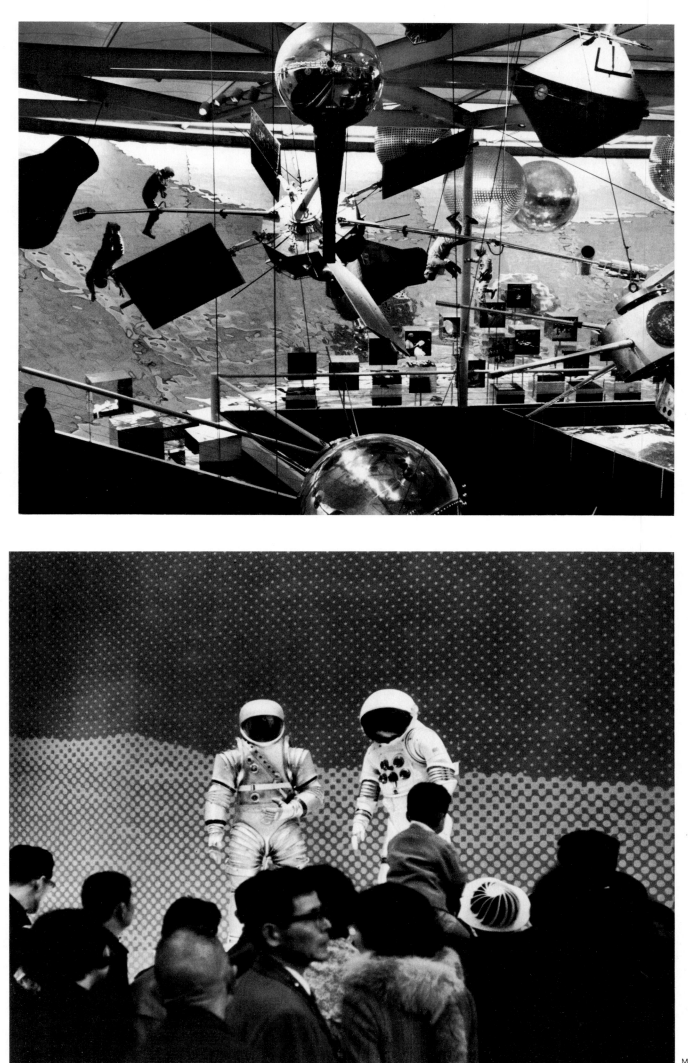

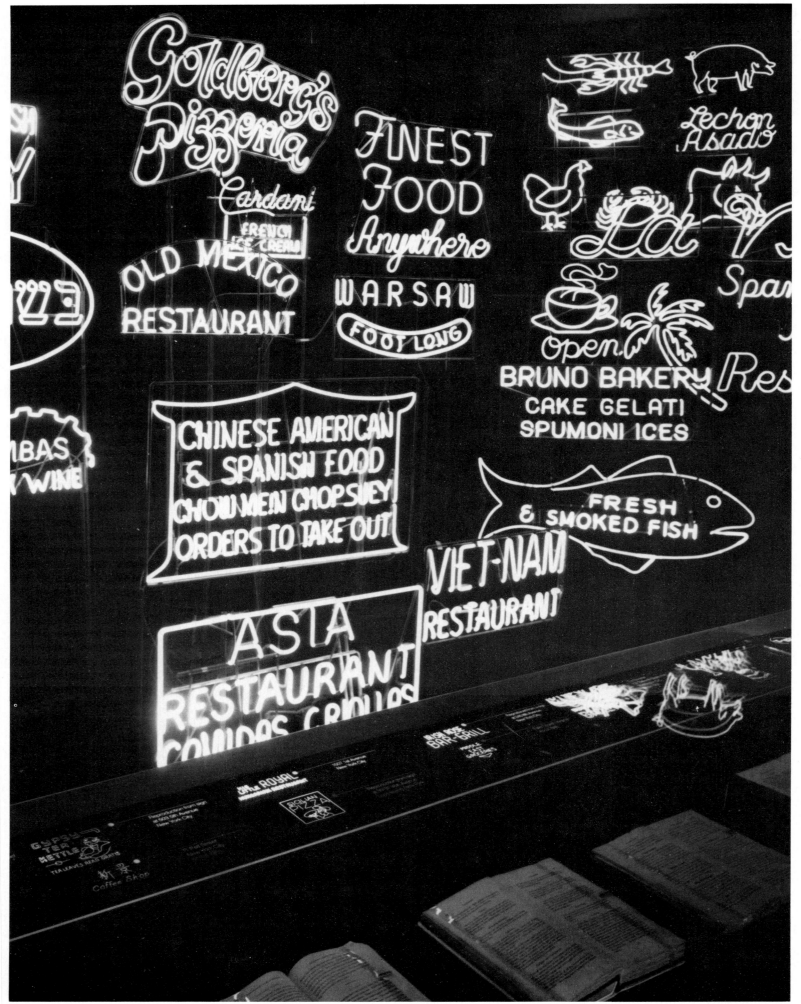

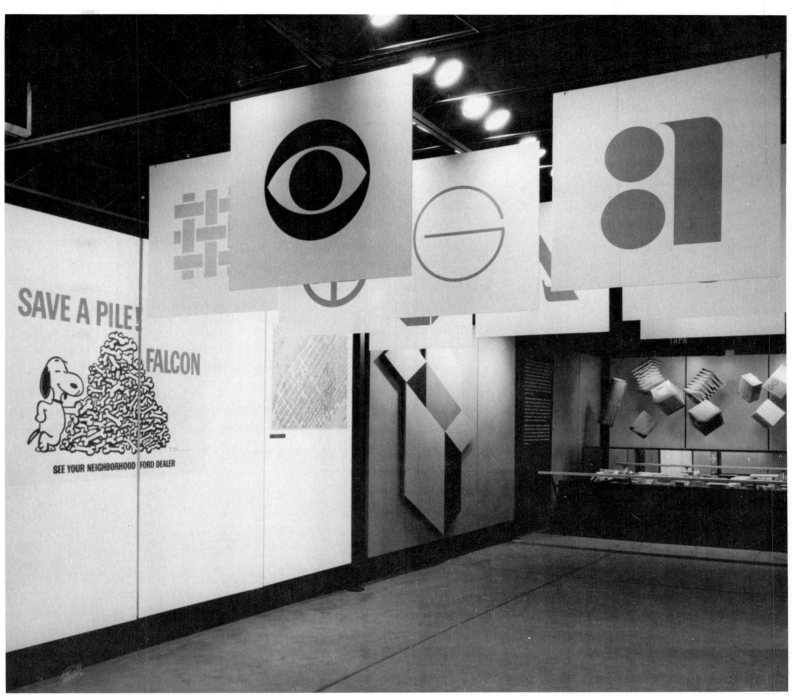

Exhibit:
U.S. Information Agency
"Graphic Arts U.S.A.," 1963

Covers

The competition for cover design, held biannually, includes book jackets and covers of paperback books, magazines and newspaper supplements, record albums, and corporate literature. Entries must have been published in an edition of 500 impressions as well as designed and printed in the United States or Canada. Of the 2,600 covers submitted to the competition this year, 120 were selected for award.

Chairman

John R. Rieben
The director of communications and design for Raychem Corporation, John Rieben studied at the University of Michigan's College of Architecture and Design and was graduated with MS and MFA degrees at Indiana University. He began his career as a graphic designer for the University of Illinois at Urbana and then spent several years as manager of design for Container Corporation of America. He has been director of design for Unimark International and a partner in Rieben & Craig Design Consultants in Denver.

Jury

Harvey Appelbaum
The New York firm of Appelbaum & Curtis was formed in 1961, after Harvey Appelbaum and William Curtis finished school together at Pratt Institute. Their firm does a spectrum of graphic work–corporate graphics, annual reports, book jackets, record covers, and, more recently, display, exhibit, and signage programs.

Harri Boller
A partner in Boller/Coates/Robert, Harri Boller is involved with corporate and interior design, product design and packaging, exhibitions and photography. Born in Switzerland, he studied at the School of Arts and Crafts in Basel and then worked for Ciba-Geigy there. Later he went to Montreal to work on the signage program for Expo '67 and then spent five years with Unimark International in Chicago before starting his present firm.

Henrietta Condak
Currently senior art director of CBS Records Classical Music Division, Henrietta Condak studied graphic design at Cooper Union. She began her design career at *Esquire* and then did freelance work for many clients, among them *McCall's* magazine and Columbia Masterworks, where she designed record album covers.

Phil Hamilton
Graphic designer and educator Phil Hamilton has been teaching typography and graphic design at the University of Wisconsin for 15 years and has served as chairman of the department of art for the past two years. He studied at the University of Cincinnati, where he took a BFA in design, and at Indiana University, where he took an MFA. His graphic design commissions include books, corporate publications, signs, logos, and posters.

Larry Klein
The principal of Larry Klein Associates in California, Larry Klein was one of the four founding partners of Unimark International in Chicago. He subsequently headed his own firm for eight years before becoming chairman of the Department of Exhibition at the Field Museum of Natural History. His design projects are primarily three-dimensional, including exhibition interiors and signage.

B. Martin Pedersen
B. Martin Pedersen is a partner in the design firm of Jonson Pedersen Hinrichs & Shakery Inc. He began his career at Benton & Bowles and subsequently worked for other agencies as well as directly with such clients as American Airlines and Geigy Pharmaceuticals. He then initiated Pedersen Design Inc., which he operated successfully for 10 years before the evolution of the present design firm. Pedersen is also a sailor and licensed pilot.

Review

For the public that covers are designed to attract, they are flashes of freshness and surprise, of color and imagination. They appear as dazzling photographs, brilliant drawings, and classic compositions of type layout from week to week on magazines and newspaper supplements, record albums, annual reports, corporate literature, paperbacks, and book jackets. They arrive at the corner newsstand, in the record store, and in the mailbox; they brighten coffee tables, desks, and bookshelves as fresh new images that delight our senses and stimulate our imaginations. They are a throw-away art collection of remarkable proportions.

For the graphic designers who create them, covers are a challenging means of communication with the public as well as a vital activity in the development of a design career and a practice. And their recognition of this fact is indicated by the history of AIGA cover awards, which have been given since 1929.

In the selection of cover designs for such awards, there is a notable paradox. And the contrasting issues are basic to graphic design: on the one hand, cover design is judged by intuitive response to invention and artistry. On the other hand, a jury of highly qualified, experienced specialists is expected to evaluate the effectiveness of covers in representing the insides or contents.

Perhaps more than any other design judging, the selection of cover design awards spotlights this paradox. For a cover is no longer something that merely protects a publication from dust. Instead, to synthesize a number of recent definitions, a cover is a posterlike announcement that must be attractive, striking, and unusual—an image that establishes a presence and demands attention, that pleases, intrigues, captures, and invites the viewer to open a publication with interest and curiosity. It must, foremost, communicate an instant impression. Yet part of a complete definition of a cover is that it must also focus on the contents of the package. It must suggest what a publication is about, must convey some message about its insides.

It came as a surprise, therefore, to hear one of the jurors bring up the old saw about not judging a book by its cover, but the reference was illuminating. It suggested turning the adage around into not judging a cover by its book. In this, the essence of the question was distilled: can we judge a cover by itself—alone? That is, can a professional jury rely only on its first impressions?

The fact is, no matter how much anyone knows about a design's effectiveness in solving its functional requirements, if it does not catch our attention, if it does not make a compelling first impression, then none of the functional concerns about problem solving amounts to anything. A jury could spend all day discussing those things, but it is the aesthetics that catch our eyes, that wrench our minds, that touch our hearts. This is the ultimate criterion for communication.

So the jury for Covers—like most design juries—looked at the covers submitted much as anyone else would come upon them and, relying on their first impressions (however enhanced by professional experience), selected the ones that appealed to them most. Those selected for award, then, were covers that spoke to this particular group of judges from an aesthetic point of view and made a strong first impression.

Of 2,606 entries submitted to Covers, only 120 were selected by the jury. That was not because relatively few made strong first impressions. Rather, the jury felt that the level of quality in graphic design in America has improved so much in recent years that its criteria for excellence have also been raised several notches up the hurdle. And this jury, like jurors at other AIGA judgings, was reluctant to reward merely competent solutions, which have become more the norm. During the rigorous two-day judging for Covers, the jury aimed to cite only those few pieces that they felt were truly original, imaginative, or special in some way.

An attempt to single out approaches and directions was also a part of the deliberations. A "1940s postcardlike nostalgia" was seen in book jackets and record covers, "like the movie posters we saw when we were children." Yet the jurors felt that they made a distinction between well designed and "trendy." If a cover design that borrowed from the 1940s style was included, it was because, in one instance, "the frontality and the symmetrical arrangement, the strong emphasis on one-point perspective as well as the cropping were new and modern." The best covers in the 1940s style went beyond recreating that style as museumlike restoration.

A second stylistic approach noted was the typographic allusion to the design idioms of the Bauhaus and the Russian Constructivists. Although that too was seen to be something of a revival, considerable discussion focused on the direct continuity from the Bauhaus to the Swiss graphics movement that has influenced graphic design in this country since the mid-1960s. The book jacket design for *Rodchenko* was considered "reflective in style" but updated to 1979. Of this historicism one juror observed that we all have to have some reference points. Creation does not occur in a vacuum—at least outside today's science laboratory.

Moreover, it was observed that style itself can be a powerful and autonomous entity. Whether there is eclecticism or a single consistent idiom, style creates a strong impression of a period—in some minds that is the most significant achievement of a period. "When disco exists and a store like Fiorucci can thrive because of it, they become valid in their own way as a statement of currentness. The style that they project is timely. It says this is what we are doing with our lives and with our graphics today." So the style adopted from the 1940s becomes not merely an adaptation or a reflection but a legitimate style of the 1970s and 1980s.

"Style is as much a selling point as the idea or content," was another statement of the idea. The book jacket for *Dreemz,* for example, was considered right for what is happening in California today, so its cover in the 1940s' "car style" was considered to be a good design. "Twenty years from now when people are looking at the AIGA annual," one juror summed up, "*Dreemz* will stand out as a symbol for this time—1977 to 1979."

The jurors agreed that they were struck by the variety of styles encountered. "I don't think we could be accused of picking a single stylistic trend," one commented. "The covers we have chosen are appropriate to what our times are all about."

Magazine Covers and Newspaper Supplements

The most notable entries selected among the magazine and newspaper covers were found to be in the newsprint area–the weekly and Sunday newspaper supplements–which until very recently, the judges thought, have been fairly undistinguished.

"We saw a lot of innovative pieces with some striking results," said one juror, "particularly the use of illustrators and the use of color." Colors on newsprint have made the quality of the paper itself look more interesting. The technology of being able to register color on newsprint on a web press was credited with making this possible.

One magazine cover in particular–*Zoetrope*–was considered subtle because it reproduces the texture of the primary color crayons that the illustration was drawn with, and the paper begins to look like children's crayon paper. This entry was praised not only for avoiding any problems that the newsprint quality might have created, but also for actually adding verisimilitude to the illustration. Of the *Minneapolis Star's* Taste section, the consensus was, similarly, that the newsprint paper added to the texture of the watercolor.

The New York Times was praised for using beautiful illustrations and photographs in its supplements. Its cover pages were thought to be well designed–not only the illustrations, but the overall composition of the covers. "It is one of the only papers in the country that does a consistently good job." it was noted, "but even there, it is the weekly sections, where they have a little bit more time, that are so well designed."

Record Albums

"Pop covers outnumber classical covers in terms of sheer volume produced as well as in the entries selected for the awards. There is more business in the popular field, and therefore a designer has more opportunity for design and for innovative work," was the jurors' overview. It was also noted that when recording artists are in great demand, they can also have a controlling influence in cover design.

Trends and fads were more apparent in rock and popular music albums than in the design of classical music jackets. "There is a much more conservative audience in the classical music area," was one explanation. Another was that popular music has to appeal to popular fads.

Only one innovation in size, shape, and packaging–as opposed to cover graphics–was noted. It is the "Blackjack" album, which is die cut to look like a three-dimensional box of playing cards, although the single record slips into it like the usual flat envelope. To the question of whether that design was innovative or merely tricky, the answer was: "Yes, the record is thin and there is no need to suggest depth, but it is a very interesting visual gimmick. People are going to stop and pick that up." And consistent with the best cover design criteria, that meant that they are going to want to know more about the contents.

Book Jackets and Covers of Paperbacks

In the category of book jackets and covers of paperbacks, the jurors found a wide range of styles and felt that the submissions selected represented almost every area of good design–straight typography, conservative layout, illustration, and photography."

One approach captured their attention: covers that had no type on the front and sometimes not even on the spine. These included a book jacket with a portrait of boxer Joe Louis, a slipcase cover of a collage by Steinberg, and a magazine cover within a slipcover for *Nautical Quarterly.* Although it was observed that this idea has been applied before to record covers, it was viewed as relatively new for book jackets.

A cover that also provoked discussion and enthusiasm–*The Burning Mystery of Anna in 1951*–had a jacket designed by painter Larry Rivers. The jurors liked the interrelationship of the line drawing with the calligraphy, but they thought it was difficult to read. Another concluded: "The fact that Larry Rivers would do this suggests that painters and artists are no longer concerned about whether it would be prostituting themselves to design a jacket for the general market."

Annual Reports

The jury expressed some surprise that it had not selected more annual reports for award, though it was noted that annual reports are also represented in the Communication Graphics section. The discussion, nonetheless, was extensive.

The frequent complaint was raised about the conformity of annual reports: "There are 8 million annual reports designed each year, and 7,999,000 are 8½ × 11 verticals. That is the way it is done. The banks like it that way; the SEC likes it that way. They will fit into their folders. And it is a rare client who allows a designer to do something different." So it was said that this category presents less range for expression than any other that is worked on by designers.

One juror stated, "The presidents of most corporations want to perpetuate a feeling of solidity and, in some instances, that means restraint or conservatism. One would not want to see radical design on an annual report cover because it would bespeak radical corporate direction, and perhaps the stockholders would be unsure about the company." Among the entries selected, there was variety nevertheless–"not all had just the big beautiful photograph with tiny little type."

The annual report for the Fannin Bank in the design of a carpenter's apron provoked animated discussion. It was the only piece of the 2,606 entries that, as the jury explicitly stated, was totally different. The texture was found innovative–a laminated paper that simulates the texture of apron cloth. "That is rare for an annual report. . . . It wins because of its texture," was the consensus.

In addition, the cover of Thermo Electron Corporation's annual report, with its energy flowchart, was said to be "super, and still answers the conservative aim, as well. . . . Its report cover is an example of one of the most exciting things happening in graphic design because it takes what is not visible and makes it understandable."

"It is also a kind of tease," observed another juror. "When you look at it, you get some kind of information, but you want to know more. It is intriguing as a piece of artwork in terms of its design and color–and that makes for a beautiful, innovative cover. Even though I don't know about that company, it makes me want to look inside and see what it has to say."

Corporate Literature
Of the cover categories, the jury thought the most varied was that of corporate literature. Entries came in many sizes, shapes, and materials. One piece that especially engaged the jurors was a booklet called *Shock of the New,* which was die cut to look as if it were seen in perspective. In this design, the use of typewriter type was taken to indicate that the budget was spent primarily to achieve the shape, which, it was noted, could have been relatively inexpensively die cut from a standard 8½ × 11 page size.

There is more room for variety in general when designing corporate literature, a member of the jury observed: "Somehow, book jackets, record albums, and annual reports are normally a prescribed shape. With corporate literature, you can do almost anything. Yet where one can do anything, why isn't there even more innovative use of papers, textures, shapes, and die cuts? Most of these pieces are 8½ × 11, printed in four colors. . . . Perhaps I mean, why haven't I done more inventive work?"

Newpaper Supplement:
The Living Section,
The New York Times,
Wed., April 19, 1978
Art Director:
Jerelle Kraus
Designer:
Jerelle Kraus
Artist:
Milton Glaser
Publisher:
The New York Times
Typographer:
The New York Times
Printer:
The New York Times

FOOD STYLE ENTERTAINMENT

The Living Section

WEDNESDAY, APRIL 19, 1978

C1

The New York Times

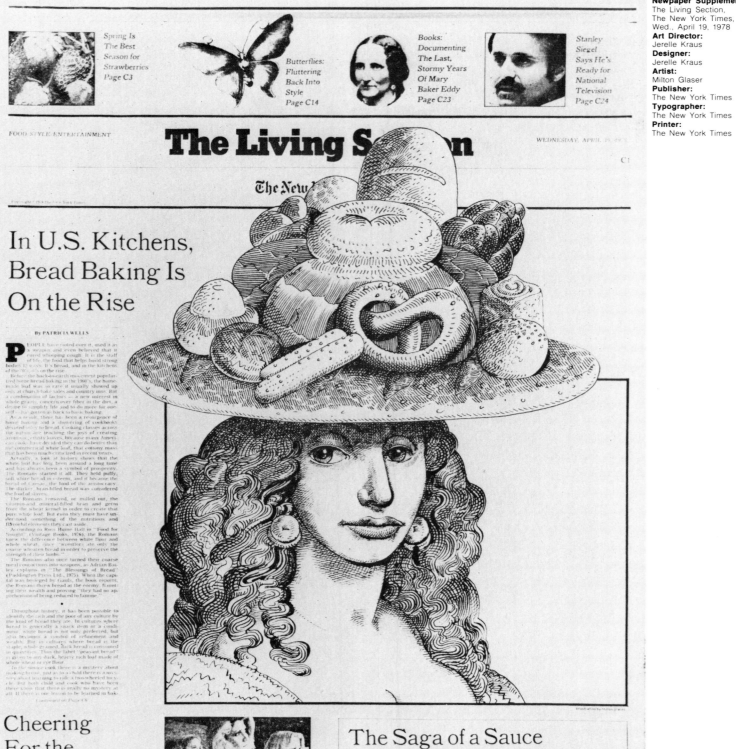

In U.S. Kitchens, Bread Baking Is On the Rise

By PATRICIA WELLS

PEOPLE have rioted over it, used it as a weapon and even believed that it cured whooping cough. It is the staff of life, the food that helps build strong bodies 12 ways. It's bread, and in the kitchens of the '70's, it's on the rise.

Before the back-to-earth movement popularized home bread baking in the 1960's, the homemade loaf was so rare it usually showed up only at church bake sales and country inns. But a combination of factors — a new interest in whole grains, concern over fiber in the diet, a desire to simplify life and to do more for oneself — has gotten us back to basic baking.

As a result, there has been a resurgence of home baking and a showering of cookbooks devoted solely to bread. Cooking classes across the nation are teaching the joys of creating aromatic, crusty loaves, because many American cooks have decided that they can do better than the commercial white loaf, that cottony mass that has been much criticized in recent years.

Actually, a look at history shows that the white loaf has long been around a long time and has always been a symbol of prosperity. The Romans started it all. They held puffy, soft white bread in esteem, and it became the bread of Caesar, the food of the aristocracy. The darker, bran-filled bread was considered the food of slaves.

The Romans removed, or milled out, the vitamin and mineral-filled bran and germ from the wheat kernel in order to create that pure white loaf. But even they must have understood something of the nutritious and flavorful elements they cast aside.

According to Ross Hume Hall in "Food for Nought" (Vintage Books, 1976), the Romans knew the difference between white flour and whole wheat, since "wrestlers ate only the coarse wheaten bread in order to preserve the strength of their limbs."

The Romans also once turned their coarse meal concoctions into weapons, as Adrian Bailey explains in "The Blessings of Bread" (Paddington Press Ltd., 1975). When the capital was besieged by Gauls, the book reports, the Romans threw bread at the enemy, flaunting their wealth and proving "they had no apprehension of being reduced to famine."

Throughout history, it has been possible to identify the rich and the poor of any culture by the kind of bread they ate. In cultures where bread is generally a snack item or a condiment, white bread is not only preferred, but also becomes a symbol of refinement and wealth. But in cultures where bread is the staple, whole-grained, dark bread is consumed in quantities. Then the label "peasant bread" is given to any dark, hearty rich loaf made of whole wheat or rye flour.

To the novice cook there is a mystery about making bread, just as to a child there is a mystery about learning to ride a two-wheeled bicycle. But both child and cook who have been there know that there is really no mystery at all. If there is any lesson to be learned in bak-

Continued on Page C6

Cheering For the Cowboys

By JOHN M. CREWDSON

Hopefuls at tryouts for team cheerleaders

IT WAS not yet 9 o'clock on a Saturday morning, and the bright spring sunshine had already begun to warm the metroplex, as the twin cities of Dallas and Fort Worth like to call themselves. But inside Texas Stadium, the $35-million, air-conditioned home of the mighty Dallas Cowboys, 138 young women sat shivering on metal folding chairs, their hair and makeup as perfect as could be expected at that hour.

More than just the chilly temperature was behind their goose bumps. The atmosphere inside that swank Stadium club was as tense as that of an open casting call for a Broadway production. The young women were about to leave their seats in groups of four and walk gingerly on their high, high heels to a temporary dance floor. There,

Continued on Page C12

The Saga of a Sauce

By CRAIG CLAIBORNE

FAIR LAWN, N.J.

THERE are certain names in the world of wine and food that are inextricably linked. These pairings include Moet and Chandon, Fortnum and Mason, Cross and Blackwell. Another joining indelibly inscribed on the gastronomic roster is Lea and Perrins, makers of the original Worcestershire sauce, "the original and genuine, from the recipe of a nobleman in the county," as it reads on the label, the county in question, of course, is Worcestershire, England. The label does not reveal the name of the nobleman nor to this day will the producers of the sauce reveal it.

Just how this sauce came about is an amusing and tangled history of secrets and intrigues, alleged detractions, family jealousies, British officialdom and two continents. It is a supposedly true account that would have done justice to the talents of Somerset Maugham.

The saga of the sauce dates back to the first years of the 1800's, when the governor general of Bengal returned from his post to his native England. He had in his possession a formula for a sauce that had been created in India, one which he had relished at his table and offered his guests.

At that time, there were two chemists in the English Midlands named John Lea and William Perrins, partners in a then-novel enterprise, a "chain" of chemist shops. Their association had begun in the 1830's. Their main office was in the town of Worcester, in the shire, or county, of the same name.

The governor general took the recipe to Mr. Lea and Mr. Perrins with a request that they try to reproduce it as closely as possible. The story goes that the chemists produced a concoction that was to their noses and tastes unpalatable. They stored it in the cellar and forgot it.

Months, perhaps years, later they sampled it once more and found it not only acceptable but haunting in its flavor. Within a short while they were bottling the stuff, and it is a matter of genuine historical record that, without any kind of advertising as it is known today, in a few short years the Worcestershire sauce of Mr. Lea and Mr. Perrins was known and coveted in kitchens throughout the world. The genuine genesis

Continued on Page C2

Magazine:
"Machines," Push Pin
Graphic Number 77
Art Directors:
Seymour Chwast,
Richard Mantel
Artist:
Haruo Miyauchi
Design Firm:
Push Pin Studio
Publisher:
Push Pin Graphic
Typographer:
Haber Typographers, Inc.
Printer:
Metropolitan Printing Service

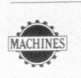

NUMBER 77

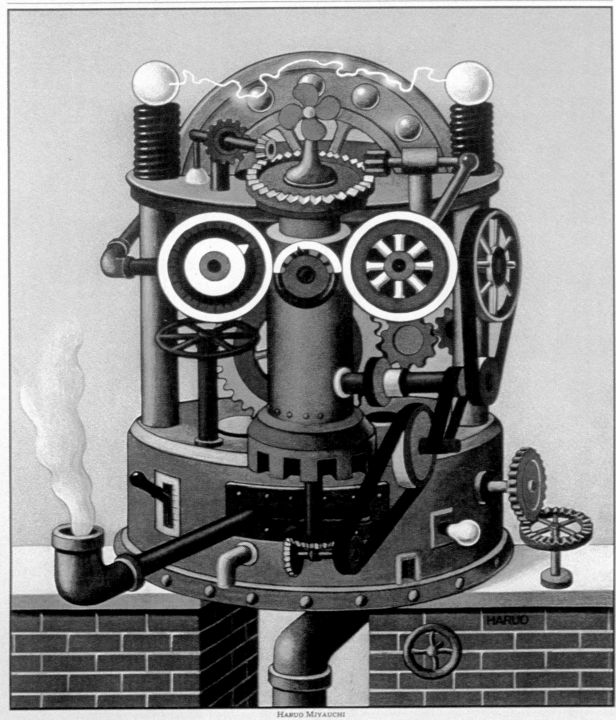

HARUO MIYAUCHI

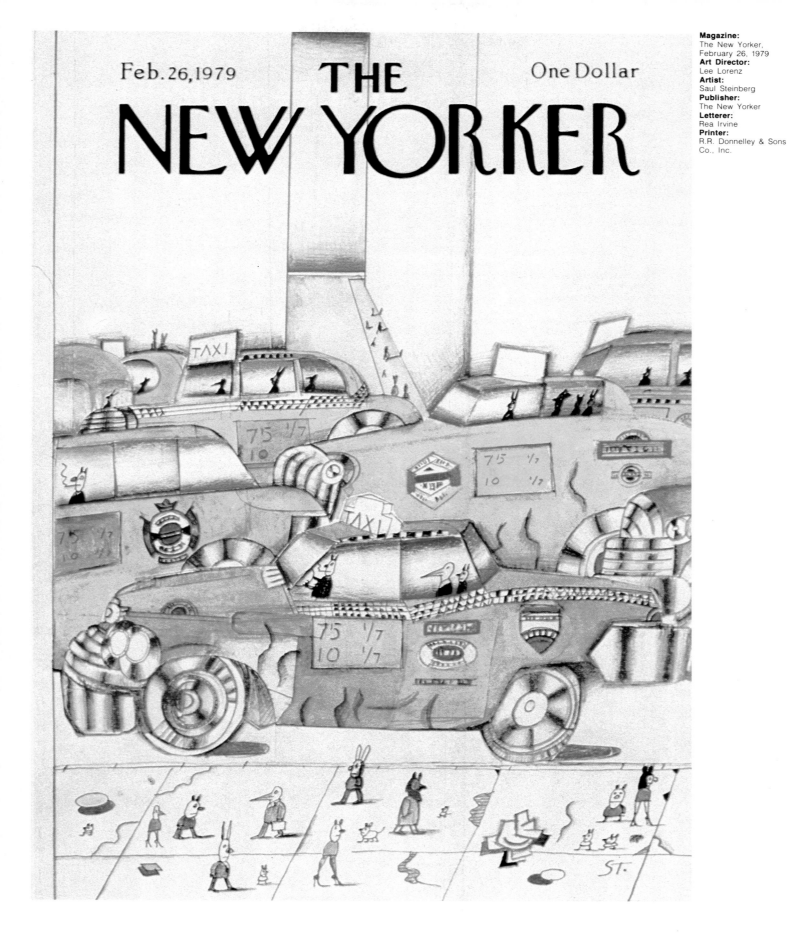

Magazine:
The New Yorker,
February 26, 1979
Art Director:
Lee Lorenz
Artist:
Saul Steinberg
Publisher:
The New Yorker
Letterer:
Rea Irvine
Printer:
R.R. Donnelley & Sons
Co., Inc.

Magazine:
New West,
September 10, 1979
Designers:
Mike Salisbury, Roger Black
Artists:
Ed Scarisbrick, Joe Heiner
Design Firm:
Mike Salisbury Design
Publisher:
New West Magazine
Printer:
Pacific Press, Division of
Arcata Graphics

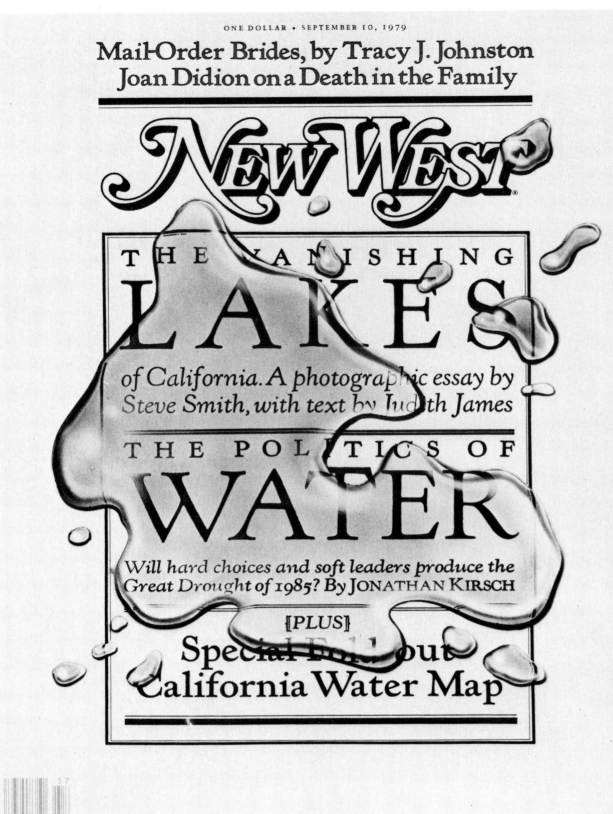

ONE DOLLAR · SEPTEMBER 10, 1979

Mail-Order Brides, by Tracy J. Johnston
Joan Didion on a Death in the Family

New West

THE VANISHING LAKES

of California. A photographic essay by
Steve Smith, with text by Judith James

THE POLITICS OF

WATER

Will hard choices and soft leaders produce the
Great Drought of 1985? By JONATHAN KIRSCH

[PLUS]

Special Foldout
California Water Map

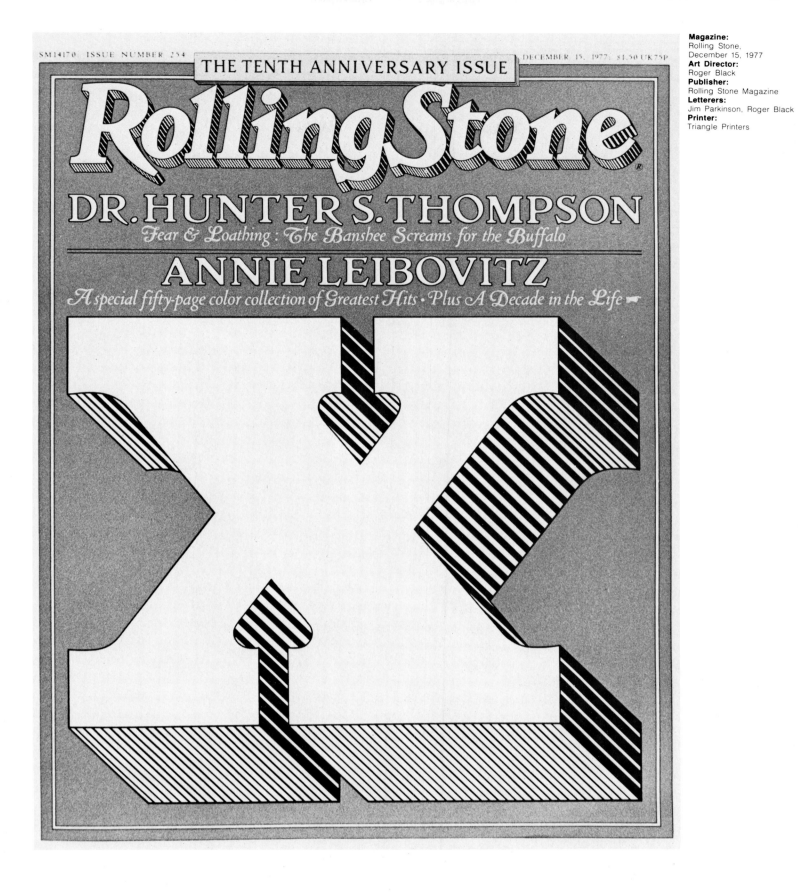

SM14170 ISSUE NUMBER 254 DECEMBER 15, 1977, $1.50 UK75P

THE TENTH ANNIVERSARY ISSUE

RollingStone

DR. HUNTER S. THOMPSON

Fear & Loathing : The Banshee Screams for the Buffalo

ANNIE LEIBOVITZ

A special fifty-page color collection of Greatest Hits · Plus A Decade in the Life

Magazine:
Rolling Stone,
December 15, 1977
Art Director:
Roger Black
Publisher:
Rolling Stone Magazine
Letterers:
Jim Parkinson, Roger Black
Printer:
Triangle Printers

Magazine:
Upper & lower case, Vol. 5
#4
Art Director:
Herb Lubalin
Designer:
Herb Lubalin
Letterer:
Tony Dispigna
Design Firm:
Herb Lubalin Associates
Publisher:
International Typeface Corp.
Typographer:
Photo-Lettering, Inc.
Printer:
Lincoln Graphics

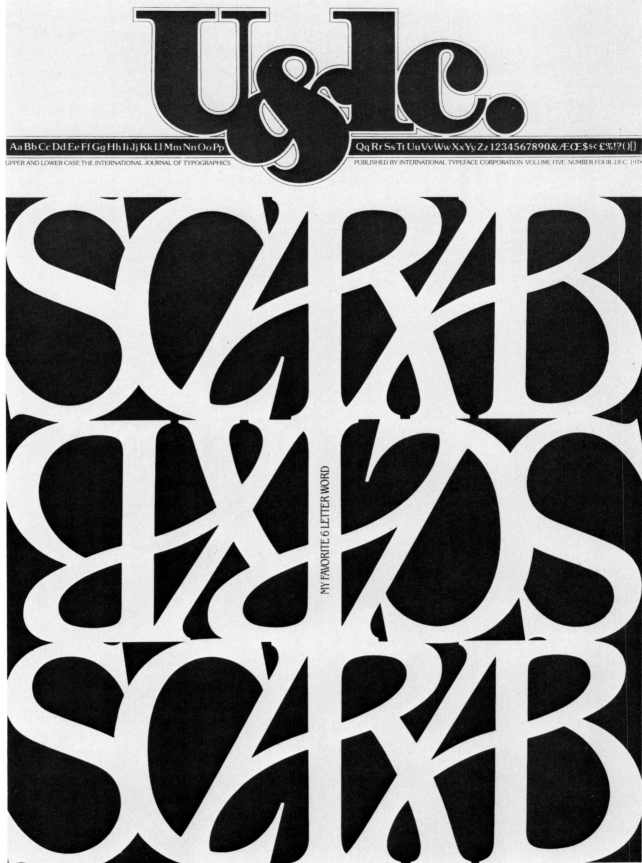

74

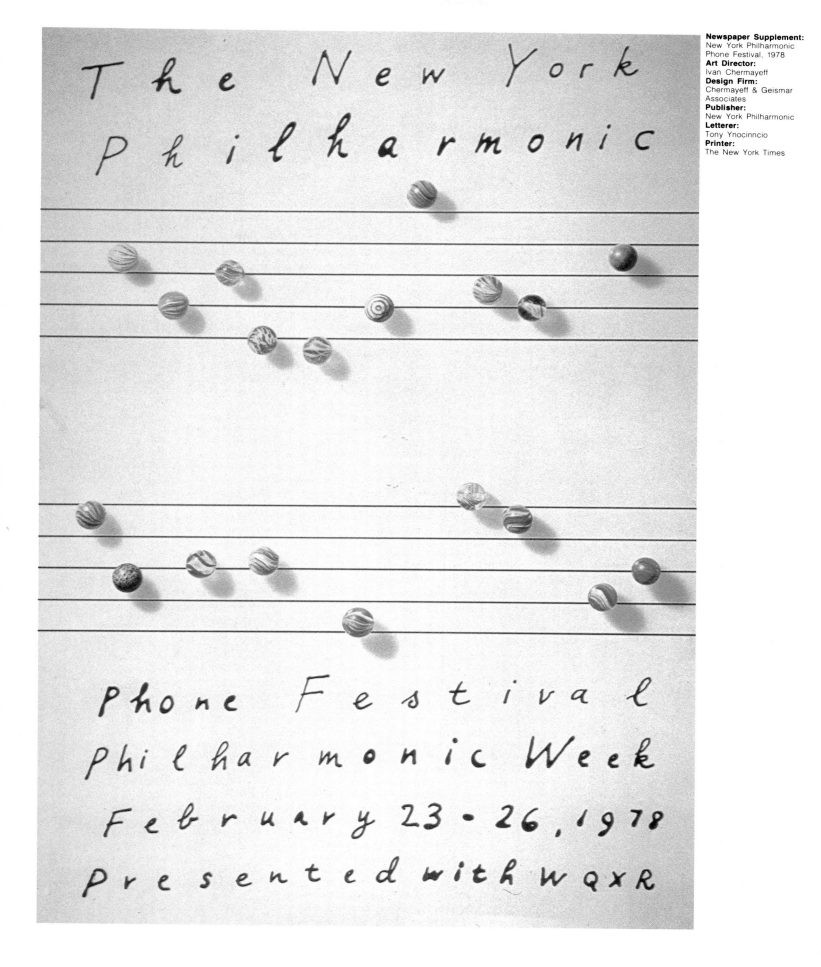

Newspaper Supplement:
New York Philharmonic
Phone Festival, 1978
Art Director:
Ivan Chermayeff
Design Firm:
Chermayeff & Geismar
Associates
Publisher:
New York Philharmonic
Letterer:
Tony Ynocinncio
Printer:
The New York Times

Magazine:
Typografische Monatsblatter,
Nr. 2, 1979
Art Director:
Willi Kunz
Designer:
Willi Kunz
Design Firm:
Willi Kunz Associates
Publisher:
Typographische.
Monatsblatter
Typographer:
Johnson Ken-Ro, Inc.
Printer:
Typographische
Monatsblatter

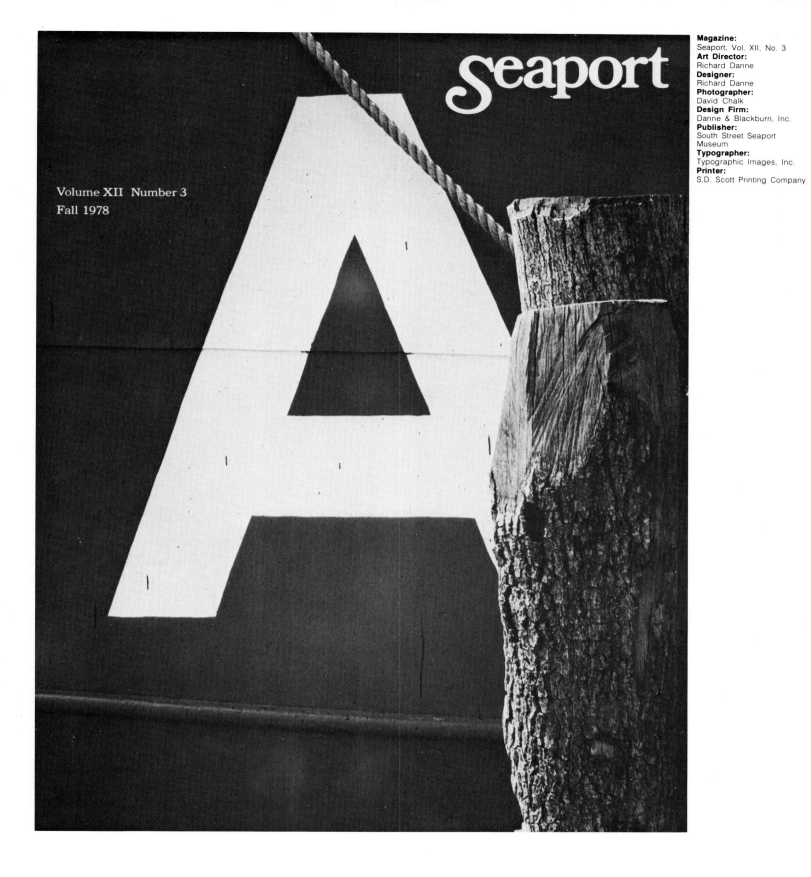

Volume XII Number 3
Fall 1978

Magazine:
Seaport, Vol. XII, No. 3
Art Director:
Richard Danne
Designer:
Richard Danne
Photographer:
David Chalk
Design Firm:
Danne & Blackburn, Inc.
Publisher:
South Street Seaport
Museum
Typographer:
Typographic Images, Inc.
Printer:
S.D. Scott Printing Company

Magazine:
Current Concepts in Pain,
Vol. 1, No. 1
Art Director:
Bruno Ruegg
Artist:
Francois Robert
Design Firm:
Sieber & McIntyre
Publisher:
Pennwalt Corp.
Typographer:
Bundscho
Printer:
Tongg Publishers

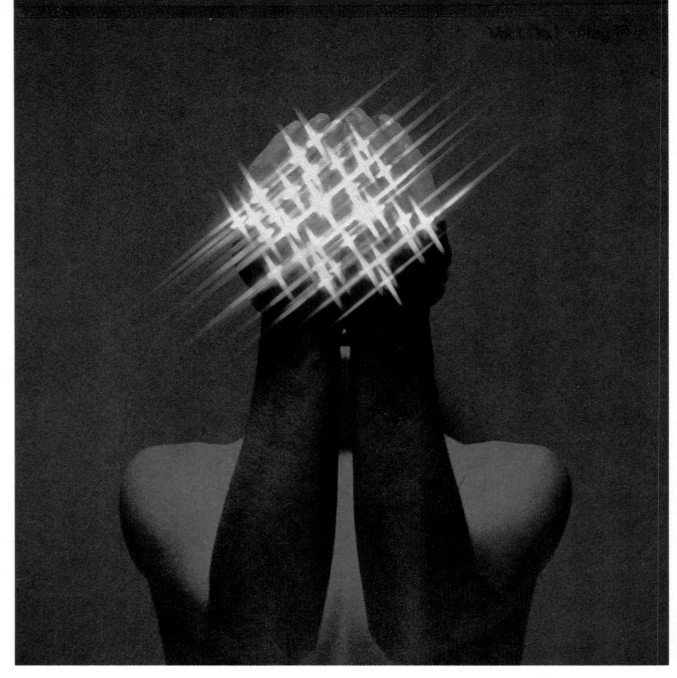

頭痛と炎症性疼痛

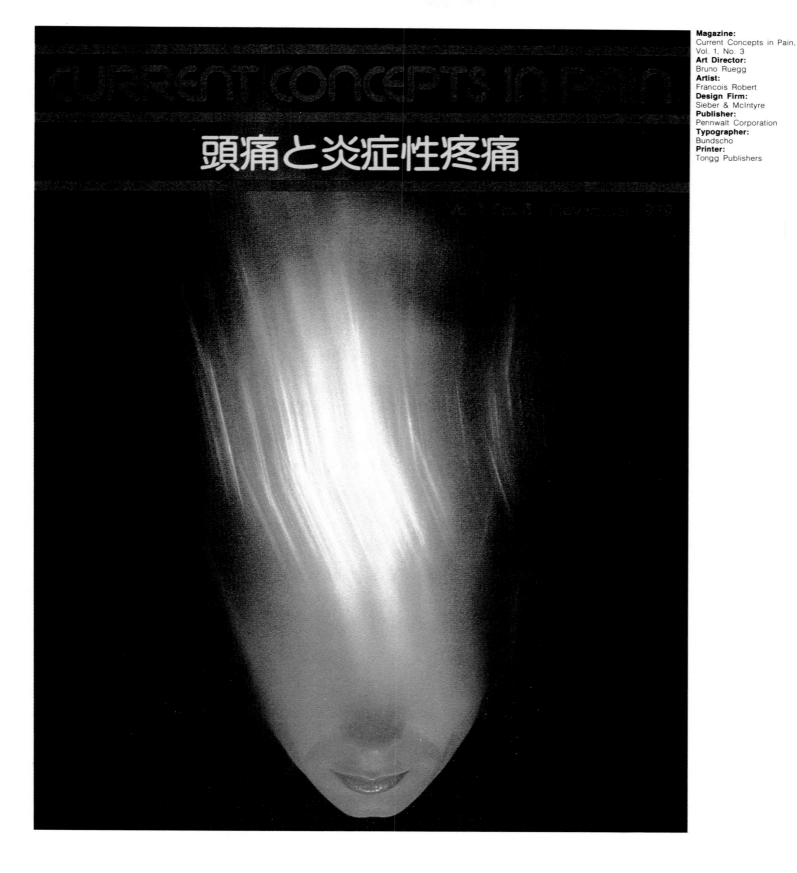

頭痛と炎症性疼痛

Magazine:
Current Concepts in Pain,
Vol. 1, No. 3
Art Director:
Bruno Ruegg
Artist:
Francois Robert
Design Firm:
Sieber & McIntyre
Publisher:
Pennwalt Corporation
Typographer:
Bundscho
Printer:
Tongg Publishers

Magazine:
Triquarterly 42
Art Director:
Cynthia Anderson
Designer:
Cynthia Anderson
Artist:
Brad Holland
Design Firm:
Cynthia Anderson Design
Publisher:
Triquarterly, Northwestern
University
Typographer:
Photofont
Printer:
Frank Prasil, Inc.

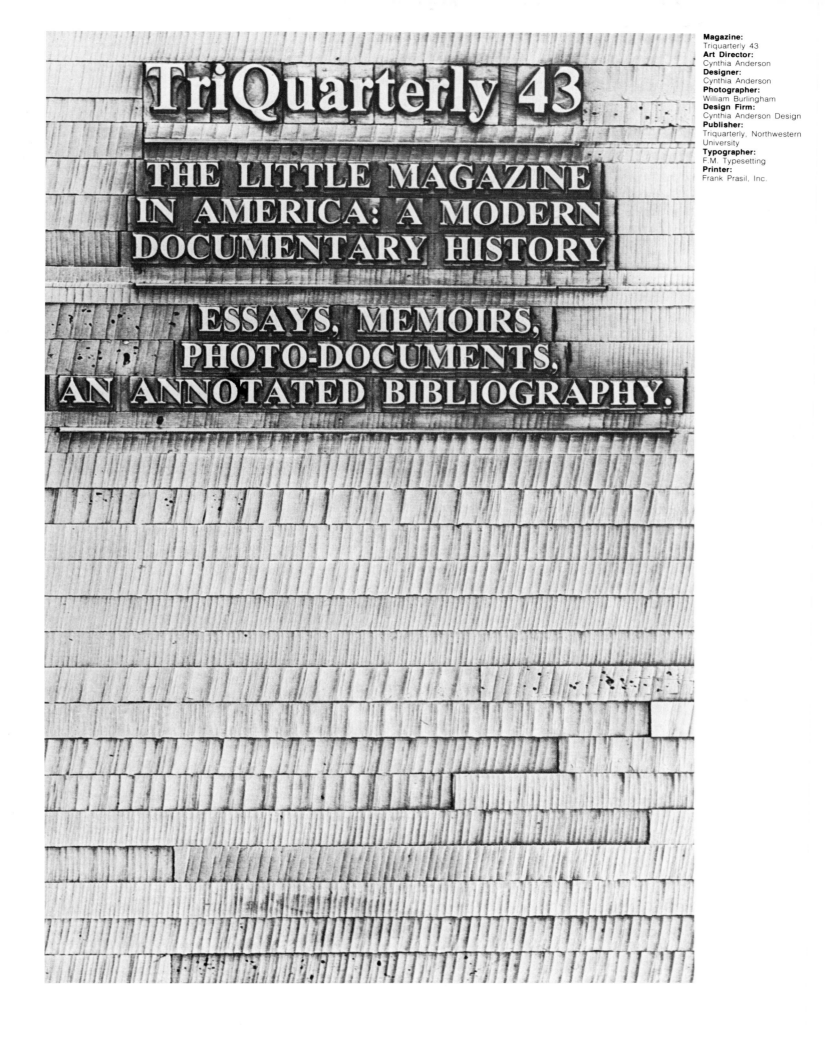

TriQuarterly 43

THE LITTLE MAGAZINE
IN AMERICA: A MODERN
DOCUMENTARY HISTORY

ESSAYS, MEMOIRS,
PHOTO-DOCUMENTS,
AN ANNOTATED BIBLIOGRAPHY.

Magazine:
Triquarterly 43
Art Director:
Cynthia Anderson
Designer:
Cynthia Anderson
Photographer:
William Burlingham
Design Firm:
Cynthia Anderson Design
Publisher:
Triquarterly, Northwestern
University
Typographer:
F.M. Typesetting
Printer:
Frank Prasil, Inc.

Magazine:
Champion Magazine 3
Art Director:
Richard Hess
Designer:
Richard Hess
Photographers:
Joe Baraban, Tom Hollyman
Design Firm:
Richard Hess, Inc.
Publisher:
Champion International Corp.
Typographer:
Lettick Typografic
Printer:
Crafton Graphic Co., Inc.

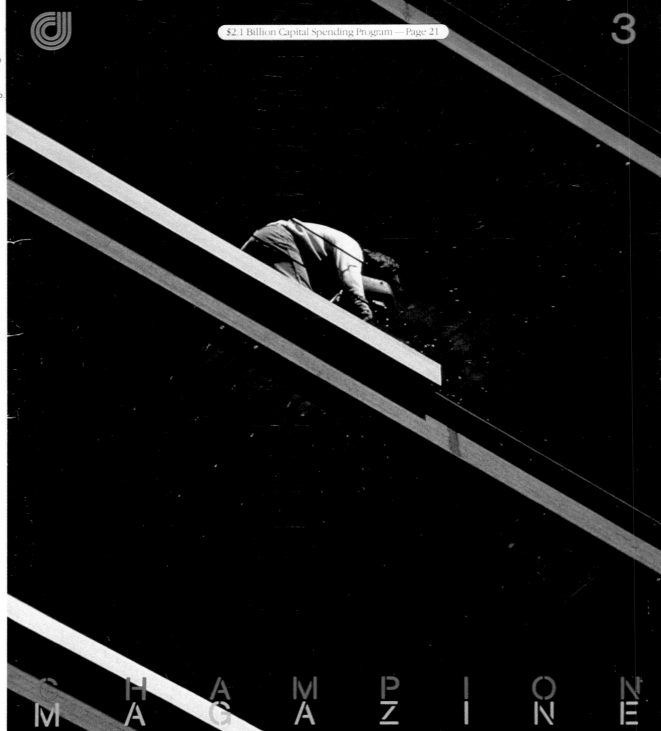

$2.1 Billion Capital Spending Program — Page 21

CHAMPION
MAGAZINE

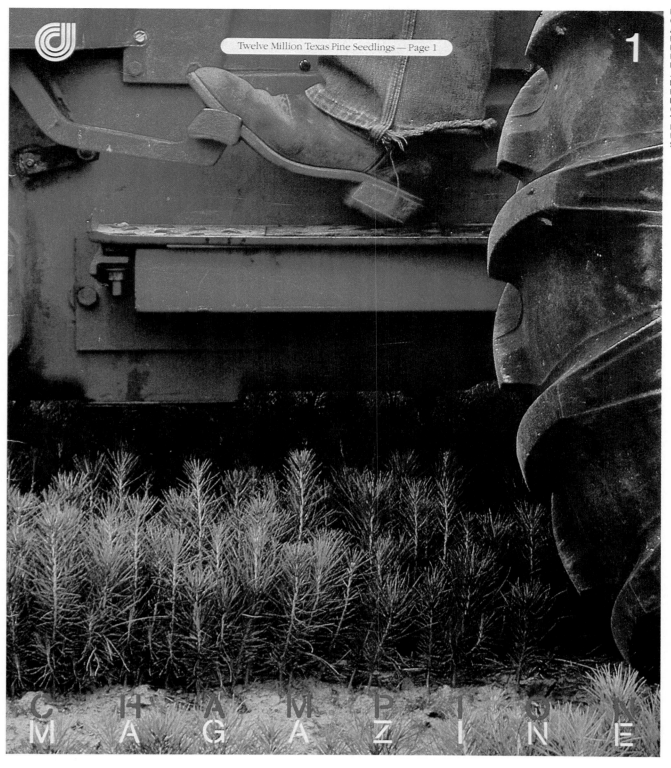

Twelve Million Texas Pine Seedlings — Page 1

CHAMPION MAGAZINE

Magazine:
Champion Magazine 1
Art Director:
Richard Hess
Designer:
Richard Hess
Photographers:
Joe Baraban, Tom Hollyman
Design Firm:
Richard Hess, Inc.
Publisher:
Champion International Corp.
Typographer:
Lettick Typografic
Printer:
S.D. Scott Printing Co., Inc.

Magazine:
Print, November/December
1978
Art Director:
Andrew Kner
Designer:
Andrew Kner
Artist:
Jack Lefkowitz
Publisher:
RC Publications
Typographer:
Type Trends
Printer:
Lucas Litho, Inc.

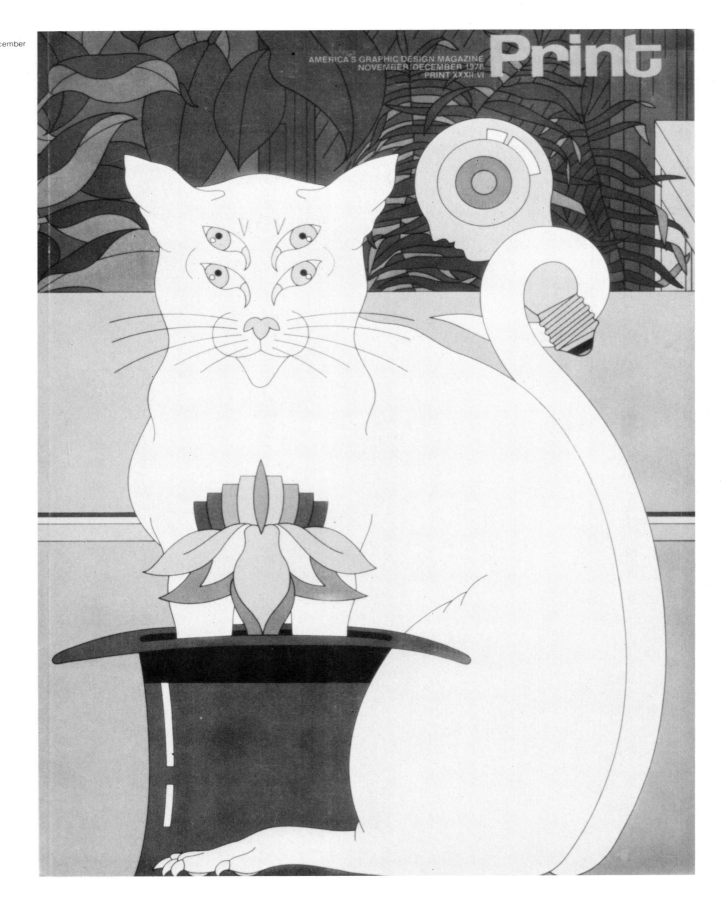

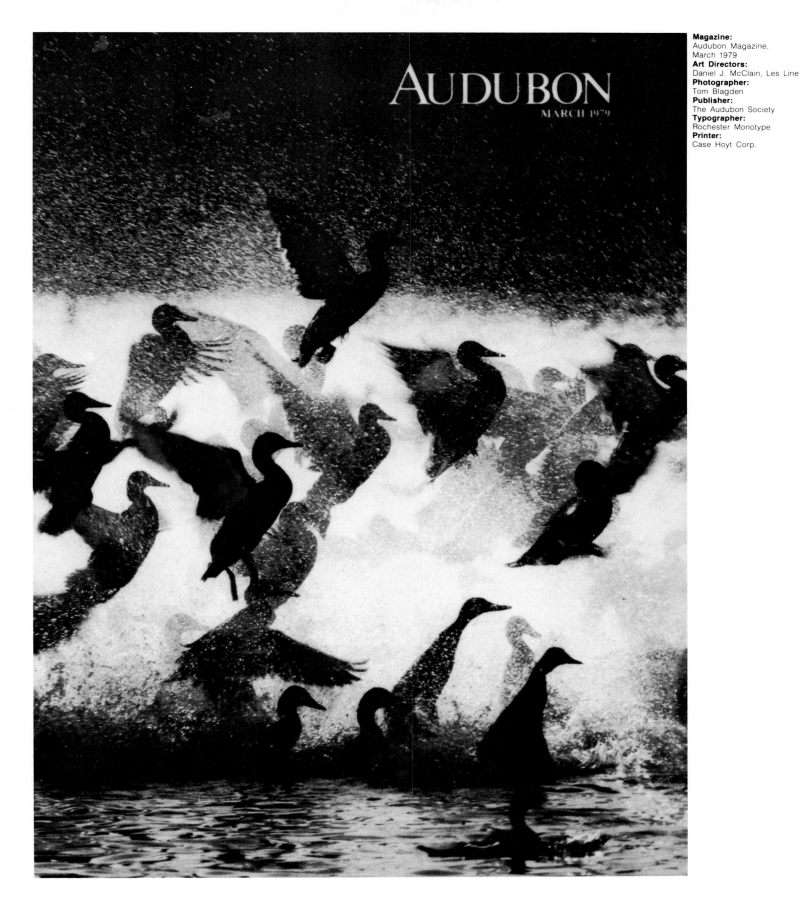

AUDUBON
MARCH 1979

Magazine:
Audubon Magazine,
March 1979
Art Directors:
Daniel J. McClain, Les Line
Photographer:
Tom Blagden
Publisher:
The Audubon Society
Typographer:
Rochester Monotype
Printer:
Case Hoyt Corp.

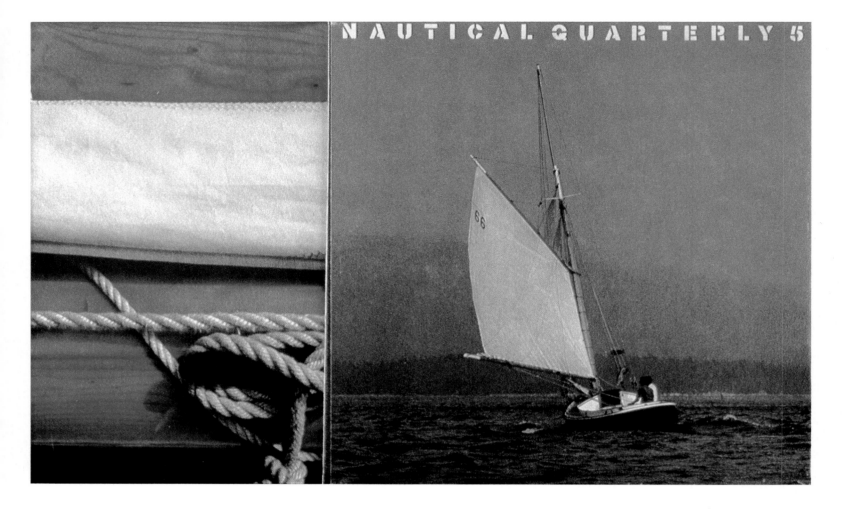

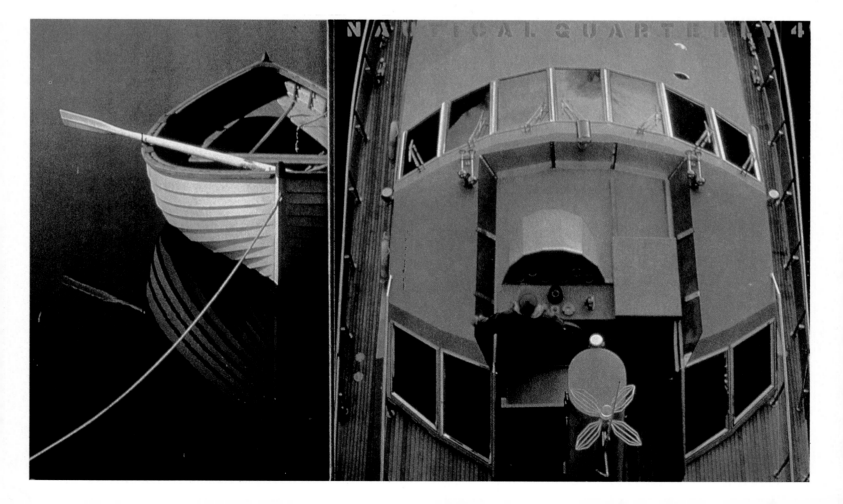

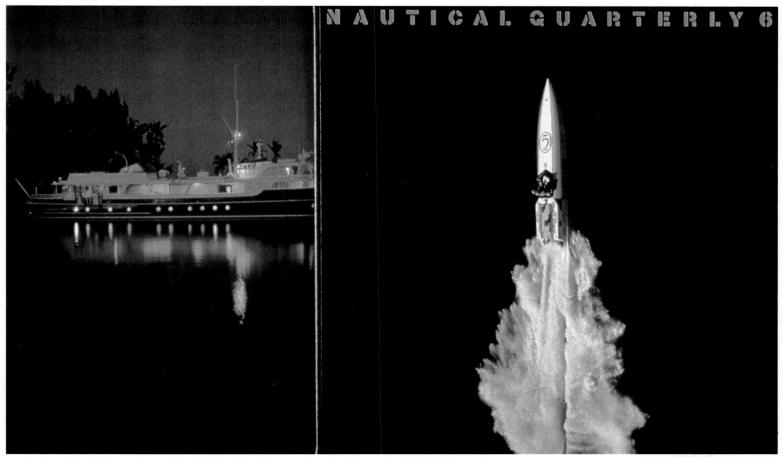

Magazine:
Nautical Quarterly 6
Art Director:
B. Martin Pedersen
Designer:
B. Martin Pedersen
Photographers:
Allen Weitz,
Roger Markham Smith
Design Firm:
Jonson Pedersen Hinrichs &
Shakery, Inc.
Publisher:
Nautical Quarterly, Inc.
Typographer:
Typographic County Forum
Printer:
LaSalle Industries

Magazine:
Nautical Quarterly 5
Art Director:
B. Martin Pedersen
Designer:
B. Martin Pedersen
Photographer:
Allan Weitz
Design Firm:
Jonson Pedersen Hinrichs &
Shakery, Inc.
Publisher:
Nautical Quarterly, Inc.
Typographer:
Typographic County Forum
Printer:
LaSalle Industries

Magazine:
Nautical Quarterly 4
Art Director:
B. Martin Pedersen
Designer:
B. Martin Pedersen
Photographers:
Massimo Vitali, Allan Weitz
Design Firm:
Jonson Pedersen Hinrichs &
Shakery, Inc.
Publisher:
Nautical Quarterly, Inc.
Typographer:
Ginny Briggs
Printer:
LaSalle Industries

Magazine:
ID/Industrial Design
Magazine, July/August 1979
Art Director:
David Sterling
Designer:
Ann Lee Polus
Photographer:
Lisa Sheble
Designer Firm:
Fulton & Partners
Publishers:
Industrial Design Magazine
Typographer:
Pastore Depamphilis
Rampone
Printer:
Byrd Press

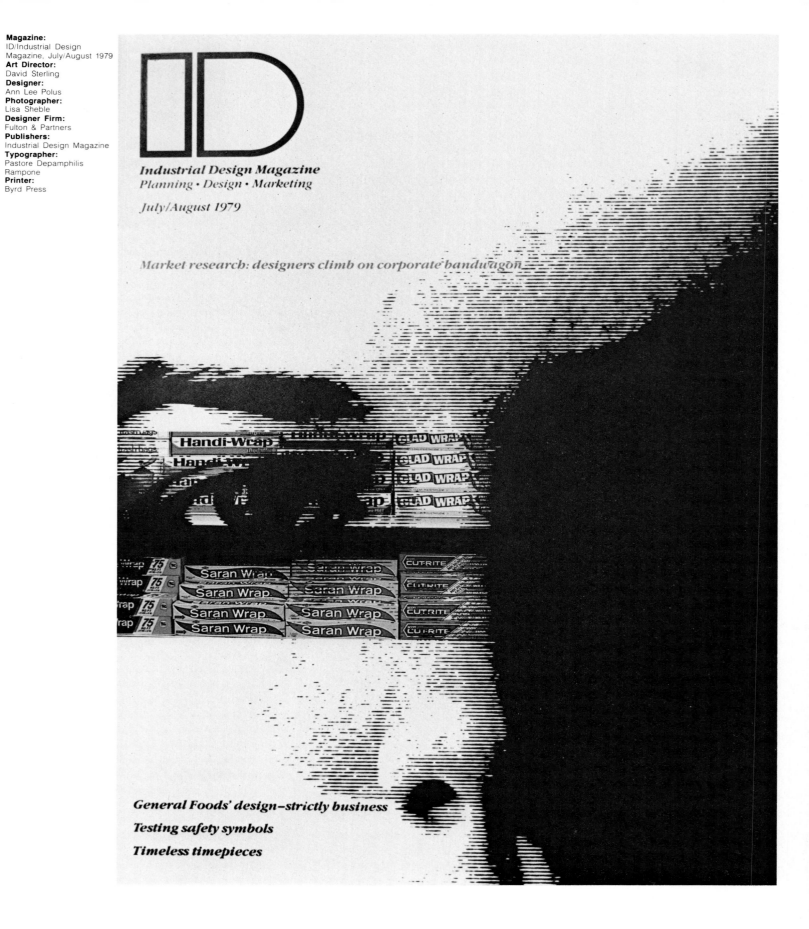

ID

Industrial Design Magazine
Planning • Design • Marketing

July/August 1979

Market research: designers climb on corporate bandwagon

General Foods' design—strictly business

Testing safety symbols

Timeless timepieces

V I S I O N

Weller.

Magazine:
Vision
Art Director:
Don Weller
Designer:
Don Weller
Artist:
Don Weller
Design Firm:
The Weller Institute for the
Cure of Design
Client:
Tokyo Design College
Typographer:
Alphagraphix
Printer:
Toppan Printing Co.

Magazine:
Zoetrope No. 4
Art Director:
Christopher Garland
Designer:
Christopher Garland
Photographer:
Gary Van Dis
Publisher:
Zoetrope Associates
Typographer:
Holland Typesetting
Printer:
Regional Publishers

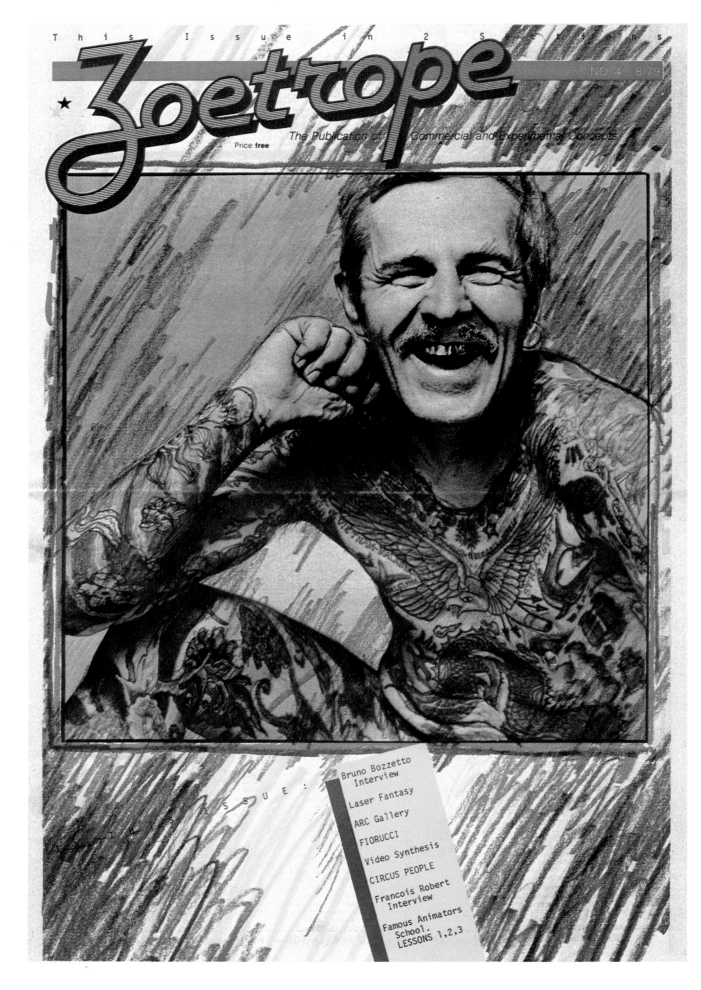

This Issue in 2 Sections

Zoetrope

NO 4 8/79

Price: **free**

The Publication of Commercial and Experimental Concepts

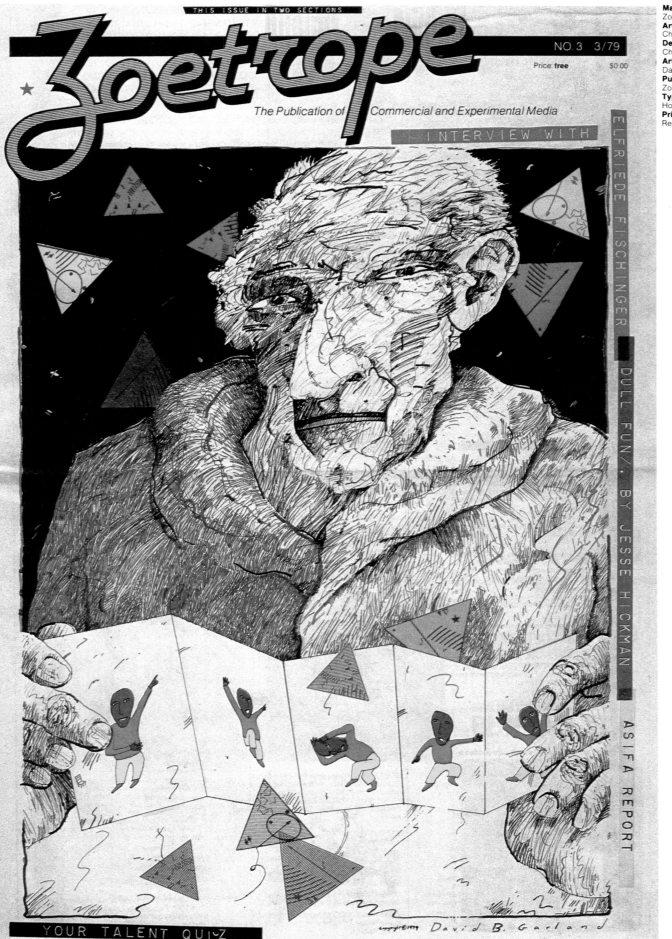

Magazine:
Zoetrope No. 3
Art Director:
Christopher Garland
Designer:
Christopher Garland
Artist:
David B. Garland
Publisher:
Zoetrope Associates
Typographer:
Holland Typesetting
Printer:
Regional Publishers

Magazine:
Art Direction, 1978
Art Director:
April Greiman
Artist:
April Greiman
Photographer:
Raul Vega
Design Firm:
April Greiman
Publisher:
Art Direction
Typographer:
Tropicana Graphics
Printer:
Colonial Press

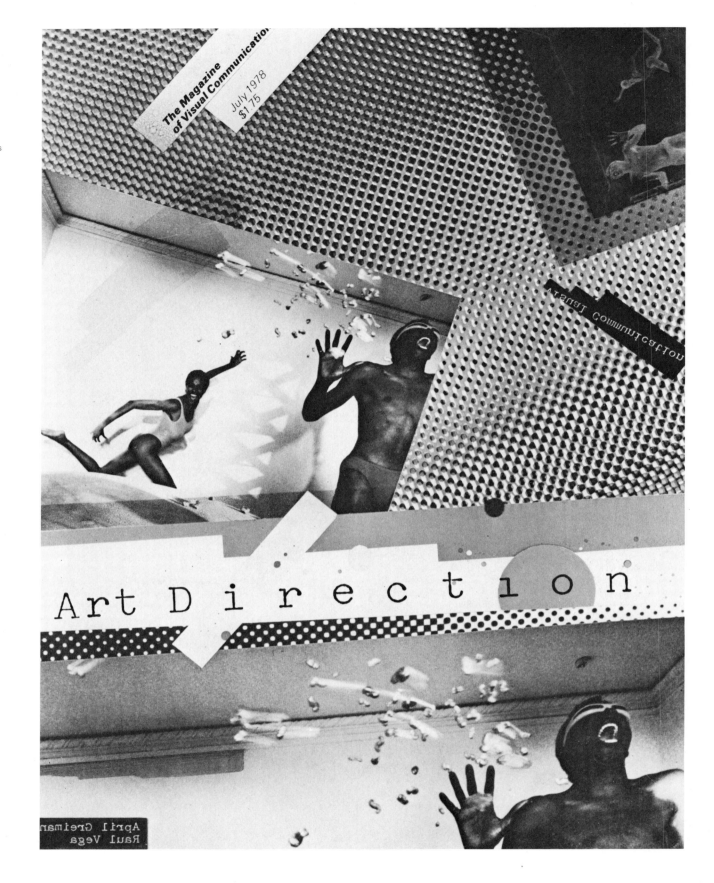

Magazine:
DQ 110
Designer:
Ivan Chermayeff
Artist:
Ivan Chermayeff
Design Firm:
Chermayeff & Geismar
Associates
Publisher:
Walker Art Center
Typographer:
Arnold Rosenberg
Printer:
Kolor Press, Inc.

Magazine:
Westways,
August 1977
Art Director:
Elin Waite
Artist:
Don Weller
Design Firm:
The Weller Institute for the
Cure of Design
Publisher:
Southern California
Auto Club
Typographer:
Alphagraphix
Printer:
Arcata Graphics

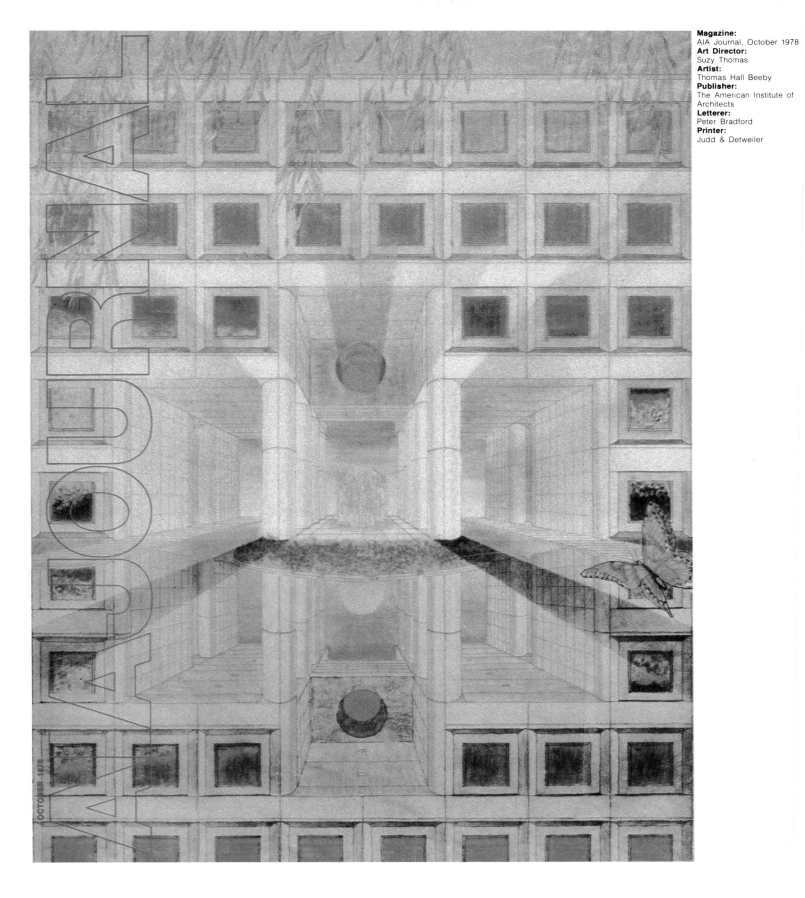

Magazine:
AIA Journal, October 1978
Art Director:
Suzy Thomas
Artist:
Thomas Hall Beeby
Publisher:
The American Institute of
Architects
Letterer:
Peter Bradford
Printer:
Judd & Detweiler

Magazine:
New York, March 20, 1978
Art Director:
Jean-Claude Suares
Artist:
Guy Billout
Publisher:
New York Magazine
Typographer:
Haber Typographers, Inc.
Printer:
Arcata Graphics

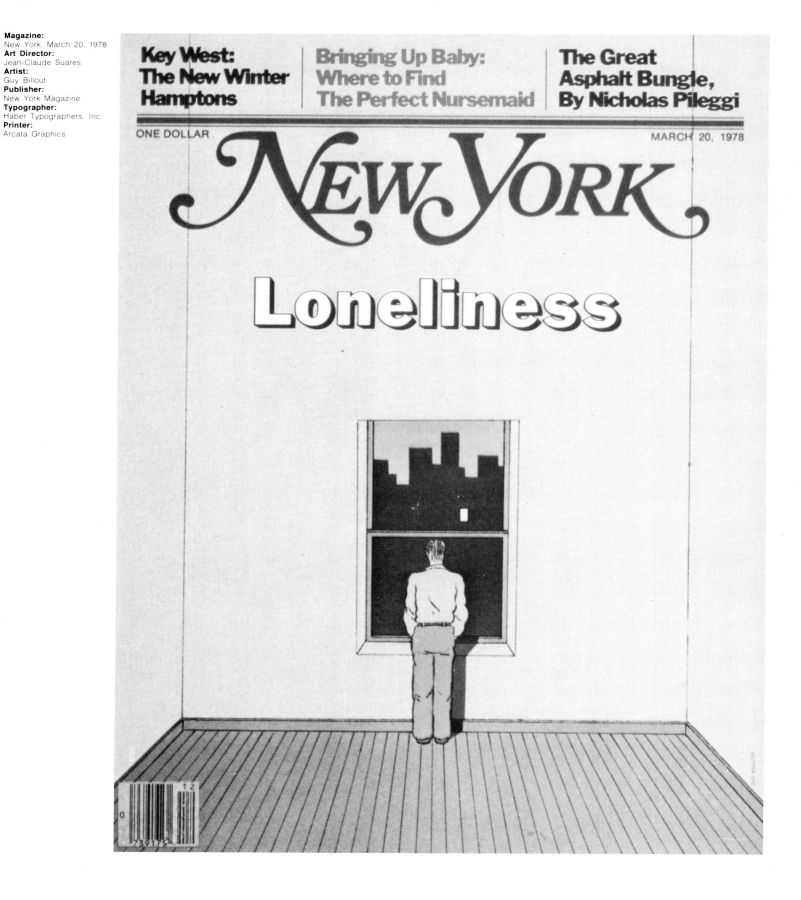

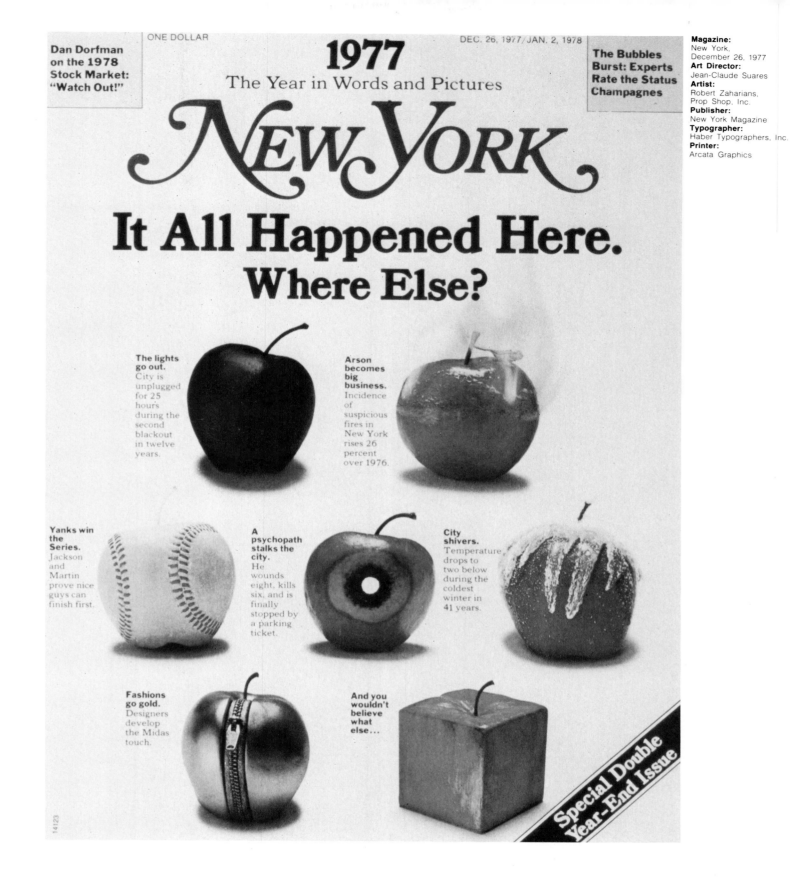

Magazine:
New York,
December 26, 1977
Art Director:
Jean-Claude Suares
Artist:
Robert Zaharians,
Prop Shop, Inc.
Publisher:
New York Magazine
Typographer:
Haber Typographers, Inc.
Printer:
Arcata Graphics

ONE DOLLAR

DEC. 26, 1977/JAN. 2, 1978

**Dan Dorfman
on the 1978
Stock Market:
"Watch Out!"**

1977
The Year in Words and Pictures

**The Bubbles
Burst: Experts
Rate the Status
Champagnes**

NEW YORK

It All Happened Here.
Where Else?

**The lights
go out.** City is
unplugged
for 25
hours
during the
second
blackout
in twelve
years.

**Arson
becomes
big
business.**
Incidence
of
suspicious
fires in
New York
rises 26
percent
over 1976.

**Yanks win
the
Series.**
Jackson
and
Martin
prove nice
guys can
finish first.

**A
psychopath
stalks the
city.** He
wounds
eight, kills
six, and is
finally
stopped by
a parking
ticket.

**City
shivers.**
Temperature
drops to
two below
during the
coldest
winter in
41 years.

**Fashions
go gold.**
Designers
develop
the Midas
touch.

**And you
wouldn't
believe
what
else...**

**Special Double
Year-End Issue**

Magazine:
Avenue, December/January
1979
Art Director:
Bob Ciano
Photographer:
Ernst Haas
Publisher:
Avenue Magazine
Typographer:
Compo-Set
Printer:
Colorcraft Offset, Inc.

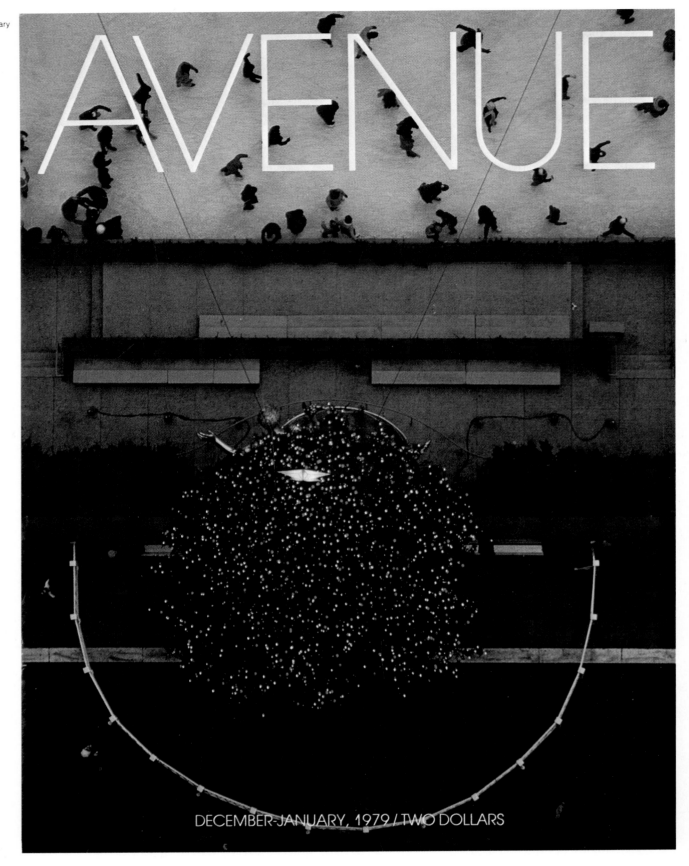

DECEMBER-JANUARY, 1979 / TWO DOLLARS

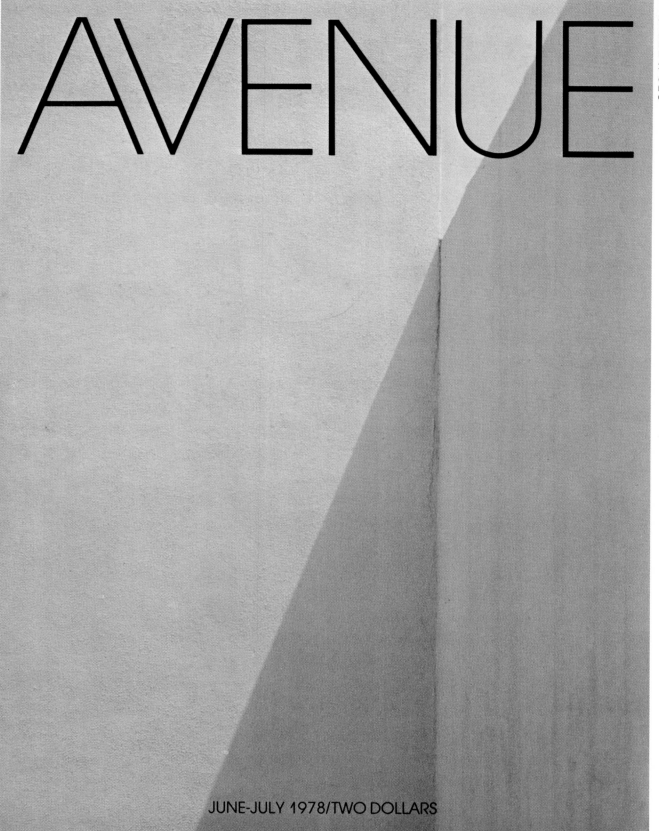

AVENUE

JUNE-JULY 1978/TWO DOLLARS

Magazine:
Avenue, June/July 1978
Art Director:
Bob Ciano
Photographer:
Ralph Gibson
Publisher:
Avenue Magazine
Typographer:
Compo-Set
Printer:
Colorcraft Offset Inc.

Newspaper Supplement:
Taste/The Minneapolis Star,
June 13, 1979
Designer:
Barbara Redmond
Artist:
Barbara Redmond
Design Firm:
Barbara & Patrick Redmond
Design
Publisher:
The Minneapolis Star
Typographer:
The Minneapolis Star
Printer:
The Minneapolis Star

☆ TASTE / MY DAD THE CHEF

The Minneapolis Star
Wednesday, June 13, 1979 1T

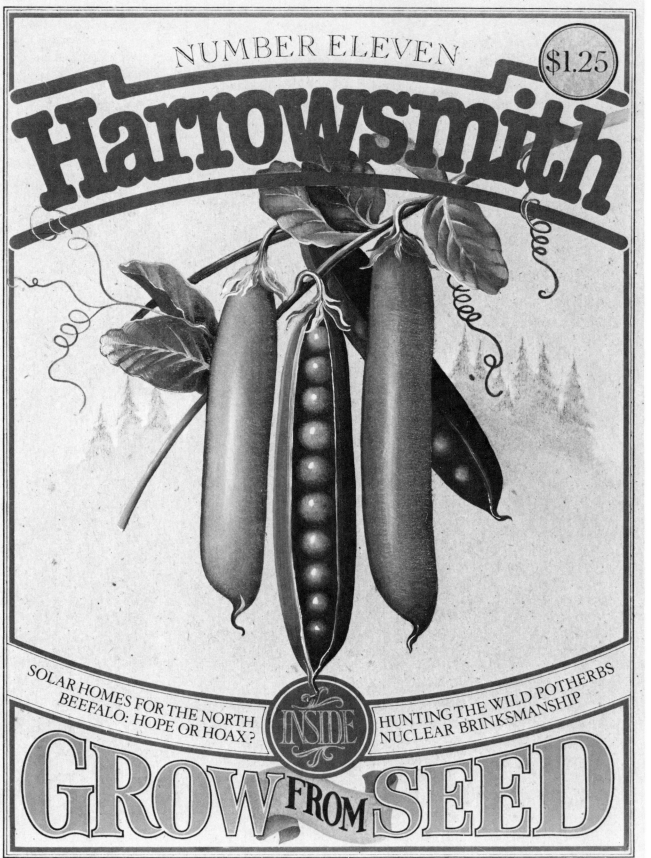

NUMBER ELEVEN

$1.25

Harrowsmith

SOLAR HOMES FOR THE NORTH
BEEFALO: HOPE OR HOAX?

INSIDE

HUNTING THE WILD POTHERBS
NUCLEAR BRINKSMANSHIP

GROW FROM SEED

Magazine:
Harrowsmith, Number 11
Art Directors:
Bruce Kendall,
Carmen Dunjko
Artist:
Heather Cooper
Design Firm:
Burns, Cooper, Hynes, Ltd.
Publisher:
Harrowsmith Magazine
Typographer:
Headliners

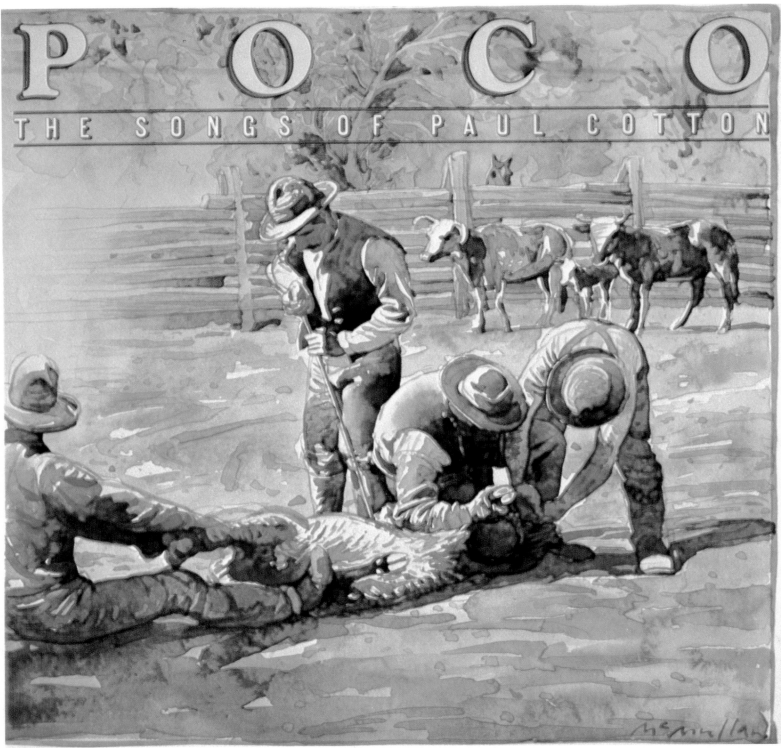

Record Album:
Poco/The Songs of
Paul Cotton
Art Director:
Paula Scher
Designer:
Paula Scher
Artist:
Jim McMullan
Design Firm:
Visible Studio
Publisher:
CBS Records
Typography:
Haber Typographers, Inc.
Printer:
Shorewood Reproductions,
Inc.

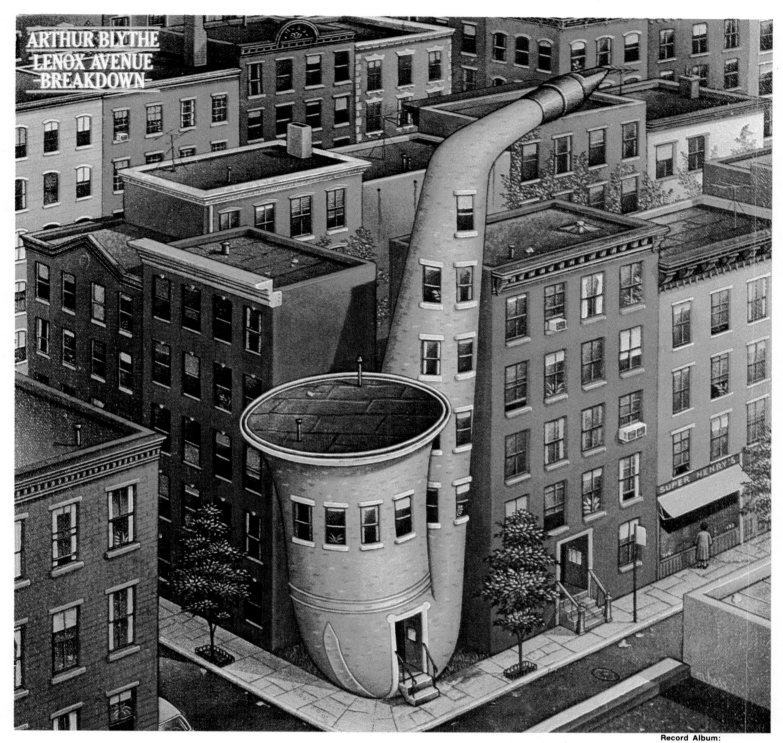

ARTHUR BLYTHE
LENOX AVENUE
BREAKDOWN

Record Album:
Arthur Blythe/Lenox Avenue
Breakdown
Art Director:
Gene Greif
Artist:
Mark Hess
Publisher:
CBS Records
Typographer:
Haber Typographers, Inc.
Printer:
Shorewood Reproduction,
Inc.

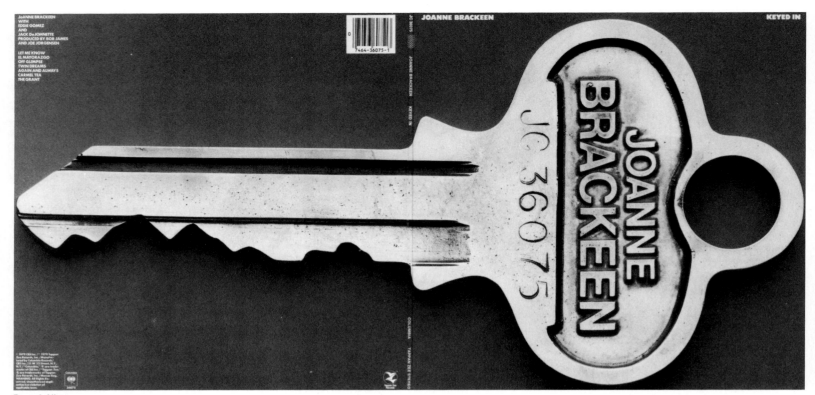

Record Album:
Joanne Brackeen
Art Director:
Paula Scher
Designer:
Paula Scher
Photographer:
Buddy Endress
Publisher:
CBS Records
Typographer:
Haber Typographers, Inc.
Printer:
Shorewood Reproductions, Inc.

Record Album:
Igor Stravinsky/Paul Hoffert
Art Directors:
Heather Cooper,
Carmen Dunjko
Artist:
Heather Cooper
Design Firm:
Burns, Cooper, Hynes, Ltd.
Publisher:
SQN Records
Typographer:
Hunter Brown, Cooper &
Beatty
Printer:
Herzig Somerville

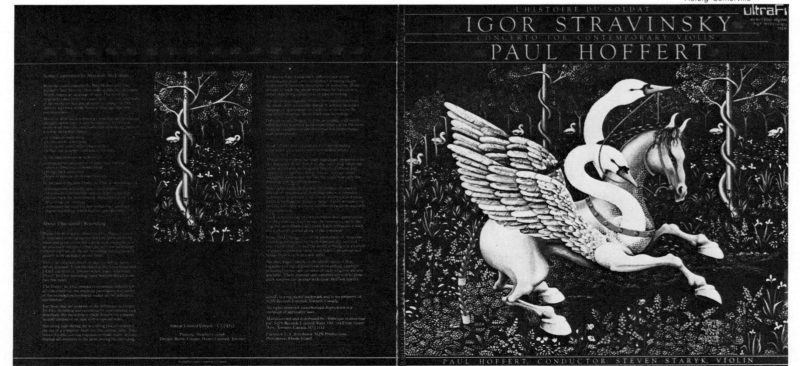

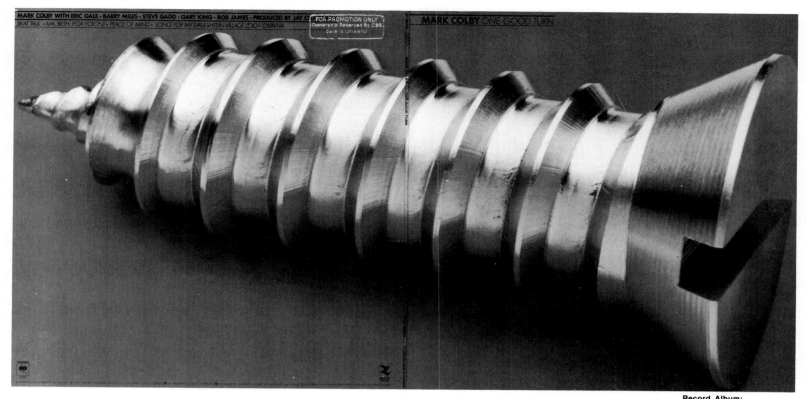

Record Album:
Mark Colby/One Good Turn
Art Director:
Paula Scher
Designer:
Paula Scher
Photographer:
Buddy Endress
Publisher:
CBS Records
Typographer:
Haber Typographers, Inc.
Printer:
Shorewood Reproductions, Inc.

Record Album:
Roy Acuff/Vol. 2
Art Director:
Ron Coro
Designer:
Richard Mantel
Artist:
Richard Mantel
Design Firm:
Push Pin Studio
Publisher:
Elektra/Asylum Records
Typographer:
Haber Typographers, Inc.
Printer:
Shorewood Reproductions, Inc.

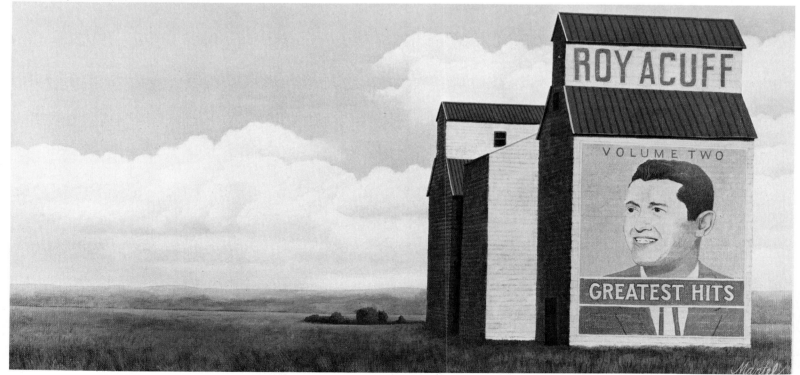

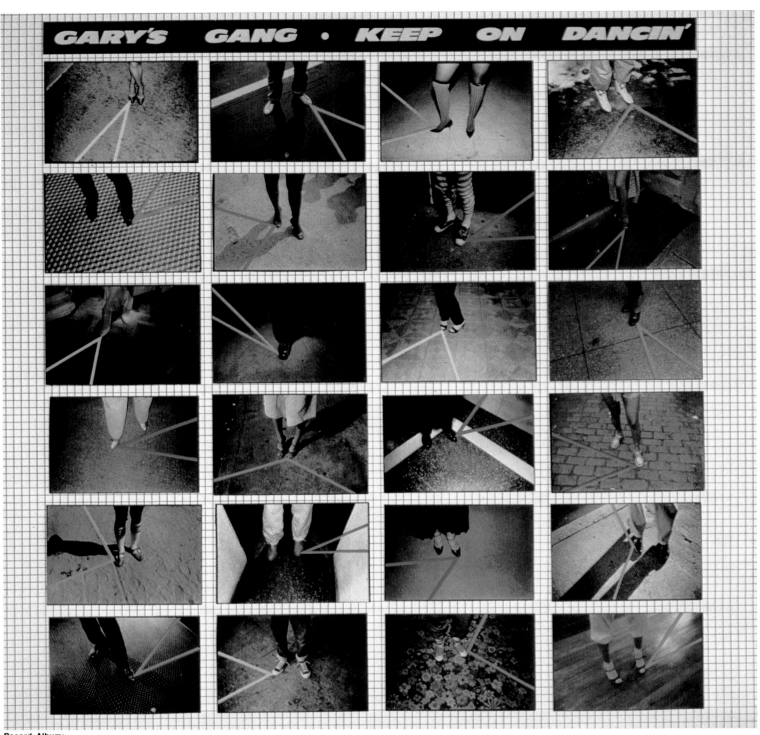

Record Album:
Gary's Gang/Keep on
Dancin'
Art Directors:
Gene Greif, Janet Perr
Designers:
Gene Greif, Janet Perr
Publisher:
CBS Records
Typographer:
Haber Typographers, Inc.
Printer:
Shorewood Reproductions,
Inc.

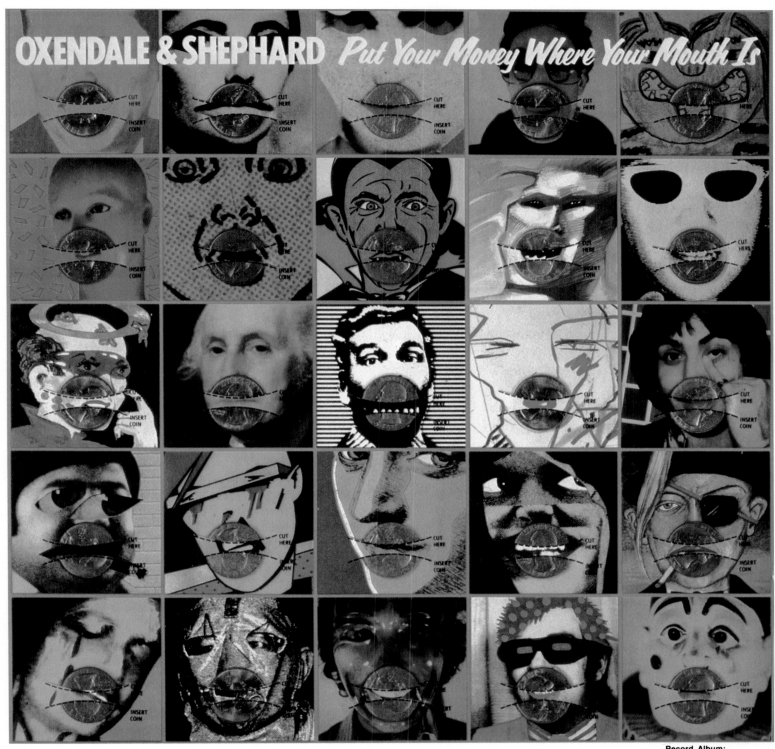

Record Album:
Oxendale & Shephard/
Put Your Money Where
Your Mouth Is
Art Director:
Janet Perr
Designer:
Janet Perr
Publisher:
CBS Records
Typographer:
Haber Typographers, Inc.
Printer:
Shorewood Reproductions,
Inc.

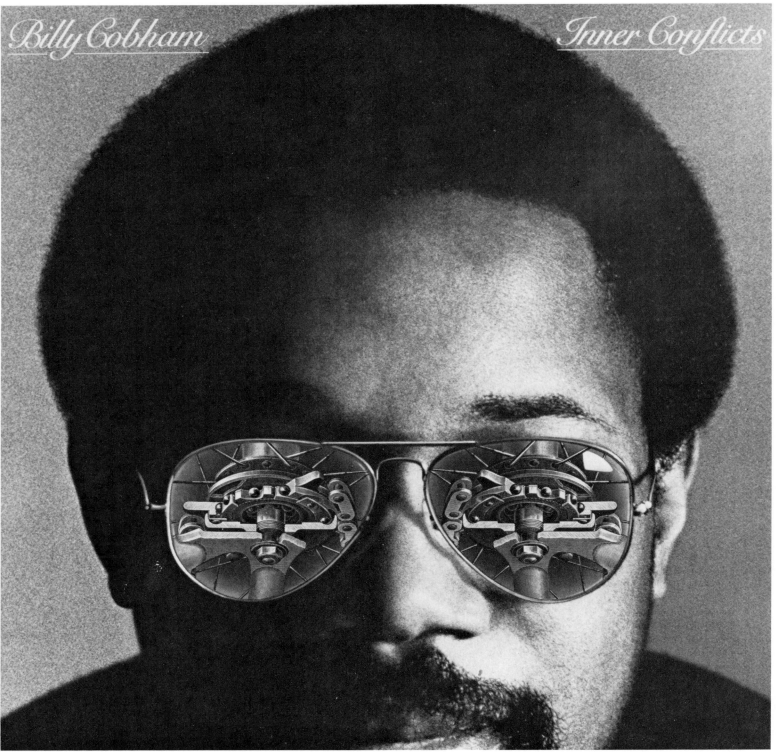

Record Album:
Billy Cobham/Inner Conflicts
Art Director:
Lynn Dreese Breslin
Designer:
Lynn Dreese Breslin
Photographer:
David Gahr
Publisher:
Atlantic Records
Typographer:
Haber Typographers, Inc.
Printer:
Shorewood Reproductions,
Inc.

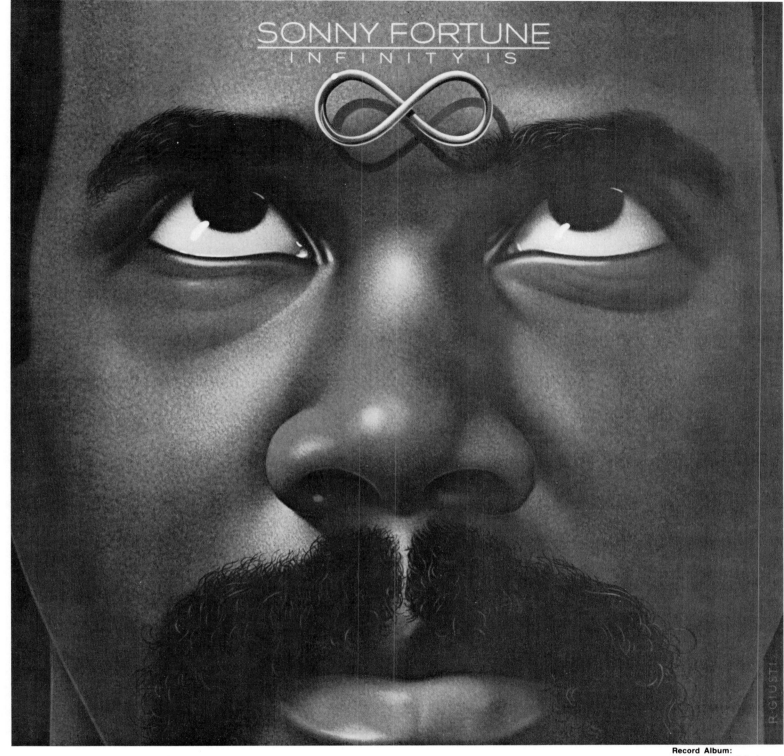

Record Album:
Sonny Fortune/Infinity Is
Art Director:
Lynn Dreese Breslin
Designer:
Lynn Dreese Breslin
Artist:
Robert Giusti
Publisher:
Atlantic Records
Typographer:
Haber Typographers, Inc.
Printer:
Album Graphics, Inc.

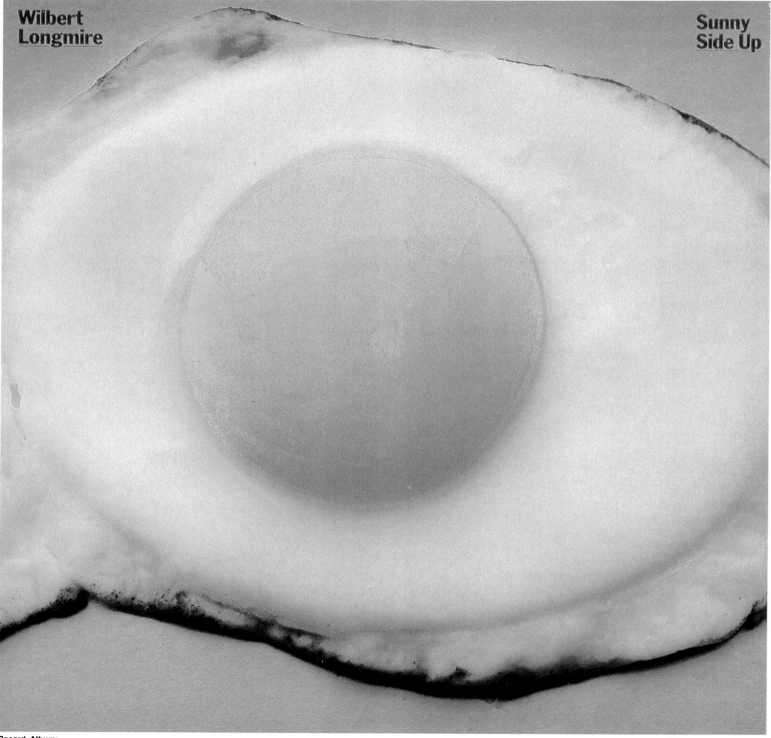

Wilbert Longmire

Sunny Side Up

Record Album:
Wilbert Longmire
Sunny Side Up
Art Directors:
Paula Scher, John Berg
Designers:
Paula Scher, John Berg
Photographer:
Buddy Endress
Publisher:
CBS Records
Typographer:
Haber Typographers, Inc.
Printer:
Shorewood Reproductions, Inc.

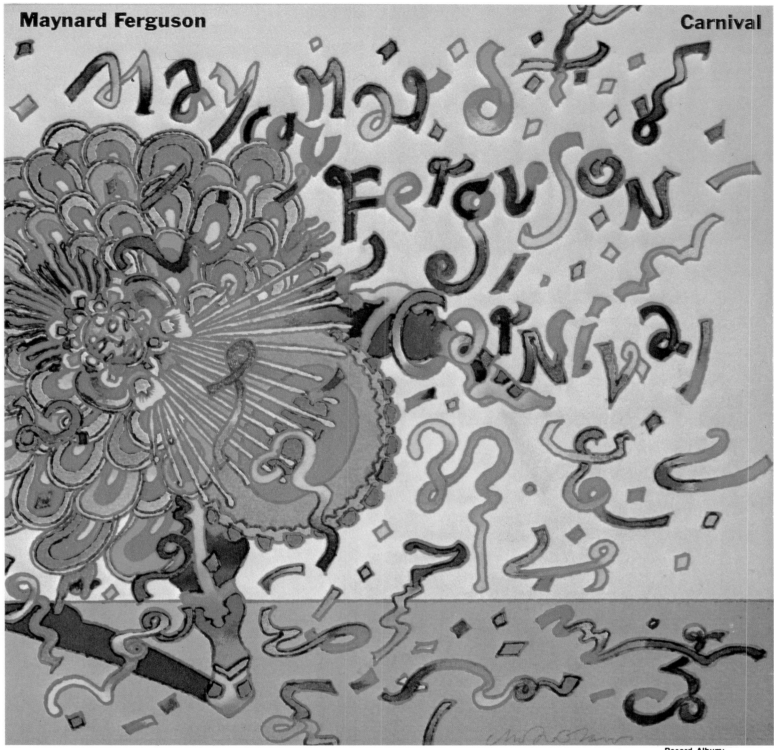

Record Album:
Maynard Ferguson/Carnival
Art Director:
Paula Scher
Designer:
Paula Scher
Artist:
Milton Glaser
Publisher:
CBS Records
Typographer:
Haber Typographers, Inc.
Printer:
Shorewood Reproductions, Inc.

Record Album:
A Bing Crosby Collection Vol. 1
Art Director:
John Berg
Designer:
John Berg
Photographer:
Culber Pictures, Inc.
Publisher:
CBS Records
Typographer:
Haber Typographers, Inc.
Printer:
Shorewood Reproductions, Inc.

Record Album:
Stravinsky/Agon
Art Director:
Henrietta Condak
Designer:
Henrietta Condak
Artist:
Cliff Condak
Publisher:
CBS Records
Typographer:
Haber Typographers, Inc.
Printer:
Shorewood Reproductions, Inc.

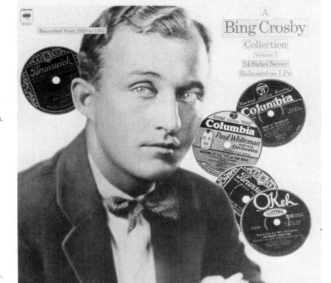

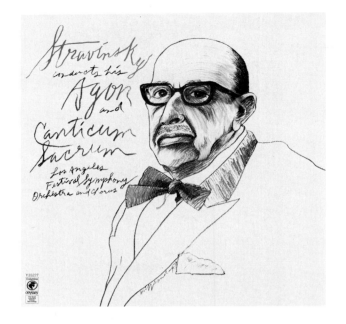

Record Album:
Flyer
Art Director:
Peter Corriston
Designer:
Peter Corriston
Artist:
Hubert Kretzschmar
Design Firm:
Creative Services
Publisher:
Infinity Records
Typographer:
M.J. Baumwell Typography
Printer:
Album Graphics, Inc.

Record Album:
"Candy-O"
Art Directors:
Ron Coro, Johnny Lee
Artist:
Alberto Vargas
Publisher:
Elektra/Asylum Records
Typographer:
Andresen Typographics
Printer:
Album Graphics, Inc.

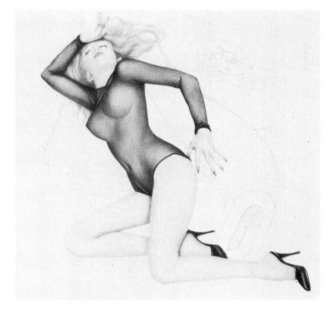

Record Album:
The Beach Boys "L.A."
Art Director:
Tony Lane
Designer:
Tony Lane
Artists:
Gary Meyer, Jim Heimann, Drew Struzan, Dave McMacken, Steve Carver, Nick Taggart, Howard Carriker, Peter Green, Neon Park, Lou Beach, Mick Haggerty, William Stout
Publisher:
CBS Records
Typographer:
Haber Typographers, Inc.
Printer:
Shorewood Reproductions, Inc.

Record Album:
Bartok
Art Director:
Paula Scher
Designer:
Paula Scher
Publisher:
CBS Records
Typographer:
Haber Typographers, Inc.
Printer:
Shorewood Reproductions, Inc.

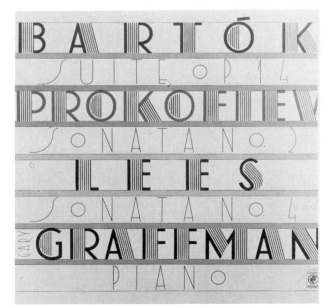

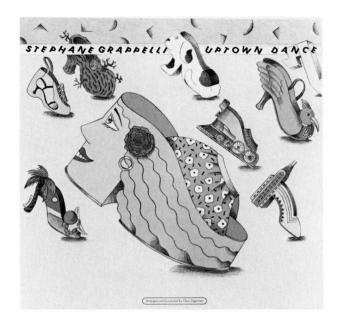

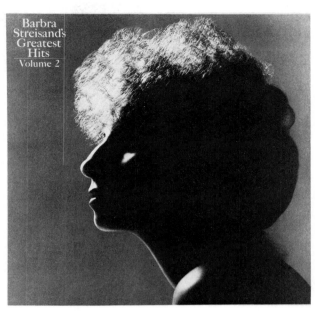

Record Album:
Stephane Grappelli
Uptown Dance
Art Director:
Paula Scher
Designer:
Paula Scher
Artist:
Seymour Chwast
Publisher:
CBS Records
Typographer:
Haber Typographers, Inc.
Printer:
Shorewood Reproductions, Inc.

Record Album:
Barbara Streisand's Greatest Hits/Vol. 2
Art Directors:
Tony Lane, Nancy Donald
Photographer:
Francesco Scavullo
Publisher:
CBS Records
Typographer:
Haber Typographers, Inc.
Printer:
Shorewood Reproductions, Inc.

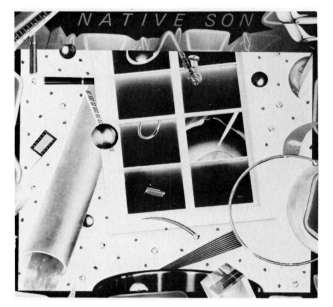

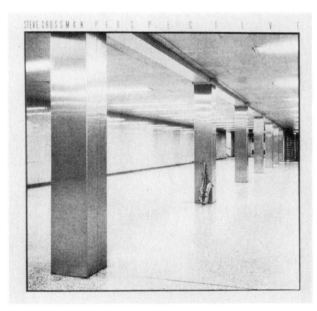

Record Album:
Native Son
Art Director:
Pat McGowan
Artist:
Lou Beach
Design Firm:
Creative Services
Publisher:
Infinity Records
Typographer:
M.J. Baumwell Typography
Printer:
Album Graphics, Inc.

Record Album:
Steve Grossman/Perspective
Art Director:
Lynn Dreese Breslin
Designer:
Lynn Dreese Breslin
Photographer:
Guiseppe G. Pino
Publisher:
Atlantic Records
Typographer:
Haber Typographers, Inc.
Printer:
Album Graphics, Inc.

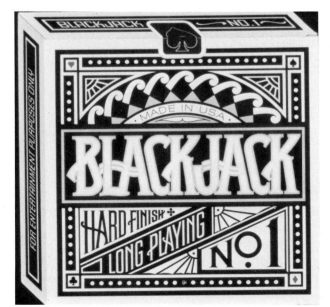

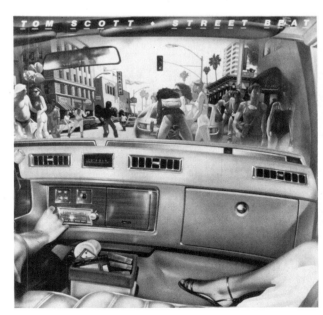

Record Album:
Blackjack
Art Director:
Abie Sussman
Designers:
Gerard Huerta,
Abie Sussman
Artist:
Gerard Huerta
Design Firm:
Gerard Huerta Design
Publisher:
Polydor Records
Printer:
Album Graphics, Inc.

Record Album:
Tom Scott/Street Beat
Art Director:
Tony Lane
Designer:
Tony Lane
Artist:
Dave McMacken
Publisher:
CBS Records
Typographer:
Haber Typographers, Inc.
Printer:
Shorewood Reproductions, Inc.

Book Jacket:
The Burning Mystery of
Anna in 1951
Art Director:
R.D. Scudellari
Artist:
Larry Rivers
Publisher:
Random House
Printer:
The Longacre Press

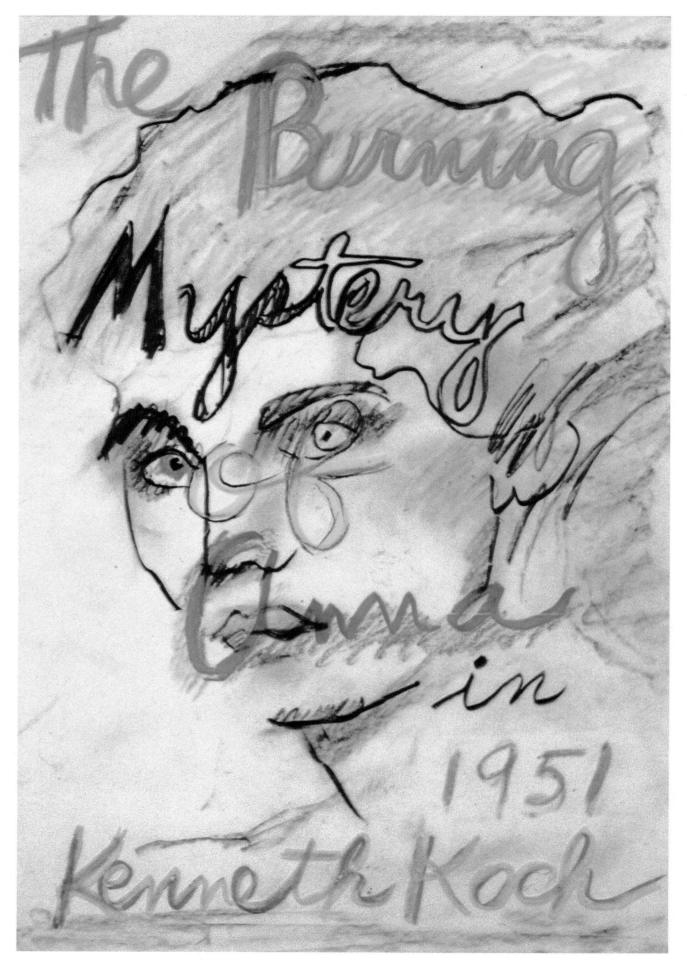

Air Powered

The Art of the Airbrush

Book Jacket:
Air Powered
Art Director:
R.D. Scudellari
Designer:
Richard Childers Associates
Artist:
Peter Sato
Design Firm:
Richard Childers Associates
Publisher:
Random House
Printer:
The Longacre Press

Book Jacket:
Stravinsky
Art Director:
Frank Metz
Designer:
Robert Anthony
Photography:
Courtesy of C B S Records
Design Firm:
Robert Anthony, Inc.
Publisher:
Simon & Schuster
Typographer:
Marvin Kommel
Productions, Inc.
Printer:
Lehigh Press

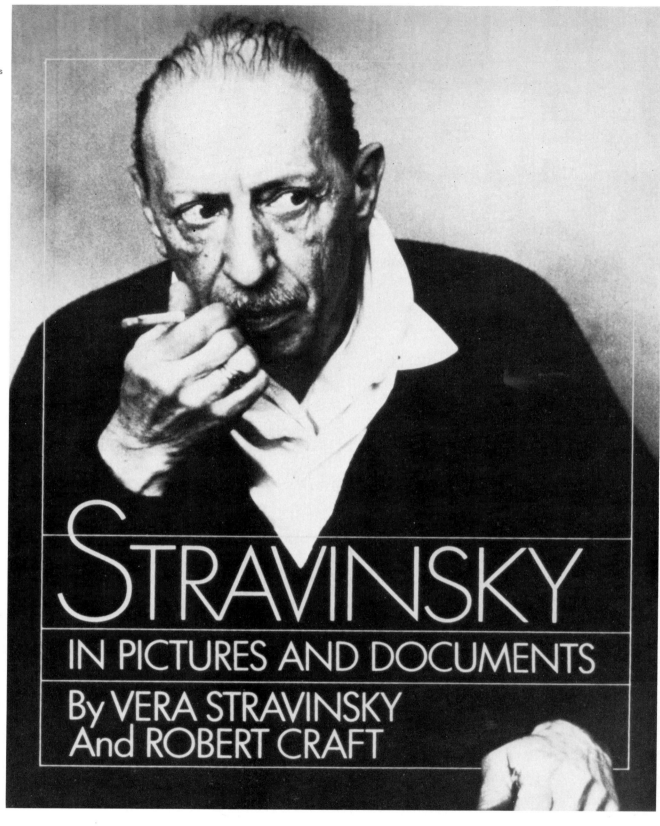

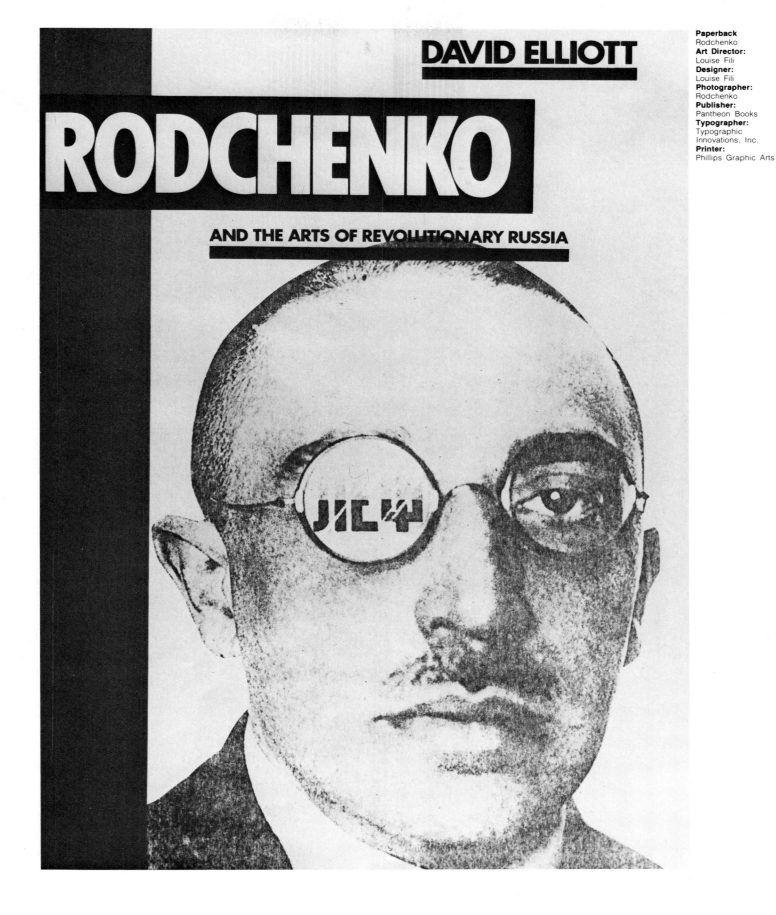

RODCHENKO

DAVID ELLIOTT

AND THE ARTS OF REVOLUTIONARY RUSSIA

Paperback
Rodchenko
Art Director:
Louise Fili
Designer:
Louise Fili
Photographer:
Rodchenko
Publisher:
Pantheon Books
Typographer:
Typographic
Innovations, Inc.
Printer:
Phillips Graphic Arts

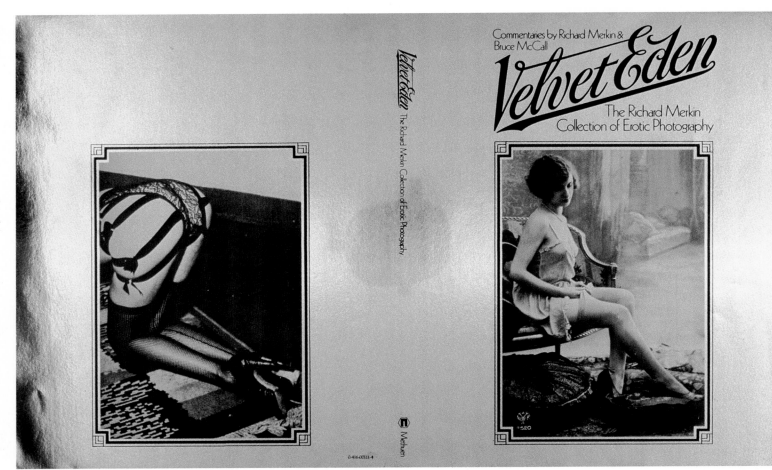

Book Jacket:
Velvet Eden
Art Director:
Harris Lewine
Designer:
Louise Fili
Artist:
Louise Fili
Design Firm:
Louise Fili Design
Publisher:
Methuen, Inc.
Letterer:
Louise Fili
Printer:
The Chaucer Press

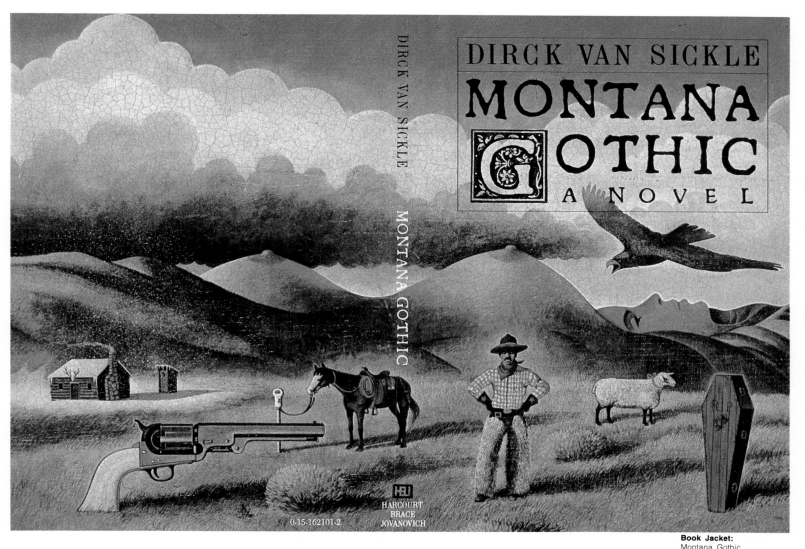

DIRCK VAN SICKLE

MONTANA GOTHIC

A NOVEL

DIRCK VAN SICKLE

MONTANA GOTHIC

0-15-162101-2

HARCOURT
BRACE
JOVANOVICH

Book Jacket:
Montana Gothic
Art Director:
Harris Lewine
Designer:
Wendell Minor
Artist:
Wendell Minor
Design Firm:
Wendell Minor Design
Publisher:
Harcourt Brace
Jovanovich, Inc.
Typographer:
Type Trends
Printer:
The Longacre Press

Paperback:
Interpretive Reading A
Art Director:
Skip Sorvino
Designers:
Stephanie Zuras,
Mike Jimenez
Artist:
George Masi
Publisher:
Scholastic Book Services
Typographer:
Letter Perfect Corp.
Printer:
George Banta Co., Inc.

Book Jacket:
The Encyclopedia of How
It's Made
Art Directors:
Thomas and Nancy Tafuri
Designers:
Thomas and Nancy Tafuri
Artist:
Dennis Miller
Design Firm:
One Plus One Studio
Publisher:
A & W Publishers
Typographer:
Set-Rite
Printer:
Rainbow Litho

Book Jacket:
Dreemz
Art Director:
Joseph Montebello
Designer:
David Myers
Artist:
David Myers
Publisher:
Harper & Row
Printer:
The Longacre Press

Book Jacket:
Fill'er Up
Art Director:
Donald Longabucco
Designer:
Bob Silverman
Artist:
Bob Silverman
Design Firm:
Bob Silverman, Inc.
Publisher:
Macmillan Publishing Co.,
Inc.
Typographer:
Cardinal Group
Printer:
The Longacre Press

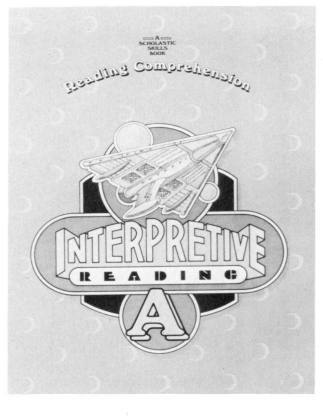

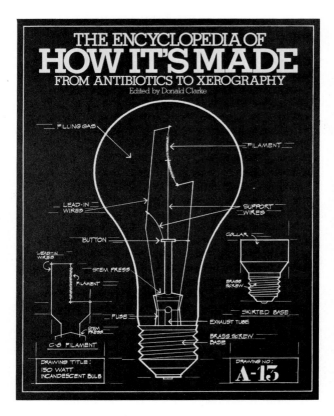

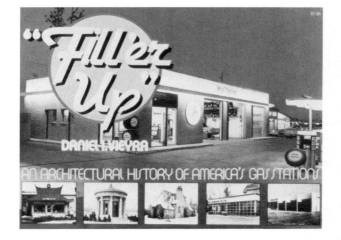

ROME

Photographs by
Fredrich Cantor

VOLUME 1

Book Jacket:
Rome, Vol. 1
Art Director:
Willi Kunz
Photographer:
Frederich Cantor
Typographer:
Johnson Ken-Ro Inc.
Printer:
Rapoport Press

Book Jacket:
Portrait of a Scoundrel
Art Director:
Alex Gotfryd
Designer:
Fred Marcellino
Artist:
Fred Marcellino
Publisher:
Doubleday & Company
Printer:
Doubleday & Company

Sprint
Reading Skills Program

2

STARTER LEVEL

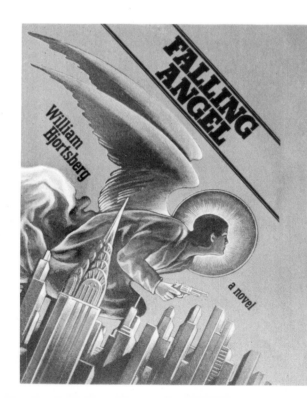

Paperback:
Sprint Reading Skills
Program #2
Art Director:
Skip Sorvino
Designers:
Stephanie Zuras,
Mike Jimenez
Artist:
Will Kefauver
Publisher:
Scholastic Book Services
Printer:
George Banta Co., Inc.

Book Jacket:
Falling Angel
Art Director:
Harris Lewine
Designer:
Stanislaw Zagorski
Artist:
Stanislaw Zagorski
Design Firm:
Stanislaw Zagorski Design
Publisher:
Harcourt Brace
Jovanovich, Inc.
Typographer:
Haber Typographers, Inc.
Printer:
The Longacre Press

Paperback:
The Shadow Scrapbook
Art Director:
Harris Lewine
Designer:
Robert Anthony
Photographer:
Neal Slavin
Letterer:
Yevtikhiev
Design Firm:
Robert Anthony, Inc.
Publisher:
Harcourt Brace
Jovanovich, Inc.
Typographer:
Marvin Kommel
Productions, Inc.
Printer:
The Longacre Press

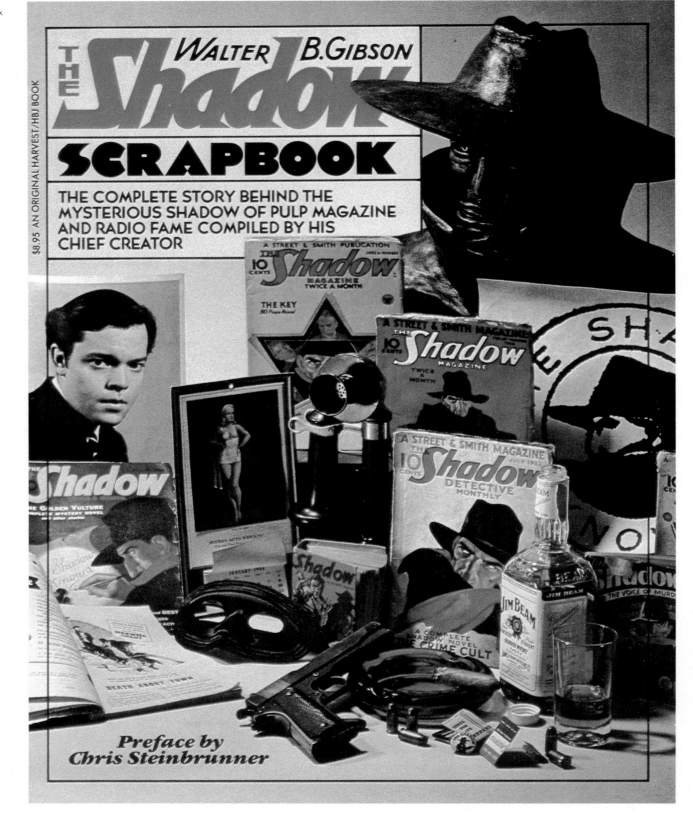

$8.95 AN ORIGINAL HARVEST/HBJ BOOK

WALTER B. GIBSON
THE Shadow
SCRAPBOOK

THE COMPLETE STORY BEHIND THE
MYSTERIOUS SHADOW OF PULP MAGAZINE
AND RADIO FAME COMPILED BY HIS
CHIEF CREATOR

Preface by
Chris Steinbrunner

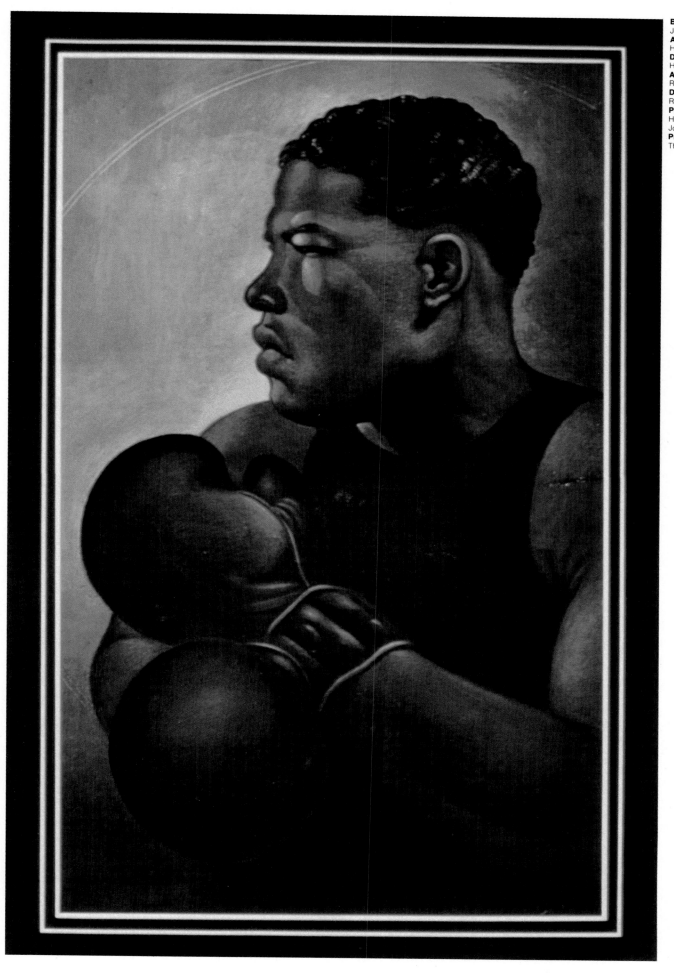

Book Jacket:
Joe Louis
Art Director:
Harris Lewine
Designer:
Harris Lewine
Artist:
Richard Hess
Design Firm:
Richard Hess, Inc.
Publisher:
Harcourt Brace
Jovanovich, Inc.
Printer:
The Chaucer Press

Book Jacket:
Eyes of Eternity
Art Directors:
Harris Lewine,
Richard Mantel
Designer:
Richard Mantel
Artist:
Richard Mantel
Design Firm:
Push Pin Studios
Publisher:
Harcourt Brace
Jovanovich, Inc.
Typographer:
Haber Typographers, Inc.
Printer:
The Chaucer Press

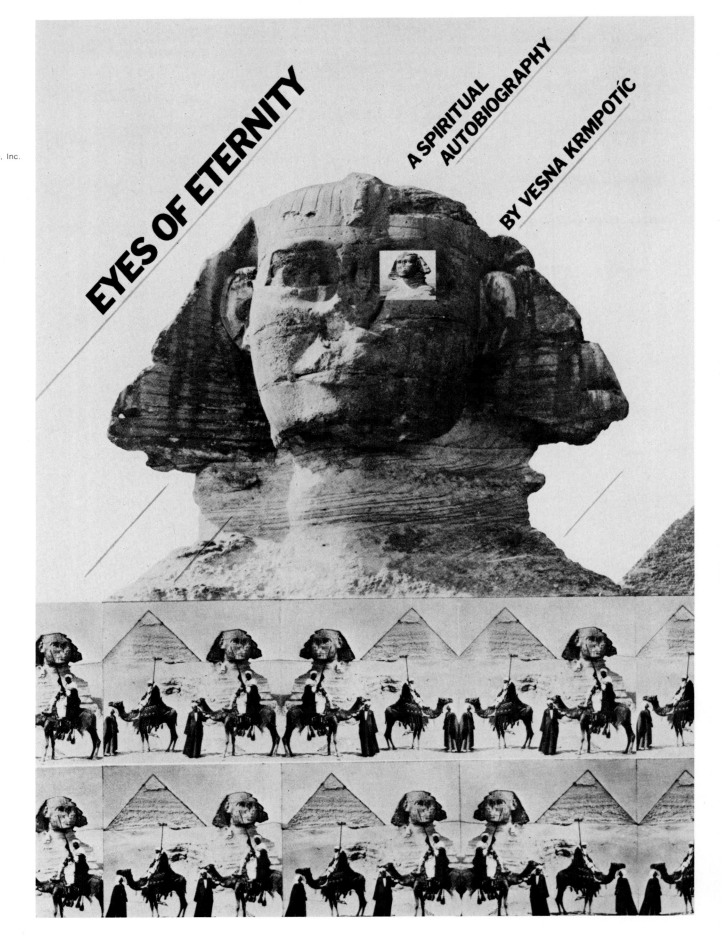

SEXY LADIES

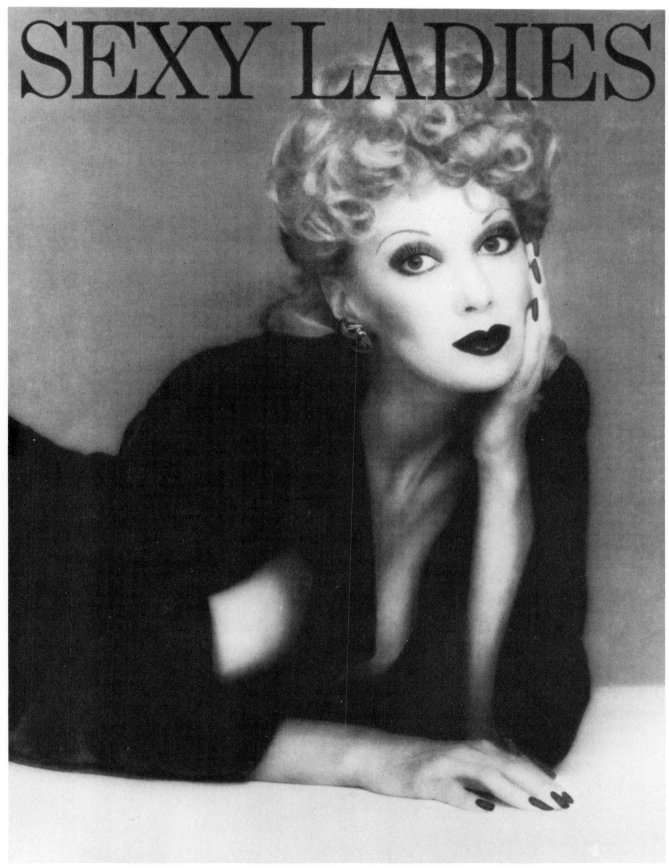

Book Jacket:
Sexy Ladies
Art Director:
Francois Robert
Designer:
Francois Robert
Photographer:
Chris Callis
Hand Coloring:
Bonnie Maller
Design Firm:
Francois Robert Associates
Publisher:
Playboy, Inc.
Typographer:
Chicago Franchise
Printer:
Anderson Lithography Co.

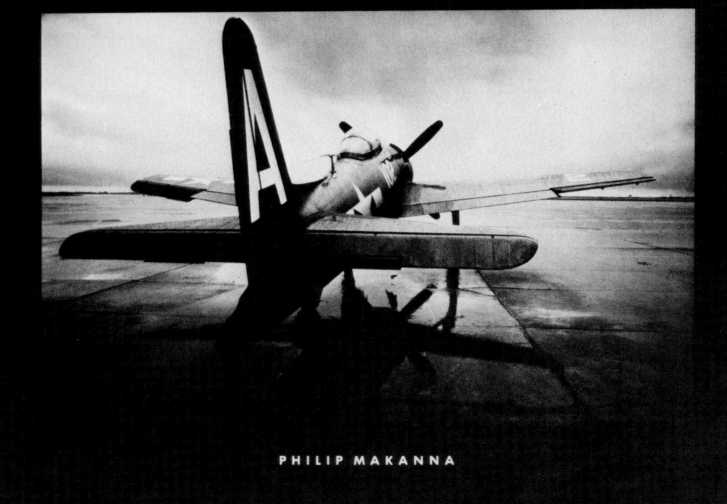

GHOSTS
A TIME REMEMBERED

PHILIP MAKANNA

Book Jacket:
Ghosts
Art Director:
Robert D. Reed
Designer:
Robert D. Reed
Artist:
Philip Makanna
Publisher:
Holt Rinehart & Winston
Typographer:
Letraset
Printer:
Pearl Pressman Liberty

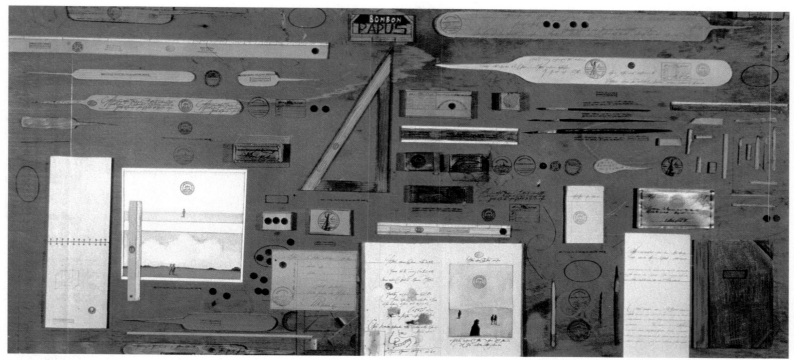

Slipcase:
Saul Steinberg
Art Director:
Robert D. Scudellari
Designer:
Saul Steinberg
Artist:
Saul Steinberg
Publisher:
Alfred Knopf, Inc.
Printer:
The Longacre Press

Annual Report:
Fannin Bank Annual Report
1977
Art Director:
Anna Wingfield
Designer:
Anna Wingfield
Artist:
Jack Amuny
Design Firm:
Art City
Client:
Fannin Bank
Typographer:
The Typehouse
Printer:
Wetmore & Co.

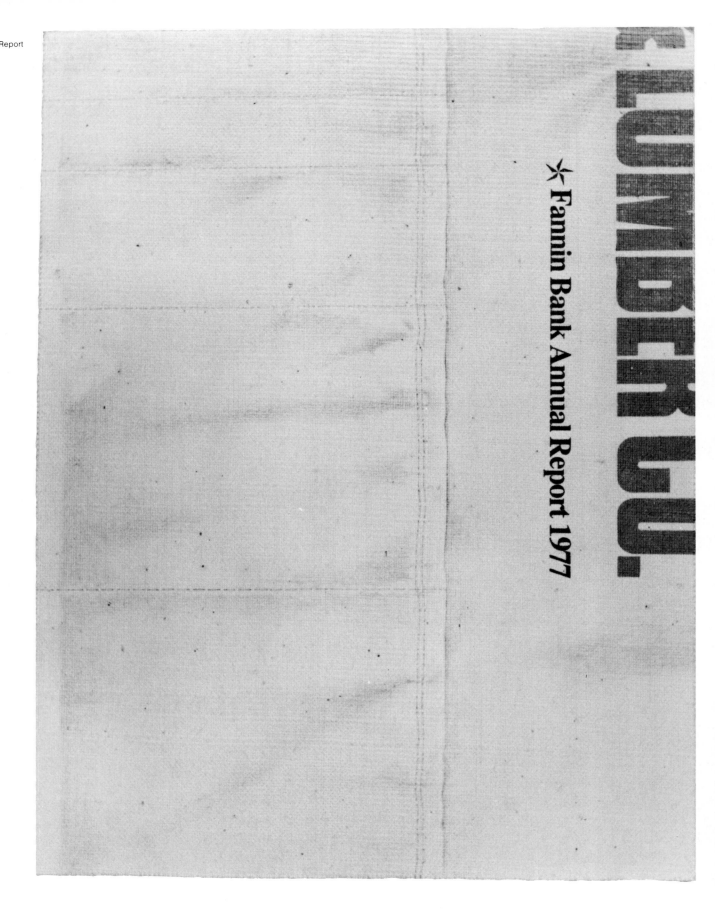

Fannin Bank Annual Report 1977

H.J. Heinz Company Annual Report 1978.
These people have something to say to you:

Annual Report:
H.J. Heinz Company Annual
Report 1978
Art Director:
Bennett Robinson
Designer:
Bennett Robinson
Design Firm:
Corporate Graphics, Inc.
Client:
H.J. Heinz Company
Typographer:
Davis & Warde
Printer:
Sanders Printing Corporation

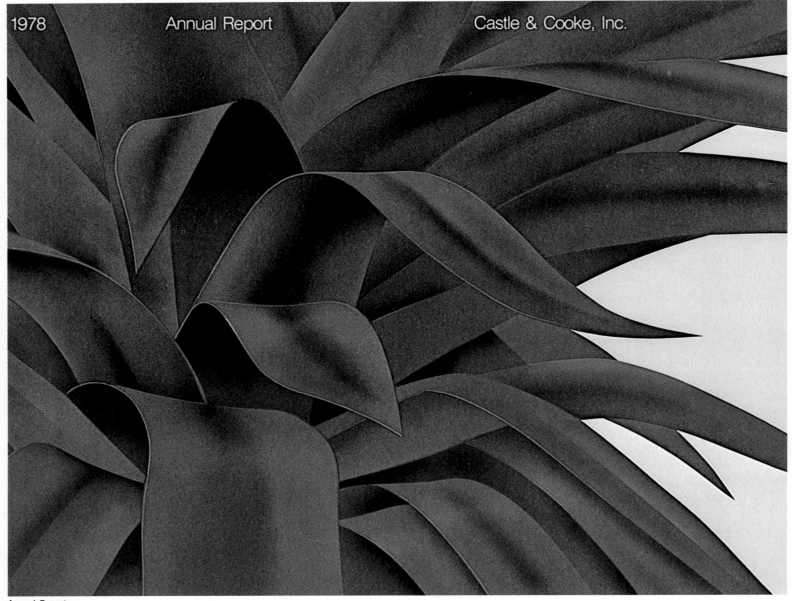

Annual Report:
Castel & Cooke, Inc. 1978
Annual Report
Art Director:
Robert Miles Runyan
Designer:
Jim Berte
Artist:
Paul Bice
Design Firm:
Robert Miles Runyan &
Associates
Client:
Castle & Cooke, Inc.
Typographer:
Composition Type
Printer:
Anderson Lithography Co.

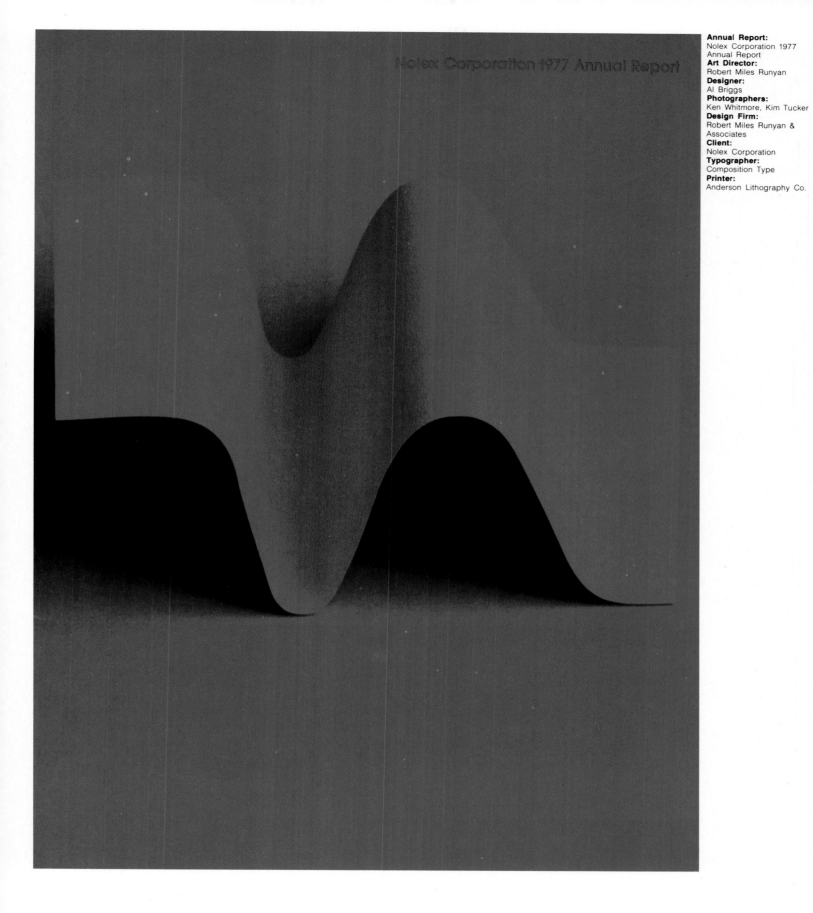

Nolex Corporation 1977 Annual Report

Annual Report:
Nolex Corporation 1977
Annual Report
Art Director:
Robert Miles Runyan
Designer:
Al Briggs
Photographers:
Ken Whitmore, Kim Tucker
Design Firm:
Robert Miles Runyan &
Associates
Client:
Nolex Corporation
Typographer:
Composition Type
Printer:
Anderson Lithography Co.

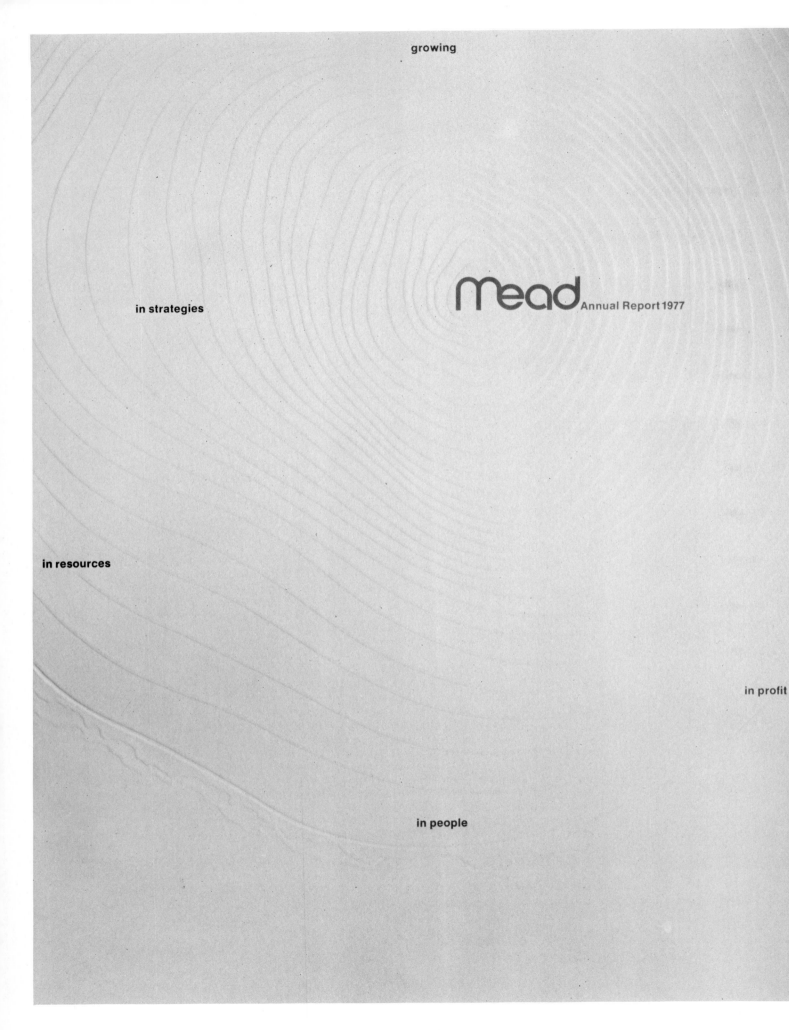

growing

in strategies

mead Annual Report 1977

in resources

in profit

in people

growing

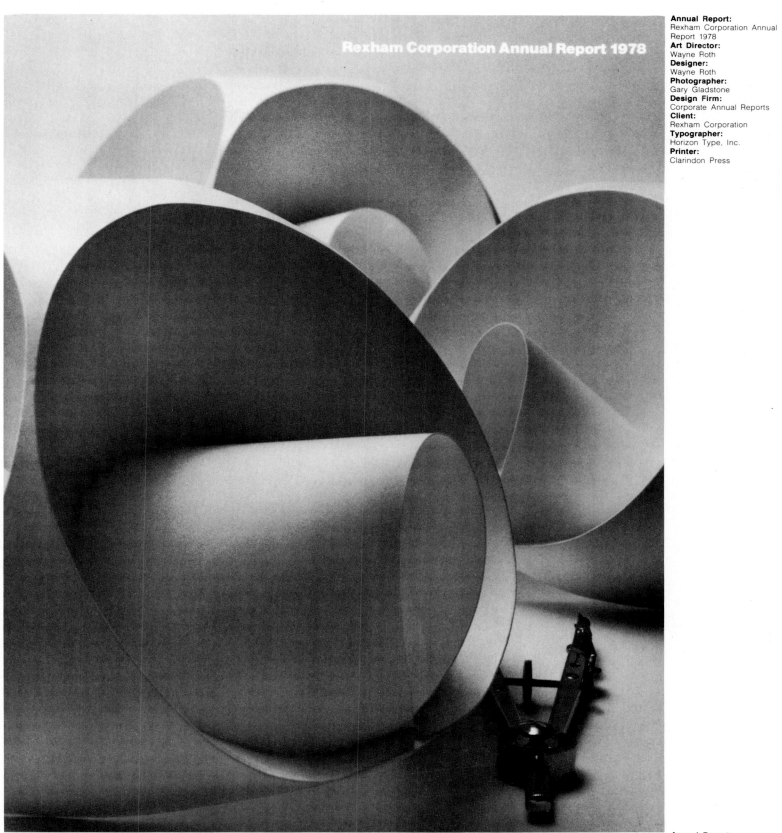

Rexham Corporation Annual Report 1978

Annual Report:
Rexham Corporation Annual
Report 1978
Art Director:
Wayne Roth
Designer:
Wayne Roth
Photographer:
Gary Gladstone
Design Firm:
Corporate Annual Reports
Client:
Rexham Corporation
Typographer:
Horizon Type, Inc.
Printer:
Clarindon Press

Annual Report:
Mead Annual Report 1977
Art Directors:
Sheldon Seidler,
William Mihalik
Designers:
Sheldon Seidler,
William Mihalik
Artist:
William Mihalik
Design Firm:
Sheldon Seidler, Inc.
Client:
The Mead Corporation
Typographer:
Tri-Arts Press, Inc.
Printer:
R.R. Donnelley & Sons Co.

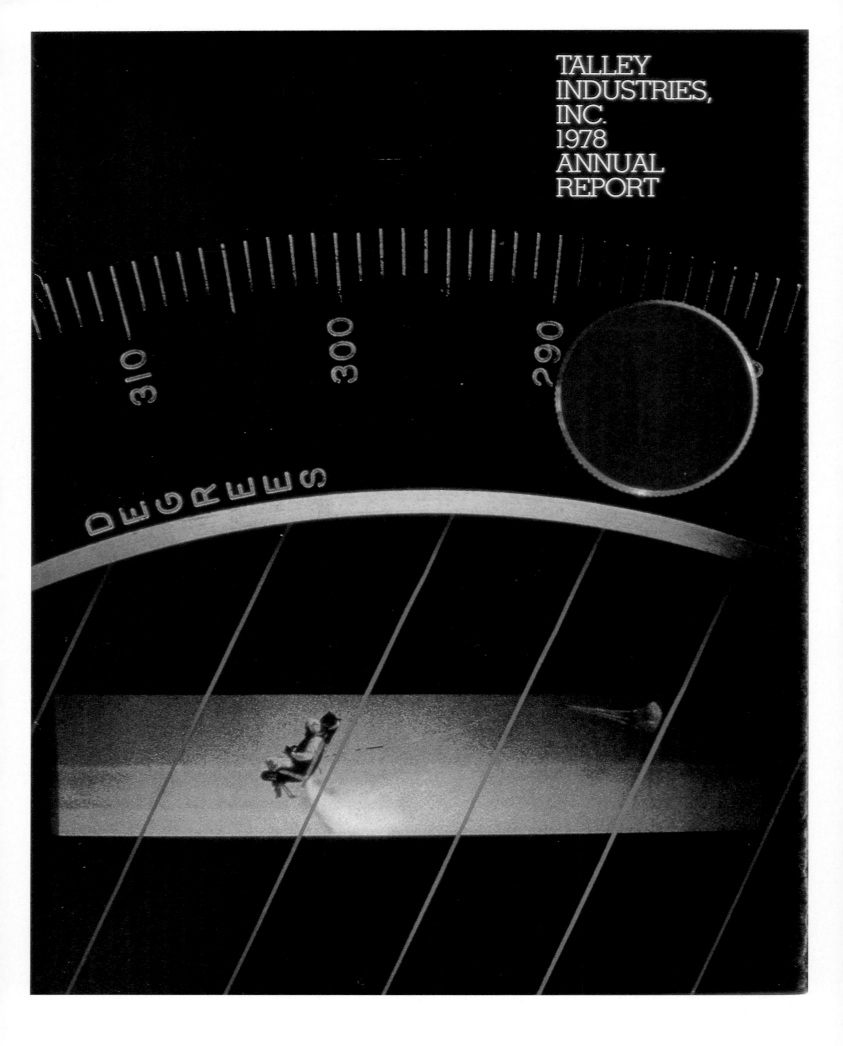

TALLEY
INDUSTRIES,
INC.
1978
ANNUAL
REPORT

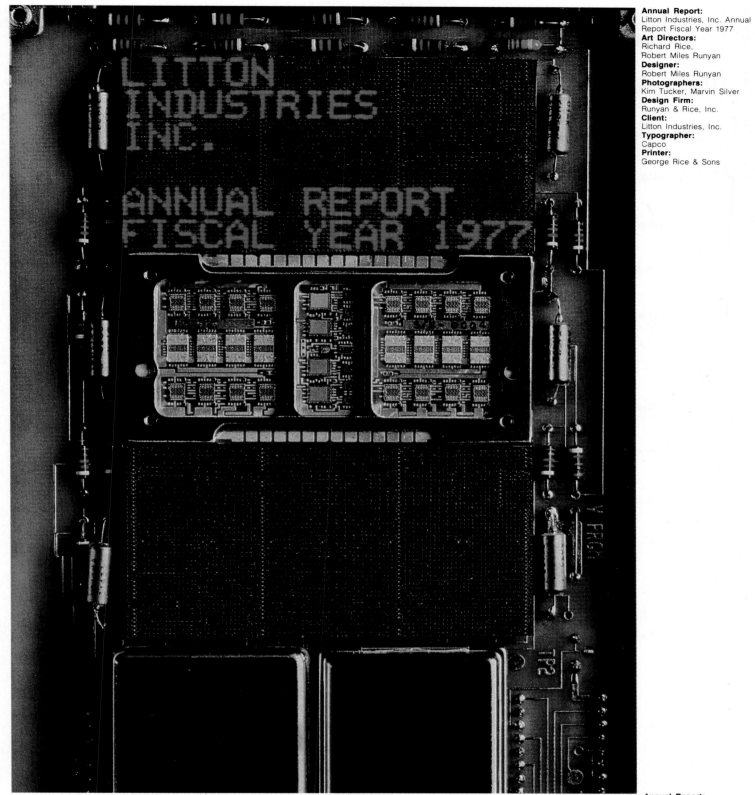

Annual Report:
Litton Industries, Inc. Annual
Report Fiscal Year 1977
Art Directors:
Richard Rice,
Robert Miles Runyan
Designer:
Robert Miles Runyan
Photographers:
Kim Tucker, Marvin Silver
Design Firm:
Runyan & Rice, Inc.
Client:
Litton Industries, Inc.
Typographer:
Capco
Printer:
George Rice & Sons

Annual Report:
Talley Industries, Inc. 1978
Annual Report
Art Directors:
Robert Miles Runyan,
Jim Berte
Designer:
Jim Berte
Photographer:
Marvin Silver
Design Firm:
Robert Miles Runyan &
Associates
Publisher:
Talley Industries, Inc.
Typographer:
Ad Compositors
Printer:
George Rice & Sons

Annual Report:
Fairchild Camera &
Instrument Corporation 1978
Annual Report
Art Directors:
Dawson Zaug,
Stephen R. Stanley
Designers:
Dawson Zaug,
Stephen R. Stanley
Photography:
U.S. Government Landsat
Design Firm:
Unigraphics, Inc.
Client:
Fairchild Camera &
Instrument Corporation
Typographer:
Reardon & Krebs
Printer:
George Rice & Sons

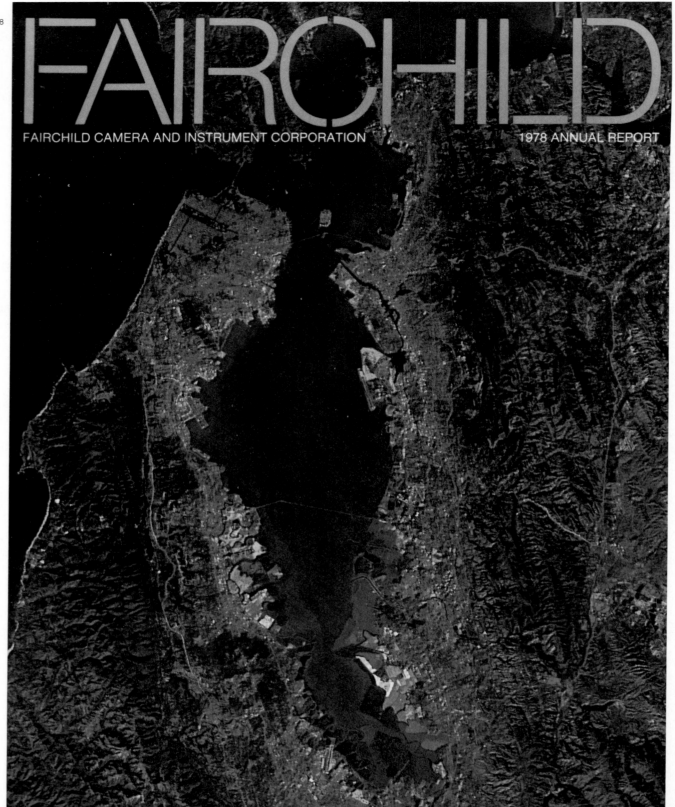

FAIRCHILD

FAIRCHILD CAMERA AND INSTRUMENT CORPORATION 1978 ANNUAL REPORT

Annual Report:
National Semiconductor
Corporation 1978 Annual
Report
Art Director:
Ken Parkhurst
Designer:
Ken Parkhurst
Artist:
Denis Parkhurst
Photographer:
Tom Engler
Designer Firm:
Ken Parkhurst &
Associates, Inc.
Client:
National Semiconductor
Corporation
Typographer:
Richards/Switzer
Typographics, Inc.
Printer:
Anderson Lithography Co.

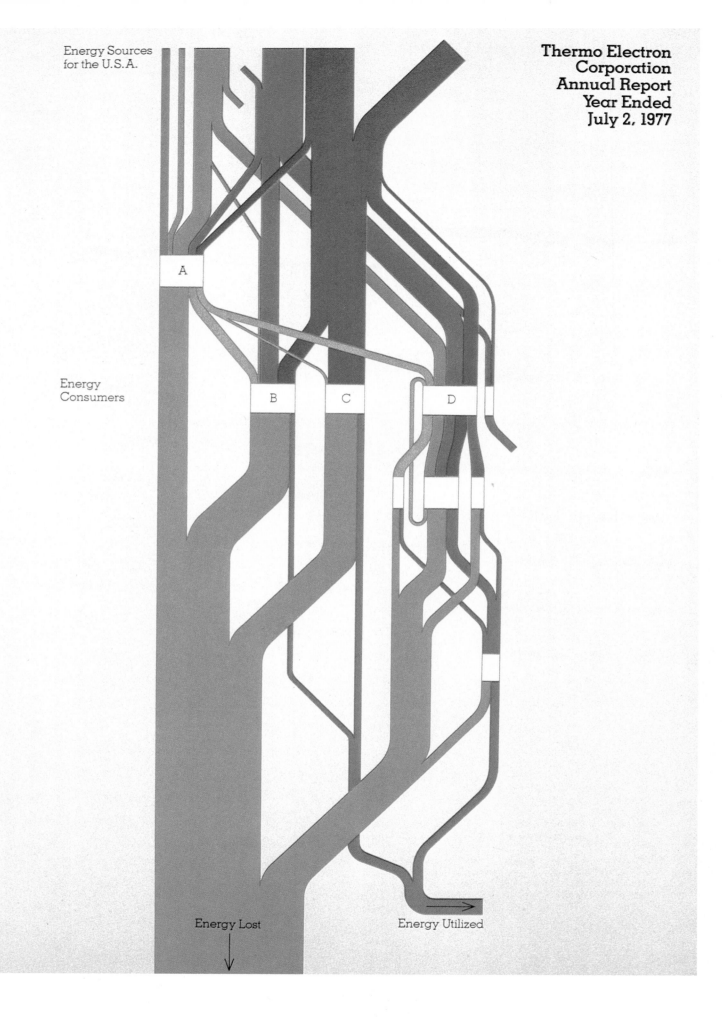

Energy Sources
for the U.S.A.

Thermo Electron
Corporation
Annual Report
Year Ended
July 2, 1977

A

Energy
Consumers

B

C

D

Energy Lost

Energy Utilized

138

Binney & Smith Inc. 1977 Annual Report

Annual Report:
Binney & Smith 1977
Annual Report
Art Directors:
Beau Gardner, Tom Guerrieri
Designers:
Beau Gardner, Tom Guerrieri
Photographer:
Jeff Smith
Design Firm:
Beau Gardner Associates
Client:
Binney & Smith
Typographer:
Barton Press
Printer:
Barton Press

Annual Report:
Thermo Electron Corporation
Annual Report 1977
Art Director:
Robert A. Cipriani
Designer:
Robert A. Cipriani
Design Firm:
Gunn Associates
Publisher:
Thermo Electron Corporation
Typographer:
Typographic House
Printer:
W.E. Andrews Co., Inc

Corporate Literature:
Herman Miller
President's Report 1979
Art Director:
Stephen Frykholm
Designer:
Stephen Frykholm
Die Cutting:
Gillispie Diecutting Co.
Publisher:
Herman Miller, Inc.
Typographer:
Type House
Printer:
Heritage Press

McCoy & McCoy

Corporate Literature:
McCoy & McCoy
Art Directors:
Katherine McCoy,
Michael McCoy
Designers:
Katherine McCoy,
Michael McCoy
Design Firm:
McCoy & McCoy
Publisher:
McCoy & McCoy
Typographer:
American Center Studios
Printer:
Signet Printing Co.

Corporate Literature:
Down to Earth
Art Directors:
Robert Burns, Lawrence Finn
Artists:
Lawrence Finn, Paul Walker
Design Firm:
Burns, Cooper, Hynes, Ltd.
Client:
David Greenspan
Publisher:
Federal Provincial Task
Force
Typographer:
Hunter Brown
Printer:
Alexander Lithographers

Down To Earth
Volume One

The Report Of The Federal/Provincial Task Force
On The Supply And Price Of Serviced Residential Land

Corporate Literature:
The Mead Library of Ideas
23rd International Annual
Report Competition
Art Director:
Ivan Chermayeff
Designer:
Ivan Chermayeff
Photographer:
Arnold Rosenberg
Design Firm:
Chermayeff & Geismar
Associates
Client:
The Mead Library of Ideas
Typographer:
Haber Typographers, Inc.
Printer:
Sanders Printing Corp.

The Mead Library of Ideas 23rd International Annual Report Competition

Corporate Literature:
Citibank Money Transfer
Art Director:
Jack Odette
Designer:
Mike Focar
Photographer:
Citibank Communication
Design Department
Publisher:
Citibank
Typographer:
King Typographers
Printer:
Sandy Alexander, Inc.

Corporate Literature:
STA 100
Art Director:
Barbara M. Wasserman
Designer:
Barbara M. Wasserman
Artist:
Barbara M. Wasserman
Design Firm:
B.M. Wasserman Design
Publisher:
Society of Typographic Arts
Typographer:
Foremost Graphics
Printer:
Aurora Midwest

Corporate Literature:
IBM 8100 Information System
Art Director:
Richard Rogers
Designer:
Richard Rogers
Photographer:
Bill Farrell
Design Firm:
Richard Rogers, Inc.
Client:
IBM Corp.
Typographer:
Southern New England
Typographic Services
Printer:
L.P. Thebault Co.

Corporate Literature:
EMSA/Eberle M. Smith
Assoc.
Art Director:
Katherine McCoy
Designer:
Katherine McCoy
Design Firm:
McCoy & McCoy
Publisher:
Eberle M. Smith Assoc.
Typographer:
Type House
Printer:
Signet Printing Co.

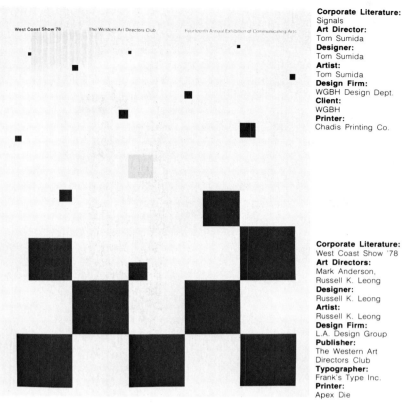

Corporate Literature:
Signals
Art Director:
Tom Sumida
Designer:
Tom Sumida
Artist:
Tom Sumida
Design Firm:
WGBH Design Dept.
Client:
WGBH
Printer:
Chadis Printing Co.

Corporate Literature:
West Coast Show '78
Art Directors:
Mark Anderson,
Russell K. Leong
Designer:
Russell K. Leong
Artist:
Russell K. Leong
Design Firm:
L.A. Design Group
Publisher:
The Western Art
Directors Club
Typographer:
Frank's Type Inc.
Printer:
Apex Die

Corporate Literature:
Conferences & Institutes
Art Directors:
Michael Richards,
Glade Christensen
Artist:
Glade Christensen
Design Firm:
University of Utah Design
Department
Publisher:
University of Utah
Typographer:
Twin Typographers
Printer:
Sun Litho

Corporate Literature:
Conservation Trust of
Puerto Rico
Art Director:
Ivan Chermayeff
Designer:
Ivan Chermayeff
Photographer:
Marvin W. Schwartz
Design Firm:
Chermayeff & Geismar
Associates
Publisher:
Conservation Trust of
Puerto Rico
Printer:
Sanders Printing Corporation

Honeywell
in Health Care:

Early Treatment for
Administrative
Control
Problems

Corporate Literature:
Smucker's Old-Fashioned
Goodness
Art Director:
Jolie Rossing
Designer:
Jolie Rossing
Photographer:
Al Fisher
Design Firm:
The D.R. Group
Client:
The J.M. Smucker Company
Typographer:
Typographic House
Printer:
Regal Lithograph Co.

Corporate Literature:
Honeywell in Health Care
Art Director:
Robert Cipriani
Photographer:
Clint Clemens
Design Firm:
Gunn Associates
Publisher:
Honeywell, Inc.
Typographer:
Typographic House
Printer:
Congraf

Corporate Literature:
The Corporate Program
Art Directors:
Kerry Bierman, Ed Hughes
Designers:
Kerry Bierman, Ed Hughes
Artist:
David Wilcox
Design Firm:
Edward Hughes Design
Publisher:
American Hospital
Supply Corp.
Typographer:
Pearson Typographers
Printer:
Rohner Printing Co.

Corporate Literature:
New York City Means
Business
Art Director:
Bruce Withers
Designer:
Bruce Withers
Photographers:
Bill Rivelli, Jon Riley
Design Firm:
Perlman Reinhart Withers
Client:
City of New York Office of
Economic Development
Typographer:
Unbekant Typo
Printer:
S.D. Scott Printing Co., Inc.

Corporate Literature:
New Releases for June
Art Director:
Carin Goldberg
Designer:
Carin Goldberg
Artist:
Bettman Archives
Publisher:
Atlantic Records
Typographer:
Haber Typographers, Inc.
Printer:
Mijef Printing Corp.

Corporate Literature:
Introducing the Soft Life
Art Director:
Kay Sabinson
Designer:
Kay Sabinson
Artist:
Betsy Ross
Photographer:
Irene Stern
Client:
Gillette
Typographer:
IGI
Printer:
Crafton Graphic Co., Inc.

Activity Equipment Analysis
Defining task and equipment needs for facility planning

Feasibility Study
Defining space and budget requirements for the office facility

Corporate Literature:
Professional Services
Brochures
Art Director:
Barbara Loveland
Designer:
Barbara Loveland
Photographers:
John Boucher, Earl Woods
Publisher:
Herman Miller, Inc.
Typographer:
Type House
Printer:
Burch Printers

ır Ⱶ **herman miller** Ⱶ **herman miller** Ⱶ **herman miller**

ller Ⱶ **herman miller** Ⱶ **herman miller** Ⱶ **herman miller**

Return on Investment:
Financial Analysis of the Office Facility

miller Ⱶ **herman miller** Ⱶ **herman miller** Ⱶ **herman miller** Ⱶ **herman miller** Ⱶ **herman miller** Ⱶ **herman miller**

Corporate Literature:
Citibank Gold Certificate
Art Director:
Jack Odette
Designer:
Vince Gagliostro
Photographer:
Citibank Communication
Design Department
Publisher:
Citibank
Typographer:
Pastore Depamphilis
Rampone
Printer:
Bucknell Press

Corporate Literature:
DJJ
Art Director:
George Tscherny
Designer:
George Tscherny
Photographer:
Roy Stevens
Design Firm:
George Tscherny, Inc.
Client:
The David J. Joseph Co
Typographer:
York Typesetting Co.
Printer:
Lebanon Valley Offset

Corporate Literature:
IBM 1979 Corporate
Recognition Book
Art Directors:
Richard Rogers,
Bonnie Judd
Designers:
Richard Rogers,
Bonnie Judd
Photographers:
Bruce Pendelton,
Herb Levart, IBM Staff
Design Firm:
Richard Rogers, Inc.
Publisher:
IBM Corp.
Typographer:
Southern New England
Typographic Services
Printer:
Herst Lithography

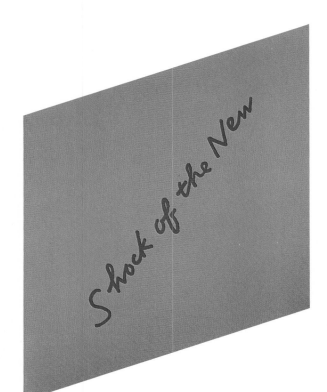

Corporate Literature:
Shock of the New
Art Director:
Ivan Chermayeff
Designer:
Ivan Chermayeff
Artist:
Ivan Chermayeff
Design Firm:
Chermayeff & Geismar
Associates
Client:
Time-Life Television
Printer:
Artonis

Corporate Literature:
Festival 9
Art Director:
Thomas E. Hall
Designer:
Thomas E. Hall
Artist:
Kathy Morgan
Publisher:
Scottsdale Center for
the Arts
Printer:
Ironwood Press

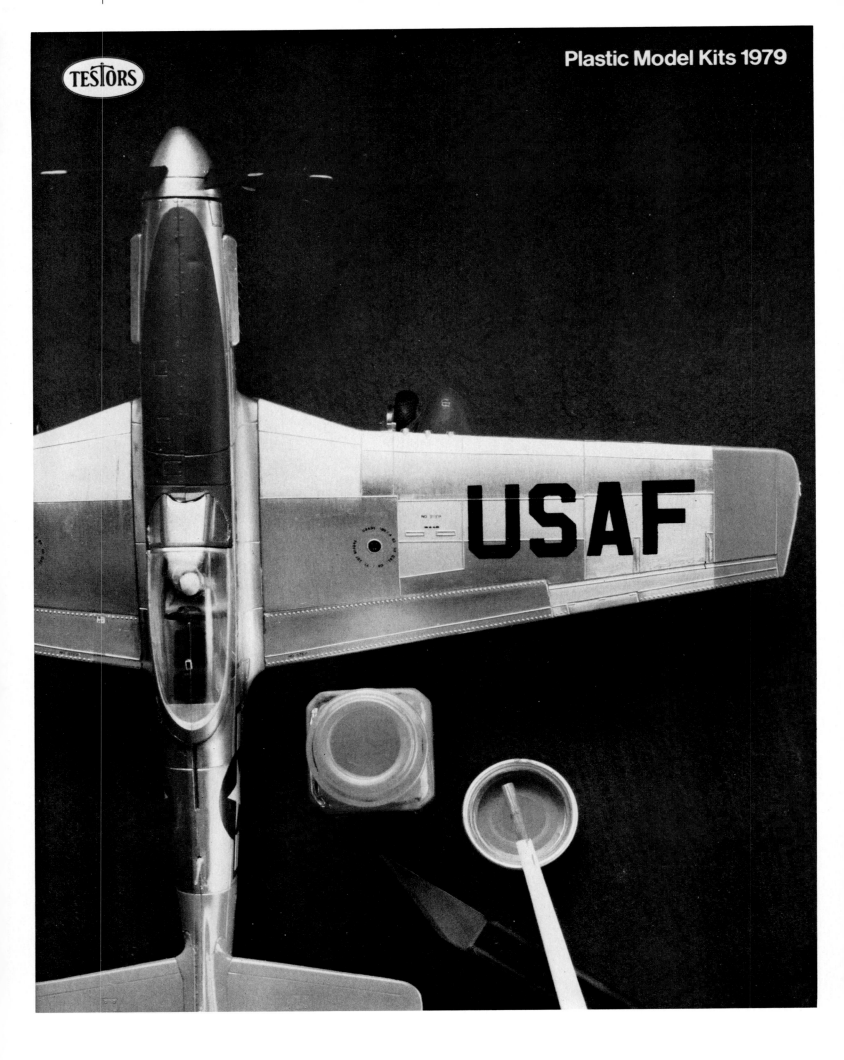

TESTORS

USAF

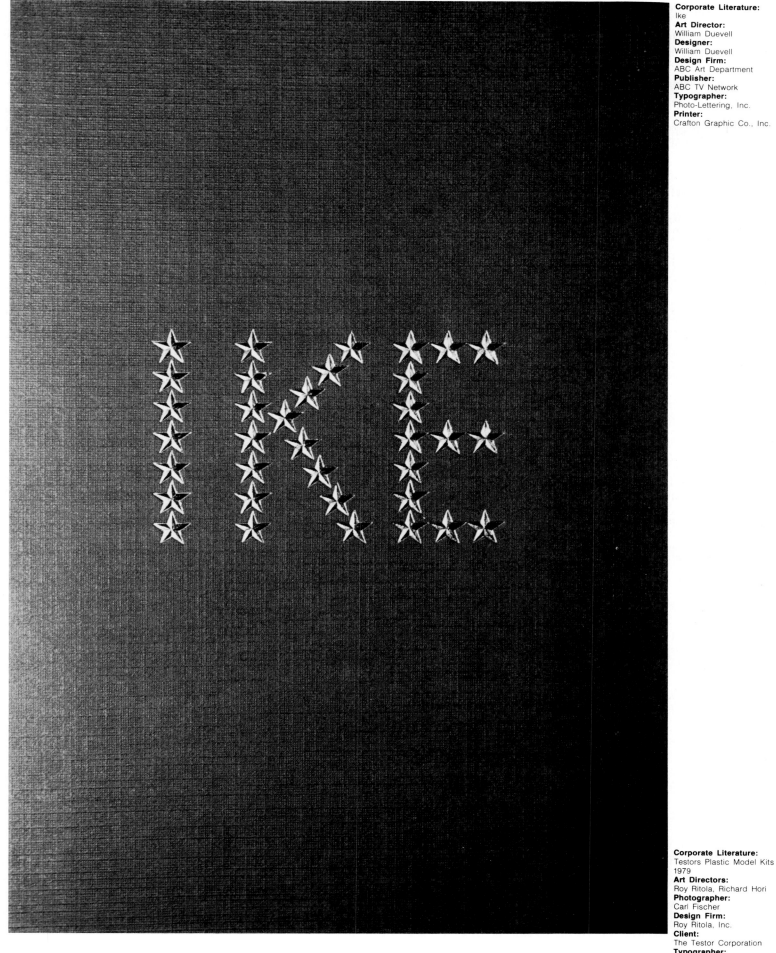

Corporate Literature:
Ike
Art Director:
William Duevell
Designer:
William Duevell
Design Firm:
ABC Art Department
Publisher:
ABC TV Network
Typographer:
Photo-Lettering, Inc.
Printer:
Crafton Graphic Co., Inc.

Corporate Literature:
Testors Plastic Model Kits
1979
Art Directors:
Roy Ritola, Richard Hori
Photographer:
Carl Fischer
Design Firm:
Roy Ritola, Inc.
Client:
The Testor Corporation
Typographer:
Timely Typographers
Printer:
Bruce Offset

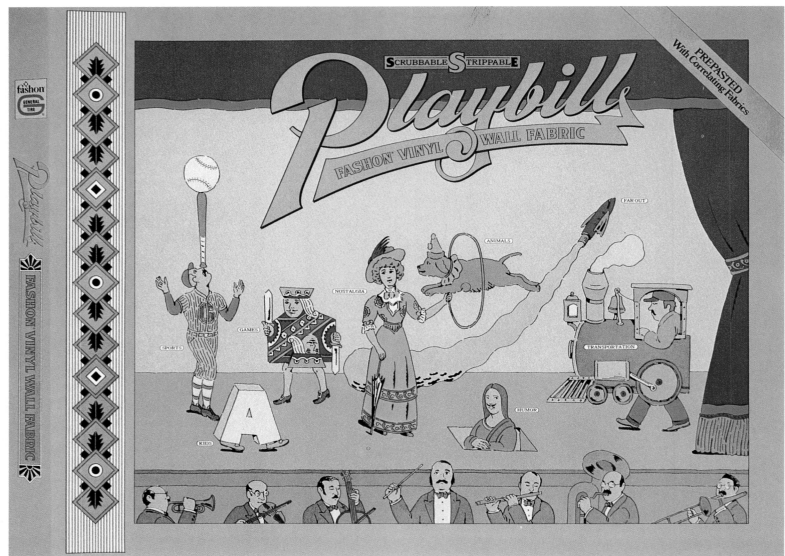

Corporate Literature:
Playbill
Art Director:
Alan Wood
Designer:
Alan Wood
Artist:
Seymour Chwast
Design Firm:
Alan Wood Graphic Design
Client:
Lionel Libson/GTR
Wallcovering Co.
Typographer:
Trendsetters
Printer:
Superior Printing Co.

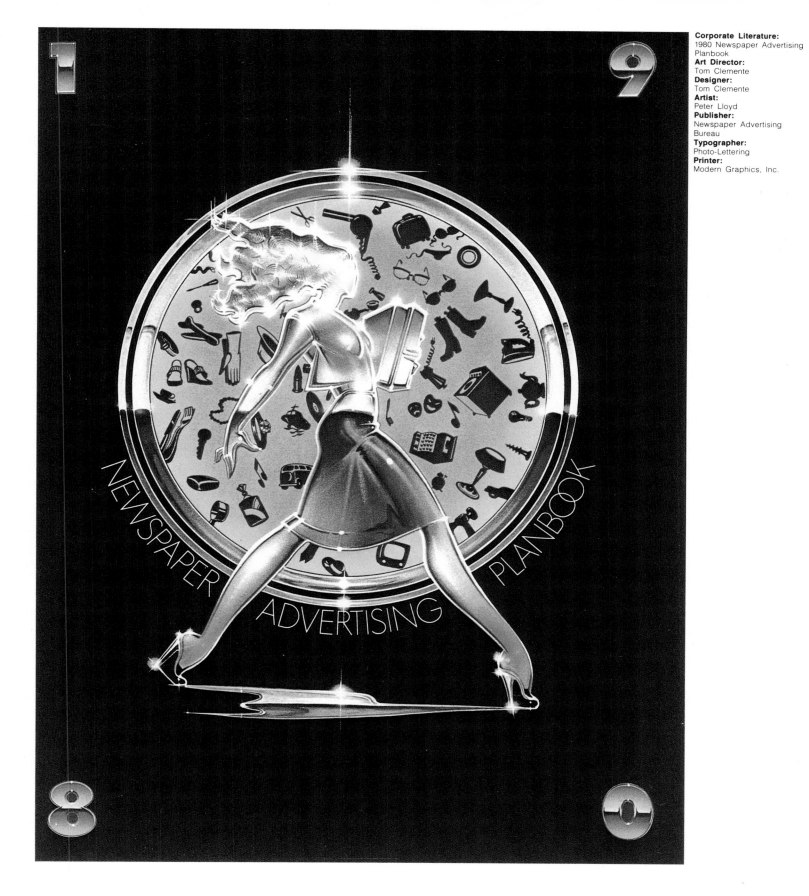

Corporate Literature:
1980 Newspaper Advertising
Planbook
Art Director:
Tom Clemente
Designer:
Tom Clemente
Artist:
Peter Lloyd
Publisher:
Newspaper Advertising
Bureau
Typographer:
Photo-Lettering
Printer:
Modern Graphics, Inc.

Corporate Literature:
Warren's Waller Press
Designer:
Michael Manwaring
Artist:
Michael Manwaring,
Rebecca Archey
Design Firm:
The Office of Michael
Manwaring
Client:
Warren's Waller Press
Typographer:
Omnicomp
Printer:
Warren's Waller Press

Warren's Waller Press The Spirit of Innovation

Corporate Literature:
Halsman Exhibition Catalog
Art Director:
James Miho
Designer:
James Miho
Photography:
Philippe Halsman
Design Firm:
Miho, Inc.
Publisher:
Champion International Corp.
Client:
International Center for
Photography
Printer:
Sanders Printing Corporation

Illustration

The Illustration competition includes illustrations for a variety of printed matter: promotional and corporate literature, posters and record albums, newspapers, magazines, paperback and hardbound books. Illustrations can be in any style, technique, or medium. To be eligible, they must have been designed and published in the United States or Canada. This year, 148 illustrators submitted from 5 to 10 pieces of work; the jury selected 80 pieces by 20 illustrators for award.

Illustration 159

Chairman

Robert Priest

Art director of *Esquire* magazine and former art director of *Weekend* magazine in Toronto, Robert Priest studied graphic design and television graphics at the Twickenham Art School in England. He began his career designing books for Spectator Publications; then became art director of *Food & Wine* magazine, followed by *Welcome Aboard,* the in-flight BOAC magazine published by the Cornmarket Press. He has been art director of the women's fashion magazine *Flair* and designed two specials for *Radio Times,* a publication he later redesigned completely.

Jury

Roger Black

The design director of *New York* and *New West* magazines, Roger Black was art director of *Rolling Stone* for three years. He studied political science at the University of Chicago, where he was involved with design and production of the student newspaper. He was also an art director for Gulf State Advertising, an agency in Houston, and headed a Los Angeles studio for type formats called Type City.

Joe Brooks

Joe Brooks came to America in 1973 as the art director of *Penthouse* magazine. He had been art director of *Penthouse* in his native London since 1965. After studying illustration, painting, and silkscreen lithography at St. Martin's School of Art, he began his career with a design firm and then worked with the London Sunday *Times* before joining *Penthouse*.

Ivan Chermayeff

A partner in Chermayeff & Geismar Associates, Ivan Chermayeff was born in London, studied at Harvard and the Institute of Design in Chicago, and was graduated with a BFA from Yale University's School of Art and Architecture. In 1957 the firm of Brownjohn, Chermayeff & Geismar was formed; three years later, it became Chermayeff & Geismar Associates. In 1963 both Ivan Chermayeff and Tom Geismar also became partners of the architecture and design firm Cambridge Seven Associates, and in 1973 they also formed Art Planning Consultants to help client organizations assemble collections and commission artwork for buildings and public spaces.

Heather Cooper

Designer-illustrator Heather Cooper formed her present partnership—Burns, Cooper, Hynes, Limited—in 1970, which has offices in Toronto and New York. Born in Lincolnshire, England, she grew up in Toronto, where she still lives. She has had no formal art education, but has painted since childhood. She apprenticed for five years with a design studio before becoming a freelance illustrator.

Jean-Paul Goude

French-born illustrator Jean-Paul Goude started his career as a fashion illustrator and then became art director of *Esquire* and artist-in-residence for that publication. He worked briefly in show business as a producer and co-wrote the movie treatment of the Stigwood production, *Angel.* He is currently writing and illustrating a book called *Jungle Fever.*

Paula Scher

As art director for Columbia Records, Paula Scher also designs record album covers. She studied at the Tyler School of Art in Philadelphia and began her career as art director of children's books at Random House. After that, she designed advertising for Columbia Records and then album covers for Atlantic Records before returning to Columbia Records.

Jean-Claude Suares

Now the design director of *New York* magazine books, Jean-Claude Suares previously served as art director of *New York* magazine for two years. Born in Alexandria, Egypt, he studied at Pratt Institute in New York City and the Scuola Svizzera di Genoa in Italy. He started his career as art editor of *Scanlan's* magazine and in 1971 became art director of the Op Ed page of *The New York Times.* Subsequently, he formed a partnership with Seymour Chwast in Push Pin Press before joining *New York.*

Review

Contemporary illustration is a varied form, and members of the AIGA jury disagreed among themselves about its definition. "An illustration tells a visual story" was one juror's quick description. "But everything illustrates something," responded another. "The question is who dictates what is being illustrated." Regardless of fine distinctions, all were firmly in agreement on one point: an illustrator's story comes from someone else—an art director, editor, author, or client. The illustrator's job is to interpret that other person's story forcefully.

"If you're trying to sell somebody's service or somebody else's idea or vision," one juror explained, "then it becomes an illustration. If a client gives you a story line with some parameters within which you have to perform, then whatever picture you make becomes an illustration." Another juror added, "Anything can be an illustration, even a copy of some famous work of art. It becomes an illustration if it serves a functional purpose in a specific context, such as arresting attention in a magazine." Yet another juror added, "The more of yourself you put into an illustration, the better it becomes. To do a really good illustration I almost have to write my own copy in my mind's eye." Several jurors agreed that an illustration should create just as much meaning as an equal amount of text.

The images in this year's illustration awards consistently achieve a genuine appeal to the viewer's understanding based on strong dramatic conflict. In many cases, violence and horror, actual or threatened, are wrapped in soft focus or gentle clouds. Other-worldly fantasy enfolds earthly squalor. The stark contrasts are generally executed in a deadly serious vein. The range of influences includes cosmic or angelic fantasies recalling William Blake, sweet impossibilities after Magritte, and grotesqueries inspired by Hieronymos Bosch and Francis Bacon. In an attempt to communicate their messages, graphic illustrators even juxtapose squalid punk and Ashcan historicism to depict beseiged values with narrative assertiveness and ruthless conviction.

This year's jury was unusually unanimous in its concern for elucidation of purpose rather than mere decoration. Good ideas, technical facility, and exciting compositions were valued highly. Speaking on behalf of the entire jury, one member noted: "We purposely excluded people who cannot draw, though they might be good technicians in other ways. We almost eliminated the wash and airbrush techniques. The real fights occurred over the realistic pieces, because beyond good technique we were looking for strong ideas."

Overall, the judges selected two basic groups of illustrators: soft-line realists such as McMullan and Collier and hard-line illustrators such as Steadman and Arisman. The school of violent illustrators was not as widely represented as expected, nor was the style derived from Sue Coe and others, which was called "punk line-drawing—splotchy stuff."

Several individual illustrators were commended for specific aspects of their work. Milton Glaser was cited for "a terrific sense of composition, skill, and drama," and Marshall Arisman for a "memorably haunting social consciousness." The paintings of Collier and McMullan were praised for exciting and spontaneous realism, and Robert Weaver was commended for his painterly quality, a style which the jury felt was returning to popularity.

It was noted that the work of several prominent illustrators was not selected. In several instances, the jury felt that those illustrators did not submit entries that were the best of their work. Two groups of illustrations were specifically noted for their absence. There were few fashion illustrators, even though that work is significant "far beyond just pretty drawings"; and there were few entries from "certain new vanguard publications."

Regardless of small gaps in the awards, it is apparent that a great deal of craftsmanship, energy, thought, imagination, and talent goes into what is being produced as illustration today.

Illustration 161

YARDBIRDS FAVORITES

Illustrator:
David Wilcox
Record Album:
Yardbird Favorites
Art Director:
Paula Scher
Publisher:
CBS Records

CHICKENMAN RETURNS

Illustrator:
Alex Murawski
Poster:
Chickenman Returns
Art Director:
Peter Coutroulis
Publisher:
Chicago Radio Syndicate

Illustration 163

Illustrator:
Alex Murawski
Magazine Illustration:
Commercial Messengers
Art Directors:
Robert Priest, Derek Ungless
Publisher:
Weekend Magazine,
Montreal Standard

Illustrators:
Richard Hess, Mark Hess
Poster:
Join the Family
Art Director:
Brooke Kenney
Publisher:
Minnesota Zoological Society
Agency:
Martin/Williams Advertising

Illustration 165

Illustrator:
Heather Cooper
Calendar:
Minotaur
Art Director:
Heather Cooper
Publisher:
Abitibi-Price, Ltd.

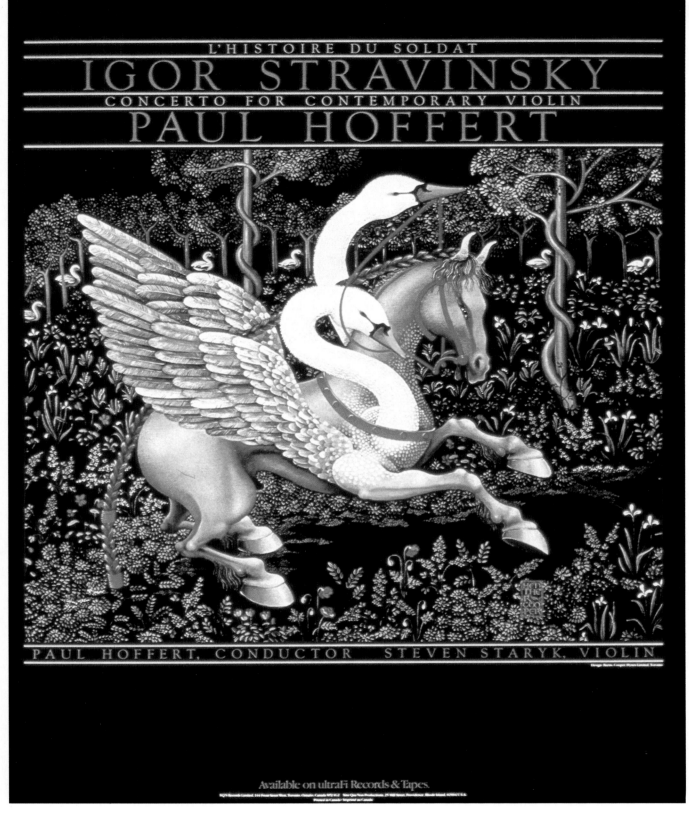

Illustrator:
Heather Cooper
Poster:
Igor Stravinsky, Paul Hoffert
Art Director:
Heather Cooper
Publisher:
SQN Records

Illustration 167

Illustrator:
Milton Glaser
Poster:
Catskills
Art Director:
Milton Glaser
Publisher:
New York State Chamber of Commerce

Illustrator:
Edward Soyka
Magazine Illustration:
Snarl
Art Director:
Gordon Mortensen
Publisher:
Politics Today Magazine

Illustration 169

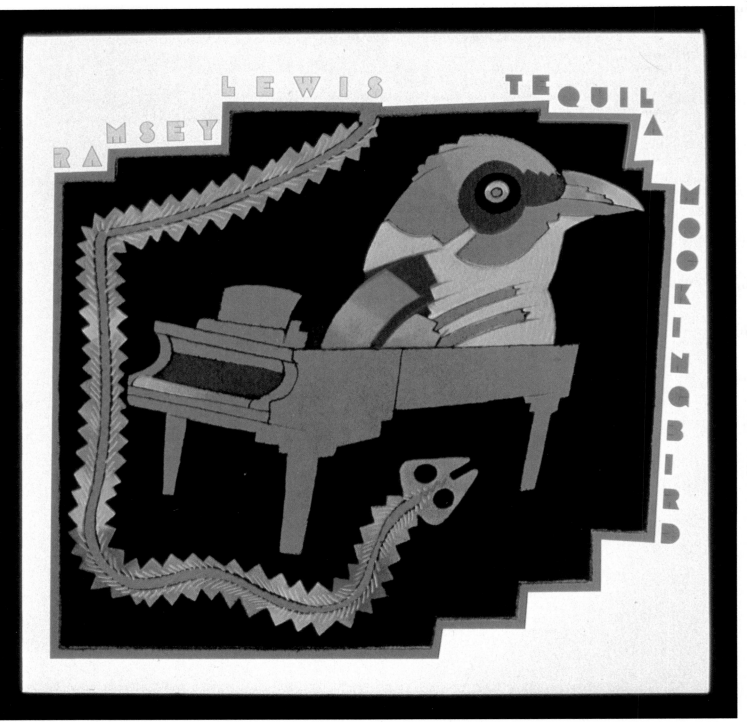

Illustrator:
Milton Glaser
Record Album:
Tequila Mockingbird
Art Directors:
Paula Scher, John Berg
Publisher:
CBS Records

Illustrator:
Alex Murawski
Poster:
Standard Brands
Confectionery
Art Director:
Robert Qually
Publisher:
Standard Brands
Agency:
Lee King & Partners

Illustration 171

Illustrator:
Edward Soyka
Magazine Illustration:
The Eisenhower Years
Art Director:
Robert Priest
Publisher:
Weekend Magazine,
Montreal Standard

Illustrator:
John Collier
Poster:
John Collier Made This
Art Director:
John Collier
Publisher:
Milton Newborn

Illustrator:
Richard Hess
Promotional Literature:
Poor Concentration/
Poor Memory
Art Director:
John de Cesare
Publisher:
CIBA-GEIGY Corp.

Illustration 173

HERBIE MANN · GERRY MULLIGAN · EARLE WARREN JAY McSHANN THE BIG APPLE BASH DOC CHEATHAM · DICKY WELLS · JOHN SCOFIELD
EDDIE GOMEZ · MILT HINTON · JACK SIX · CONNIE KAY JOE MORELLO · SAMMY FIGUEROA · JANIS SIEGEL

Illustrator:
Mark Hess
Record Album:
Jay McShann/
Big Apple Bash
Art Director:
Lynn Dreese Breslin
Publisher:
Atlantic Records

Illustrator:
Mark Hess
Magazine Illustration:
Don King
Art Director:
James Kiehle
Publisher:
Oui Magazine

Illustration 175

Illustrator:
Brad Holland
Record Album:
Modern Jazz Sextet
Art Director:
Katherine Smith
Publisher:
Verve/Polydor Inc.
Agency:
Album Graphics, Inc.

Illustrator:
Brad Holland
Magazine Illustration:
The Devil & Billy Markham
Art Directors:
Arthur Paul, Kerig Pope
Publisher:
Playboy Magazine

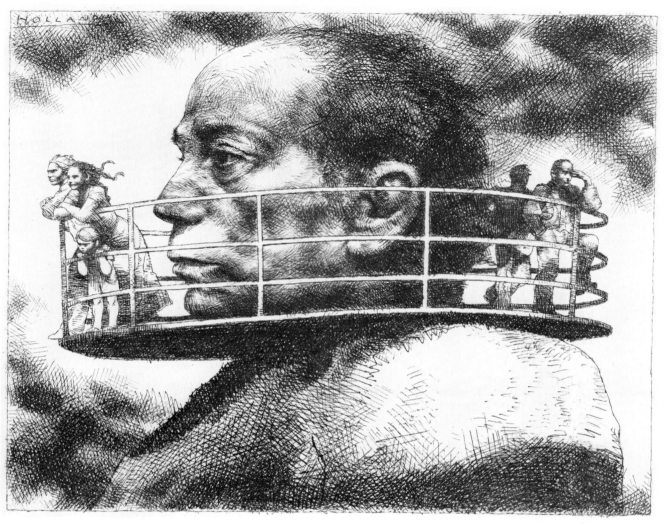

Illustrator:
Brad Holland
Newspaper Illustration:
The Observation Deck
Art Director:
Pamela Vassil
Publisher:
The New York Times

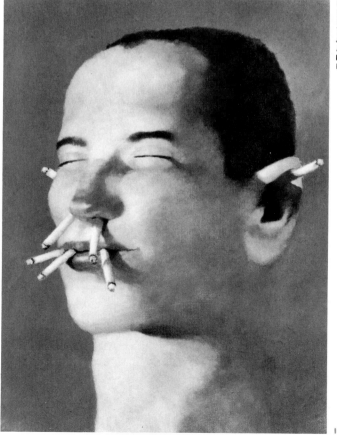

Illustrator:
Brad Holland
Magazine Illustration:
The Perfect High
Art Directors:
Arthur Paul, Kerig Pope
Publisher:
Playboy Magazine

Illustration 177

Illustrator:
Marshall Arisman
Magazine Illustration:
The Executioner's Song
Art Director:
Robert Priest
Publisher:
Weekend Magazine,
Montreal Standard

Illustrator:
Marshall Arisman
Magazine Illustration:
The Executioner's Song
Art Director:
Robert Priest
Publisher:
Weekend Magazine,
Montreal Standard

Illustration 179

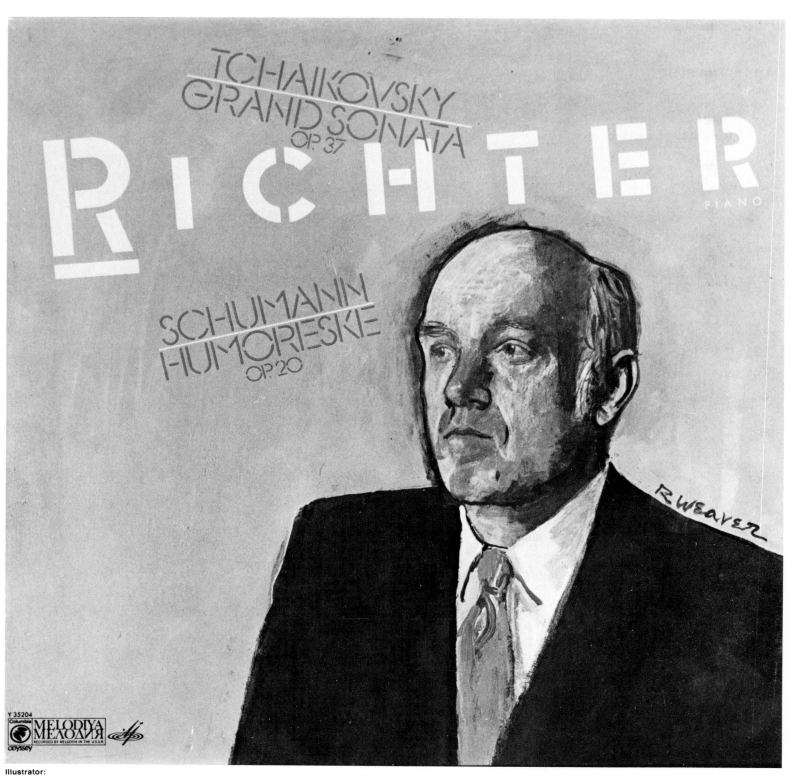

Illustrator:
Robert Weaver
Record Album:
Richter
Art Director:
Henrietta Condak
Publisher:
CBS Records

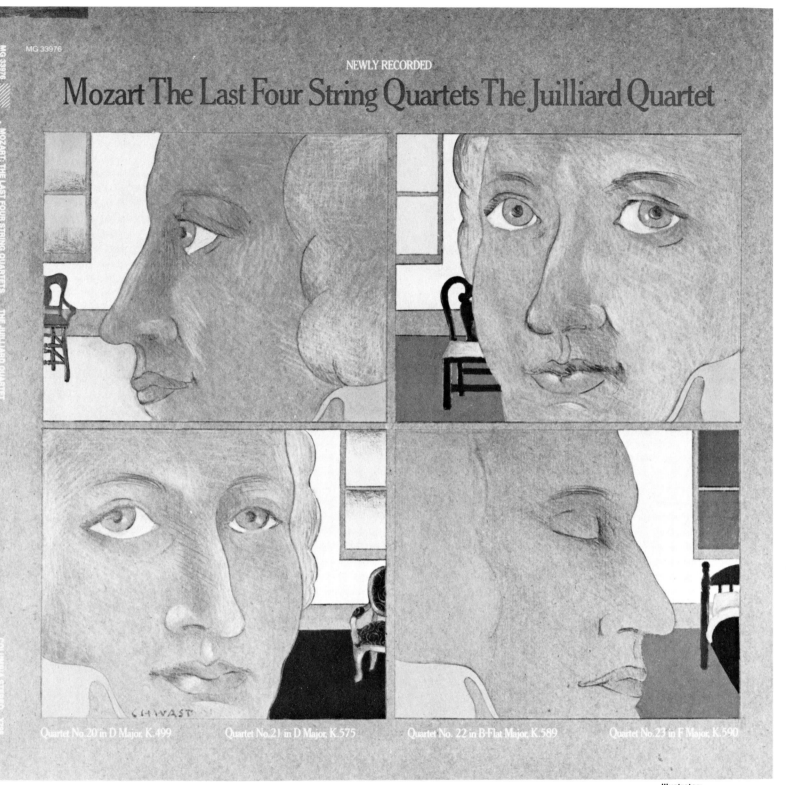

NEWLY RECORDED

Mozart The Last Four String Quartets The Juilliard Quartet

Quartet No. 20 in D Major, K.499 Quartet No. 21 in D Major, K.575 Quartet No. 22 in B-Flat Major, K.589 Quartet No. 23 in F Major, K.590

Illustrator:
Seymour Chwast
Record Album:
Mozart: The Last Four String
Quartets
Art Director:
Paula Scher
Publisher:
CBS Records

Illustration 181

Illustrator:
Richard Hess
Magazine Illustration:
Man of the Year/
Teng Hsiao-p'ing
Art Director:
Walter Bernard
Publisher:
Time, Inc.

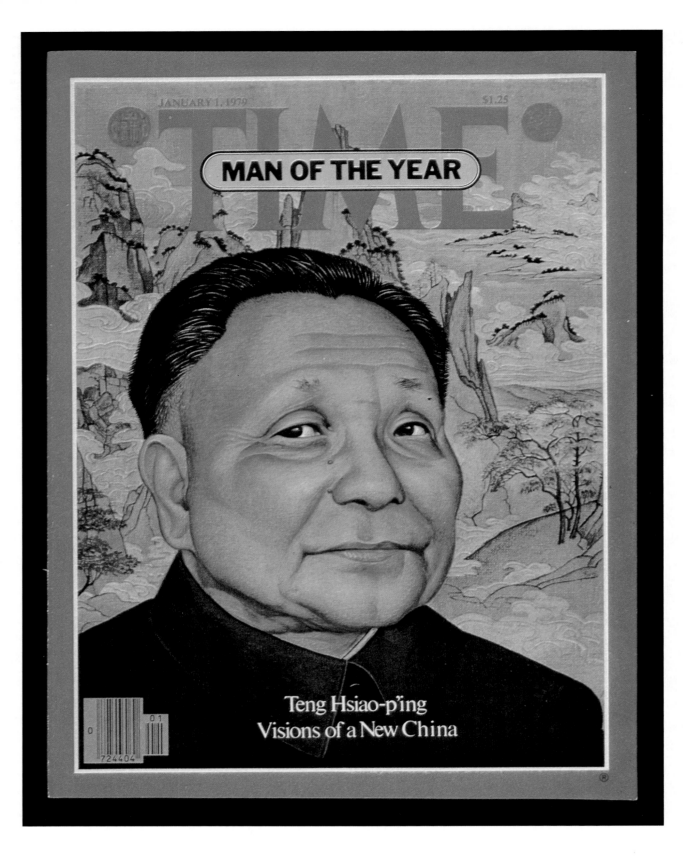

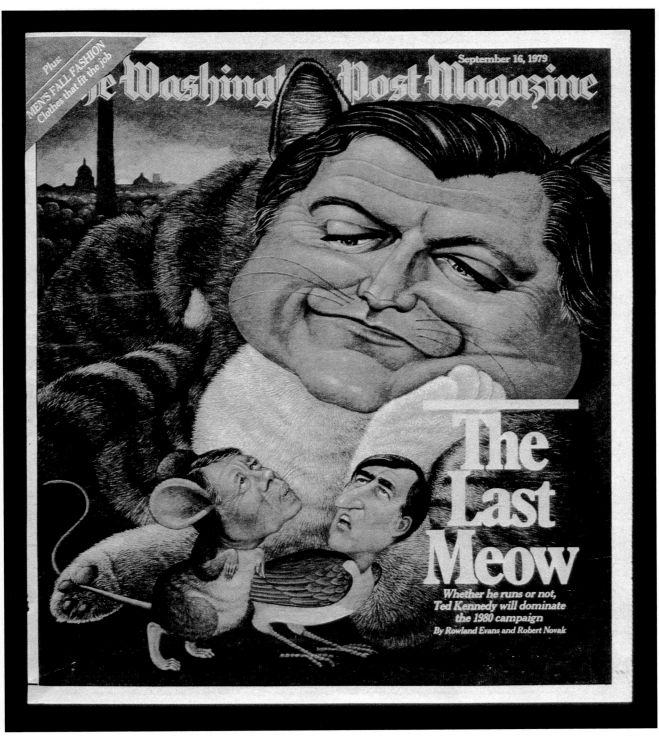

September 16, 1979

The Washington Post Magazine

Plus
MEN'S FALL FASHION
Clothes that fit the job

The Last Meow

Whether he runs or not,
Ted Kennedy will dominate
the 1980 campaign

By Rowland Evans and Robert Novak

Illustrator:
Richard Hess
Newspaper Magazine
Cover:
The Last Meow
Art Director:
Ed Schneider
Publisher:
The Washington Post
Magazine

Illustration 183

Illustrator:
Julian Allen
Magazine Illustration:
Atlantic City
Art Director:
Robert Priest
Publisher:
Weekend Magazine,
Montreal Standard

Illustrator:
Julian Allen
Magazine Illustration:
Nixon's Dawn Wanderings
Art Director:
Peter Blank
Publisher:
Newsweek Magazine

Illustrator:
Julian Allen
Magazine Illustration:
Erlichman, Haldeman, Helms
Art Director:
Peter Blank
Publisher:
Newsweek Magazine

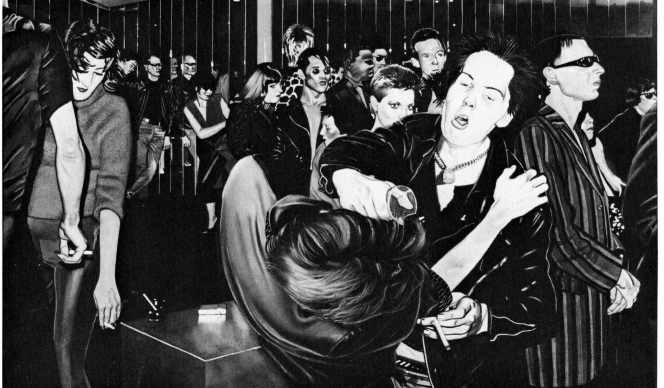

Illustrator:
Julian Allen
Magazine Illustration:
Sid Vicious
Art Director:
Jean-Claude Suares
Publisher:
New York Magazine

Illustration 185

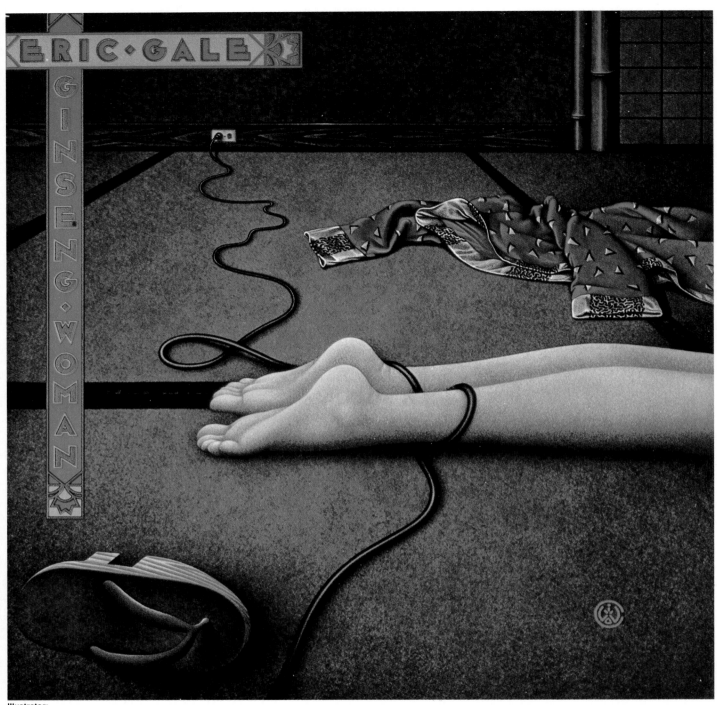

Illustrator:
David Wilcox
Record Album:
Ginseng Woman
Art Directors:
Paula Scher, Andy Engel
Publisher:
CBS Records

Illustrator:
James McMullan
Magazine Illustration:
Staying Alive
Art Directors:
Roger Black, Philip Hays
Publisher:
New West Magazine

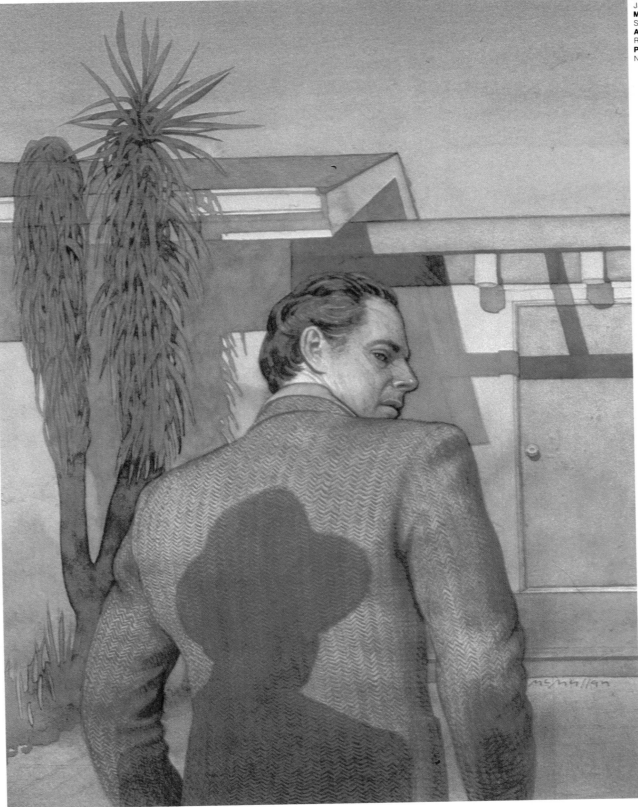

Illustration 187

Illustrator:
Marshall Arisman
Magazine Illustration:
The Unseen Monster
Art Director:
Robert Priest
Publisher:
Weekend Magazine,
Montreal Standard

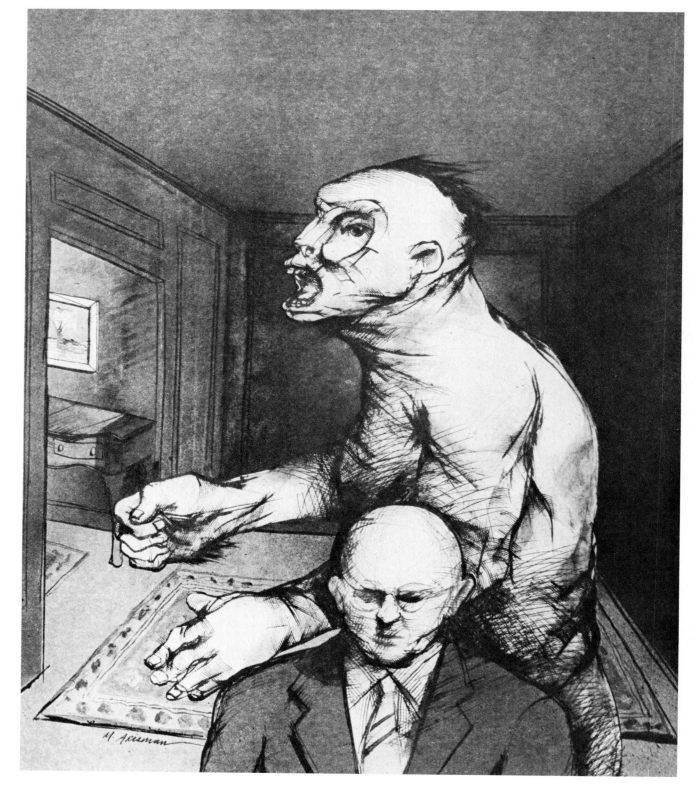

Illustrator:
Marshall Arisman
Magazine Illustration:
The Violent Vet
Art Director:
Robert Priest
Publisher:
Esquire Magazine

Illustrator:
Marshall Arisman
Magazine Illustration:
Electric Chair
Art Directors:
Len Willis, Kerig Pope
Publisher:
Playboy Magazine

Illustrator:
Elwood H. Smith
Magazine Illustration:
Komic Kalamaties
Art Directors:
Seymour Chwast,
Richard Mantel
Publisher:
Push Pin Graphic

Illustrator:
Seymour Chwast
Magazine Illustration:
The Death of the Machine
Art Directors:
Seymour Chwast,
Richard Mantel
Publisher:
Push Pin Graphic

SEYMOUR CHWAST

Illustration 191

Illustrator:
James McMullan
Record Album:
Poco: The Songs of
Paul Cotton
Art Director:
Paula Scher
Publisher:
CBS Records

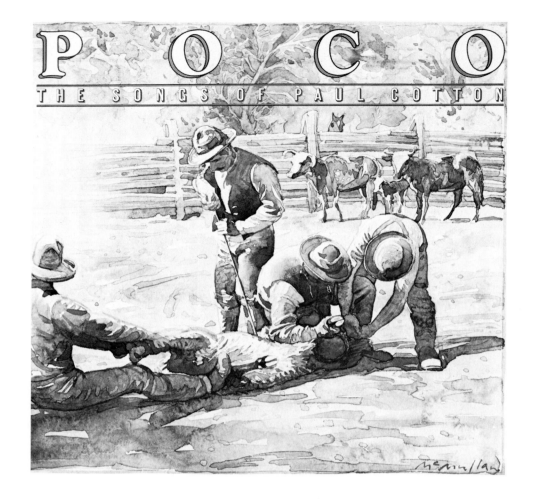

Illustrator:
Robert Weaver
Record Album:
Charlie Parker
Art Director:
John Berg
Publisher:
CBS Records

Illustrator:
Brad Holland
Magazine Illustration:
Snooker
Art Directors:
Arthur Paul, Kerig Pope
Publisher:
Playboy Magazine

Illustrator:
R.O. Blechman
Stationery:
Brooks, Fulford, Cramer,
Seresin, Ltd.
Art Director:
Alan Fletcher
Agency:
Pentagram

BROOKS, FULFORD, CRAMER, SERESIN LTD
59 NORTH WHARF ROAD, LONDON W2 ILA
TELEPHONE 01-402-5561 TELEX NO. 27823

Illustration 193

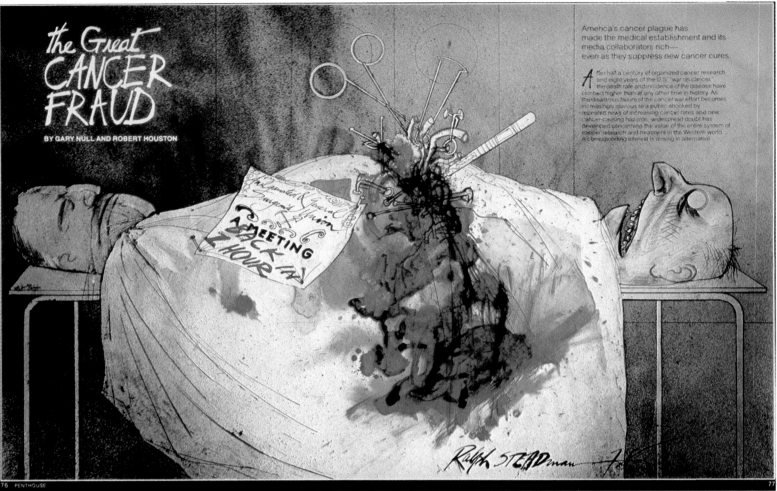

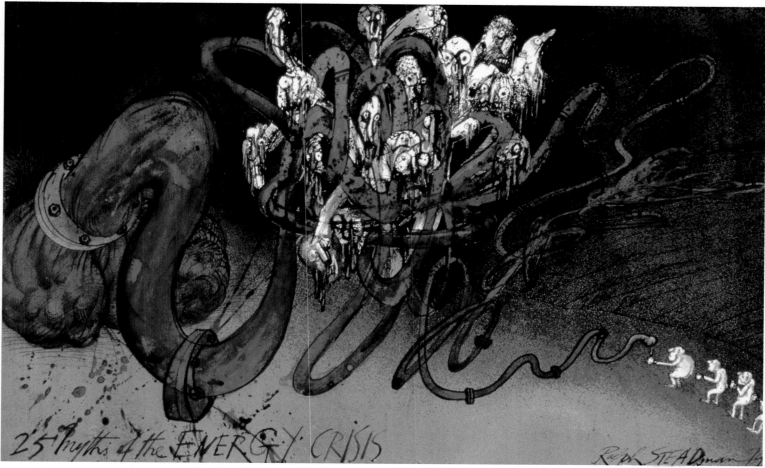

25 Myths of the ENERGY CRISIS

Ralph STEADman

Illustrator:
Ralph Steadman
Magazine Illustration:
25 Myths of the Energy
Crisis
Art Director:
Joe Brooks
Publisher:
Penthouse Magazine

Illustration 195

Illustrator:
Ralph Steadman
Magazine Illustration:
Freud
Art Director:
Joe Brooks
Publisher:
Penthouse Magazine

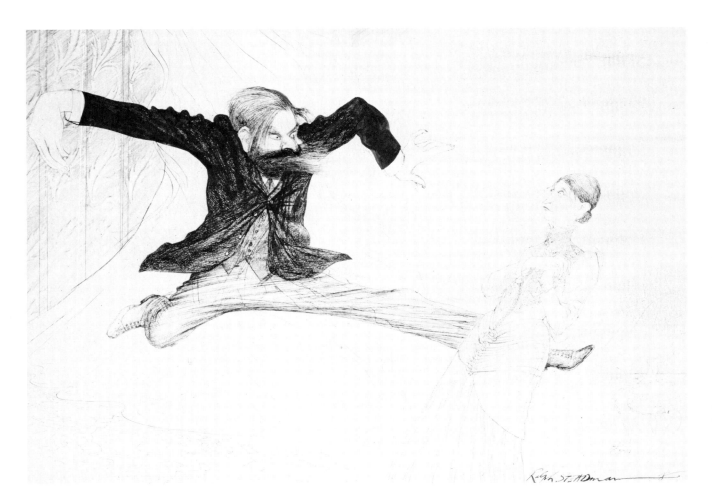

Illustrator:
Ralph Steadman
Magazine Illustration:
Freud
Art Director:
Joe Brooks
Publisher:
Penthouse Magazine

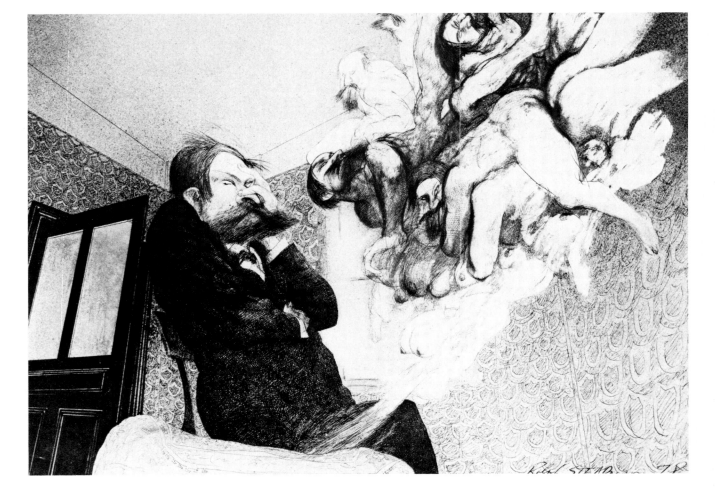

Illustrator:
Ralph Steadman
Magazine Illustration:
Freud
Art Director:
Joe Brooks
Publisher:
Penthouse Magazine

Illustration 197

GASTRIC AGGRESSION OR WHY GERMANY WENT TO WAR

continued from page 7
of the Third Reich. Germany was in debt; they suffered the blame and the burdens of the first world war; there was national shame and international depression. None of the causes of a hostile, aggressive Germany were removed. They only smoldered. However, Adolf Hitler would be a mere footnote in History today if the League of Nations had bothered to make a study of the causes of German aggression.

The conditions in Germany prior to World War II only intensified the German gastric need to make war. The simplest solution would have been a decision by the League of Nations to establish a special canal that would allow the Germans easy access to the Mediterannean. This would consist of a strip of land no wider than a mile stretching from Bavaria, southward through Austria and Italy and ultimately connecting with the sea. This canal would be jointly owned by Germany, Austria and Italy, and could have been politically monitored through the League of Nations. This German "rectum" would have helped the Germans to consume their horrendous cuisine without the disastrous results of having to go to war to win every outlet to every sea in the world. It is true that hostile relations between the Italians, Austrians and Germans would be a likely result of the implementation of the canal plan, but the real alternative was far more deadly.

The other solution, of course, was to rob the Germans of their cuisine. This would have been a fatal tactic. A nation that is in debt, and has already lost its sense of national pride, could not possibly deal with the ultimate insult of having its cuisine banned. In psychologically healthy nations such as France or England, there is a cry of outrage if the national cuisine is in any way maligned.

Nations will fight to the death to defend their cuisines, no matter how rotten they are. Americans have been fighting for Mom and apple pie for centuries.

GERMANY WILL RISE AGAIN UNLESS—

The popular opinion among our contemporary political leaders is that a divided Germany cannot stand. There is no greater fallacy. The allied victory over Berlin will do nothing to prevent a Fourth Reich from rising unless some positive steps are taken to solve Germany's gastric problem immediately.

Here is a list of some feasible suggestions:
1) A reduction, world wide, of air, sea and train costs for all German citizens so as to encourage them to travel and sample other national cuisines. This may provide an incentive for ecclecticism in their own home cooking.
2) International subsidies for French, Italian and Chinese restauranteurs to open restaurants all through Germany.
3) Tax incentives for the manufacturers of gastric relief medicines such as Alka-Seltzer, Pepto-Bismal, Rolaids and Ex-Lax, so they may develop and market laxatives and antacids strong enough for the needs of the German population, and to keep the price low enough to attract the thrifty German consumer.
4) A propaganda campaign designed to allow the German population to recognize their problem without feelings of inferiority or shame. This could be done in the form of popular entertainment with the continuous showing of *"Blazing Saddles,"* or a series of diet workshops that would be set up in small communities.

It is time for the international community to recognize its responsibility to the German community. Or—bratwurst, anyone?

Illustrator:
Seymour Chwast
Magazine Illustration:
Gastric Aggression or Why
Germany Went to War
Art Directors:
Seymour Chwast,
Richard Mantel
Publisher:
Push Pin Graphic

Illustrator:
Seymour Chwast
Magazine Illustration:
Toulouse-Lautrec
Art Director:
Milton Glaser
Publisher:
Esquire Magazine

Illustration 199

Illustrator:
Heather Cooper
Calendar:
Garden
Art Director:
Heather Cooper
Publisher:
Abitibi-Price, Ltd.

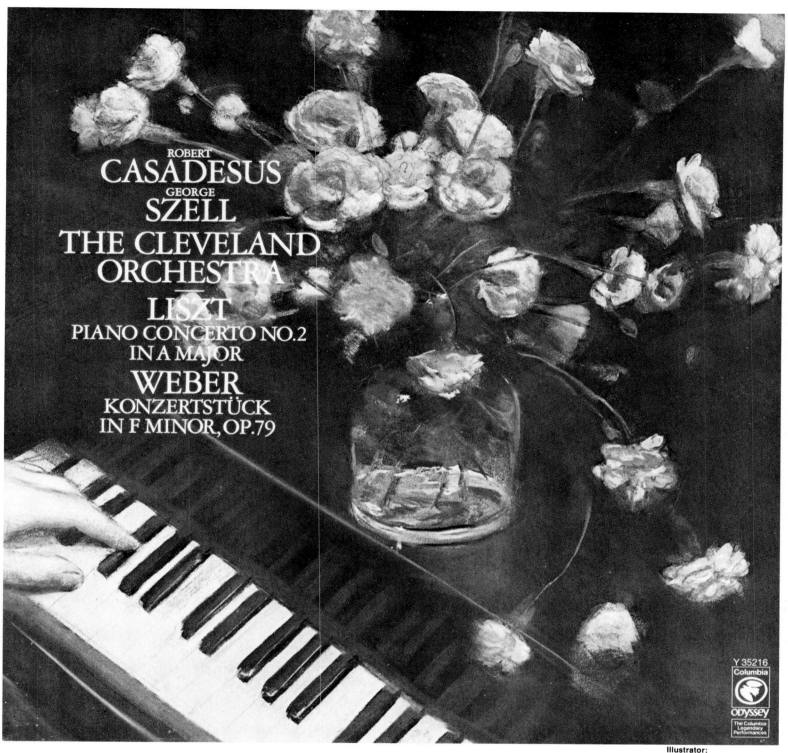

ROBERT
CASADESUS
GEORGE
SZELL
THE CLEVELAND ORCHESTRA
LISZT
PIANO CONCERTO NO.2
IN A MAJOR
WEBER
KONZERTSTÜCK
IN F MINOR, OP.79

Y 35216
Columbia
ODYSSEY
The Columbia
Legendary
Performances

Illustrator:
John Collier
Record Album:
Casadesus/Szell: The
Cleveland Orchestra
Art Director:
Henrietta Condak
Publisher:
CBS Records

Illustration 201

To be good is not enough, when you dream of being great.

Degree and Non-Degree Programs. Day and Evening. Film, Photography, Media Arts (Advertising, Copy Writing, Fashion, Illustration, Graphic Design), Crafts (Ceramics, Jewelry), Fine Arts (Painting, Sculpture, Printmaking), Video Tape, Dance, Humanities, Art Education, Art Therapy.

School of Visual Arts
School of Visual Arts, 209 East 23rd Street, New York City 10010 (212) 683-0600

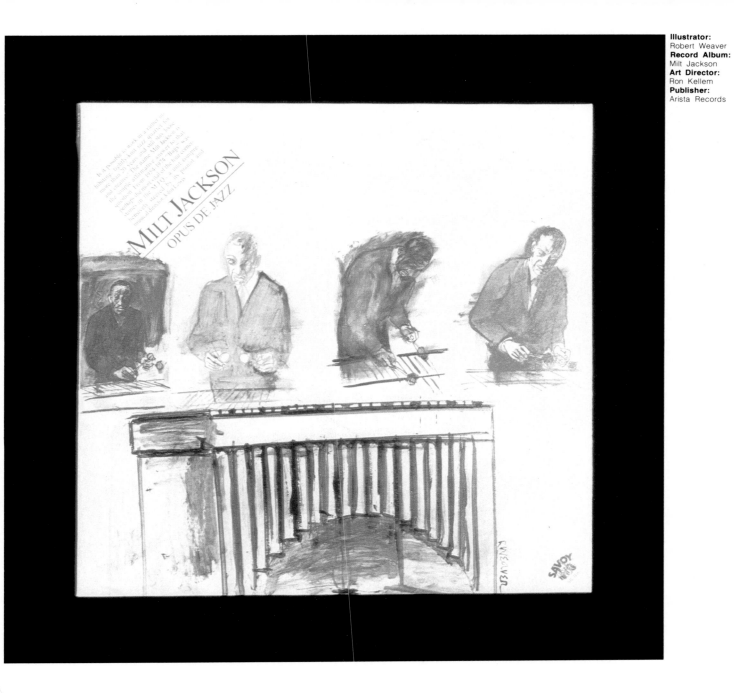

Illustrator:
Robert Weaver
Record Album:
Milt Jackson
Art Director:
Ron Kellem
Publisher:
Arista Records

Illustration 203

Dear Mom + Dad
Please send... I need

"We started to tell each other camp stories – trying to re-create how it felt in that wonderful moment just before you kiss a girl for the first time – and as we remembered we wrote"

Illustrator:
Elwood H. Smith
Magazine Illustration:
Cooking Up Meatballs
Art Director:
Robert Priest
Publisher:
Weekend Magazine,
Montreal Standard

Illustrator:
James McMullan
Poster:
Illustrators 20
Art Director:
Doug Johnson
Publisher:
Society of Illustrators

ANNUAL EXHIBITION
THE SOCIETY OF ILLUSTRATORS
128 EAST 63RD STREET, N.Y.C., MONDAY—FRIDAY 10 A.M.-5 P.M.
EDITORIAL & BOOK, FEBRUARY 8—MARCH 7, 1978
ADVERTISING, INSTITUTIONAL & TV, MARCH 15—APRIL 12, 1978

Illustration by James McMullan, Art Direction by Doug Johnson, Design by Anne Leigh/Performing Dogs, Printing by Grinthal Press Inc. N.Y.C., Separation by Computerized Quality Separation N.Y.C., Typography by The Type Group Inc., Printed on Pastelle 80 Text "Natural White" by Strathmore Paper Co.

Illustration 205

Illustrator:
Elwood H. Smith
Magazine Illustration:
Great Heroes
Art Directors:
Seymour Chwast,
Richard Mantel
Publisher:
Push Pin Graphic

Illustrator:
R.O. Blechman
Magazine Cover:
October 1, 1979
Art Director:
Lee Lorenz
Publisher:
The New Yorker

Illustration 207

Illustrator:
Milton Glaser
Poster:
Sony Full Color Sound
Art Director:
Howard Title
Client:
Sony Corporation of America
Agency:
Waring & LaRosa, Inc.

Sony Tape. Full Color Sound.

Illustrator:
R.O. Blechman
Magazine Ad:
Full Color Sound. Sony Tape
Art Director:
Howard Title
Client:
Sony Corporation of America
Agency:
Waring & LaRosa, Inc.

SONY TAPE. FULL COLOR SOUND.

Sound has color. And Sony audio tape with Full Color
Sound reproduces every shade of color that's in the sound
itself. It can actually record more
sound than you can hear. Try it, and listen to all that color!

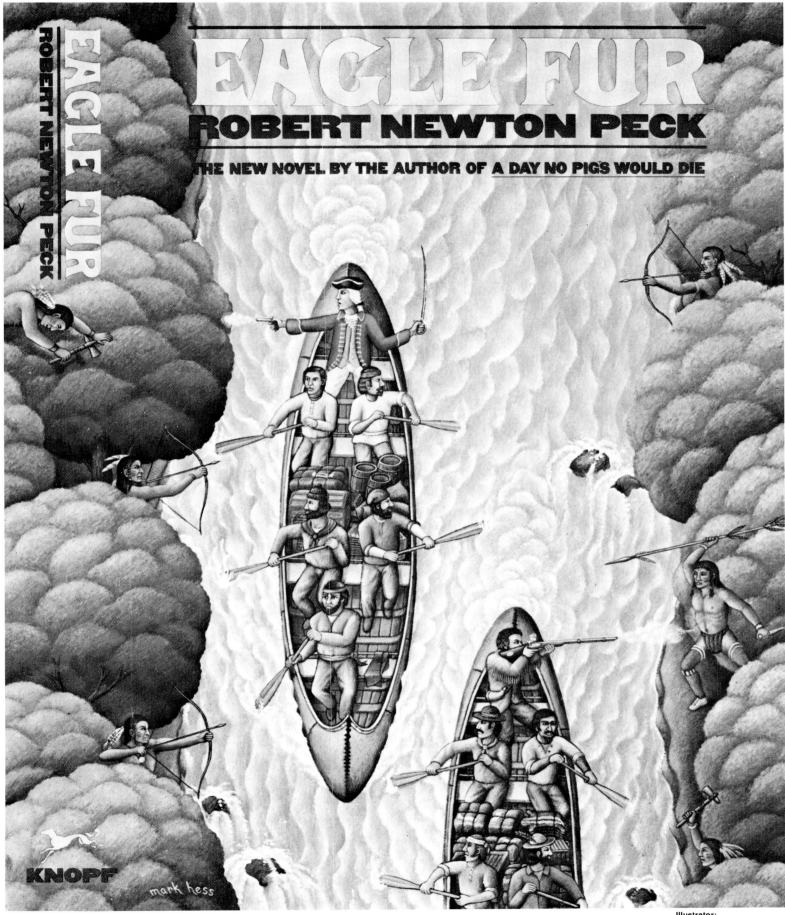

EAGLE FUR

ROBERT NEWTON PECK

Illustrator:
Mark Hess
Book Jacket:
Eagle Fur
Art Director:
Lidia Ferrara
Publisher:
Alfred A. Knopf, Inc.

Illustration 209

Illustrator:
Alan E. Cober
Book Jacket:
Cober's Choice
Art Directors:
Riki Levinson, Meri Shardin
Publisher:
E.P. Dutton

Illustrator:
Alan E. Cober
Promotional Literature:
Anxiety
Art Director:
John de Cesare
Publisher:
CIBA-GEIGY Corp.

The Assassination of Martin Luther King Jr. AP. Alan E. Cober '78

Illustrator:
Alan E. Cober
Magazine Illustration:
The Assassination of
Martin Luther King, Jr.
Art Director:
Peter Hudson
Publisher:
Atlanta Magazine

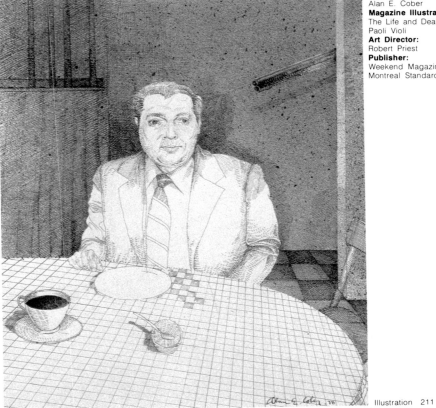

Illustrator:
Alan E. Cober
Magazine Illustration:
The Life and Death of
Paoli Violi
Art Director:
Robert Priest
Publisher:
Weekend Magazine,
Montreal Standard

Illustration 211

Illustrator:
Guy Billout
Book Illustration:
Helicopter
Art Director:
Cheryl Tortoriello
Publisher:
Prentice-Hall, Inc.

Illustrator:
Guy Billout
Book Illustration:
Car
Art Director:
Cheryl Tortoriello
Publisher:
Prentice-Hall, Inc.

Illustrator:
Guy Billout
Book Illustration:
Truck
Art Director:
Cheryl Tortoriello
Publisher:
Prentice-Hall, Inc.

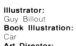

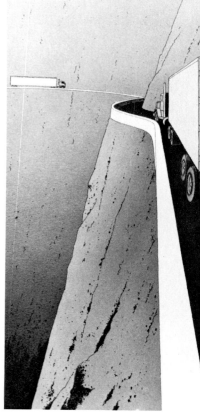

Illustrator:
Guy Billout
Book Illustration:
Bus
Art Director:
Cheryl Tortoriello
Publisher:
Prentice-Hall, Inc.

Illustrator:
David Wilcox
Record Album:
The Writers
Art Director:
Paula Scher
Publisher:
CBS Records

Illustration 213

Illustrator:
John Collier
Magazine Illustration:
Landscape
Publisher:
McCall's Magazine

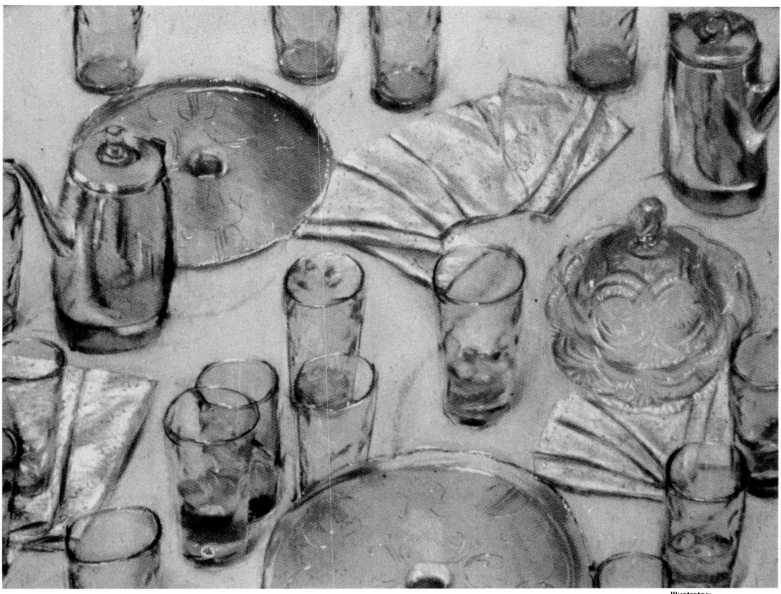

Illustrator:
John Collier
Magazine Illustration:
Still Life
Publisher:
Idea Magazine

Illustration 215

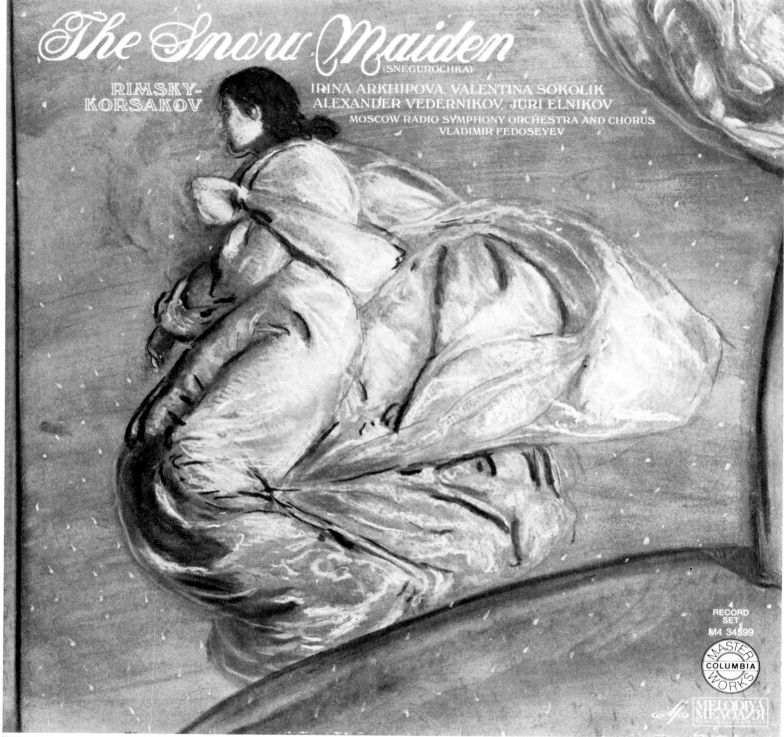

Illustrator:
John Collier
Record Album:
The Snow Maiden
Art Director:
Henrietta Condak
Publisher:
CBS Records

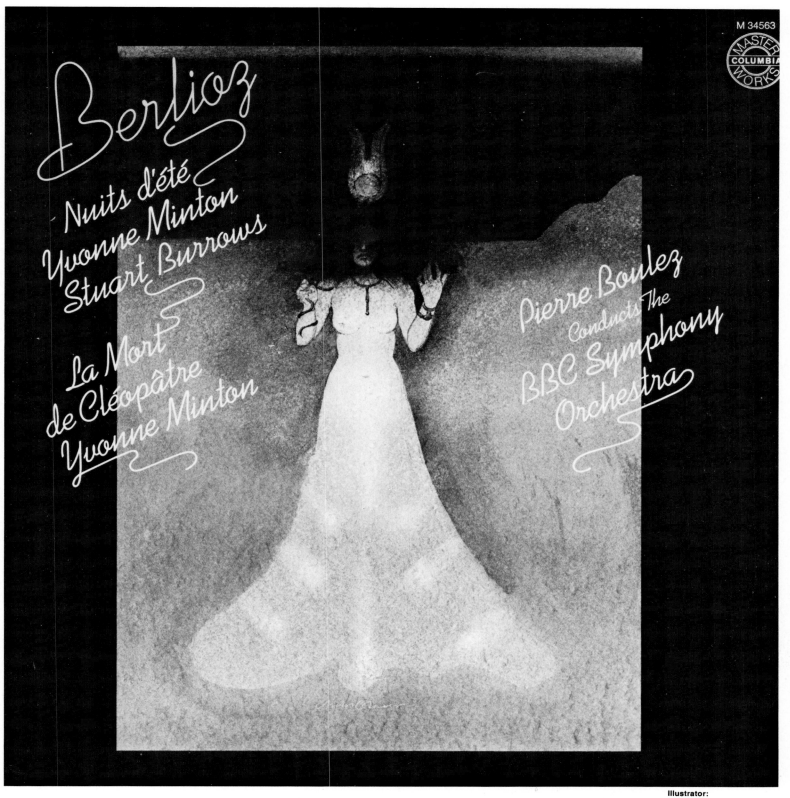

M 34563

MASTERWORKS COLUMBIA

Berlioz
Nuits d'été
Yvonne Minton
Stuart Burrows

La Mort
de Cléopâtre
Yvonne Minton

Pierre Boulez
conducts The
BBC Symphony
Orchestra

Illustrator:
Milton Glaser
Record Album:
Berlioz/Nuits d'Été
Art Director:
Henrietta Condak
Publisher:
CBS Records

Illustration 217

Illustrator:
John Van Hamersveld
Poster:
New Theater for Now
Art Director:
John Van Hamersveld
Client:
Mark Taper Forum

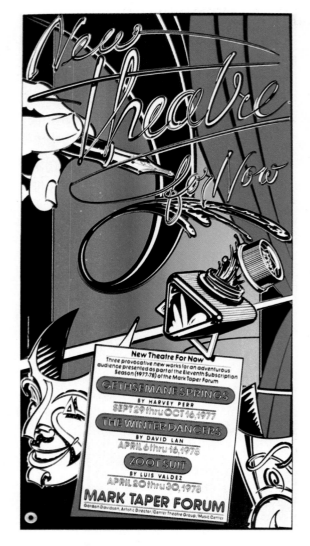

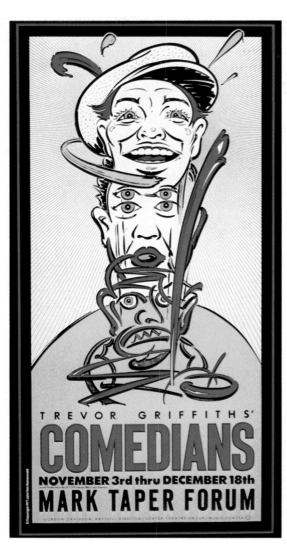

Illustrator:
John Van Hamersveld
Poster:
Comedians
Art Director:
John Van Hamersveld
Client:
Mark Taper Forum

Illustrator:
John Van Hamersveld
Poster:
The Modern Chair
Art Director:
John Van Hamersveld
Publisher:
La Jolla Art Museum

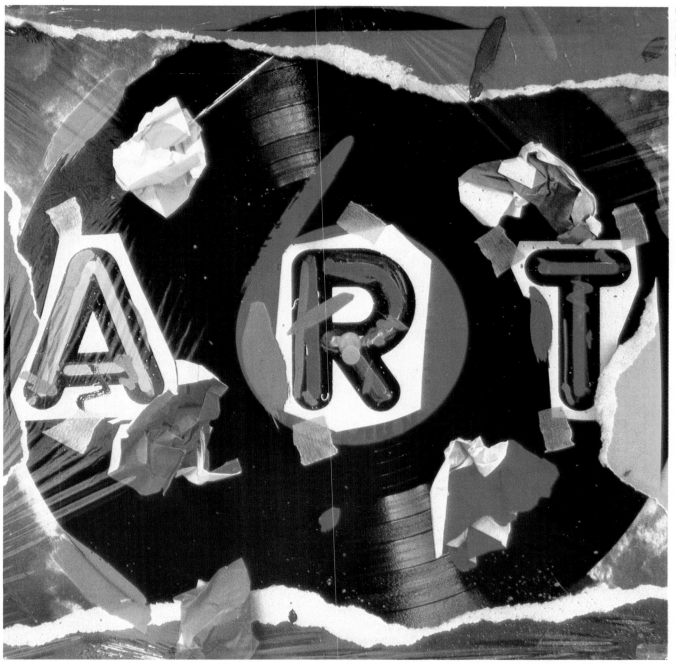

Illustrator:
John Van Hamersveld
Cover:
Record Album Art
Art Director:
Glen Christensen
Publisher:
Syracuse University

Illustration 219

Illustrator:
David Wilcox
Record Album:
Multiplication
Art Director:
Paula Scher
Publisher:
CBS Records

Illustrator:
Heather Cooper
Calendar:
Toth
Art Director:
Heather Cooper
Publisher:
Abitibi-Price, Ltd.

Illustrator:
Milton Glaser
Poster:
Angel Alley/Linda Cohen
Art Director:
Milton Glaser
Publisher:
Tomato Music Company

Illustrator:
James McMullan
Record Album:
Lake
Art Director:
Paula Scher
Publisher:
CBS Records

Sonny Fortune/Serengeti Minstrel

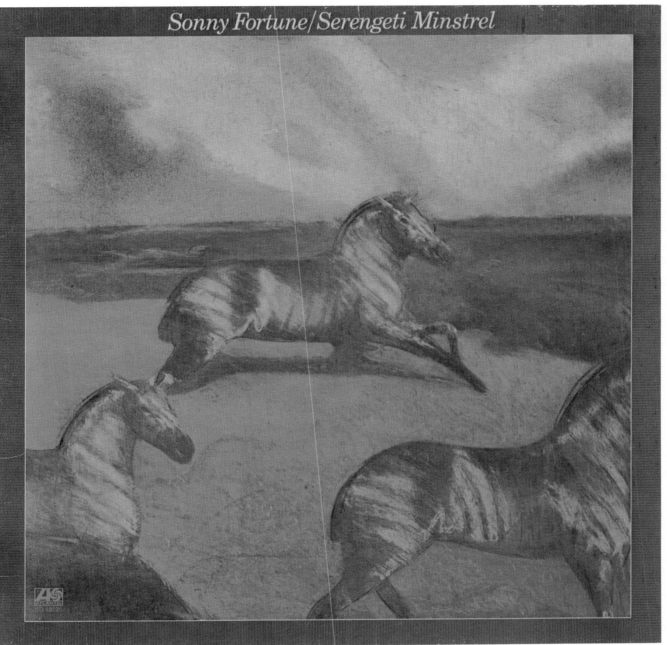

Illustrator:
John Collier
Record Album:
Sonny Fortune,
Serengetti Minstrel
Art Director:
Bob Defrin
Publisher:
Atlantic Records

Illustration 223

Packaging

Commercial packaging that has been designed and produced in the United States or Canada is eligible for the Packaging design awards program. From 428 entries submitted this year, 63 package designs were selected for award by the jury.

Co-Chairman
Robert E. Vogele

The founder and chairman of RVI Corporation in Chicago, Robert Vogele is a planner and design consultant in corporate and marketing communications programs—including identity, product marketing, packaging, and exhibition. A graduate of the University of Illinois in design and communications, he founded his own consulting design organization in 1958.

Co-Chairman
Joseph Michael Kornick

Now the manager of the Chicago office of Cato Johnson Inc., Joseph Michael Kornick was previously affiliated with the Graphic and Package Design Department of Procter & Gamble Company and the Corporate Communications Department of Container Corporation of America. Born in Pittsburgh, Pennsylvania, he took a BS in design from the University of Cincinnati's School of Design, Art, and Architecture and then an MBA in marketing from Columbia University's Graduate School of Business.

Louis Danziger

Designer, consultant, educator, Louis Danziger is senior faculty member of the Graphic Design Program at the California Institute of the Arts. He is design consultant to the Atlantic Richfield Corporation and is currently consulting on the redesign of the *Los Angeles Times.* He has taught for over 25 years at various institutions, including the Carpenter Center at Harvard, Cal Arts, and Art Center. He has had a private design practice in Los Angeles since 1949.

Morton Goldsholl

A principal in Goldsholl Associates in Chicago, Morton Goldsholl's work is divided fairly evenly between graphic design and movie production. Of the graphics half, he estimates that 70 percent is in package design. Born in Chicago, where he has based his design career, he studied with Moholy-Nagy and Gyorgy Kepes, who fixed his career goals, at the School of Design in Chicago.

James Lienhart

A partner in the Chicago design firm of Murrie, White, Drummond, Lienhart & Associates, James Lienhart was born on a farm in Nebraska. He has a design degree in illustration from the Kansas City Art Institute and began his career as a graphic designer in Des Moines, Iowa, first with *Better Homes & Gardens* and then with *Look.* He later moved to Chicago and became vice-president, director of design, for RVI Corporation and Unimark International. He is currently working on a full range of design programs, from publishing and corporate identity to packaging.

Herbert Meyers

The New York firm of Gerstman + Meyers Inc., in which Herbert Meyers is a partner, specializes in packaging and corporate communications. Herbert Meyers was born in Germany, came to New York as a teenager, and studied at Pratt Institute. He first worked in general design for a pharmaceutical agency and a design studio and then gravitated to packaging because of its disciplined approach and multiple facets. He was a vice-president, account supervisor, with Sandgren & Murtha for seven years before forming Gerstman + Meyers in 1970.

Review

Does mass mean mediocrity? Does mass-market appeal automatically require mediocre design taste? That was the fundamental issue that aroused the Package Design jury in Chicago.

Jurors were divided on this point into a group of practical realists against a critical idealist. The idealist made a stand for innovative design, for stimulating touches of inspiration and brilliance. The pragmatists countered for recognition of advances that work in the marketplace, for workable designs that are effective sales tools, for designs that satisfy the multiple requirements of packaging. The two points of view were not regarded as subtle differences. It was an outspoken confrontation between thoughtful and concerned professionals who were articulate and experienced debaters. The question was resolved in theory by appealing to the higher moralities of resource conservation and social conscience.

Along the way, the debate raised a question at the heart of graphic design: Is the mass market yet another factor that distinguishes graphic design from the fine arts? Is it not only the client's programmatic requirements, but also the requirements of mass-market appeal that make graphic design an applied rather than a fine art?

In defining a package the jurors agreed as a group on "a container that is protective"–primarily "a graphic entry" in which "the structure of the package sometimes plays a role." They agreed that of the 450 entries received for evaluation–half of them individual packages and the other half groups of packages–there was a "reasonable cross section" of package design in this country. (It was noted that approximately 15,000 packages are in major supermarkets today and by 1985 that figure is expected to double.) But the judges felt the entries were not completely representative. Missing were sporting goods industry packaging and "generic packaging," or nonbrand products. Part of the psychology of the generic package, it was understood, is that it be "nondesign."

The judges made a cautious appraisal of the selections–not unlike the cautious process of designing nationally distributed packages. As they described it: when package design is for a national brand and $100 million-plus is at stake, a responsible designer is "terribly cautious." The caution avoids failures, but it also limits innovative successes. This means there is less chance for real adventure in nationally distributed package design. As one juror commented: "The whole spirit of this country is a kind of legal, defensive positioning; no one takes any chances."

However, one of the pragmatists countered, "With a major client, caution can clearly constitute good design." The long process of getting approval for a mass-market design encourages caution and discourages radical design. Since every package must be approved by a hierarchy of committees, from president to marketing researcher, a design usually gets diluted in the process. The marketing department wants "a lot of type" to explain what is inside, or it wants the package "to look bigger" because the competitor has a larger package. In the case of the soft-drink industry, one has to deal with not only the company representatives, but also the franchise bottlers, who have leverage and can approve or disapprove a design.

Louis Danziger felt these factors should not affect the Package Design jury's criteria: "For the AIGA Package Design awards, competence is not a sufficient criterion. I looked only for designs that had something special about them, either structurally, conceptually, or aesthetically." He felt that the jury ought to applaud only a high level of innovation and risk taking and that an AIGA

show should be inspirational and provide regeneration. "I'm voting for something that is distinguished," he said, "package designs with extra creative concept, application of wit or intelligence, or different aesthetic qualities that stand out, are novel, are superior." He granted the pragmatists that a designer must achieve the client's objectives, no matter how beautiful or inventive his solutions, "but we ought to award, if possible, something more than merely what works. The fact that you have to sell it to millions of people is a marketing criterion that I would make the least important of our criteria. The purpose of this show is to single out those pieces that are a notch above that. Let's try not to continue our defensive, market-oriented design," he exhorted. "Let's put some soul into it, some individuality, some ideals." It was a charge that many design-conscious people would eagerly follow.

For the pragmatists on the jury, Morton Goldsholl countered: "There is a certain sense of practicality that, as a designer, I prefer to deal with—not compromise with—deal with. To work within the framework of the market that I think is the best market in the world—the mass market, the consumer market. There, more people are affected by design. Since my student days with Moholy-Nagy in Chicago, since the very first moment I decided to become a designer, my viewpoint has always been that it was more important to design for the 5 & 10-cent store than to design a Cadillac automobile. As difficult as it is, I would do whatever I could to create, within that framework, the kinds of things that I felt most people would use and want.

"We have to act not only as designers, but also as participants. It doesn't mean that I will compromise my views at all. I will fight every inch of the way, always, for the things that Danziger is proposing, and yet I know very well that if I accept that job, it has got to work in the marketplace. A package must be sales-effective. Effectivity is not diametrically opposed to creativity; it is best served by creativity.

"We have done a lot of battling for good package design," he added, "and when we see some breakthrough that you may view as being modest or average, we ask, 'How did they get *that* through?' To us it feels just about 3 percent better, so we say we ought to reward the designer for doing something decent in the marketplace. We find it difficult to divorce our thinking about good graphics from sympathizing with the problems these people had to run up against. We are living with this as a reality, not an art."

To show the intensity of the discussion at its most heated, the pragmatists took the offensive, making their mark in a genial manner but roundly on target: "There is a difference between being a judge and a critic. A judge is someone who has come up from being a trial lawyer, a prosecuting attorney, and knows what the process is all about. Only after all that experience is he called to the bench. A critic comes from the outside and doesn't know the problems that keep the system from being what visionaries dream it might be. He is an idealist unconcerned about the problems."

"If our criterion is the satisfaction of the mass market," came the rebuttal, "then obviously we are going to come up with safe solutions. I am questioning whether it is the fundamental purpose and mandate of this show to applaud that kind of activity and those breakthroughs that only those people who are privy to the problems understand. Or is it our function to single out what become benchmarks or ideals for us to shoot for? I think it is important to see the excitement and the creativity."

It was becoming clear that mass means mess or mediocrity, at least to some degree. Yet the Bauhaus goal, the discussion reminded us, was that good design could be mass-produced for the masses and, thereby, improve life socially as well as aesthetically. One juror recalled that when Moholy-Nagy discussed design, he wanted only to carry his audience one step further along—not to make advances that were light-years ahead. "The Bauhaus believed," he said, "that well-designed things need to be a little bit better because people who are used to buying ugly things are otherwise not going to buy the nice ones." And this country, he noted, has made great improvements—which the advancements in the quality of AIGA shows have represented—only because there is a great mass here with sufficient affluence that permits greater opportunity for such advances.

One suggestion was made to resolve this major difference: that the packaging awards be divided into separate categories—one for mass-appeal national-distribution packages and another for local, limited-market packages—with separate sets of criteria for evaluation. The pragmatists did not like this idea of separation. One suggested another criterion or category—"rather than precious versus nonprecious"—and that would be consideration for designers who show concern for "sanity in packaging. The problems that our society faces today," he maintained, "are enormous and far more important than whether we can find a new inspiration to be able to use type in a better way.

"We need to get into the problem of resource usage, recycling of materials, the whole problem of the nature of society today," he continued. "From the public standpoint, there are real responsibilities to package design. Designers, as well as marketers, have to ask themselves if they are being wasteful of resources. The public doesn't understand that to get fresh orange juice in the middle of winter takes some packaging and some technology.

"The next great period to evolve for packaging will be when the basic usefulness of the package will no longer be tied in with the process of selling. Then we can actually work ourselves out of this profession and into functional, meaningful design for the future. We will all have to recognize that a bag that's transparent contains the very best peas, and no more than that. We will then become a decent, human society," he projected.

"Do you think that packaging is dehumanizing?" another juror asked. "The marketing aspect of it means that one human is really trying to lead another human to the marketplace," came the reply. "If we put all that aside, the farmer would benefit from growing the peas and the consumer would benefit from getting the peas. The only people who might not benefit are those who advertise and do the interim steps, for which they collect enormous amounts of money."

"Like package designers?" someone asked. "Oh, yes, of course," answered the spokesman. "I'm not putting us aside."

It was clear that this Package Design jury had experience, criteria, perspective, and idealism far beyond mediocrity. When all was said and done, of course, the jury selected essentially on the basis of its cumulative experience those package designs that each juror intuitively responded to on an aesthetic level. And the majority opinion of this experience and intuition is what makes their selections representative of package design in America today.

Package:
Trillium Brandy
Art Director/Designer:
Raymond Lee
Design Firm:
Raymond Lee &
Associates Ltd.
Client:
Rieder Distillery Ltd.,
Ontario, Canada
Manufacturers:
Label: Arthur-Jones
Lithographing Ltd.
Package: Karen Lawrence

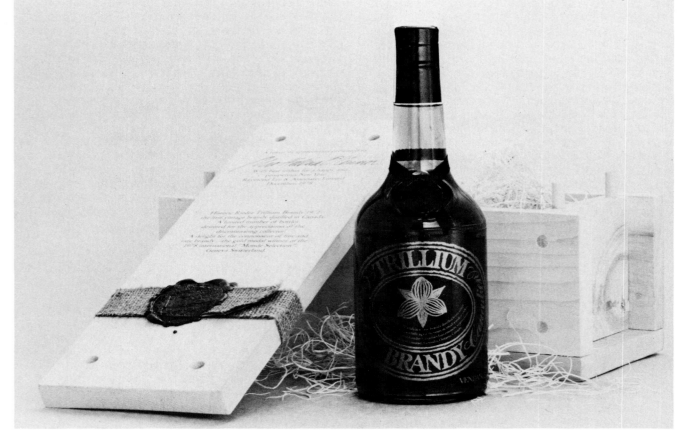

Package:
Teaching Slides
Art Director/Designer:
Bob Paganucci
Design Firm:
Bob Paganucci Design
Client:
CIBA-GEIGY Corp.
Manufacturer:
Packaging Coordinators

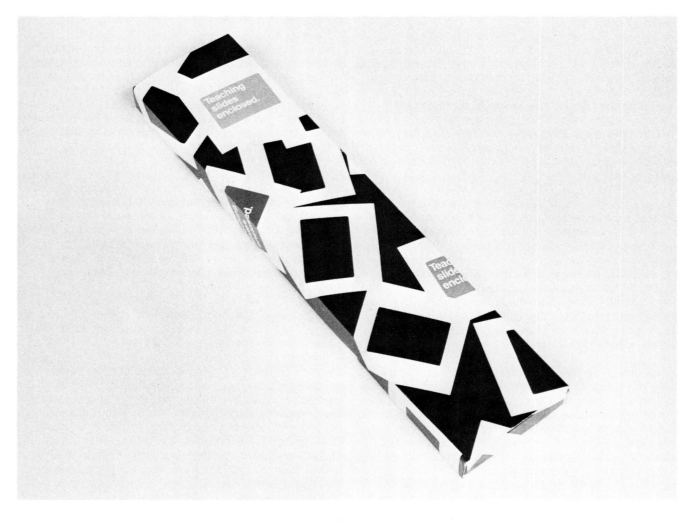

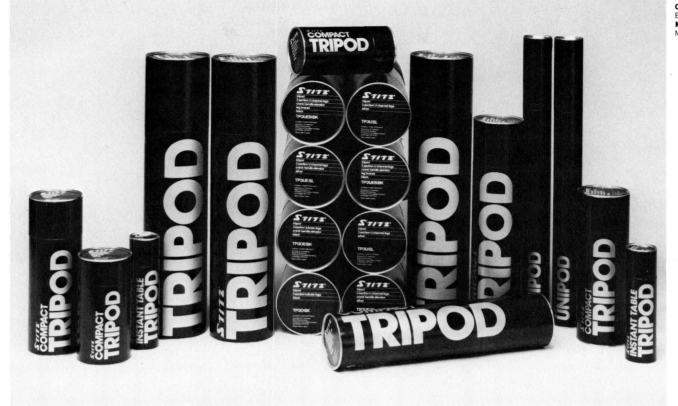

Package:
Stitz Tripod
Art Director:
David Sandstrom
Designer:
David Zerba
Design Firm:
Nason Design Associates
Client:
Braun North America
Manufacturer:
Marshall Paper Tube

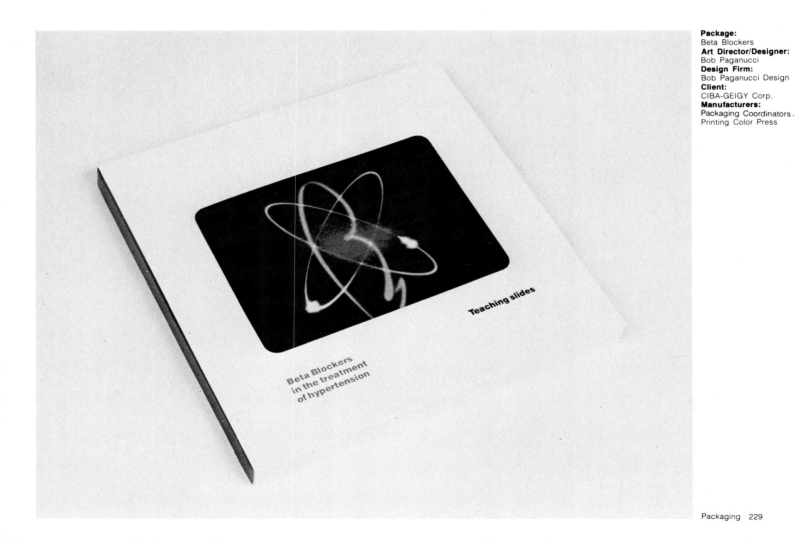

Package:
Beta Blockers
Art Director/Designer:
Bob Paganucci
Design Firm:
Bob Paganucci Design
Client:
CIBA-GEIGY Corp.
Manufacturers:
Packaging Coordinators,
Printing Color Press

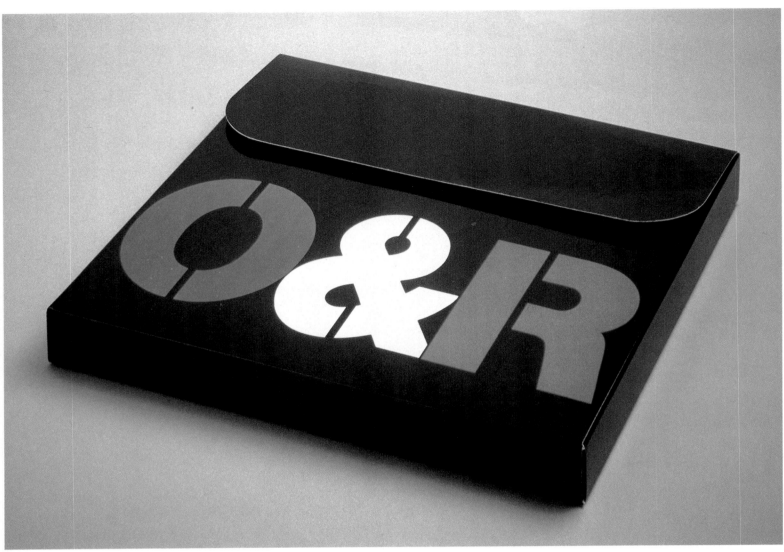

Package:
O & R
Designer:
W. Chris Gorman
Design Firm:
W. Chris Gorman
Associates, Inc.
Client:
American Business Press,
Inc.
Manufacturer:
Earle & Jones

Package:
Template
Designer:
Linda Powell
Design Firm:
Corporate Communications,
Herman Miller, Inc.
Client:
Herman Miller, Inc.
Manufacturer:
National Cover of Atlanta

Package:
Tavist
Designer:
Tiit Telmet
Design Firm:
Gottschalk + Ash Ltd.
Client:
Anca Inc.
Manufacturer:
American Packaging
Corporation (Montreal)

here it is...
the better
mousetrap.™

Get'm!

pet-safe
clean kill
reuseable

Package:
'Get'M!" Mousetrap
Design Director:
Joe Selame
Designer:
Richard Edlund
Design Firm:
Selame Design Associates
Client:
Wicander Enterprises, Inc.
Manufacturer:
Lithocolor

Package:
SeaMist Tin
Art Director/Designer:
Heather Cooper
Design Firm:
Burns, Cooper, Hynes
Limited
Client:
BAC Cosmetiques

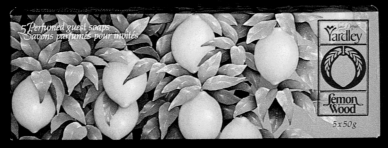

Package:
SeaMist Soap Packages
Art Director:
Robert Burns
Designers:
Heather Cooper,
Carmen Dunjko
Design Firm:
Burns, Cooper, Hynes
Limited
Client:
BAC Cosmetiques

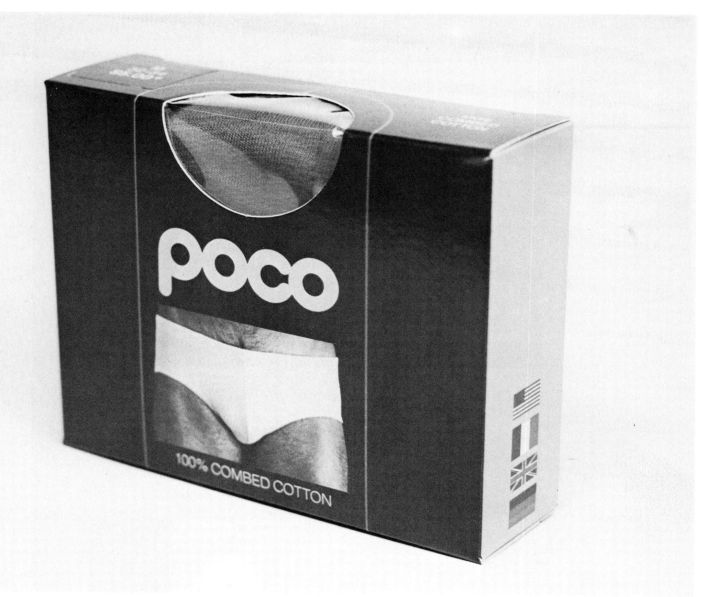

Package:
Poco
Art Director/Designer:
Tom White
Design Firm:
Murrie White Drummond
Lienhart & Associates
Client:
Jockey International, Inc.
Manufacturer:
Package Products

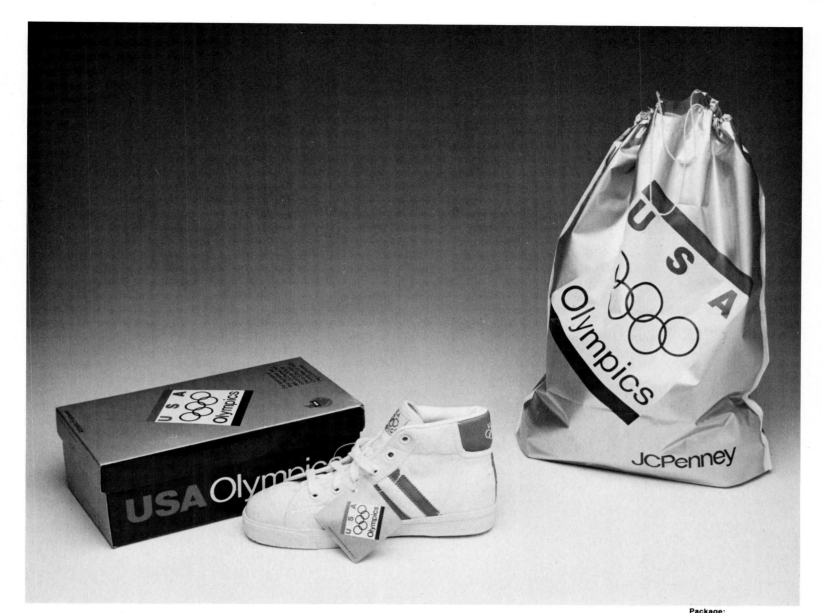

Package:
Olympic Box and Bag
Art Director/Designer:
Bill Bonnell/Bonnell and
Crosby Inc.
Design Firm:
JCPenney Packaging
Department
Client:
J.C. Penney Inc.

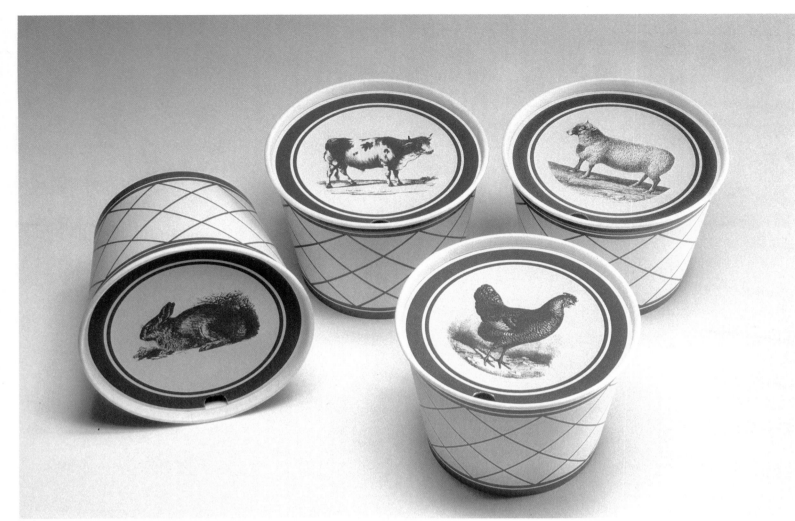

Package:
Porcellana Paperware Pack
Designers:
Gerald Reis, Ann Schroeder,
Wilson Ong
Design Firm:
Gerald Reis & Company
Client:
Porcellana
Manufacturer:
Lily, Beach Products, and
Velvetone Gallagher

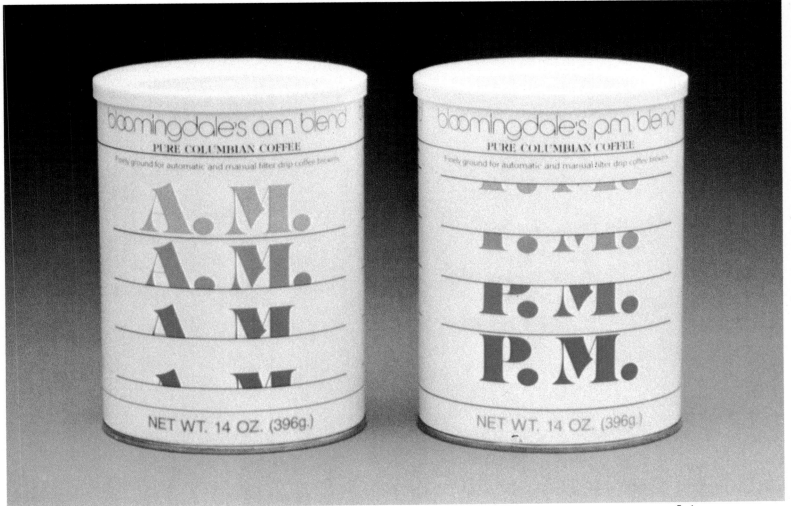

Package:
A.M. & P.M. Coffees
Designer:
Steven Liska
Design Firm:
Liska & Associates
Client:
Bloomingdale's/New York
Manufacturer:
First Colony Tea and Coffee

Package:
Sesame Rice Spirals
Designer:
David Gauger
Design Firm:
Gauger Sparks Silva
Client:
Westbrae Natural Foods
Manufacturer:
Stecher Traung Schmidt
Corporation

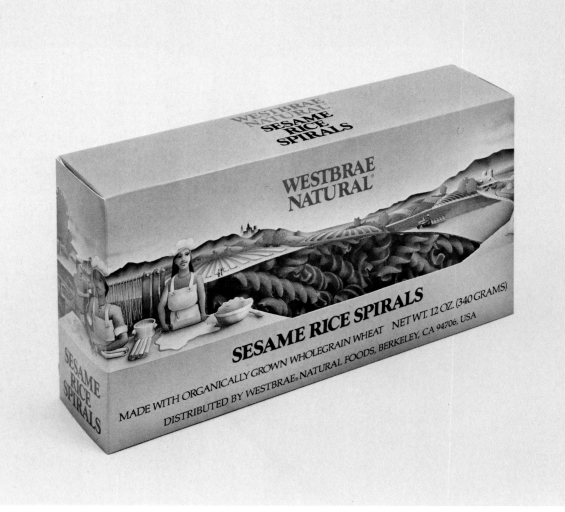

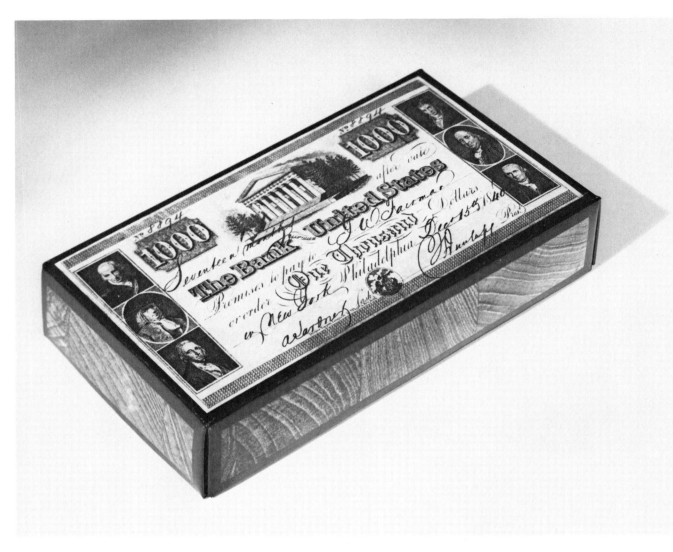

Package:
DeLuxe Checks
Art Director:
W.F. Meyer, Jr.
Designers:
Steven Rutiezer,
Marvin Steck
Photographer:
F. Stanley Jorstad
Design Firm:
Design and Market Research
Laboratory, Container
Corporation of America
Client:
DeLuxe Check Printers, Inc.
Manufacturer:
Container Corporation of
America

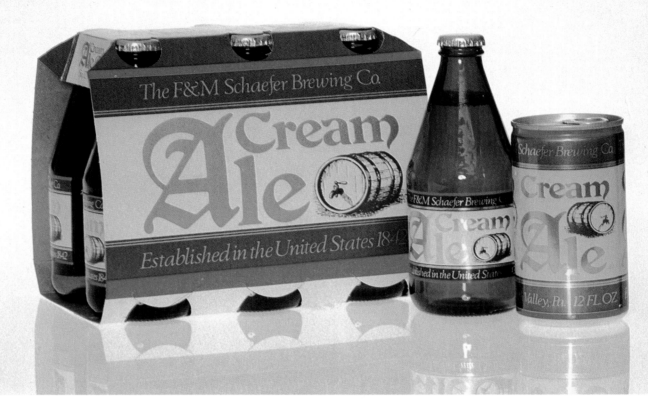

Package:
Schaefer Cream Ale Bottle/
Can/6-Pack
Art Director:
Clive Chajet
Designer:
Richard Shear
Design Firm:
Chajet Design Group
Client:
The F & M Schaefer Brewing
Company

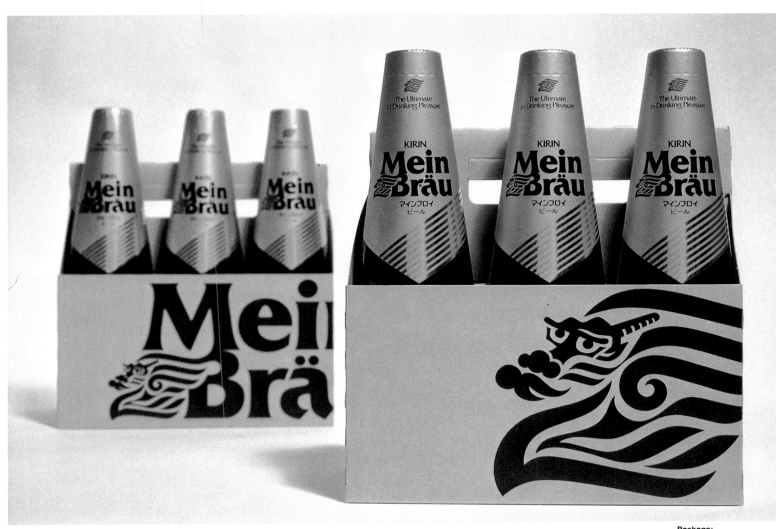

Package:
Mein Bräu
Designer:
Rei Yoshimura
Design Firm:
Yoshimura-Fisher
Client:
Kirin Brewery Company,
Ltd., Tokyo, Japan
Manufacturers:
Mitsubishi Aluminum Co.,
Ltd., The Toppan Printing Co.

Package:
Johnston's Frozen Yogurt
Containers
Art Director:
Keith Bright
Designer:
Julie Riefler
Design Firm:
Bright & Agate, Inc.
Client:
Johnston's Food Company
Manufacturer:
Sweetheart Cup Corporation

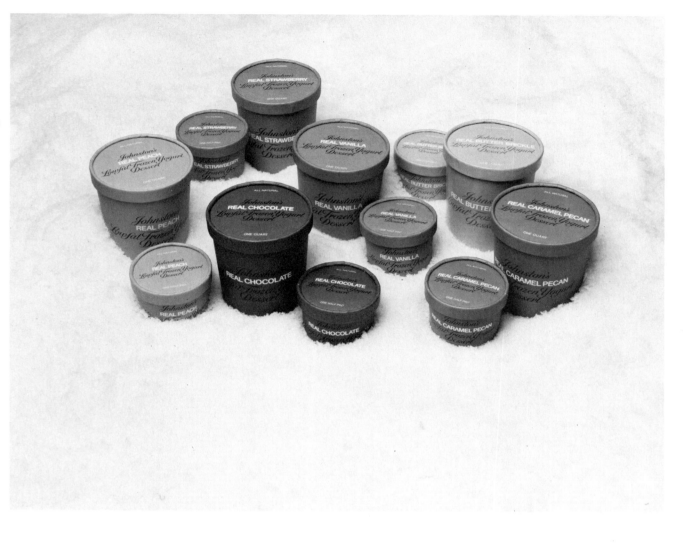

Package:
White Meat Fish in Batter
Designer:
Joe Selame
Design Firm:
Selame Design Associates
Client:
Brilliant Seafood
Manufacturer:
New England Paper Box
Company

Package:
Good Mews Dry Cat Food
Design Supervisor:
Herbert M. Meyers
Art Director:
Larry Riddell
Illustrator:
Jerry Dior
Design Firm:
Gerstman+Meyers Inc.
Client:
Ralston Purina Company

Package:
Old Philadelphia Ice Cream
Art Director:
Irv Koons
Designers:
Irv Koons, Malcolm
Feinstein, Paul Gee
Design Firm:
Irv Koons Associates, Inc.
Client:
Abbotts Dairies
Manufacturer:
Seal Right

Package:
Hi-C Orange Drink
Art Director/Designer:
Sheldon Rysner
Design Firm:
Goldsholl Associates
Client:
Coca-Cola Company
Manufacturer:
Various

Package:
Summit
Design Supervisor:
Herbert M. Meyers
Art Director:
Larry Riddell
Design Firm:
Gerstman+Meyers Inc.
Client:
M&M/Mars Inc.

Packaging 245

Package:
Midwest Handpiece
Packaging System
Designer:
Jeffrey Swoger
Design Firm:
Jeffrey Swoger/Grafik
Client:
American Midwest
Manufacturer:
Arandell Corporation

Package:
Lemonwood Wooden Box
Art Director/Designer:
Heather Cooper
Illustrator:
Heather Cooper
Design Firm:
Burns, Cooper, Hynes
Limited
Client:
BAC Cosmetiques

Package:
Adhesives Problem Solving
Kit
Art Director:
Markus J. Low
Designer:
Frank Vigliotti
Design Firm:
CIBA-GEIGY Corp.,
Corporate Art Services
Client:
CIBA-GEIGY Corp.

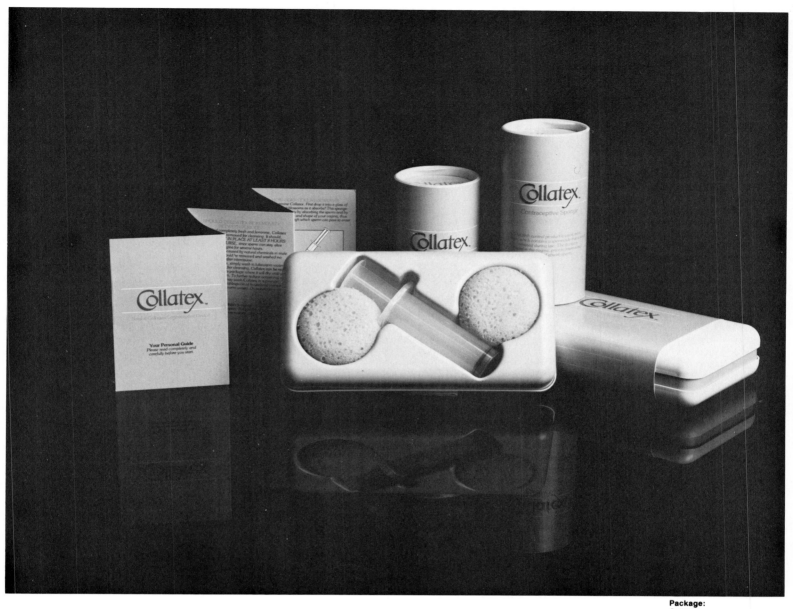

Package:
Collatex
Designer/Art Director:
Jann Church Advertising &
Graphic Design, Inc.
Design Firm:
Jann Church Advertising &
Graphic Design, Inc.
Client:
Vorhaurer Lab

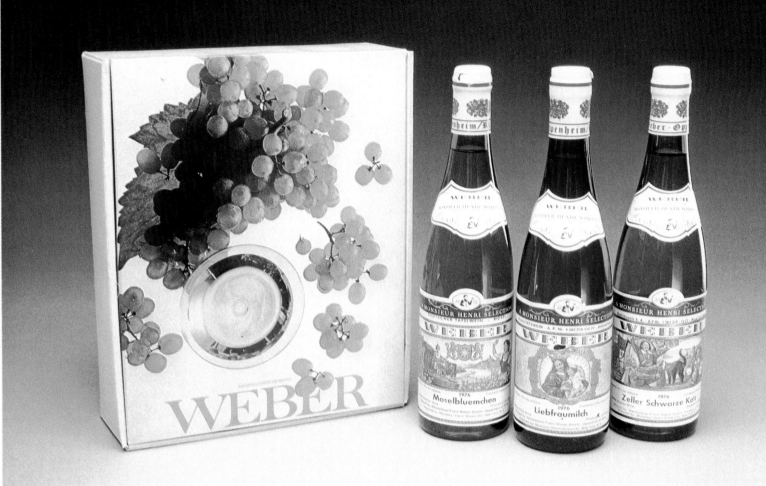

Package:
Weber Gift Box
Art Director:
Frank Rupp
Designer:
Sondra Schoultz
Photographer:
Leon Kuzmanoff
Design Firm:
Graphic Arts Dept.,
Pepsi-Cola Company
Client:
Pepsico Wines & Spirits
Manufacturer:
Container Corporation of
America

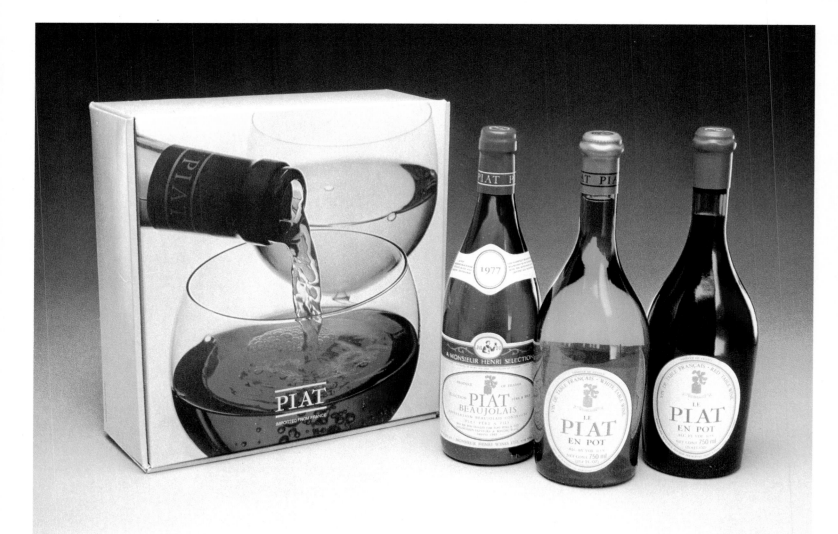

Package:
Piat Gift Box
Art Director:
Frank Rupp
Designer:
Sondra Schoultz
Photographer:
Leon Kuzmanoff
Design Firm:
Graphic Arts Dept.,
Pepsi-Cola Company
Client:
Pepsico Wines & Spirits
Manufacturer:
Container Corporation of
America

Package:
The Audible Audubon
Designer:
Ken Parkhurst
Design Firm:
Ken Parkhurst &
Associates, Inc.
Client:
Microsonics Corporation
Manufacturer:
Advance Paper Box

Package:
Coppertone
Art Director:
Edward C. Kozlowski
Designers:
Edward C. Kozlowski, James
M. Keeler, Alicia L. Sulit
Design Firm:
Edward C. Kozlowski
Design Inc.
Client:
Plough, Inc.

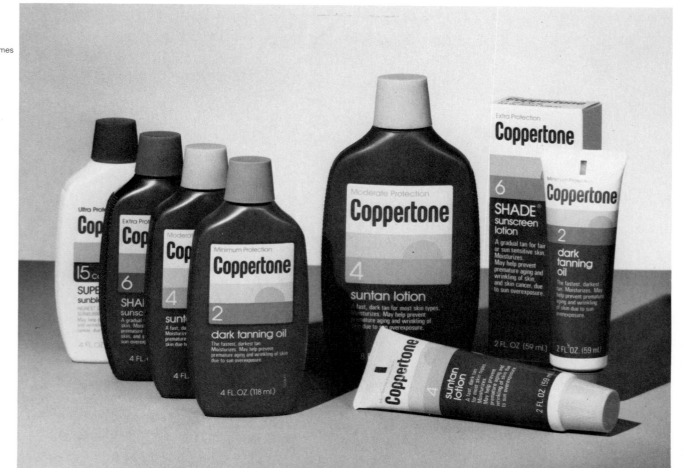

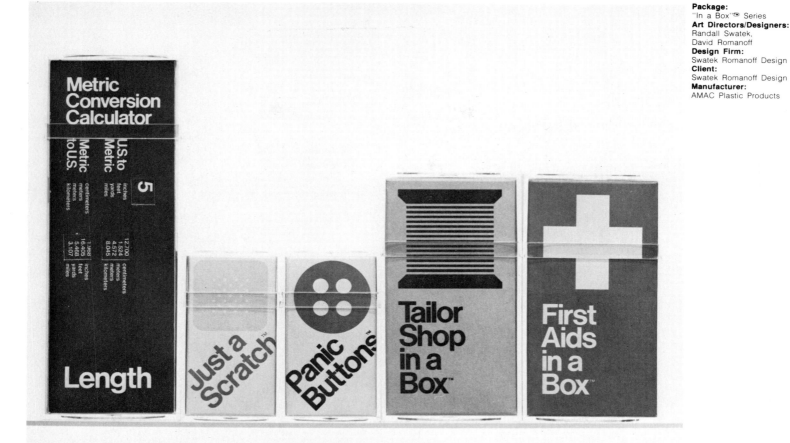

Package:
"In a Box"™ Series
Art Directors/Designers:
Randall Swatek,
David Romanoff
Design Firm:
Swatek Romanoff Design
Client:
Swatek Romanoff Design
Manufacturer:
AMAC Plastic Products

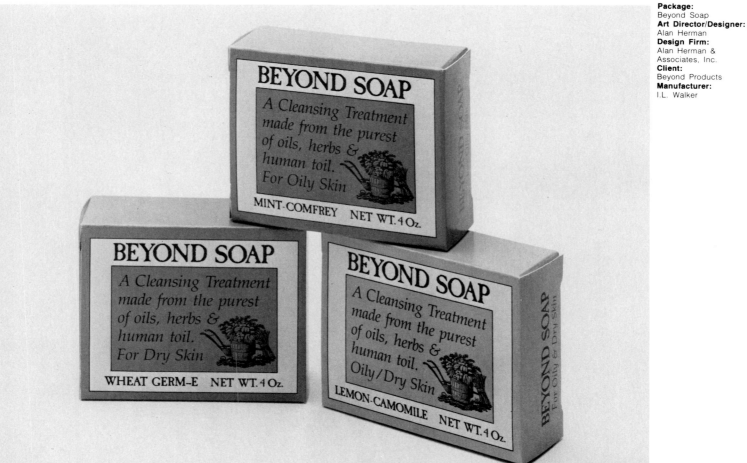

Package:
Beyond Soap
Art Director/Designer:
Alan Herman
Design Firm:
Alan Herman &
Associates, Inc.
Client:
Beyond Products
Manufacturer:
I.L. Walker

Package:
Esidrix Pencil Pad
Art Director:
Ron Vareltzis
Designer:
Frank Mayo
Design Firm:
CIBA-GEIGY Design
Client:
CIBA Pharmaceuticals
Manufacturer:
L.P. Thebault

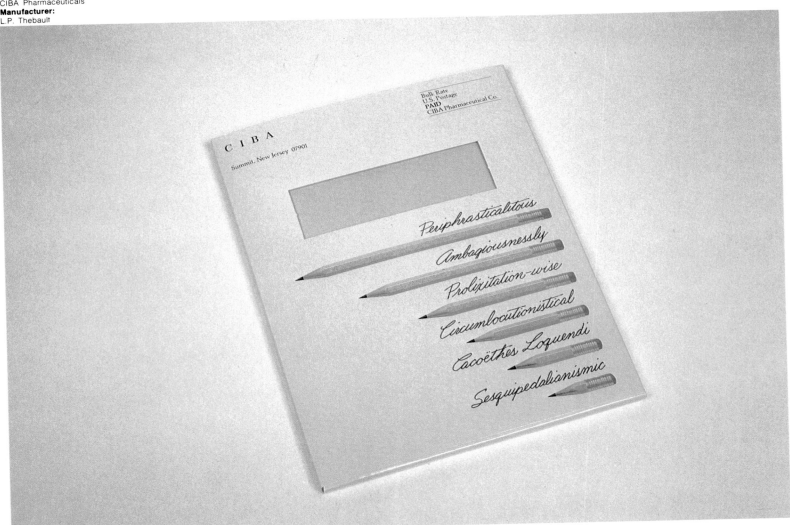

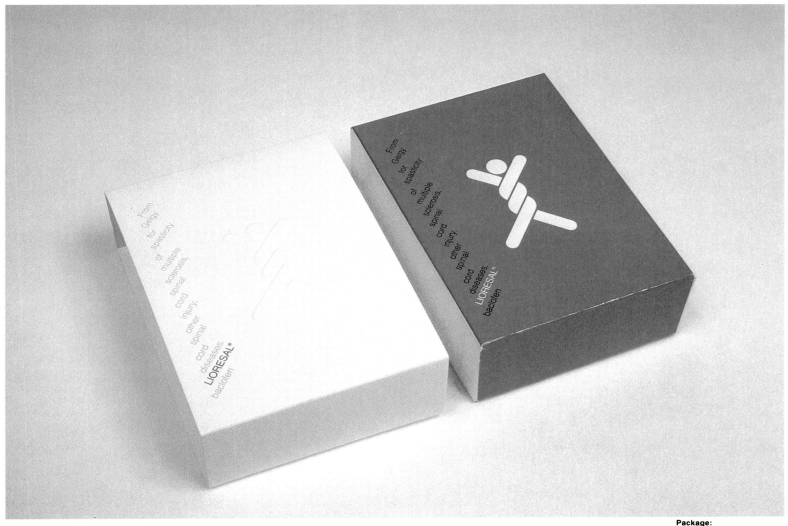

Package:
Lioresal
Art Director/Designer:
Bob Paganucci
Design Firm:
Bob Paganucci Design
Client:
CIBA-GEIGY Corp.
Manufacturers:
Lehigh Packaging,
Color Press

Package:
Contemporary Bras
Art Director/Designer:
Bill Bonnell/Bonnell and
Crosby Inc.
Photographers:
Francois Robert,
Natasha Robert
Design Firm:
JCPenney Packaging
Department
Client:
J.C. Penney Inc.
Manufacturer:
Container Corporation of
America

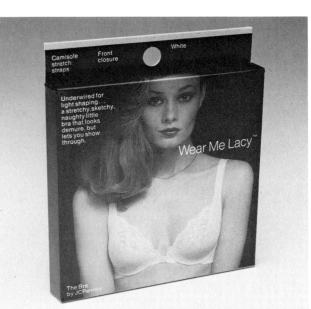

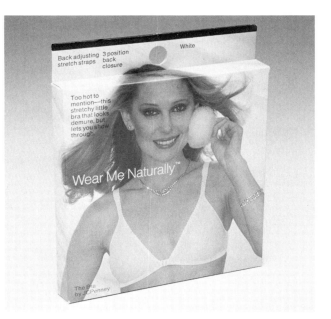

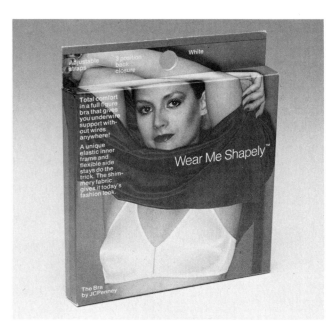

Shadow heel
Nude toe
Extra sheer legs
100% Nylon

Seamed
Stockings

JCPenney

1 PAIR

Package:
JCPenney Seamed Stockings
and Seamed Pantihose
Designer:
Marsha C. Adou
Design Firm:
JCPenney Packaging
Department
Client:
J.C. Penney Inc.
Manufacturer:
Rexham

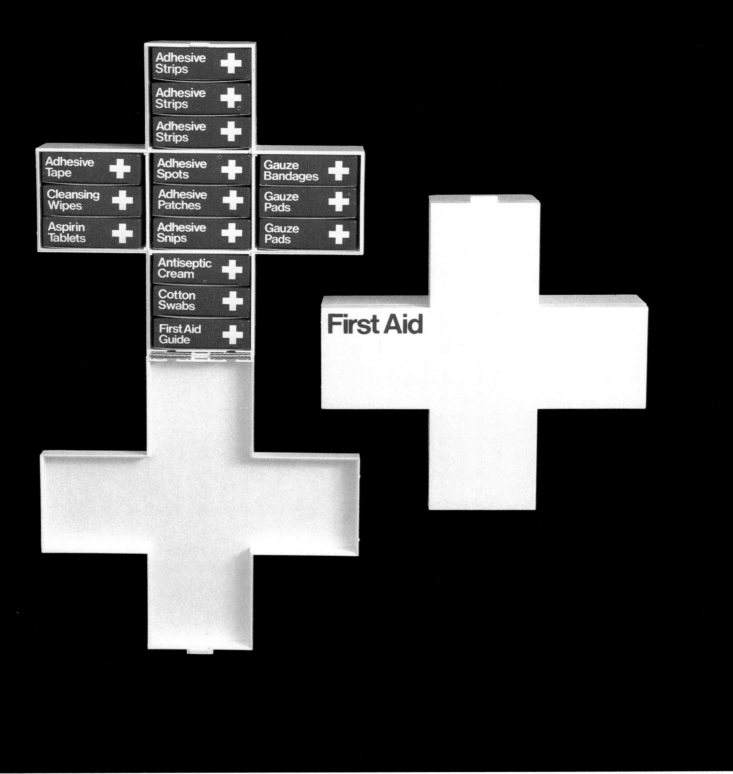

Package:
MediSign® Chest
Art Director/Designer:
David Romanoff
Design Firm:
Romanoff Design
Client:
Romanoff Design
Manufacturer:
Hathaway Plastics

Package:
Mello Yello Can/Bottle/6-Pack
Art Director:
Clive Chajet
Designer:
Tom Courtos
Design Firm:
Chajet Design Group
Client:
Coca-Cola Company

Package:
Shorty Handpiece Package
Designer:
Jeffrey Swoger
Design Firm:
Jeffrey Swoger/Grafik
Client:
American Midwest
Manufacturer:
Plastofilm Inc.

Package:
Marks' Cutlery Nail Clipper
Design Director:
Joe Selame
Designers:
Richard Edlund, Robert Selame
Design Firm:
Selame Design Associates
Client:
Marks' International
Manufacturer:
Atlantic Carton, Alga Plastics

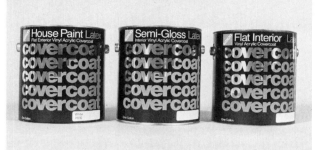

Package:
Covercoat Paint Labels
Designer:
Allen Porter
Design Firm:
Design Investigation Group
Client:
Saxon Paint & Home Care
Centers
Manufacturer:
Miracle Press

Package:
Wright's Silver Cleaner and
Polish
Design Director:
Joe Selame
Designers:
Joe Selame, Robert Selame
Design Firm:
Selame Design Associates
Client:
J.A. Wright and Company
Manufacturer:
American Can Co.

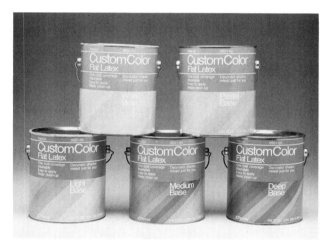

Package:
Custom Color Paint Cans
Art Director/Designer:
Bill Bonnell/Bonnell and
Crosby Inc.
Design Firm:
JCPenney Packaging
Department
Client:
J.C. Penney Inc.

Package:
Paint Packaging Program
Art Director/Designer:
Roger L. Johnson
Designer:
William A. Fredricks
Design Firm:
Deere & Company Staff
Client:
Deere & Company
Manufacturer:
Moline Paint Mfg. Co.

Package:
H.B. Fuller Towne'n Country
Decorative Brick
H.B. Fuller Decorative Brick
Adhesive Mortar
Art Director:
Bozell & Jacobs/Minneapolis
Designer:
Nancy Rice
Photographer:
Marvy Advertising
Photography
Advertising Agency:
Bozell & Jacobs Advertising,
Minneapolis
Client:
H.B. Fuller Company
Manufacturers:
Box: St. Regis
Can: Allied Container

Package:
Mobil Specialty
Designer:
Thomas H. Geismar
Design Firm:
Chermayeff & Geismar
Associates
Client:
Mobil Oil Corporation
Manufacturer:
Mobil Oil Corporation

Package:
Copco Knives
Designer:
Marshall Harmon
Ad Agency:
Benton & Bowles
Client:
Copco Inc.

Package:
Primary Range Pillar
Candles
Designer:
William R. Thauer
Design Firm:
General Housewares Corp.
Client:
Colonial Candle
Manufacturer:
Regent Box Co.

Package:
Morningstar Designs
Art Director:
Nicholas Zarkades
Designer:
W. Nicholas Fader
Design Firm:
Fader, Jones + Zarkades
Client:
Data Packaging Corp.
Manufacturer:
Various

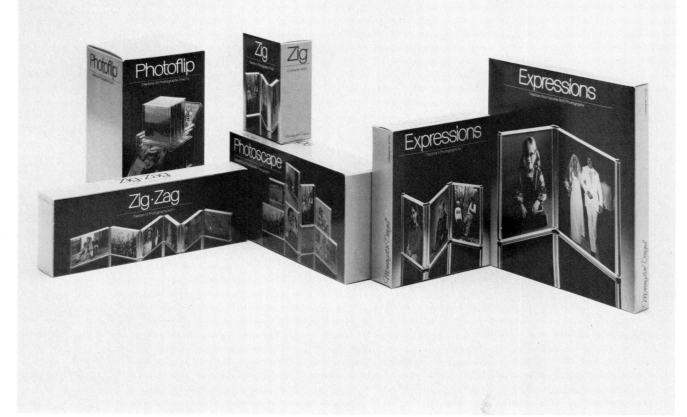

Package:
Canned Couture
Art Director/Designer:
Kenneth R. Cooke
Photographer:
Phil Koenig
Design Firm:
Kenneth R. Cooke
Client:
Canned Couture, Inc.

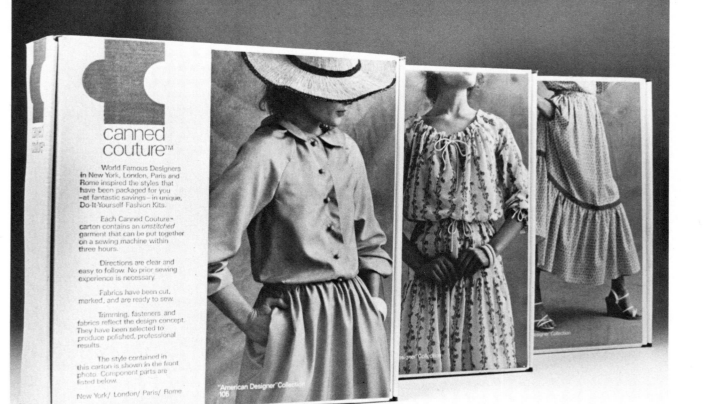

**3 Men's Pre-shrunk A-Shirts
100% Natural Combed Cotton**

The fabric is pre-shrunk, absorbent, and knit of a heavier yarn. For comfort, the shoulder straps are wider, the body is cut longer and the armholes are cut deeper.
Unconditionally Guaranteed.

**3 Men's
Pre-shrunk T-Shirts
100% Natural Combed Cotton**

The fabric is pre-shrunk, absorbent, and knit of a heavier yarn. The neck and shoulder seams are reinforced. The reinforced collar retains its shape. The sleeves are tapered to fit your arms.
Unconditionally Guaranteed.

**3 Men's
Pre-shrunk V-Shirts
100% Natural Combed Cotton**

The fabric is pre-shrunk, absorbent, and knit of a heavier yarn. The neck and shoulder seams are reinforced. The V-neck is wider and deeper. The reinforced collar retains its shape. The sleeves are tapered to fit your arms.
Unconditionally Guaranteed.

**3 Men's
Pre-shrunk Briefs
100% Natural Combed Cotton**

The fabric is pre-shrunk, absorbent, and knit of a heavier yarn. The elastic waistband won't detach, roll or lose its stretch, and the legbands are reinforced to keep their shape.
Unconditionally Guaranteed.

Package:
BVD Men's Basic & Fashion Underwear
Program Director:
Robert P. Gersin
Designer:
Robert P. Gersin
Design Firm:
Robert P. Gersin Associates Inc.
Client:
BVD Company
Manufacturers:
Mason Transparent Packaging and Packaging Systems, Crafton Graphic Co., Inc.

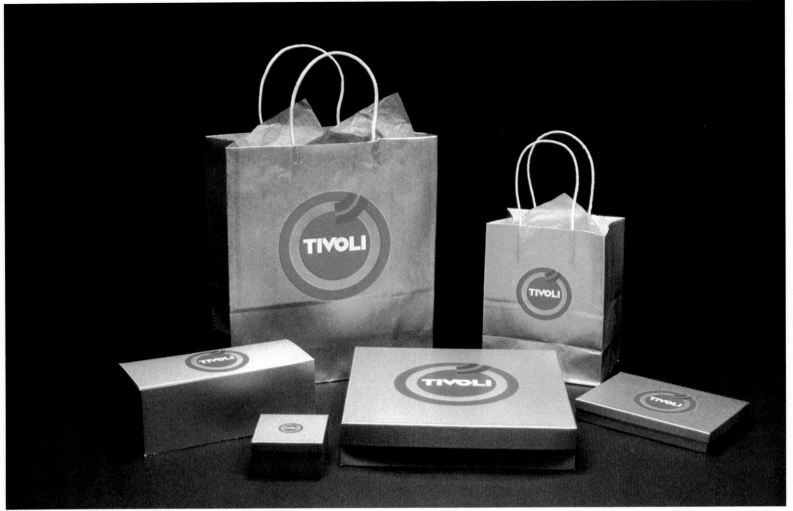

Package:
Tivoli Packaging
Designers:
Katherine & Michael McCoy
Design Firm:
McCoy & McCoy
Client:
Linda McKenney
Manufacturer:
Signet Printing

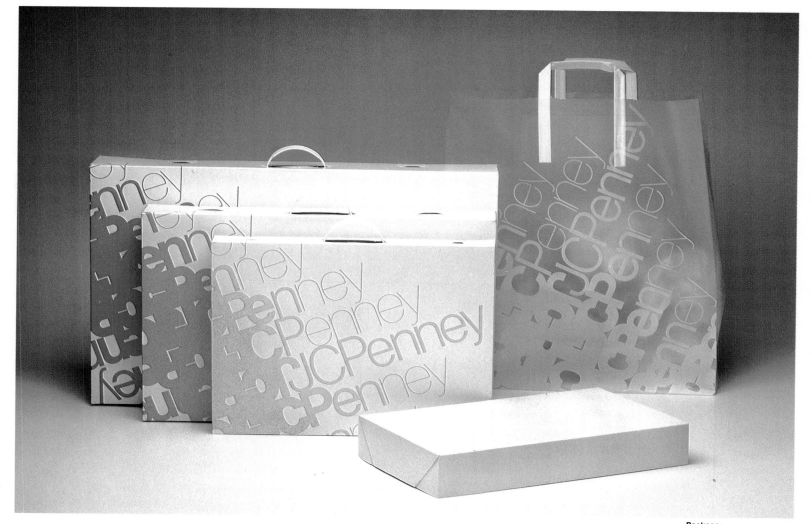

Package:
Post Sale Packaging
Art Director:
David Law
Designer:
Lawrence Wolfson
Design Firm:
JCPenney Packaging
Department
Client:
J.C. Penney Inc.
Manufacturers:
Shopping Bag: Continental
Extrusion
Garment Box: Container
Corporation of America
Gift Box: Container
Corporation of America

Package:
The Law as a Tool
Art Director/Designer:
Ed Brodsky
Design Firm:
Brodsky Graphics Inc.
Client:
J.C. Penney Inc.
Manufacturer:
Stephen Gould Corporation

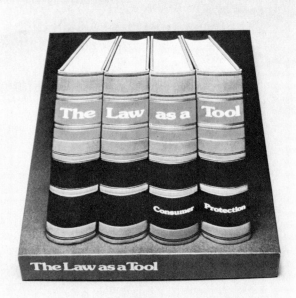

Package:
C&S United States Flag Set
Art Director/Designer:
Inge Fox
Photographer:
Neal Higgins Studio
Client:
The Citizens and Southern
National Bank, Atlanta
Manufacturer:
Interstate Folding Box
Company

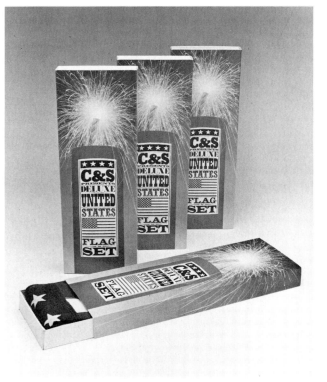

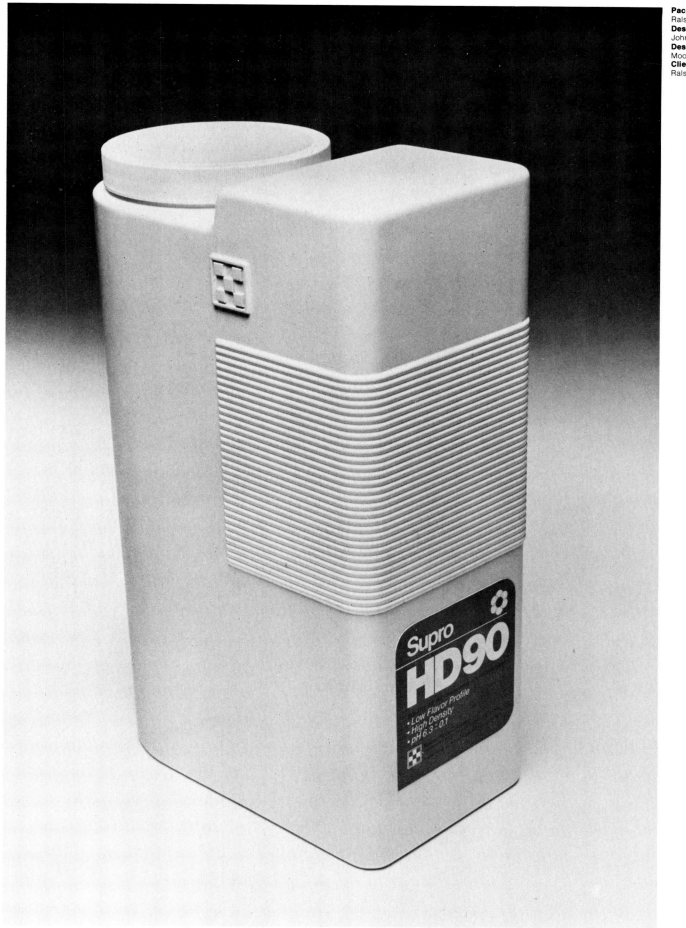

Package:
Ralston Soy Protein
Designer:
John Downs
Design Firm:
Moonink, Inc.
Client:
Ralston Purina Company

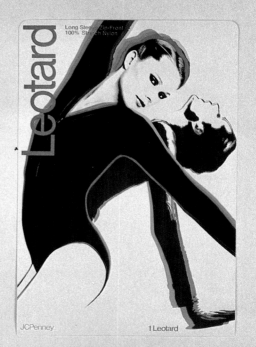

Package:
JCPenney Basic Leotard
and Tights Line
Designer:
Marsha C. Adou
Design Firm:
JCPenney Packaging
Department
Client:
J.C. Penney Inc.
Manufacturer:
Rexham

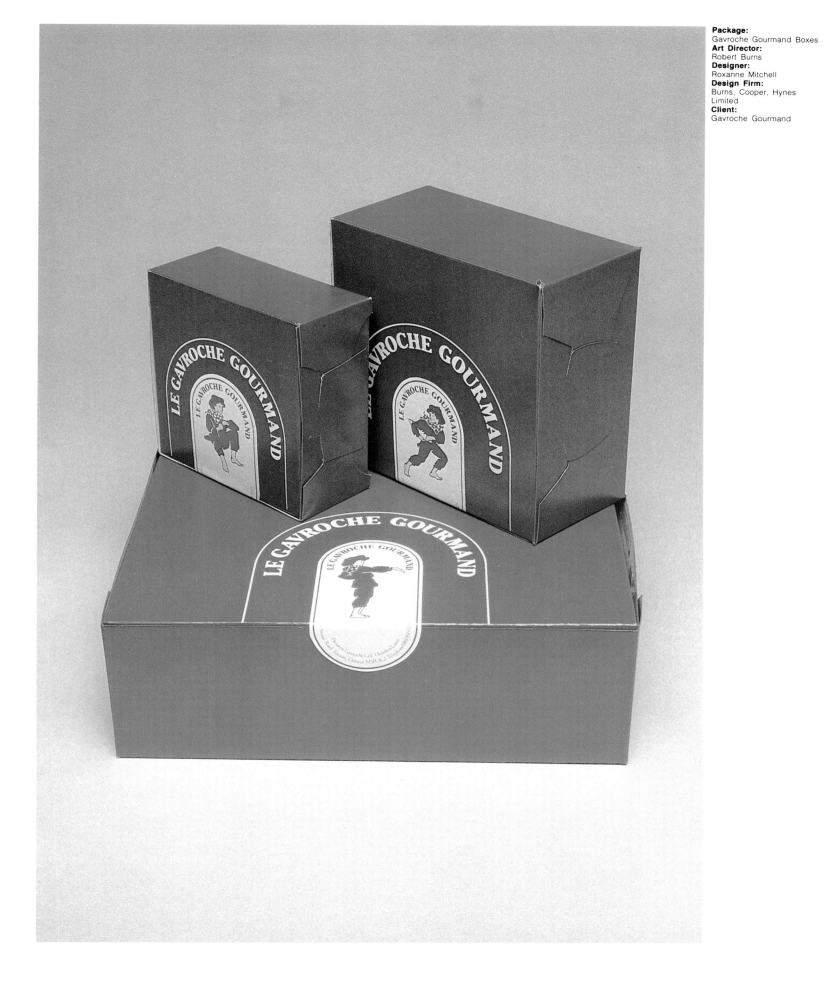

Package:
Gavroche Gourmand Boxes
Art Director:
Robert Burns
Designer:
Roxanne Mitchell
Design Firm:
Burns, Cooper, Hynes
Limited
Client:
Gavroche Gourmand

Package:
WhisperSteps Showbox
Art Director/Designer:
Bill Bonnell/Bonnell and
Crosby Inc.
Illustrator:
Deborah Pierce
Design Firm:
JCPenney Packaging
Department
Client:
J.C. Penney Inc.

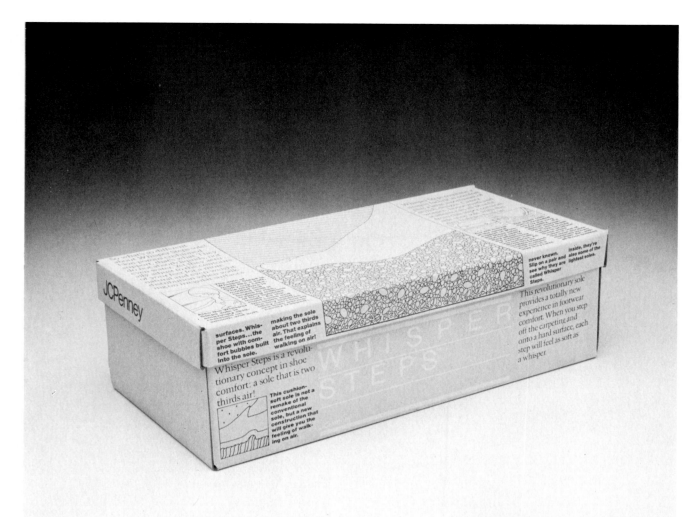

Package:
Esidrix Telephone Pad
Art Director:
Ron Vareltzis
Designer:
Frank Mayo
Design Firm:
CIBA-GEIGY Design
Client:
CIBA Pharmaceuticals
Manufacturer:
L.P. Thebault

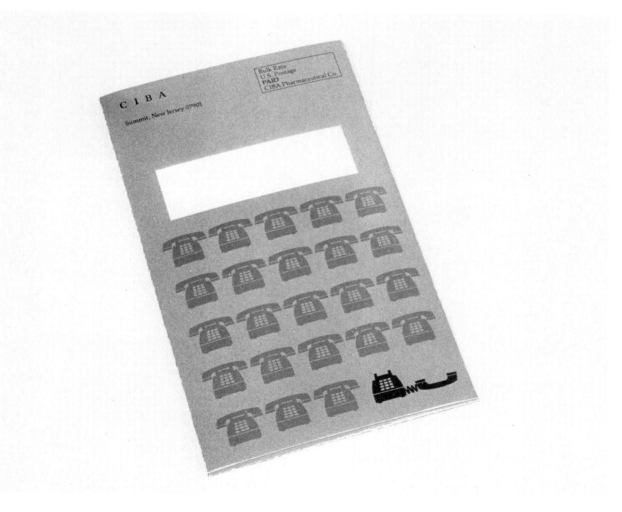

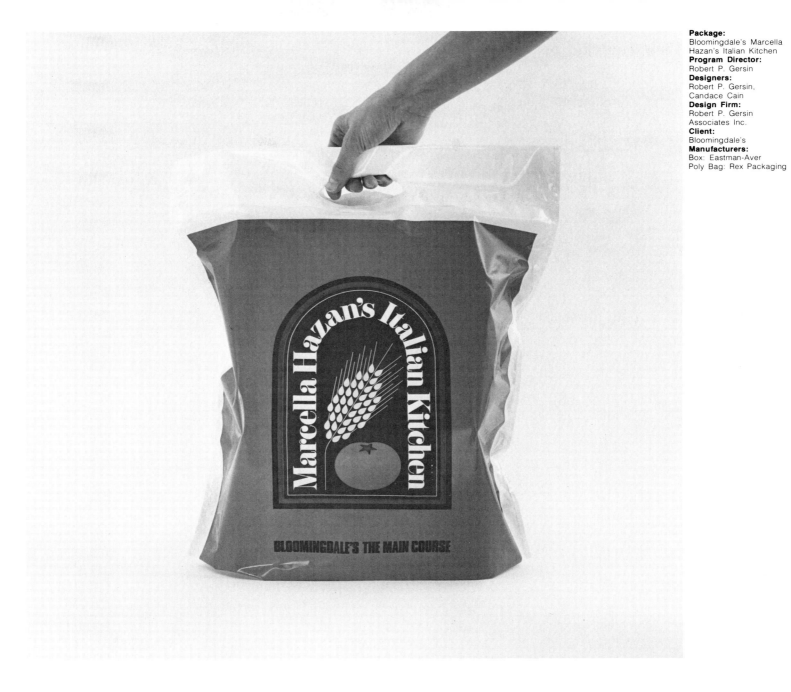

Package:
Bloomingdale's Marcella
Hazan's Italian Kitchen
Program Director:
Robert P. Gersin
Designers:
Robert P. Gersin,
Candace Cain
Design Firm: Robert P. Gersin
Associates Inc.
Client:
Bloomingdale's
Manufacturers:
Box: Eastman-Aver
Poly Bag: Rex Packaging

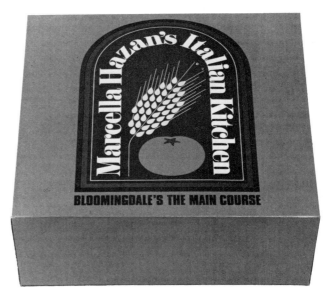

Communication Graphics

The design award program for Communication Graphics includes printed matter for special distribution that has been designed to promote, inform, or identify corporate, institutional, or individual clients. Works in the following categories are eligible: announcements and invitations; brochures and booklets; calendars and mailing cards; leaflets and folders; labels, letterheads, and logos; programs and posters; advertising portfolios, instructional manuals, and menus; catalogs and sales promotion materials; annual reports and house organs. Of the 2,028 entries this year, the jury selected 114 pieces by 71 designers.

Chairman

Jack Hough

Prior to forming Jack Hough Associates, Inc., of Stamford, Connecticut, in 1971, Jack Hough was a designer with IBM and *Fortune* magazine and assistant to the design director of CIBA Pharmaceuticals. He joined Xerox Corporation in 1962 and formed its corporate design department; in 1968 he became director of communications for the Xerox Education Group with responsibility for public relations, advertising, and design. He is currently Xerox Corporation's design consultant for its corporate identification and design programs. Jack Hough received his BFA degree from the Massachusetts College of Art and his MFA from the Yale University School of Art and Architecture.

Jury

Samuel Antupit

Both as executive art director of Book-of-the-Month Club and as proprietor of The Cycling Frog Press, Samuel Antupit is actively engaged in editorial design. He began his professional career as an assistant art director at *Harper's Bazaar*, at *Show* magazine, and later at Condé Nast Publications where he designed for *Vogue, Glamour, House & Garden,* and *Mademoiselle.* He also designed the *New York Review of Books, Foreign Policy,* and *Art in America.* He was art director of *Esquire* from 1963 to 1969 and briefly again in 1977. His firm Antupit & Others serves as consultant and designer for book and magazine publishers, record companies, and corporate publications.

Wilburn Bonnell, III

A partner in Bonnell & Crosby, with offices in New York and Chicago, Wilburn Bonnell studied at the University of Illinois, graduating cum laude with a BFA in industrial design. A native Midwesterner, he began his career with a small industrial design firm in Chicago before joining Container Corporation of America, where he became manager of design in 1974. In 1978 he joined J.C. Penney in New York as manager of design development-packaging.

Nicholas Fasciano

Designer and illustrator Nicholas Fasciano graduated from Cooper Union and was awarded a Fulbright Scholarship shortly thereafter. Since then his design and illustration work has included a broad range of projects—from typographic design to dimensional illustration and exhibits. His clients include Time Inc., ABC, CBS, NBC, Exxon, Mobil, Xerox, and IBM.

Katherine McCoy

Co-chairperson of the Department of Design at Cranbrook Academy of Art, Katherine McCoy is also a partner in McCoy & McCoy Associates of Bloomfield Hills, Michigan. Her firm offers consulting services in industrial design, interior design, and graphic design. Previously McCoy was a designer for Unimark International, has worked in corporate identity and advertising design, and has developed informational programs for feminist and community groups.

Massimo Vignelli

Born in Milan and trained at the Brera Academy of Art there and at the University of Venice School of Architecture, Massimo Vignelli and Lella, his wife, established the Lella and Massimo Vignelli Office of Design and Architecture in Milan in 1960. He was a co-founder of Unimark International in 1965. Since 1971 he has been president of Vignelli Associates in New York, which has liaison offices in Paris and Milan.

Review

Of all AIGA awards programs, Communication Graphics most fully demonstrates the importance of good clients in the creation of good graphic design. Instead of being concerned with their products through packaging or advertising design, Communication Graphics focuses specifically on the clients themselves, their procedures, their approaches, their personalities, and their successes.

Behind all the best design, of course, are good clients who sponsor the work: those people who, in increasing numbers, have worked together with graphic designers to make the design advances of the past two decades. Clients come to designers for organization and for the presentation of visual and verbal messages in quick and succinct ways. And it is that instinctive recognition of the problem and that ability to edit and organize visually that is the designer's craft.

So much higher is the overall quality of promotion and identity graphics, so much more broadly established is the basic language of the profession, that, the jury stated, what was considered good 10 years ago is now almost commonplace. As little as five years ago, many of the clients awarded by this year's Communication Graphics jury would not have had graphics of good enough quality to submit them, much less receive awards. The best of the work selected this year, conversely, would have been called fantastic 10 years ago. In addition, the work done outside New York City has improved dramatically. Whereas before it was generally imitative of the New York studios, today it is often considered better. And what was once aimed only at design-conscious people is now aimed at a broader audience—at everyone in the overall marketplace.

What this reveals is that the graphic environment in America is gradually being improved to offset negative aspects of an explosive proliferation of promotional graphics and signage. However unconscious the general public may be of that contribution by graphic designers, it is affected by the language, rules, and history of the profession in America. And this contribution is the major issue raised by these awards. Communication graphics—and its clients—can be given a large share of the credit for this improvement.

To outline their criteria for selection, the Communication Graphics jurors did not attempt to arrive at the usual ex post facto guidelines. Instead, they explained the critical method as a reversal of the creative process. A critic's process, they agreed, is first to respond emotionally to the finished solution—that is, he responds to the last step of the design process first. Then he goes backward and recreates the process—back to the original problem. "When it appears that the problem has been solved to your satisfaction," they said, "then the piece works."

The jurors analyzed their responses to final products. "It is curious," they mused, "how we are moved by trends, whether we like them or not. What motivates us? Why do we respond?" One juror answered: "I always look for something that strikes me with the wish that I had done that." Another added: ". . . or that you could never conceive of doing because it's beyond interpretation, idea, subject matter, or just form. Sometimes merely how the image or the color or type is manipulated is new enough to grab our attention."

The curious effects of style, however, provide the implicit recognition of good solutions to problems. And for that, the AIGA Communication Graphics awards were ac-

claimed. They are not "just a design show," but "design as solving a problem." The best designers solve problems like the best editors. They separate the different levels of information and present one piece of information at a time, sequentially.

Again, good clients were given much of the credit for good solutions, especially because they are in an unenviable position. Although designers have 20 to 30 years of experience in the visual arts, it was pointed out, clients with relatively little background in the field are expected to make judgments about what designers do. Therefore, when a client is willing and secure enough in his judgment to take a chance on a design without going off to consult five other people, then he has the attitude of a good client. But that is rare, as the jury stated: "After all, how many corporations hire good architects–or even good presidents?"

The courage of clients to produce innovative designs was acclaimed by one juror in stating his criteria: "These awards should not be objective. That is the reason why exhibitions fail to be interesting. Usually the quirky things end up on the floor and they should end up on the wall for exhibition. Our awards should be strongly subjective." Anything given an award should demonstrate not only the strength of designers' imaginations, but also how very much aware the corporate world is of the benefits of good design.

Annual Reports
Of all the categories of promotional and identity graphics considered, annual reports were thought to be the best submitted. The Charles Stark Draper Laboratory's report was praised because "It is refreshing to see that someone can still do an annual report with illustration. The use of paintings and drawings in annual reports is entirely overlooked as an area that could lend a great deal of variety to annual reports. Corporations don't feel that that's really reporting."

Naturally, the jurors discussed the sameness of annual reports–their 8½ × 11 format, the four-color bleed photographs "of our happy employees"–but they admitted the probability that stockholders gain secret pleasure in the success implied by thick stock, glossy pages, and four-color, even though those same stockholders may say they are happy when their corporations conserve money by not doing so elaborate an annual report. However, the jurors found the two-color reports that they selected to be more interesting because they varied this formula.

Two reports especially provoked discussion–the Technicolor, Inc. report, which has bands of calibration along the vertical edge to recall a soundtrack, and the Morgan Stanley report, which was said to have among the best charts of the past 15 years.

Playing gadfly to the profession, one of the jurors said that in an annual report, the graphics are a questionable asset. After all, he noted, accountants do not care what the report looks like. They flip through all the graphic designer's work and go right to the charts and the numbers and say: "Now that's a corporation." By contrast, he observed, graphic designers go through and say: "Look at that–3 points of letterspacing with the Garamond. Now that's a corporation."

What both viewpoints demonstrated was that the totality of an annual report reveals its corporation and indicates whether it is attentive to details or helter-skelter, whether it is sophisticated, or whether it has humanistic concerns. And graphics, as the corporate world has come to see, tell an important part of this story.

Letterheads and Self-Promotion
By contrast, the jury found the letterhead designs and self-promotional graphics interesting because the standards are so different from other corporate graphics and from each other within this subcategory of work. Designers' letterheads predominated, even though they represent a small fraction of all the promotional graphics that are designed.

These designs were called "terrific, but not believable . . . like design-school problems in which the level of work is good but the problem is nonexistent." The reason is that they don't have to solve anyone's problems but the designer's.

Calendars
The remarkably high quality of reproduction on the calendars–especially calendars produced by four-color separators and by printers for self-promotion–elicited enthusiastic comments. "It is just amazing what they are able to do," one juror said. "It would be just terrific if we could get that kind of color separation from our printers when we wanted it for one of our own jobs."

Logos and Symbols
Logos and corporate symbols have been a major part of designers' lives since around 1960, when the first of the new abstract symbols began to appear. Yet in the past 20 years, so many of these devices have been created–sometimes needlessly, many think–that designers have recently shown signs of dissatisfaction with them, if not boredom. The jurors wanted to know more about the problems that the logo and symbol designs were intended to solve. They also questioned whether, in this day of ubiquitous symbols, the category was a valid one or whether it should be discontinued so as to discourage the design of corporate symbols. Leaving a perfectly adequate symbol alone was acclaimed as a good thing, instead of redesigning it merely to update it.

Still, the submission of logos and symbols was said to portray "the highest level I've ever seen," one juror exclaimed. "We passed by things that were very good in order to choose the really knockout designs."

Newsletters and Manuals
Some inexpensive but well-designed newsletters known to the jurors were not submitted, since many people think, erroneously, the AIGA competitions are only for high-budget and high-style newsletters. Of the manuals, there were many that were extremely well thought out, consistent, and creative. One juror said that corporate design manuals were an indication of the best work and the highest goals of graphic designers, since he saw the designer's role "as helping to make graphics something that anyone can do, as opposed to making it an art form."

Finally, it was agreed that high budget had not been one of the jury's criteria. It was the thought process–not high design–that added vigor to the winning designs. And the time taken by the jurors themselves in their critical process was proportionate to the thought time taken by the designers in creating the pieces. "It was easy to move along through the rather light, thin designs," it was said, "and it took longer to find out what the challenging designs were about and what the designers were dealing with." In that statement, once again, the jury reiterated the analogy of the critical process as being a reversal of the creative process.

Brochure:
CCA/Recycled Paperboard
Division
Art Director:
Joseph Hutchcroft
Designers:
Bill Bonnell,
Joseph Hutchcroft
Photographers:
Wayne Sorce, Rudy Jann,
Charles Shotwell
Design Firm:
Container Corporation
of America
Publisher:
Container Corporation
of America
Typographer:
Ryder Types, Inc.
Printer:
Accurate Silkscreen,
Rohner Printing Co.

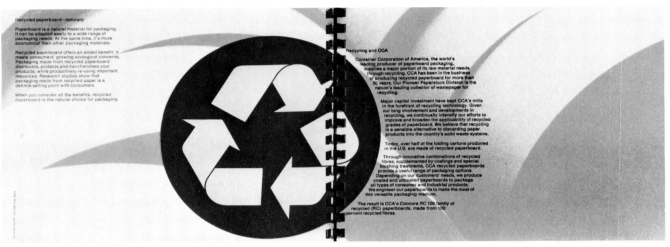

Annual Report:
The Charles Stark Draper
Laboratory, Inc., 1979
Annual Report
Design Director:
Robert L. Steinle, CSDL
Art Director:
Robert Cipriani
Designer:
Robert Cipriani
Design Firm:
Gunn Associates
Publisher:
The Charles Stark Draper
Laboratory, Inc.
Typographer:
Typographic House
Printer:
Recording & Statistical

Catalogue:
Esprit
Art Director:
John Casado
Creative Director:
Gwen Mazer
Designer:
John Casado
Photographer:
Arthur Elgort
Design Firm:
Casado Design
Publisher:
Esprit de Corp
Typographer:
Reprotype
Printer:
Westwood Press

Catalogue:
Esprit
Art Director:
John Casado
Creative Director:
Gwen Mazer
Designer:
John Casado
Photographer:
Oliviero Toscani
Design Firm:
Casado Design
Publisher:
Esprit de Corp
Typographer:
Reprotype
Printer:
Freemont Litho.

Promotional Literature:
801 Travis
Art Director:
Charles Hively
Designer:
Charles Hively
Artist:
Daniel Schwartz
Design Firm:
Metzdorf Advertising Agency
Publisher:
Ragsdale Development
Corp.
Printer:
Hurst Printing Co.

Promotional Literature:
Man and His Machines
Art Director:
Jack Hough
Designer:
Thomas D. Morin
Artists:
Nick Fasciano,
R.O. Blechman
Photographer:
Gregg Booth
Design Firm:
Jack Hough Assoc.
Publisher:
Champion International Corp.
Typographer:
Pastore DePamphilis
Rampone, Inc.
Printer:
The Hennegan Co.

Petroleum Processing: A Conservation Science

Crude oil is rapidly becoming too costly to convert into marginal-value products, or to refine at traditional levels of efficiency. Within our lifetimes, petroleum may also become too scarce.

Hence, much of Mobil's research has focused on refining technology, dramatically improving both the quality and yield of products from crude oil. Petroleum process technology is also being successfully applied to alternative energy sources.

Mobil has traditionally been a recognized leader in petroleum process technology. Cracking catalysts developed by Mobil are used worldwide in oil refining by many companies. In the U.S., Mobil produces 83 barrels of gasoline and distillates from each 100 barrels of crude, compared with an industry average of 79 barrels.

Coal and nuclear energy are expected to displace heavy oils for such uses as industrial fuel and electricity generation. With that in mind, Mobil researchers are working to upgrade the heavier portions of the petroleum barrel to gasoline, which presently has no feasible substitutes for use in internal combustion engines.

Photo Right: Major research and development projects are directed toward developing new fuels and lubricants for transportation.

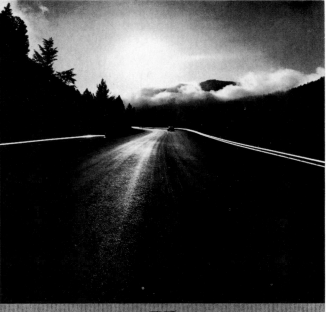

Promotional Literature:
Research and Development at Mobil
Art Director:
Bob Pellegrini
Designers:
Bob Pellegrini,
Madelene Lees
Artists:
Jay Maisel
Camille Vickers
Design Firm:
Pellegrini & Kaestle, Inc.
Client:
Mobil Oil Corp.
Typographer:
Haber Typographers, Inc.
Printer:
Crafton Graphic Co., Inc.

Crop Yield Enhancement

The next major step in increasing mankind's food production will come, Mobil scientists believe, from chemical modification of plant metabolism itself.

At Mobil Chemical Company, an interdisciplinary team is trying to enhance crop yields by increasing the productivity of plant bio- systems. Most food plants, the researchers believe, have made less than optimal evolutionary adaptations to an oxygen-rich environment. As a consequence, they grow more slowly and less abundantly than they could. Just as pharmaceuticals intervene in the biochemistry of the human body, researchers believe that plants can be chemically induced to overcome environmental obstacles to their growth. They seek the plant "medicines" that will result in faster, more abundant plant growth.

Diagram of Chloroplast Mechanism

a sun-light energy
b water H_2O
c phosphate
d carbon dioxide CO_2
e chlorophyll
f hydrogen
g oxygen O_2
h ATP
i cellulose, sugar, lipid
j starch
k sugar phosphate

cell wall
chloroplast
nucleus with nucleolus
mitochondrion

plant cell

Greeting Card:
Time Keeping by Sun and Shadow
Program Director:
Robert P. Gersin
Designers:
Robert P. Gersin,
Pam Virgilio
Design Firm:
Robert P. Gersin Assoc., Inc.
Publisher:
Robert P. Gersin Assoc., Inc.
Typographer:
Cardinal Type Service
Printer:
Circle Press

Time Keeping by Sun and Shadow:
Position gnomon vertically.
Direct arrow North.
Shadow's edge will indicate daylight hour.
See back for latitude adjustments.

↑ N

Robert P. Gersin Associates Inc New York NY · Latitude 40.45N

top
Tokyo, Japan
Los Angeles, California
Houston, Texas
Atlanta, Georgia
Latitude 30° N Raise top edge 3.5 cm. from horizontal surface.

Honolulu, Hawaii
Mexico City, Mexico
Rio de Janeiro, Brazil
Miami, Florida
Latitude 20° N Raise top edge 7 cm. from horizontal surface.

Latitude 40° N Card lies flat on horizontal surface.
San Francisco, California
Denver, Colorado
Chicago, Illinois
New York, New York
Ibiza, Spain

Latitude 60° N Raise bottom edge 7 cm. from horizontal surface.
Helsinki, Finland

Latitude 50° N Raise bottom edge 3.5 cm. from horizontal surface.
Seattle, Washington
London, England
Zurich, Switzerland
Frankfurt, Germany
bottom

Christmas Greeting:
Skidmore Sahratian
Art Director:
Al Evans
Designer:
Al Evans
Artists:
33 Staff Artists
Design Firm:
Skidmore Sahratian, Inc.
Publisher:
Skidmore Sahratian, Inc.
Typographer:
Marino & Marino
Printer:
Signet Printing Co.

KIDMORE SAHRATIAN HAS TRADITIONALLY PRODUCED A SPECIAL CHRISTMAS GREETING EACH YEAR FOR ITS CLIENTS AND FRIENDS. NEVER BEFORE HAS THE EFFORT BEEN AS AMBITIOUS AS THIS, HOWEVER. THIRTY-THREE ARTISTS PLUS THE CONTRIBUTIONS OF MANY OTHERS WERE REQUIRED TO ASSEMBLE THIS COLLECTION OF LITTLE KNOWN ASPECTS OF THE HOLIDAY CELEBRATION: THE RITUALS, LEGENDS, TRADITIONS, CUSTOMS AND ATTITUDES FROM THE STONE AGE TO THE PRESENT, THAT HAVE LED US TO CELEBRATE CHRISTMAS THE WAY WE DO. WHAT FOLLOWS ARE FRAGMENTS FROM A VAST ARRAY OF MATERIAL THAT INTRIGUED US. WE HOPE YOU ENJOY THE RESULT THIS YEAR.

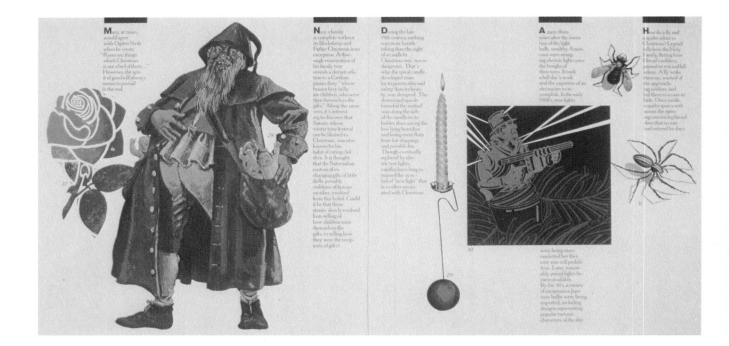

M V P awards 1979
Most Valuable Promotion

Promotional Literature:
MVP Awards, Most Valuable Promotion Awards
Art Director:
Frank Rupp
Designer:
Russell Tatro
Photographer:
Tom Wittbold
Design Firm:
Pepsi-Cola Graphic Arts Dept.
Client:
Pepsi-Cola Co.
Typographer:
Production Typographers, Inc.
Printer:
Rapoport Printing

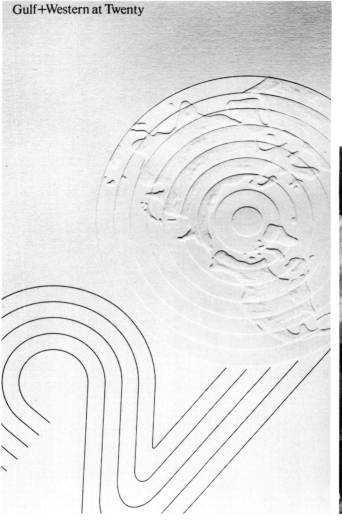

Gulf+Western at Twenty

Promotional Literature:
Gulf and Western at Twenty
Art Director:
Sheldon Seidler
Designer:
Irene Liberman
Artist:
Various
Design Firm:
Sheldon Seidler, Inc.
Publisher:
Gulf and Western Co.
Typographer:
Tri-Arts Press
Printer:
Detroy-Bergen

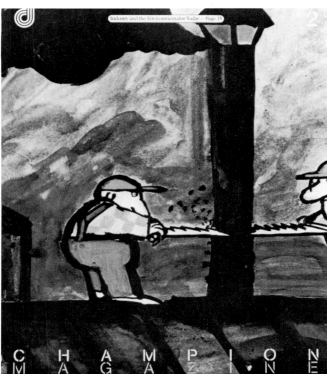

House Organ:
Champion Magazine #2
Editor:
David R. Brown
Designer:
Richard Hess
Photographers:
Various
Design Firm:
Richard Hess, Inc.
Publisher:
Champion International Corp.
Typographer:
Lettick Typographic, Inc.
Printer:
Davis-Delaney-Arrow, Inc.

Stationery:
Patrice Pallone
Art Director:
Robert Meyer
Designer:
Robert Meyer
Design Firm:
Robert Meyer Design
Client:
Patrice Pallone
Typographer:
Rochester Mono/Headlin
Printer:
Ayer & Streb

Stationery:
Dan Lynch
Private Investigator
Art Director:
Harry Murphy
Designer:
Harry Murphy
Artist:
Sheldon Lewis
Design Firm:
Harry Murphy & Friends
Publisher:
Dan Lynch

Promotional Literature:
100 Years of Creativity in America
Art Director:
The Burdick Group
Designer:
Michael Manwaring
Design Firm:
The Office of Michael Manwaring
Publisher:
Chevron Oil Co.
Typographer:
Omnicomp
Printer:
Phelps/Schaefer

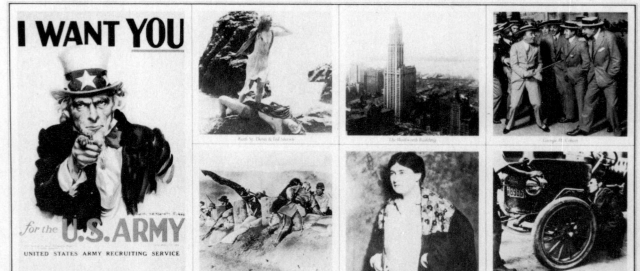

C H A M P I O N
M A G A Z I N E

House Organ:
Champion Magazine #4
Editor:
David R. Brown
Designer:
Richard Hess
Photographers:
Various
Design Firm:
Richard Hess, Inc.
Publisher:
Champion International Corp.
Typographer:
Lettick Typographic, Inc.
Printer:
S.D. Scott Printing Co., Inc.

Promotional Literature:
The Enveloping Manual
Art Director:
James Miho
Designer:
James Miho
Artist:
Marge Guarcello
Design Firm:
Miho, Inc.
Publisher:
Champion International Corp
Typographer:
Tri-Arts Press, Inc.
Printer:
Young & Klein, Inc.

"Neither snow nor rain or heat..."

Part and parcel with the evolution of the envelope went the development of workable postal systems. Now the Post Office, like the paper envelope itself, is something we take for granted, but it too was a latecomer to history. It was not by accident that national postal systems and paper envelopes entered the scene about the same time, for each influenced the other in a synergistic relationship.

Stationery:
Kit and Linda Hinrichs
Art Directors:
Kit Hinrichs, Linda Hinrichs
Designer:
Kit Hinrichs, Linda Hinrichs
Design Firm:
Jonson Pedersen Hinrichs &
Shakery, Inc.
Typographer:
Omnicomp

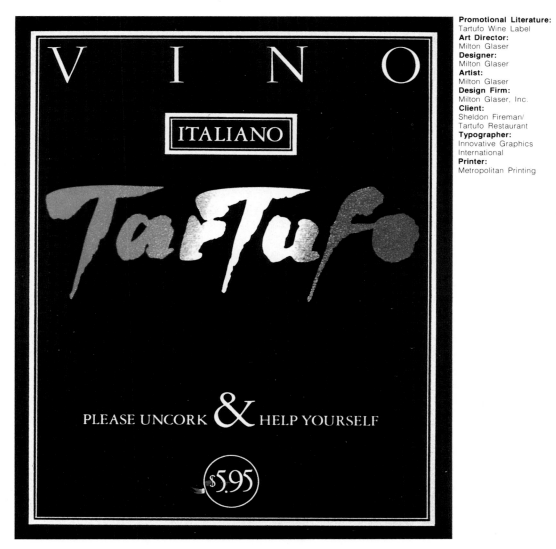

Promotional Literature:
Tartufo Wine Label
Art Director:
Milton Glaser
Designer:
Milton Glaser
Artist:
Milton Glaser
Design Firm:
Milton Glaser, Inc.
Client:
Sheldon Fireman/
Tartufo Restaurant
Typographer:
Innovative Graphics
International
Printer:
Metropolitan Printing

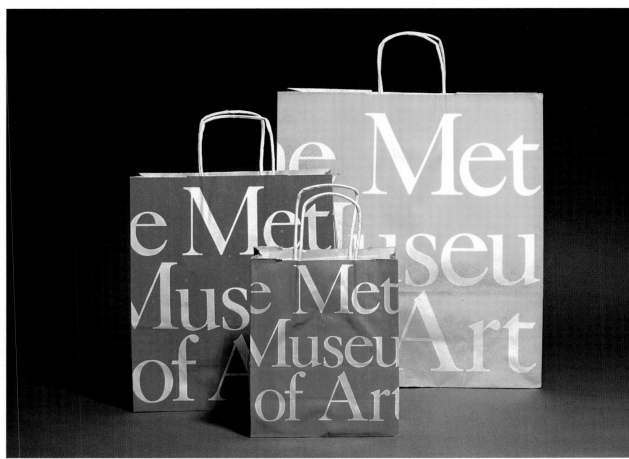

Shopping Bags:
The Metropolitan
Museum of Art
Art Director:
Rudolph de Harak
Designer:
Rudolph de Harak
Design Firm:
Rudolph de Harak &
Associates, Inc.
Publisher:
The Metropolitan
Museum of Art
Typography:
Composet Typographers
Manufacturer:
Equitable Bag Co., Inc.

Brochure:
A Teacher's Guide to NOVA
Art Directors:
Tom Sumida,
Christopher Pullman
Designer:
Tom Sumida
Artist:
Mark Fisher
Design Firm:
WGBH Design
Publisher:
WGBH
Typographer:
The Type Shop
Printer:
Clark-Franklin-Kingston Press

A Teacher's
Guide
to NOVA

Prepared in cooperation with the National Science Teachers Association, and the National Council for the Social Studies.

Winter 1980. This guide is made possible by grants from TRW Inc. and the International Paper Company Foundation.

Poster:
Quebec Canada
Art Director:
Ernst Roch
Designer:
Ernst Roch
Design Firm:
Roch Design
Publisher:
Imasco Ltd.
Printer:
Up-North Ltd.

Logo:
"Brands"
Art Director:
Harry Murphy
Designer:
Harry Murphy
Artist:
Warren Welter
Design Firm:
Harry Murphy & Friends
Client:
Brands Stores

BⓇANDS®

Logo:
Young Presidents'
Organization Tape Program
Art Director:
Bruce Withers
Designer:
Bruce Withers
Artist:
Bruce Withers
Design Firm:
Bruce Withers Inc.
Publisher:
Young Presidents,
Organizations Inc.
Printer:
Crafton Graphic Co., Inc.

Logo:
Minnesota Power &
Light Co.
Art Directors:
John Greiner
Designer:
John Greiner
Design Firm:
John Greiner &
Assoc.
Client:
Hewitt Associates
Typographer:
Lakeshore Typographers

Logo and Stationery:
Street Shoes
Art Director:
Dan Friedman
Designer:
Dan Friedman
Artist:
Dan Friedman
Design Firm:
Pentagram Design
Publishers:
Street Shoes
Typographer:
Expertype
Printer:
SBS Graphics

Promotional Item:
Life Kaleidoscope
Art Director:
Gilbert Lesser
Designer:
Gilbert Lesser
Design Firm:
Life Magazine
Publisher:
Time, Inc.
Typographer:
Images
Printer:
Dalcon, React

Doiron's Janitorial &
Maintenance Company

Bill Grange
Associate

Invoice

91 Taylor Drive
Fairfax, Ca. 94930

415 454-1119
415 332-0730

To

Janitorial $

Maintenance

Other

Date

Total Current Month $

Previous Balance $

Total Amount Due $

Stationery:
Doiron's/Invoice
Art Director:
Harry Murphy
Designer:
Harry Murphy
Artist:
Sheldon Lewis
Design Firm:
Harry Murphy & Friends
Client:
Doiron's Janitorial &
Maintenance Co.

Stationery:
Hixo "Seal of Approval"
Art Director:
Mike Hicks
Designer:
Mike Hicks
Artist:
Janice Ashford
Design Firm:
Hixo, Inc.
Publisher:
Hixo, Inc.
Printer:
Capitol Rubber Stamp
Service

Stationery:
Hixo, "Past Due"
Art Director:
Mike Hicks
Designer:
Mike Hicks
Artist:
Janice Ashford
Design Firm:
Hixo, Inc.
Publisher:
Hixo, Inc.
Printer:
Capitol Rubber Stamp
Service

Stationery:
Connolly, Starr & Ames
Interior Design and Space
Planning
Art Director:
Harry Murphy
Designers:
Harry Murphy, Stanton Klose
Artist:
Stanton Klose
Design Firm:
Harry Murphy & Friends
Client:
Connolly, Starr & Ames

May your Christmas be white.
And your holidays merry and bright.

Richards, Sullivan, Brock and Associates

Christmas Card:
Richards, Sullivan,
Brock & Assoc.
Art Director:
Richards, Sullivan,
Brock & Assoc.
Designer:
Dick Mitchell
Design Firm:
Richards, Sullivan,
Brock & Assoc.
Publisher:
Richards, Sullivan,
Brock & Assoc.
Typographer:
Chiles & Chiles
Printer:
Richards, Sullivan,
Brock & Assoc.

Poster:
Bluegrass Music Festival of
the United States
Art Director:
Dan Stewart
Designer:
Pam Gregory
Design Firm:
Designers Stewart & Winner
Publisher:
Bluegrass Music
Typographer:
Lettergraphics
Printer:
Fetter Printing

Folder:
Good Scouts
Art Directors:
Jack Summerford,
Bart Forbes
Designer:
Jack Summerford
Artist:
Various
Design Firm:
Jack Summerford Design
Publisher:
Good Scouts
Typographer:
TypoGraphics, Ltd.
Printer:
Ussery Printing

We've already helped some of Dallas' best-known art directors, photographers and illustrators.

Be prepared. Give us a call. We'd like to do a good deed for you too.

Invitation:
The Work of Lella and
Massimo Vignelli at Parsons
School of Design
Art Director:
Massimo Vignelli
Designers:
Lella and Massimo Vignelli
Design Firm:
Vignelli Associates
Typographer:
Pastore DePamphilis
Rampone, Inc.
Printer:
Izmo Productions Inc.

Announcement:
Million Dollar Baby
Art Director:
Gilbert Lesser
Design Firm:
Life Magazine
Publisher:
Time Inc.
Typographer:
Images
Printer:
Nicholas David

Invitation:
"Come celebrate. We're
expanding."
Art Director:
Phil Gips
Designer:
Stephen Fabrizio
Design Firm:
Gips + Balkind +
Associates
Publisher:
Gips + Balkind +
Associates
Typographer:
Innovative Graphics
International
Printer:
Crafton Graphic Co., Inc.

Announcement:
Willi Kunz
Designer:
Willi Kunz
Design Firm:
Willi Kunz Assoc.
Publisher:
Willi Kunz Assoc.
Typographer:
S. Bolhack, Inc.
Printer:
Crest Litho., Inc.

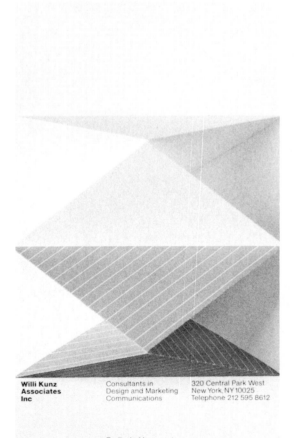

General Dentistry for Adults & Children — John R. Sechena D.D.S. — Aurora Village Medical Center — 1207 N. 200th Suite 214 — Seattle, Washington 98133 — Phone: Off. 542-6129 Res. 783-4325 — Office Hours by Appointment

MERRY CHRISTMAS

AND A HAPPY NEW YEAR
THE RICHARDS GROUP 1979

Stationery:
John R. Sechena, D.D.S.
Art Director:
Jack R. Anderson
Designer:
Jack R. Anderson
Artist:
Jack R. Anderson
Design Firm:
TRA
Client:
John R. Sechena, D.D.S.
Typographer:
Thomas & Kennedy
Printer:
Litho Craft, Inc.

Christmas Card:
Richards Group
Art Director:
Steve Miller
Designer:
Steve Miller
Artist:
Steve Miller
Design Firm:
Richards, Sullivan, Brock & Assoc.
Client:
Richards Group
Typographer:
Chiles & Chiles
Printer:
Heritage Press

Annual Report:
United Guaranty Corporation
1978 Annual Report
Art Director:
Bob Newman
Designer:
Bob Newman
Photographer:
James Broderick
Design Firm:
Hill and Knowlton
Publisher:
United Guaranty Corp.
Typographer:
Chelsea Typographers
Printer:
Crafton Graphic Co., Inc.

Program Guide:
Evening at Symphony
Art Directors:
Douglass Scott,
Christopher Pullman
Designer:
Douglass Scott
Design Firm:
WGBH Design
Publisher:
WGBH
Typographer:
Zee Ann MacDonald
Printer:
Clark-Franklin-Kingston Press

Stationery:
Designer Installation
Services, Inc.
Art Direction:
Katherine McCoy
Designer:
Robert Monize
Design Firm:
McCoy & McCoy
Client:
Designer Installation
Services, Inc.
Typographer:
Typehouse, Inc.
Printer:
Signet, Inc.

Poster:
Cranbrook/Downtown
Detroit Artists
Art Director:
Katherine McCoy
Designer:
James Houf
Artist:
Leo Patrick Binns
Design Firm:
Cranbrook Design Dept.
Client:
Cranbrook Academy of
Art Museum
Typographer:
Typehouse, Inc.
Printer:
Signet, Inc.

Promotional Literature:
At Cranbrook/Downtown
Detroit
Art Director:
Katherine McCoy
Designer:
James Houp
Photographer:
Leo Patrick Binns
Design Firm:
McCoy & McCoy
Publisher:
Cranbrook Academy of Art
Museum
Typographer:
Lettergraphics, Inc.
Printer:
Signet, Inc.

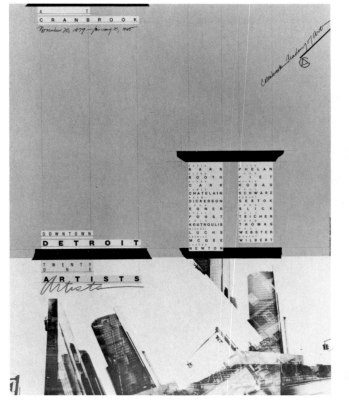

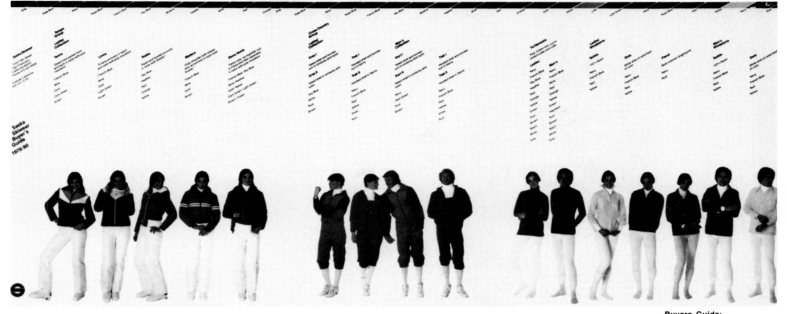

Buyers Guide:
Saska Skiwear
Art Directors:
Richard Burns, Sally Smith
Designer:
Sally Smith
Photographer:
Dennis Gray
Design Firm:
The GNU Group
Client:
Saska Skiwear
Typographer:
CTS
Printer:
Continental Printers

47 Maiden Lane • San Francisco, California 94108 • (415) 398-4707 • Member American Gem Society

Stationery:
Theodora
Art Director:
John Casado
Designer:
John Casado
Design Firm:
Casado Design
Client:
Theodora
Typographer:
Reprotype
Printer:
House of Printing

Program:
Cincinnati Symphony
Orchestra
Art Director:
Mike Zender
Designer:
Mike Zender
Artists:
D. Steinbrunner,
W. Gregory Wolfe
Design Firm:
Zender & Associates, Inc.
Publisher:
Cincinnati Symphony
Orchestra
Typographer:
Craftsman Type, Inc.
Printer:
Young & Klein, Inc.

Award for Excellence:
Performance of American
Music
Art Director:
Dan Friedman
Designer:
Dan Friedman
Artist:
Dan Friedman
Design Firm:
Pentagram Design
Publisher:
John F. Kennedy Center/
Rockefeller Foundation
International Competition
Typographer:
Expertype
Printers:
Lassiter Meisel, Lehman
Brothers, Inc.

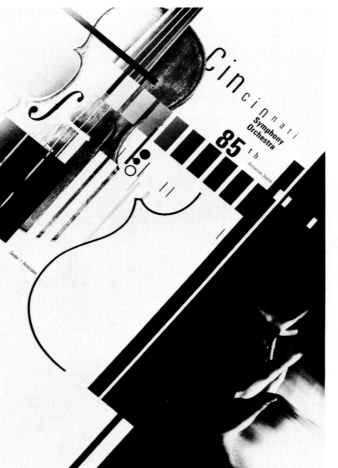

Poster:
Stravinsky Firebird Suite
Art Director:
Nancy Skolos
Designer:
Nancy Skolos
Artist:
Thomas Wedell
Design Firm:
Skolos, Wedell and Raynor
Publisher:
Yale Symphony Orchestra
Typographer:
Nancy Skolos
Printer:
Reynolds-DeWalt Printing

AGNES DENES 1968·1980

Retrospective Exhibition
January 7-26, 1980

Hayden Gallery and Hayden Corridor Gallery
Massachusetts Institute of Technology
Hayden Memorial Library Building
160 Memorial Drive
Cambridge, Massachusetts 02139

Lecture by the Artist
January 9, 8 pm, Room 9-150

Public Reception for the Artist
January 11, 5-7 pm, Hayden Gallery

Informal Discussion with the Artist
January 14, 7 pm, Hayden Gallery

Artist-in-Residency in collaboration with
the MIT Creative Photography Laboratory
January 7-15

Gallery Hours 10-4 daily
6-9 Wednesday evening
Telephone
Gallery 253-4680, Office, 253-4400

Organized by the MIT Committee on
the Visual Arts with the generous support
of the National Endowment for the Arts,
a Federal agency, Washington, DC

Poster:
Agnes Denes 1968–1980
Designer:
Jacqueline S. Casey
Design Firm:
MIT Design Services
Client:
Massachusetts Institute
of Technology

Whitney Museum of American Art
50th Anniversary 1930–1980

Concentrations

A Series of Exhibitions Sponsored by
Champion International Corporation

Maurice B. Prendergast
January 9–March 2, 1980

Gaston Lachaise
March 5–April 27

John Sloan
April 30–June 22

Charles Burchfield
June 25–August 17

Stuart Davis
August 20–October 12

Charles Sheeler
October 15–December 7

Ad Reinhardt
December 10–February 1

Alexander Calder
February 4–March 29, 1981

Poster:
Concentrations
**Creative Consultant/
Art Director:**
Edward Russell, Jr.
Designer:
Tomoko Miho
Artist:
Alexander Calder
Design Firm:
Miho, Inc.
Client:
Champion International
Corp.
Publisher:
Whitney Museum of
American Art
Printer:
The Hennegan Company

Calendar:
1980
Art Director:
Albert Leutwyler
Designers:
Grace Kao, Kelly Kao
Design Firm:
Leutwyler Associates, Inc.
Publisher:
Albert Leutwyler
Typographer:
Cardinal Type Service
Printer:
Litho Concern, Inc.

Poster:
The United States Speed
Skating Team
Art Directors:
Bob Pellegrini,
David Kaestle
Designers:
Bob Pellegrini,
Ted Williams
Photographer:
Phil Leonian
Design Firm:
Pellegrini and Kaestle, Inc.
Publisher:
Champion International Corp.
Printer:
Sanders Printing Corp.

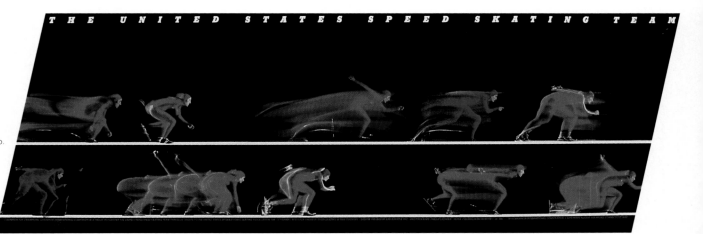

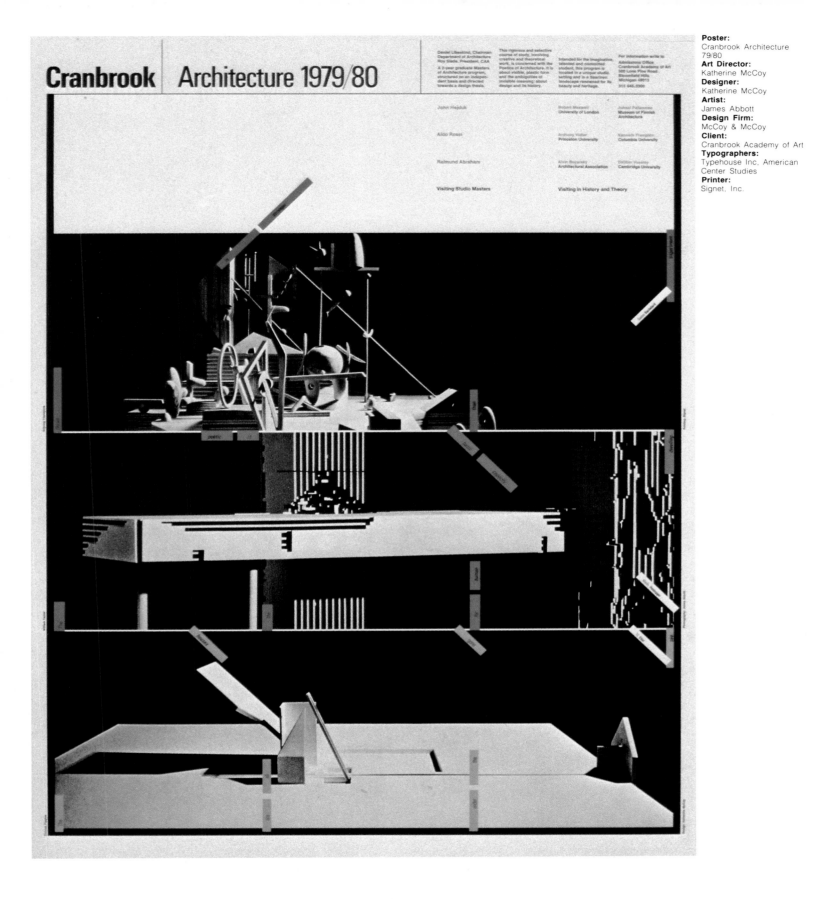

Poster:
Cranbrook Architecture
79/80
Art Director:
Katherine McCoy
Designer:
Katherine McCoy
Artist:
James Abbott
Design Firm:
McCoy & McCoy
Client:
Cranbrook Academy of Art
Typographers:
Typehouse Inc, American
Center Studies
Printer:
Signet, Inc.

Poster:
Books
Art Directors:
Nathan Felde,
Julius Friedman
Designer:
Nathan Felde
Design Firm:
Implement Ltd.
Publisher:
Kentucky Arts Commission
Typographer:
Weimer Typesetting Co.
Printer:
Pinaire Lithography Inc.

Make, Measure, Glue, Cut, Line, Label, Cover, Sew, Square, Press, Paste, Mark, Attach, Fold, Mitre, Collate, and Finish Handbound Books

Poster:
Fibers '78
Art Director:
Dan Lynch
Designer:
Dan Lynch
Artist:
Dan Lynch
Design Firm:
Richards, Sullivan, Brock &
Assoc.
Client:
Dallas Handweavers Guild
Typographer:
JCS
Printer:
Williamson Printing

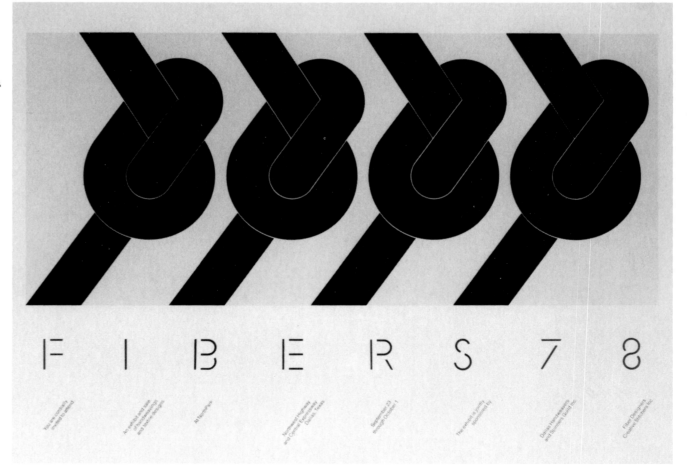

FIBERS 78

Helvetica

Poster:
Helvetica
Art Director:
Jack Summerford
Designer:
Jack Summerford
Design Firm:
Jack Summerford Design
Publisher:
Typographics
Typographer:
Typographics
Printer:
Newman/Melton

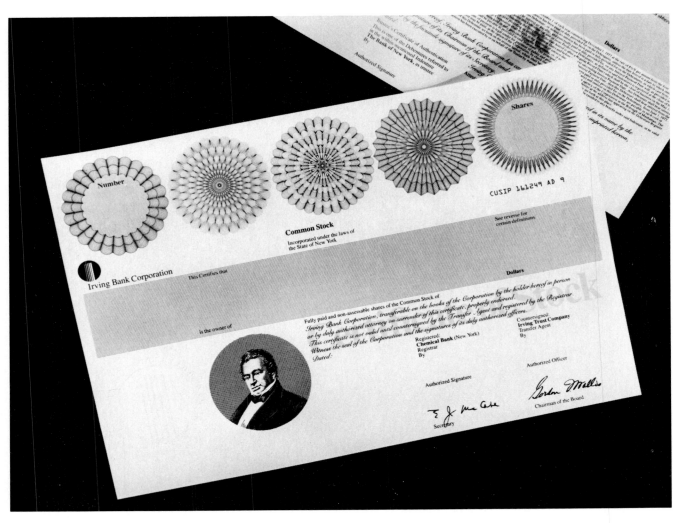

Stock Certificate:
Irving Trust Company
Design Director:
Eugene J. Grossman
Designers:
Vernon Ford, Sandra Meyer
Design Firm:
Anspach Grossman
Portugal, Inc.
Client:
Irving Trust Co.

Poster:
Thrillers from the Forties
Art Directors:
Julius Friedman,
Nathan Felde
Designer:
Julius Freidman
Artist:
John Beckman
Design Firm:
Implement Ltd.
Publisher:
D.W. Griffith Film Center
Typographer:
Letter Graphics
Printer:
Pinaire Lithography, Inc.

Poster:
Park City Conference
Art Director:
Don Weller
Designer:
Don Weller
Artist:
Stan Caplan
Design Firm:
The Weller Institute for the
Cure of Design
Publisher:
Park City Design
Conference 1980
Typographer:
Alpha Graphics

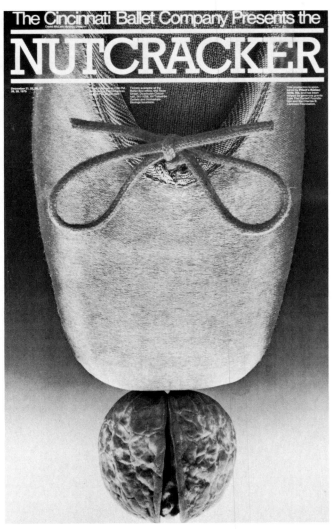

Poster:
Art Expo New York 1979
Art Director:
Ivan Chermayeff
Designer:
Ivan Chermayeff
Design Firm:
Chermayeff & Geismar
Assoc.
Publisher:
Art International
Printer:
Crafton Graphic Co., Inc.

Poster:
Nutcracker
Art Director:
Dan Bittman
Designer:
Dan Bittman
Photographer:
Jeff Kauck
Design Firm:
Sive Associates
Publisher:
Cincinnati Ballet Co.
Typographer:
Cincinnati Typesetting
Printer:
Westerman Printing

Poster:
Thom Brown/"The
Photographer and the
Landscape. . ."
Art Director:
Hans-Ulrich Allemann
Designer:
Hans-Ulrich Allemann
Publisher:
Philadelphia College of Art
Typographer:
Hans-Ulrich Allemann
Printer:
Smith, MacVaugh & Hodges,
Inc.

Poster:
Two Views/Peter Berg,
Two Sculptures/Ed Rothfarb
Designer:
Jacqueline S. Casey
Design Firm:
MIT Design Services
Client:
Massachusetts Institute
of Technology

Calendar:
S.D. Scott Calendar Series
Art Director:
Richard Danne
Designer:
Richard Danne
Photographers:
Paul Marco, Eric Meola,
Robert Colton,
Thomas Francisco,
John Paul Endress,
Steven Langerman
Design Firm:
Danne & Blackburn, Inc.
Client:
S.D. Scott Printing Co., Inc
Typographer:
Typographic Images
Printer:
S.D. Scott Printing Co., Inc

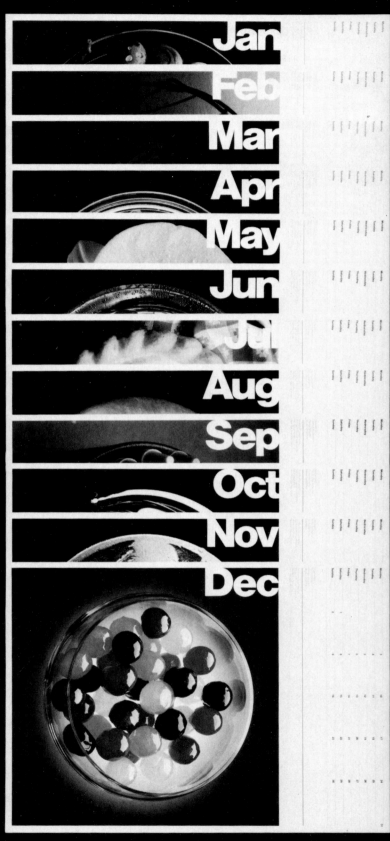

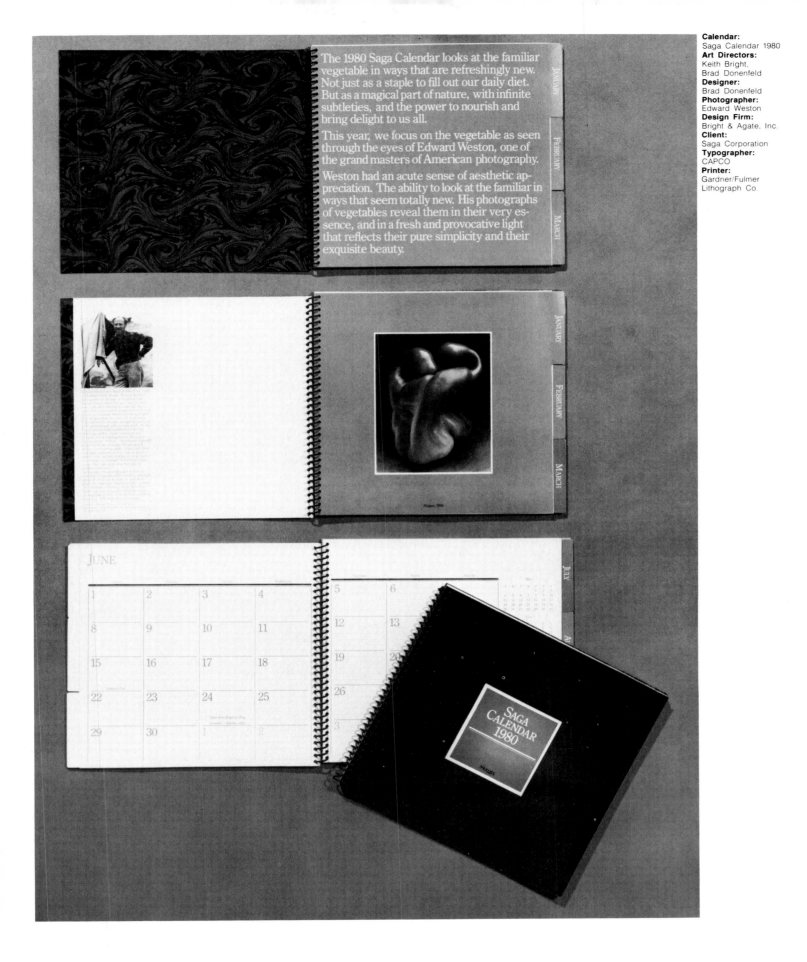

The 1980 Saga Calendar looks at the familiar vegetable in ways that are refreshingly new. Not just as a staple to fill out our daily diet. But as a magical part of nature, with infinite subtleties, and the power to nourish and bring delight to us all.

This year, we focus on the vegetable as seen through the eyes of Edward Weston, one of the grand masters of American photography.

Weston had an acute sense of aesthetic appreciation. The ability to look at the familiar in ways that seem totally new. His photographs of vegetables reveal them in their very essence, and in a fresh and provocative light that reflects their pure simplicity and their exquisite beauty.

Calendar:
Saga Calendar 1980
Art Directors:
Keith Bright,
Brad Donenfeld
Designer:
Brad Donenfeld
Photographer:
Edward Weston
Design Firm:
Bright & Agate, Inc.
Client:
Saga Corporation
Typographer:
CAPCO
Printer:
Gardner/Fulmer
Lithograph Co.

Calendar:
Insights 1980
Art Director:
James A. Sebastian
Designers:
James A. Sebastian,
Michael Lauretano,
Michele Evola,
Kathleen Lee
Artist:
Joe Standart
Design Firm:
Designframe, Inc.
Client:
Martex/West Point Pepperell
Typographer:
Haber Typographers, Inc.
Printer:
Crafton Graphic Co., Inc.

Invitation:
"Open" Invitation
Art Director:
Ron Sullivan
Designer:
Ron Sullivan
Artist:
Ron Sullivan
Design Firm:
Richards, Sullivan, Brock
& Assoc.
Client:
Heritage Press
Typographer:
Chiles & Chiles
Printer:
Heritage Press

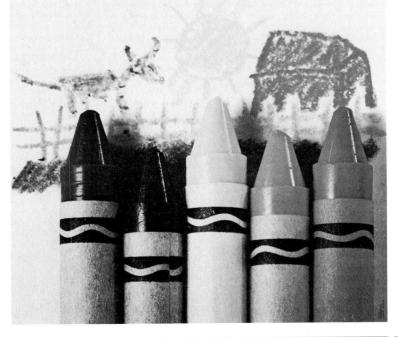

Poster:
What Color is Farming?
Art Directors:
Julius Freidman,
Nathan Felde
Designer:
Nathan Felde
Artist:
Infinity Ltd.
Design Firm:
Implement Ltd
Publisher:
Federal Intermediate Credit
Bank
Typographer:
Weimer Typesetting Co.
Printer:
Pinaire Lithography, Inc.

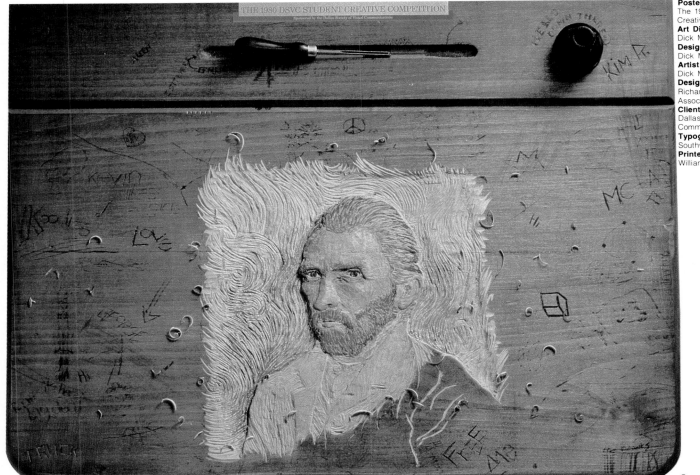

Poster:
The 1980 DSVC Student
Creative Competition
Art Director:
Dick Mitchell
Designer:
Dick Mitchell
Artist:
Dick Mitchell
Design Firm:
Richards, Sullivan, Brock &
Assoc.
Client:
Dallas Society of Visual
Communication
Typographer:
Southwestern Typographics
Printer:
Williamson Printing

Annual Report:
The Johns Hopkins 1979
Annual Report/New
Dimensions
in Discovery
Art Director:
David Ashton
Designer:
David Ashton
Photographer:
Richard Anderson
Design Firm:
Ashton-Worthington, Inc.
Publisher:
Johns Hopkins Hospital
Typographer:
Deans Composition
Printer:
Reese Press

Poster:
Diamond Jubilee,
75 Years of People
Moving People
Art Director:
Bill Bonnell
Designer:
Bill Bonnell
Coordinator:
Deborah Pierce
Design Firm:
Bonnell and Crosby Inc.
Client:
Metropolitan Transit
Authority of NYC
Publisher:
Joan Davidson,
J.M. Kaplan Fund
Typographer:
Typographics
Communications
Printer:
Triumph Advertising
Productions, Inc.

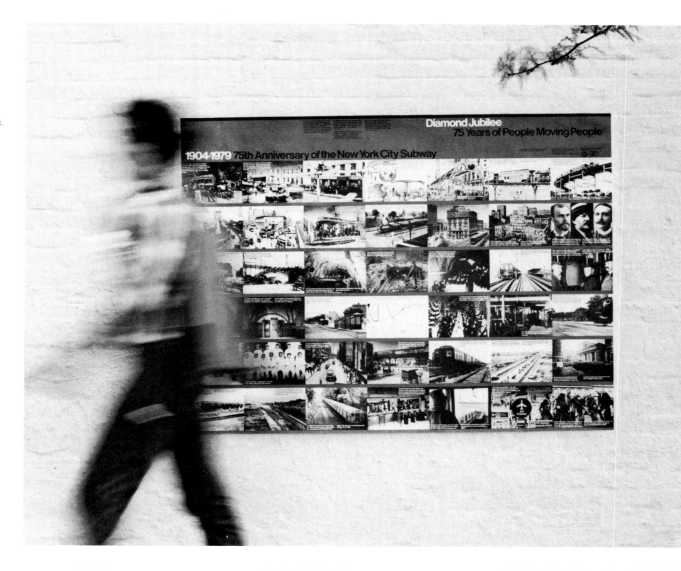

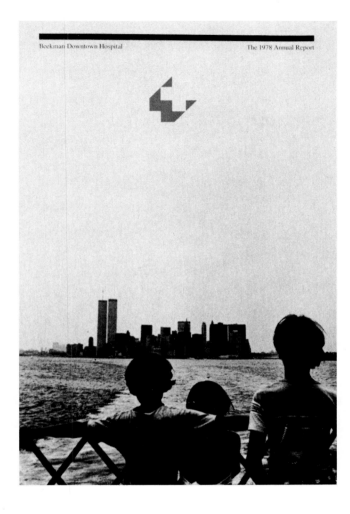

Human Resources Planning
and Development Guide

Beekman Downtown Hospital

The 1978 Annual Report

Annual Report:
Beekman Downtown
Hospital 1978 Annual Report
Art Director:
Aubrey Balkind, Phil Gips
Designer:
Michael McGinn
Photographer:
George Haling
Research:
Research Reports
Design Firm:
Gips + Balkind +
Associates, Inc.
Publisher:
Beekman Downtown Hospital
Typographer:
Innovative Graphics
International
Printer:
Crafton Graphic Co., Inc.

Brochure:
Human Resources Planning
and Development Guide
Art Director:
Frank Rupp
Designer:
Russell Tatro
Design Firm:
Pepsi-Cola Graphic Arts
Dept.
Client:
Pepsi-Cola Co.
Typographer:
Production Typographers,
Inc.
Printer:
Cali Litho, Inc.

Searle
Corporate
Identification
Standards
Manual

SEARLE

Presbyterian/Saint Luke's Medical Center

Health care the Rocky Mountain West has been asking for.

Corporate Literature:
Searle Corporate
Identification Standards
Manual
Art Director:
Bart Crosby
Designer:
Bart Crosby
Design Firm:
Bonnell and Crosby, Inc./RVI
Publisher:
G.D. Searle & Co.
Typographer:
Western/Chicago
Printer:
Great Northern Design
Printing

Brochure:
Presbyterian/Saint Luke's
Medical Center
Art Director:
Don Strandell
Designer:
Strandell-Baker Design
Photographer:
John Youngblut
Agency:
Donald A. Campbell
& Co., Inc.
Client:
Presbyterian/Saint Luke's
Medical Center
Typographer:
Western Typesetting
Printer:
Citron Press

Catalog:
Michael Wurmfeld
Art Director:
Rudolph de Harak
Designer:
Rudolph de Harak
Artist:
Michael Wurmfeld
Design Firm:
Rudolph de Harak &
Associates, Inc.
Publisher:
The Cooper Union
Typographer:
Innovative Graphics
International
Printer:
Joma Printing Co.,
The Cooper Union Press

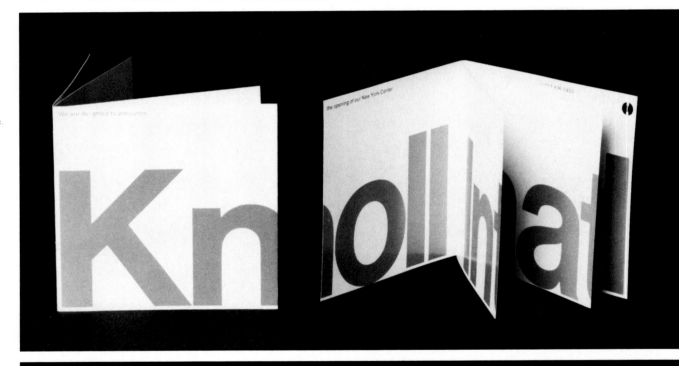

Theater, Delphi
April 20, 1970

Announcement:
Knoll International
Moving Announcement
Art Director:
Bill Bonnell
Designer:
Bill Bonnell
Design Firm:
Bonnell and Crosby, Inc.
Client:
Knoll International
Typographer:
Haber Typographers, Inc.
Printer:
Kenner Printing Co., Inc.

Invitation:
"Join Us In An Important
Search"
Art Director:
Bill Bonnell
Designer:
Bill Bonnell
Artist:
Deborah Pierce
Design Firm:
Bonnell and Crosby, Inc.
Client:
Sid Gross Associates
Publisher:
Phillips Petroleum
Typographer:
Typographics
Communications, Inc.
Printer:
Rohner Printing Co.

January 1980

Calendar:
1980 Sports Calendar
Art Directors:
Roger Cook, Don Shanosky
Designers:
Roger Cook, Don Shanosky
Photographer:
Arthur Beck
Design Firm:
Cook and Shanosky
Assoc., Inc.
Client:
S.D. Scott Printing Co., Inc.
Typographer:
Typographic Service Inc.
Printer:
S.D. Scott Printing Co., Inc.

June 1980

1 Sunday
2 Monday
3 Tuesday
4 Wednesday
5 Thursday
6 Friday
7 Saturday
8 Sunday
9 Monday
10 Tuesday
11 Wednesday
12 Thursday
13 Friday
14 Saturday
15 Sunday
16 Monday
17 Tuesday
18 Wednesday
19 Thursday
20 Friday
21 Saturday
22 Sunday
23 Monday
24 Tuesday
25 Wednesday
26 Thursday
27 Friday
28 Saturday
29 Sunday
30 Monday

Promotional Literature:
Clinical Focus 1, 2 & 3
Art Director:
Bob Paganucci
Designer:
Bob Paganucci
Photography:
Associated Press
Design Firm:
GIBA-GEIGY Corp.
Client:
CIBA-GEIGY Corp.
Typographer:
Haber Typographers
Printer:
Colorpress

Bulletin:
N.Y.U. School of
Continuing Education
Designer:
Stephanie Tevonian of Works
for Flex, Inc.
Design Firm:
Works
Client:
N.Y.U. School of
Continuing Education
Typographer:
Graphicomposition, Inc.
Printer:
Georgian Press

Promotional Literature:
Health Education
Art Director:
Ralph Lapham
Designer:
Ralph Lapham
Photographer:
Jonathan Rawle
Design Firm:
Lapham/Miller Assoc., Inc.
Client:
Public Relations Dept.,
New England Memorial
Hospital
Typographer:
Wrightson Typographers
Printer:
Noonan Press

Annual Report:
Cullinane Corporation,
1979 Annual Report
Art Director:
Roger Sametz
Designer:
John Kane
Artists:
Various
Design Firm:
Sametz Blackstone Assoc.
Publisher:
Cullinane Corp.
Typographer:
Monotype Composition Co.
Printer:
W.E. Andrews, Inc.

Annual Report:
The Commonweath of Mass.
Council on the Arts and
Humanities,
Annual report 1978
Designer:
Julie Curtis Reed
Artists:
Various
Design Firm:
Sametz Blackstone Assoc.
Publisher:
Mass. Council on the Arts
and Humanities
Typographer:
Litho Composition Co.
Printer:
Shawprint Inc.

Annual Report:
Ramtek Annual Report 1979
Art Director:
Lawrence Bender
Designer:
Linda Brandon
Photographers:
Tom Tracy, Ron May
Design Firm:
Lawrence Bender & Assoc.
Publisher:
Ramtek Corp.
Typographer:
Franks Type
Printer:
George Rice & Sons

GRAPHICS

If a picture is worth a thousand words, a graph is certainly worth a stack of computer printouts. And a graph in color is worth even more. The market covers a broad range from classrooms to boardrooms to control rooms.

Armchair Traveling

After shooting more than 50,000 photographs of downtown Aspen, Colorado, and its streets, researchers at the Massachusetts Institute of Technology's Architecture Machine Group used a Ramtek RM-9300 to generate and display animated sequences derived from these photographs, topographical surveys, aerial photography, maps and other sources.

Photographs can be made of the animated sequences direct from data using Ramtek's new GM-311 Recording Camera. Sequences are assembled to provide a visual interactive tour of the town.

At the Heart of High Technology

In the complex world of semiconductor memories (used in calculators and computers), being able to spot quickly a malfunctioning "bit" or "debug" a memory design can mean significant savings to a manufacturer.

At Teradyne Corporation, a Ramtek RM-9050 graphic display is part of a very sophisticated process called Real-Time Bit Mapping. The terminal operator can perform a wide range of tests to detect failures and design problems. Seeing bit failures change—in color—gives the operator a new perspective.

A Colorful Learning Experience

Cienega School in California uses a Ramtek 6200A Colorgraphics terminal in an exciting experimental program. By associating color codes with words and manual signs, deaf preschool and kindergarten children are being taught the basics of reading, writing and other language skills.

Instant Answers

Management Information Systems (MIS) are one of the fastest growing markets in the graphics industry. One of the best examples of MIS is the system at PepsiCo, which uses a Ramtek 6200A to translate an avalanche of computer-generated statistics into a steady stream of easily understood graphs and charts.

PepsiCo has developed standardized graphics to illustrate the five year performance of its divisions which generate total annual revenues of $5 billion. Other graphs are used to plot market share, operating expenses and return on assets, to mention a few. Once a graph is created on the Ramtek display screen, a paper copy can be produced on a Xerox Color Graphics Printer linked to the terminal.

1 *A Teradyne Corporation J387 semiconductor memory tester uses a Ramtek RM-9050 for characterization and design. Color displays of "bits" also help technicians determine when partially defective chips are salvageable, significantly increasing yield.*
2 *A program called "Computer Assisted Instruction on Language and Reading for the Deaf" uses a Ramtek color terminal to code different parts of speech so students will understand the concept of nouns, verbs, adjectives and adverbs.*
3 *For PepsiCo, the 60th largest U.S. industrial corporation, computer graphics helps the firm spot trends quickly, seek opportunities and track performance in a form that could not easily be duplicated manually. Some 700 to 800 graphs are generated every four weeks for review by top management.*

Research being done at MIT may make it possible for travelers to learn their way around a city before making the trip. This graphic representation of downtown Aspen, Colorado, was taken directly from data digitized by a RM-9300.

Poster:
Container Corporation of
America
Art Director:
Bruce Naftel
Designer:
Bruce Naftel
Design Firm:
Design Center
Client:
The Department of Art,
Western Michigan University
Printer:
Industrial Graphics

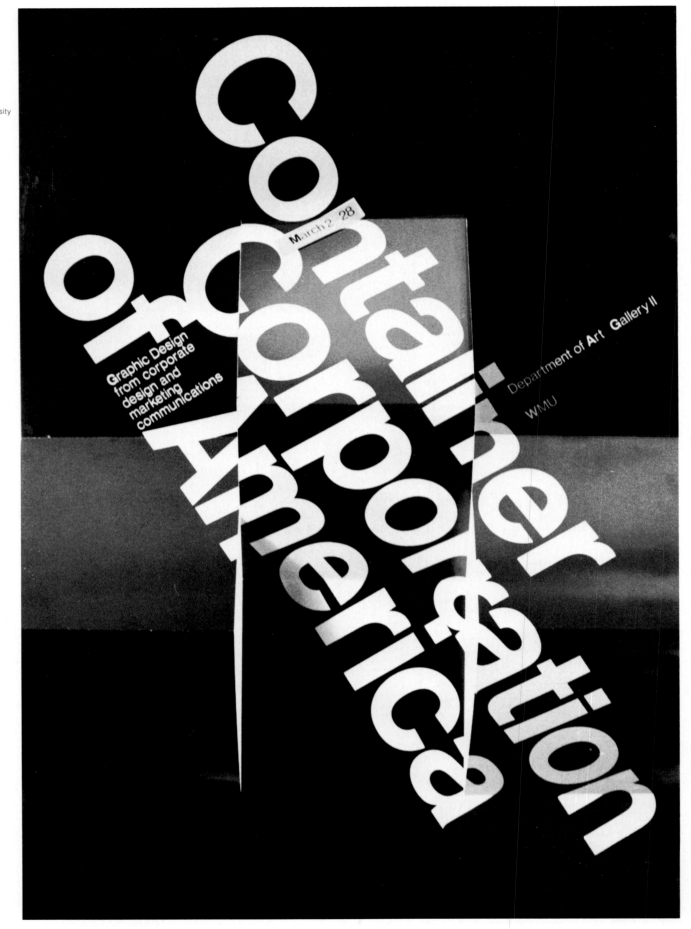

FORGING AND FOUNDRY

Corporate Literature:
United Industrial Syndicate
Art Director:
B. Martin Pedersen
Designer:
B. Martin Pedersen
Artist:
Andrew Unangst
Design Firm:
Jonson Pedersen Hinrichs
& Shakery, Inc.
Client:
United Industrial
Syndicate, Inc.
Typographer:
Pastore DePamphilis
Rampone, Inc.
Printer:
LaSalle Industries

Terre Haute Malleable and Manufacturing Co.

Terre Haute Malleable was a closely-held public company which was acquired in 1968 when UIS tendered for its stock with management's blessing. President Don Meiners, who manages the 119-acre, three-furnace jobbing foundry, was brought in by UIS when Terre Haute's former president retired, and new capital and technology were introduced to modernize the operation. Today,

the firm produces all grades of malleable and ductile castings, which are sold to manufacturers of earth-moving equipment, automotive and industrial trucks, agricultural equipment, railroad equipment, and other types of tools and machines.

The Union Forging Company

The Union Forging Company had been in business for more than 75 years when UIS acquired it privately in 1968. Whereas owner

retired, Francis V. Moran assumed the presidency and, with the rest of the management team, continued to produce the quality forgings for industry which had earned the firm its excellent reputation over the years. Producing such products as tie bars, brake levers, shaft forks, motor mount brackets, U-bolts, and end gate hinges, the company has seen its income from sales to such clients as GMC, Chevrolet, Kenworth, and Mack Truck triple over the past nine years.

Annual Report:
Champion International
Corporation '78
Designer:
Richard Hess
Photographers:
Various
Design Firm:
Richard Hess, Inc.
Publisher:
Champion International Corp.
Typographer:
Tri-Arts Press, Inc.
Printer:
Case-Hoyt Corp.

(Left) Intensive inventorying of timberlands acreage yields improved data on species mix, quantity of fiber available, and optimum harvesting and management techniques.

(Overleaf) Champion International nurseries, such as this one in Lebanon, Oregon, provide a dependable supply of high-quality seedlings for replanting harvested lands.

Posters:
Lower Manhattan,
Midtown Manhattan
Art Director:
Diana Graham
Designer:
Diana Graham
Artist:
Albert Lorenz
Design Firm:
Gips + Balkind + Assoc.
Client:
Williamson, Picket,
Gross, Inc.
Typographer:
Innovative Graphics
International
Printer:
Sanders Printing Corp.

Lower Manhattan

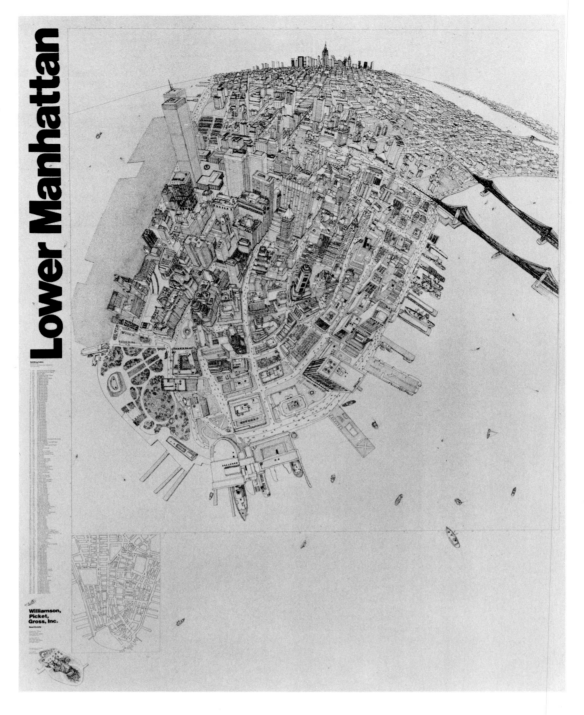

Midtown Manhattan

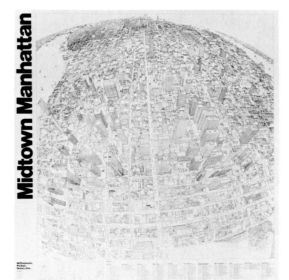

Poster:
The Mead Library of Ideas
23rd Annual International
Annual Report Competition
Art Director:
Ivan Chermayeff
Designers:
Charles Unger,
Ivan Chermayeff
Photographer:
Arnold Rosenberg
Design Firm:
Chermayeff & Geismar
Assoc.
Publisher:
The Mead Library of Ideas
Printer:
Sanders Printing Corp.

Brochure:
Ulrich Franzen and
Associates Capabilities
Brochure
Art Director:
Bill Bonnell
Designer:
Bill Bonnell
Artist:
Isabel Escalas
Photographers:
Ezra Stoller,
Wayne Sorce
Design Firm:
Bonnell and Crosby, Inc.
Publisher:
Ulrich Franzen and Assoc.
Typographer:
Haber Typographers, Inc.
Printer:
Rohner Printing

Annual Report:
Mercantile Texas Corporation
Annual Report 1978
Art Director:
Dick Mitchell
Designer:
Dick Mitchell
Artist:
Greg Booth
Design Firm:
Richards, Sullivan, Brock
& Assoc.
Client:
Mercantile Texas Corporation
Typographer:
Southwestern Typographics
Printer:
Heritage Press

Mercantile Texas Corporation
Annual Report 1978

Corporate Literature:
Welding Inspection
Handbook
Art Director:
Frank B. Marshall III
Designers:
Frank B. Marshall III,
Richard Tesoro
Publisher:
GAF Corporation
Typographer:
Typographics
Communications Inc.
Printer:
Pictorial Offset

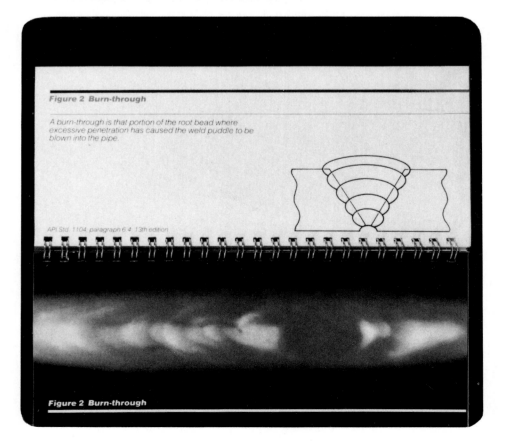

Figure 2 Burn-through

A burn-through is that portion of the root bead where
excessive penetration has caused the weld puddle to be
blown into the pipe.

API Std 1104; paragraph 6.4; 13th edition

Figure 2 Burn-through

SINCE RECEIVING MY EMBA, ALL THE FUNCTIONAL AREAS OF MY COMPANY AND ITS SUBSIDIARIES HAVE IMPROVED ACROSS THE BOARD. I ATTRIBUTE THE MAIN REASON FOR THIS TO INCREASED COMMUNICATIONS, BETTER PLANNING AND INDIVIDUAL GOAL AWARENESS OF ALL MY KEY EMPLOYEES, A DIRECT RESULT OF COMBINING THEORY AND PRACTICAL APPLICATION TAUGHT IN THE EMBA PROGRAM.

Annual Report:
Annual Report 1978–79
Edwin L. Cox
School of Business,
Southern Methodist
University
Art Director:
Richards, Sullivan, Brock
& Assoc.
Designer:
Dick Mitchell
Artist:
Dick Mitchell
Design Firm:
Richard, Sullivan, Brock
& Assoc.
Client:
Southern Methodist
University
Typographer:
Chiles & Chiles
Printer:
Heritage Press

Brochure:
IBRD
Art Director:
Jann Church
Designer:
Jann Church
Photographer:
John Lawder
Design Firm:
Jann Church Advertising &
Graphic Design, Inc.
Publisher:
Institute for Biologic
Research & Development,
Inc.
Typographer:
Alpha Set
Printer:
George Rice & Sons

Brochure:
Kentucky Printing Corp.
Capabilities
Art Director:
Dan Stewart
Designer:
Ken Delor
Design Firm:
Designer Stewart & Winner
Publisher:
Kentucky Printing Corp.
Typographer:
Weiner Typesetting Inc.
Printer:
Kentucky Printing Corp.

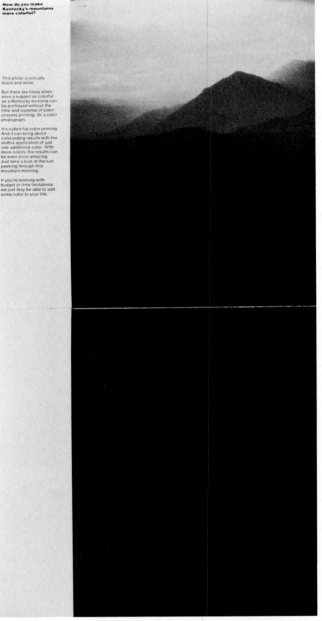

How do you make Kentucky's mountains more colorful?

This photo is actually black and white.

But there are times when even a subject as colorful as a Kentucky morning can be portrayed without the time and expense of color process printing. Or a color photograph.

It's called flat color printing. And it can bring about outstanding results with the skillful application of just one additional color. With more colors, the results can be even more amazing. Just take a look at the sun peeking through this mountain morning.

If you're working with budget or time limitations, we just may be able to add some color to your life.

Annual Report:
Reeves Teletape Corp.
Annual Report 1978
Art Directors:
Stan White, Edward Marson
Designer:
Edward Marson
Artist:
David Pruitt
Design Firm:
Design Concern
Publisher:
Reeves Teletape
Typographer:
Typographic Images
Printer:
Rapoport Printing

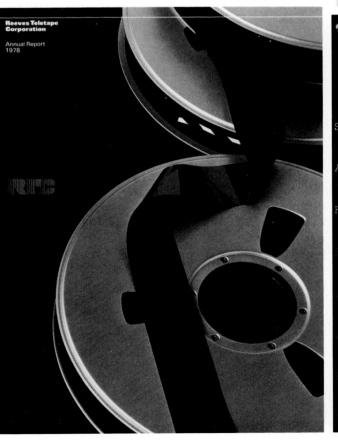

Reeves Teletape Corporation

Annual Report 1978

SIGNAL 78
ANNUAL 78
REPORT 78

Annual Report:
Signal 1978
Art Director:
Robert Miles Runyan
Designer:
Jim Berte
Photographer:
Ken Whitmore
Design Firm:
Robert Miles Runyan
& Assoc.
Publisher:
The Signal Companies
Typographer:
Composition Type
Printer:
Anderson Lithograph Co.

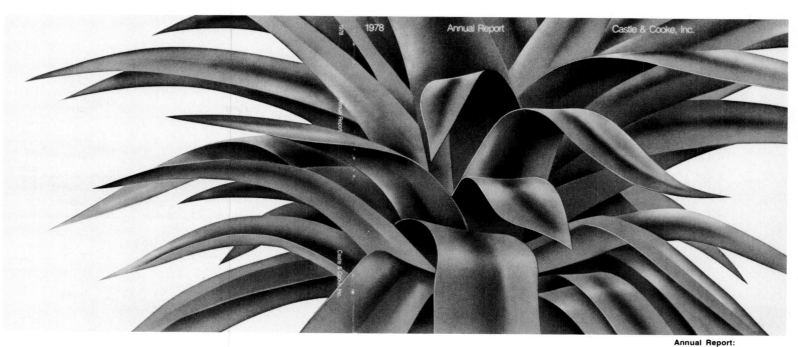

Annual Report:
Castle & Cooke Inc., 1978
Annual Report
Art Director:
Robert Miles Runyan
Designer:
Jim Berte
Artist:
Paul Bice
Design Firm:
Robert Miles Runyan
& Assoc.
Publisher:
Castle & Cooke Inc.
Typographer:
Composition Type, Inc.
Printer:
Anderson Lithograph Co.

Our cover
Harun Al Rashid, 23th Caliph of Baghdad, was said to have a magic carpet which could carry him through the air swiftly and safely to any place in his Kingdom. His boon companions were Ja'afir the Barmecide and Masrur, his Sworder, both good ole' boys who could be counted on to amuse their boss while doing their share at table and with the wineskin. Many trips were made to faraway places with strange sounding names, ostensibly on business of the Caliphate but it is rumored that a report of a handsome houri or even a beauteous bayadere in some corner of the Kingdom would call for a ride on the rug.

Old Harun had the perfect flying machine and we have been trying to make another one ever since, an effort led on the National scale by a persistent, imaginative and resourceful Air Force which has been in charge of improving the science of flying since it was proved it could be done. The pages of this book carry 57 examples of applied ingenuity that contributed mightily to the arts and crafts of flying. It is safe to say that our air arm, by whatever name it carried, was in on every one of them and usually the principal supporter. We are happy to salute the U.S. Air Force with this display, in our fifth year as an independent research laboratory and our 40th year of close contact with this great Service in a common cause.

this laboratory is a working laboratory, i.e., an active alembic extracting selected knowledge from the reservoir of science for application to real-world problems at the vanguard of the possible technologies by which society can be served. An important factor in our process is a feedback of new technical knowledge into the reservoir. Another is the education of people who choose to serve in technological fields and who will inherit the challenges of the future.

As a working laboratory interested in the transfer of academic fact into hardware that can be produced by industry, we take pains to avoid a competitive position so that our role as the government's agent may not be compromised. We initiate concepts or attack problems that are posed to us, we design systems for satisfying the requirements of the problems, we craft prototype hardware, prove that it will work and return it to the sponsor, whose problem it is, for eventual disposition, usually production contracts competitively arrived at. An integral part of our end-result package is a bill of particulars, including criteria by which performance can be measured, software schedules, proof of performance by testing, cost assessments, lead-time estimates,

instructions for field use, maintenance and technical support generally. We also transfer our empirical knowledge to producers of the systems and to the eventual users, partly by documentation of our experience in the developmental stage, and partly by accepting their people into the development, fabrication, and testing stages.

The role of research in the national posture is a vital one for two reasons. First, it enables more effective end-result products. Second, it reduces reliance on sheer numbers in the achievement of national goals. This laboratory feels strongly that its dedication to precision and its continuous pursuit of excellence produces increasingly effective devices, and its cost-consciousness sets a cost threshold, and the combination benefits everyone.

We undertake, at the behest of the government, the research and development of systems, in our field of expertise, needed to maintain the nation in an advantageous position vis-a-vis any nation in the world. Technical superiority is a powerful deterrent to world strife, and by doing our share in the establishment of national technical superiority we help discourage the aspirations of potential aggressors and thus make it easier to keep the peace, uneasy though it may be from time to time. The specific

How it all began.
This is page 1 of Patent Application by the Wright Brothers. Patent was granted in 1906. There was no pilot in hurrying the patent process as nobody else had anything at all in the field.

On the following pages of this book are simplistic illustrations of what have been, in our opinion at least, significant engineering developments that advanced aviation to what it is today, our most important, most popular and safest means of travel.

Annual Report:
The Charles Stark Draper
Laboratory, Inc. 1978
Annual Report
Design Director:
Robert Steinle, CSDL
Art Director:
Advertising Designers, Inc.
Tom Ohmer
Designers:
James Marrin, Ed Kysar
Artists:
Ed Kysar, Don Oka
Design Firm:
Advertising Designers, Inc.
Client:
The Charles Stark Draper
Laboratory, Inc.
Typographer:
Ad Compositors
Printer:
Mark Burton Inc.

Brochure:
Arthur Young
Art Director:
John Casado
Designer:
John Casado
Photographer:
Wolf von den Bussche
Design Firm:
Casado Design
Publisher:
Arthur Young & Co.
Typographer:
Reprotype
Printer:
House of Printing

Annual Report:
Technicolor Inc., 1979
Annual Report
Art Directors:
Robert Miles Runyan,
Jim Berte
Designer:
Jim Berte
Photographer:
Ken Whitmore
Design Firm:
Robert Miles Runyan
& Assoc.
Publisher:
Technicolor, Inc.
Typographer:
Composition Type Inc.
Printer:
George Rice & Sons

Promotional Literature:
"Credit is a sales tool"
Art Director:
Frank Rupp
Designer:
Russell Tatro
Design Firm:
Pepsi-Cola Graphic Arts
Dept.
Client:
Pepsi-Cola Co.
Typographer:
Ad Agency Headliners
Printer:
Pan American Litho

Corporate Literature:
"You and Xerox"
Art Directors:
Earl Dobert, Ford Park
Designer:
Ford, Byrne & Assoc.
Photographer:
Steven Tarantel
Design Firm:
Ford, Byrne & Assoc.
Client:
Xerox Corp.
Typographer:
PHP Graphic Arts Corp.
Printer:
Case-Hoyt Corp.

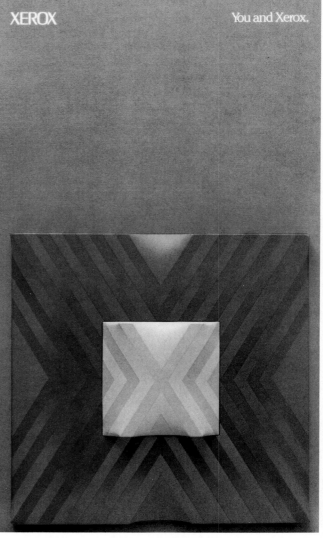

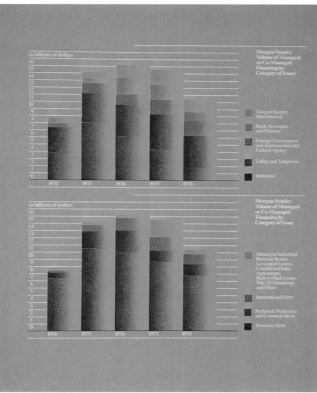

Annual Report:
Morgan Stanley
Annual Review 1978
Art Directors:
Stephan Geissbuhler,
Thomas Geismar
Designers:
Jill Rossi,
Stephan Geissbuhler
Photographers:
Roy Stevens,
Francois Robert,
George Haling
Design Firm:
Chermayeff & Geismar
Assoc.
Client:
Morgan Stanley, Inc.
Typographer:
Haber Typographers, Inc.
Printer:
Sanders Printing Corp.

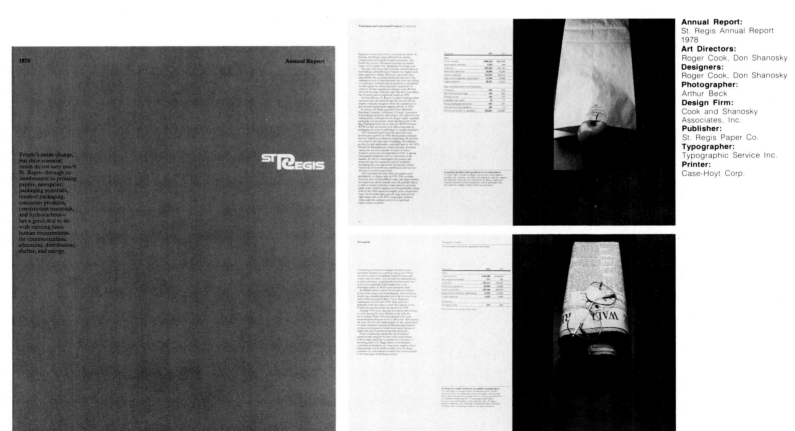

Annual Report:
St. Regis Annual Report
1978
Art Directors:
Roger Cook, Don Shanosky
Designers:
Roger Cook, Don Shanosky
Photographer:
Arthur Beck
Design Firm:
Cook and Shanosky
Associates, Inc.
Publisher:
St. Regis Paper Co.
Typographer:
Typographic Service Inc.
Printer:
Case-Hoyt Corp.

Annual Report:
Northrop Corporation,
Annual Report 1978
Art Director:
James Cross
Designers:
James Cross, Carl Seltzer
Photographer:
Cheryl Rossum
Design Firm:
James Cross Design
Office, Inc.
Publisher:
Northrop Corp.
Typographer:
Vernon Simpson
Typographers, Inc.
Printer:
George Rice & Sons

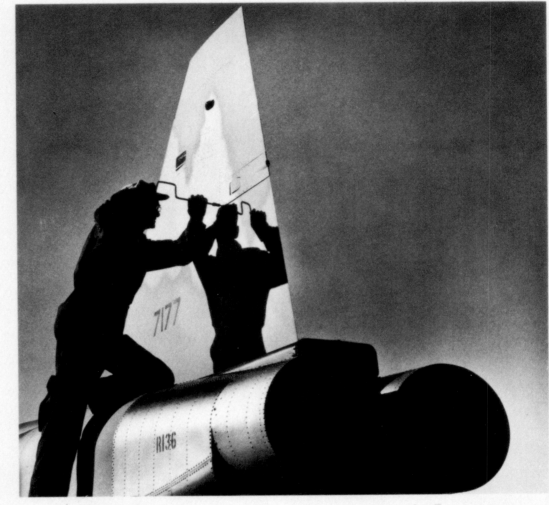

Northrop Corporation Annual Report 1978

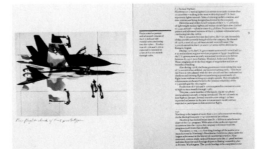

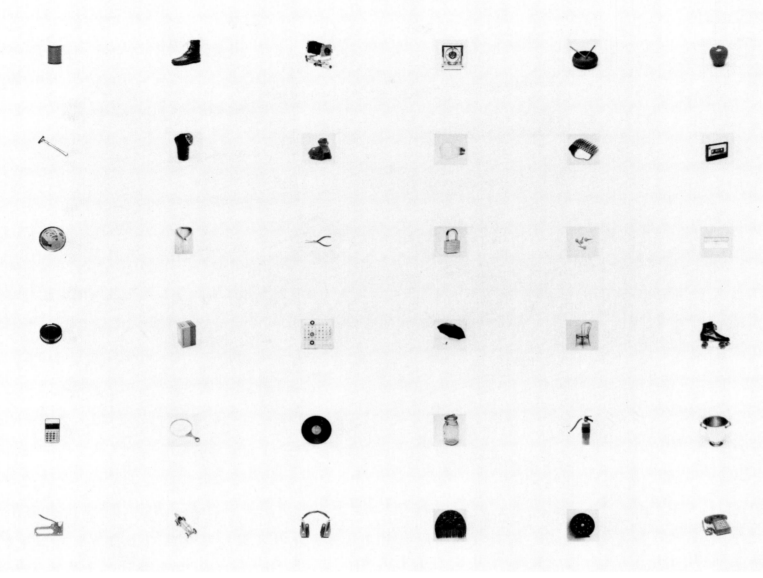

Promotional Literature:
Imagination XXIII
Art Director:
James Miho
Designer:
James Miho
Artists and Photographers:
Henry Wolf,
Seymour Chwast,
Milton Glaser, Earl Glass,
James McMullan,
M. Jackson,
Giovanni Guarcello, Nigel
Homes, John Paul Endress
Design Firm:
Miho, Inc.
Publisher:
Champion International Corp.
Typographer:
Tri-Arts Press, Inc.
Printer:
Tempo Communications

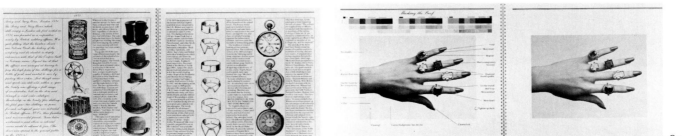

Poster:
Change
Art Director:
Chris Rovillo
Designer:
Chris Rovillo
Artist:
Chris Rovillo
Design Firm:
Richards, Sullivan,
Brock & Assoc.
Client:
Richards, Sullivan,
Brock & Assoc.
Typographer:
Southwestern Typographics
Printer:
Heritage Press

Brochure:
Park Avenue Plaza
Art Director:
Diana Graham
Designer:
Diana Graham
Photographers:
Jean-Marie Guyeux,
Hank Ganz
Design Firm:
Gips + Balkind +
Associates
Client:
Fisher Brothers
Typographer:
Innovative Graphics
International
Printer:
Crafton Graphic Co., Inc.

PARK AVENUE PLAZA

Annual Report:
Polychrome '78
Art Director:
Bob Salpeter
Designer:
Bob Salpeter
Photographers:
Jay Maisel, Art Kane,
Yousuf Karsh,
Richard Avedon,
Gordon Parks, Cornell Capa
Corporate Photography:
Jim Broderick
Design Firm:
Lopez Salpeter Inc.
Client:
Polychrome Corp.
Typographers:
Gerard Assoc., Pastore
DePamphilis Rampone Inc.
Printer:
Raleigh Printers

Polychrome

Annual Report
1978

Print Ads of the Year

Print Ads of the Year is the title given to the AIGA's Advertising awards program. Printed ads that have been published in American or Canadian magazines, newspapers, or periodicals are eligible. Of the 640 submissions this year, 69 were selected for award.

Chairman

Gene Federico
Since 1967, when he formed his present partnership, Gene Federico has been executive vice-president of Lord, Geller, Federico, Einstein, Inc. Born in New York City, he studied at Pratt Institute and began his professional career at Abbott Kimball Advertising. He has designed for *Fortune* magazine, and done editorial projects for Henry Luce, Grey Advertising, and Doyle Dane Bernbach. Subsequently he worked with Douglas D. Simon Advertising and served as vice-president and art group head at Benton & Bowles.

Jury

Stavros Cosmopulos
As executive vice-president of creative services for Arnold & Company Inc., in Boston, Stavros Cosmopulos has been the moving force behind many of New England's advertising campaigns. A native of Boston, he worked in the creative departments of agencies in New York, Detroit, and of his own firm in Palm Beach before returning to his home town. He helped found Hill, Holliday, Connors, Cosmopulos and was that agency's co-creative director and board chairman for 10 years. He also works as a painter, toy maker, sculptor, cabinet maker, and inventor.

Martin Lipsitt
The senior vice-president/creative director of DKG Advertising Inc., Martin Lipsitt began his career in fashion and pharmaceutical agencies. He first joined DKG in 1962 as vice-president/art supervisor and in 1965 went to McCann-Erickson as vice-president/creative group head. In 1967 he joined Carl Ally Inc., as vice-president/creative group head and the next year rejoined DKG as senior vice-president/co-creative director and also creative director of the agency's New Product Group. He earned a BFA degree from Pratt Institute.

Sam Scali
Sam Scali, vice-chairman and creative director of Scali, McCabe, Sloves, Inc., was one of the founders of the agency in 1967. He began his career in advertising in 1953 after attending the High School of Industrial Arts (now the School of Art and Design). He continued his education at Pratt Institute's evening classes. In his earlier years, Scali worked as an art director at Doyle Dane Bernbach. Later he moved to Papert, Koenig, Lois, Inc., where he became vice-president and senior art supervisor before forming Scali, McCabe, Sloves.

Barbara Schubeck
A senior art director for Ammirati & Puris, Inc., Barbara Schubeck previously worked with Scali, McCabe, Sloves and with Calderhead, Jackson, Inc. Born in Detroit, she graduated from the University of Michigan at Ann Arbor, where she majored in photography. She came to New York in 1968 and studied advertising at the School of Visual Arts before beginning her professional career.

Constance von Collande
Senior art director of Revlon's Creative Workshop, Constance von Collande was born in Dresden, Germany, and received her degree there in graphic design and advertising. She began her professional career in an agency in Zurich and then joined Publicis in Paris as art director. She came to the U.S. in 1965 and joined *Vogue* to design promotion and, later, editorial pages. In 1971 she joined Elizabeth Arden as promotion art director and in 1976 took her present position at Revlon.

Review

In this country advertising has always been one of the most dynamic areas of graphic design. Newspapers, magazines, buses and trains, direct mail, and now television make it not only seemingly ubiquitous but also seemingly irresistible. It has become a world of its own, the subject of films, novels, and sociological studies, a world with its own royal families and court jesters. It attracts some of the best talent in the fields of writing and design and elicits the most immediate responses from the broadest segments of our population.

Yet to most people, Print Ads of the Year will look markedly different in terms of aesthetic quality from other AIGA awards programs. Four out of five jurors agreed on each ad selected for award, yet there will be critics who find that hard to believe. The ads awarded are not what graphic design professionals would normally consider beautiful–though there were a good number of truly beautiful ads submitted. Some of these got awards.

Additionally, awards have gone to a number of ads that designers might definitely consider something other than beautiful. The criterion of the jurors was that they were looking for something more. It was easy to put a beautiful picture together with a line of copy and make a beautiful ad. But, the jury insisted, that does not necessarily make an effective ad. For them, effectiveness was the goal. Concept had to be part of design.

For AIGA awards programs, traditionally, the criterion has been strictly good design–meaning visual style or how something looks. For this year's Ad jury, the concept and the words are integral to good design–good advertising design. The controversy that criterion raised represents the quintessential argument that has run through most of this year's AIGA juries: the conflict in cover design between first impressions and problems solved, in illustration between fine art and applied art, in limited book editions between designers' problems and clients' problems, in book design between good looks and readable content, and in packaging–most clearly–between aesthetic appeal and consumer appeal.

AIGA does not judge books according to whether they sell–though others do so. The AIGA purpose is to judge good design. The Advertising jury would say that that is like judging an apple by the way it looks instead of by how it tastes. If their criterion were only how an ad looks, they would not be considering the entire profession. This ideological split is reflected in advertising distinguishing itself as a profession separate from graphic design. Though trained as designers, creative directors and art directors in advertising consider design a specialty. Theirs is the generalist activity of "communication," as this year's jury explained. If part of this separation is because of advertising's hierarchical nomenclature, which places "designer" subordinate to "creative director," it is also because of the view that "communication" through advertising looms as a larger conceptual horizon for them.

Still in America today, advertising is in a transitional if not a conservative stage. The heydays of the late 1960s to the middle 1970s are over. Occasionally, the jury saw efforts to do something different and new, but in general they felt that advertising designers are designing less flamboyantly, more cautiously. It was agreed that there is a return to conservatism–and not for lack of imagination on the part of designers. We need only compare what is happening in fashion, politics, and with students on campus–there is a great concern about where one is going to get a job and other practical concerns. All this is reflected in the ads, which were "very purposeful."

They were also very carefully executed, the jury observed. In general, conservative times foster concentration on craftsmanship. In the materials submitted, the jury noted "a greater sensitivity toward the finer things." Attention to detail seemed to be apparent again. Borders were straight, corners neat, spaces even, paragraph indentations consistent, and other subtleties manifested. These elements, which are the traditional responsibility of art directors, were consistently produced with more care, the jury observed. The once-forgotten element of "innate design sensitivity" was returning. "We look to these shows as guides for our profession," one juror said, and he felt that this year's Advertising exhibition was an important activity for AIGA to be involved in.

The predominance of catchy headlines and of ideas that are conveyed more by words than by pictures or other graphic means provoked serious discussion. In a profession that has become associated with the slogan "A picture is worth a thousand words," the jurors debated the current trend to make illustration subservient to copy. They discussed several design judgings elsewhere in the profession where "there is regard only for copy." And they saw that approach in a number of the ads they selected for award this year. For example, *Playboy's* rebuttal of *Cosmopolitan's* recent centerfold of Burt Reynolds nude states that *Playboy* is "exposing" something special by showing what is inside the actor. It was the copy that was most intriguing, not the design.

Conversely, the jury discussed ads in which the designer was not concerned with what was said in the copy, but just with the design and the product. They felt that a good ad must have good copy but must also show an effectiveness in design or quality in the choice of typeface, style of illustration, or some other visual feature to balance the copy. They concurred that words and visual material must never be in conflict—or an ad will fail—and that good advertising designers strive to merge the two.

"Sometimes you look at an ad and think that design is predominant," said one juror. "Then if you look a little more closely, you find that there is good supportive copy." The fine line of balance was the admired state. Five words, it was observed, can evoke such a strong image that they need no illustration. The point was that the words have to be designed too—and that is visual. That is design.

Design is gaining importance again, one juror said. Art directors had become so intrigued with words and writing headlines "that we forgot what our discipline is supposed to be." Now there is "more sensitivity in design, more interest in maximizing the impact on the page." In the ads most admired, the words and the copy both worked together in balance to express an idea.

The advertising history of Herman Miller was described by the jury as an object lesson in the balancing of words and visual material to convey an idea. Not too long ago, it was said, Herman Miller's ads were, simply, beautiful pictures of pieces of furniture. They did not have a concept or statement to make about the furniture other than to show what it looked like. "The picture was the idea," as the jury said. Today, Herman Miller is incorporating marketing ideas with the pictures of the furniture. The jury selected for award a Herman Miller ad that says, in effect, our furniture is well made—or rather is made by more modern techniques than other furniture. It was, admittedly, a sophisticated statement that may not be clear to laypeople, but the ad was intended for a sophisticated, professional furniture-design audience.

It was the idea or concept, and the balanced expression of it, then, that the jurors held in highest esteem. The "striving for excellence" was their general guideline, and they were in agreement that they had been rigorously discriminating in their selections.

Small ad space was noted for being difficult to design because it "teases." Small ads have "to promote in a small way quickly." The jury noted, however, that spreads are also difficult to design.

In their comments about specific ads the jurors demonstrated their criteria for selection. The ad for Marantz audio equipment with the image of a pie in the face was called successful, effective, and graphic. "That's what it is, it is graphic," was the acclamation. A device everyone is familiar with had never been seen frozen at that moment of impact, so it comes as a surprise.

The trade ad for *Life* magazine is directed at creative directors, media buyers, and other prospective advertisers in *Life*. It capitalizes on the large-page size of the original publication. "*Life* is a double-size publication and creative people are frustrated with the shrinking size of other magazines. Since *Life* permits life-size ads, they are stressing that point successfully."

Several trade ads for *The New Yorker* were admired because they establish an immediate identity without using the *New Yorker* logo. The ads are set like the magazine's page format. They "zero in on the people who are interested in reading," who are the magazine's chief customers. And the ads give a taste of what is coming in the magazine without being subscription ads with coupons. Perhaps only *The New Yorker* is well enough known—its own typeface is called *The New Yorker*—so that it need not have a logo.

The ad campaign for Dior was admired because it was provocative yet in good taste—and interesting to both men and women. And the Dior tradition, "elegant, erotic, and sensual," is continued. An ad series for Fortunoff was found intriguing because "without copy, they manage to communicate an upgraded image of the store simply by picturing Lauren Bacall with a Fortunoff bag."

Sony's campaign about Full-Color Sound was admired for "the whole idea of describing sound and the way people think about it. No one has ever put it into words that way, and they made it their point of difference. They make it sound like a superior product. It is a really fresh approach."

The Perdue Chicken ad was awarded because "it talks directly to the person who is reading it—the person who uses the oven." Since it attracts attention immediately and leads one to read the copy, the ad was found to be "beautifully arranged."

Several ads in a country-catalog style were selected for awards, to the surprise of one juror who questioned how a style of presentation that verged less on classical design and more on the messy, the homespun, and the hokey could be considered good design.

Evidently this style should not look as if it were designed and not read as if it were composed. Some ads in this style were thought to be well done because they communicated a good deal of information with many verbal and pictorial elements. "If it is necessary to have many design elements in a particular ad to make it work, then the problem is to put these elements together in a way that is pleasing and effective. It may not look designed, yet this is where a designer is really necessary."

DON'T BUY A COPIER THAT GIVES YOU A BAD IMAGE.

Cutler & Webb
PUBLIC RELATIONS
600 PARK AVENUE, NEW YORK, N.Y. 10017

G. WEBB President

Smudges caused by wet toner.
Wet toner can smudge the copy before drying. The Toshiba BD-601 uses dry toner that doesn't smudge.

Broken, blurred type.
Inexpensive wet copiers often reproduce type with inconsistent clarity. The Toshiba BD-601 dry copier produces clean, crisp copies with remarkable consistency.

William O'Brien, President
Fabriques International
1271 Sixth Avenue
New York, New York 10020

Dear Mr. O'Brien:

I received your sample of Velvalon, your revolutionary new fabric. It has all the makings of a major success. We will proceed to prepare the introductory publicity campaign, using the strategy discussed.

May we plan to show the campaign to you for your approval on the 18th? This will allow us eight weeks to prepare the materials for the trade show in Atlanta.

Please advise if this schedule meets your requirements.

Sincerely yours,

G. Webb

GW/an

Paper that feels funny.
Most inexpensive copiers use special-finish paper. On the Toshiba BD-601 you can copy on almost any kind of paper.

Dirty gray background.
Wet toner and special-finish paper often cause the copy background to come out dirty. The Toshiba BD-601 uses neither, so the background comes out clean.

The trouble with most inexpensive copiers is that they turn out cheap-looking copies. Which does little to help your business image.

The Toshiba BD-601 is an exception.

It's an economical desktop copier that consistently delivers sharp, clean, dry copies on letterheads, colored stock — on almost any kind of paper in your office.

Unlike other copiers in its price range, the Toshiba BD-601 uses no messy wet toner. No special-finish duplicating paper.

So send in the coupon and find out more about the remarkable Toshiba BD-601. Its image could do a lot for yours.

TOSHIBA
Toshiba America, Inc.
Business Equipment Division
P.O. Box 846, Bellmore, N.Y. 11710

Please tell me more about the Toshiba BD-601 copier.

NAME_____ TITLE_____

FIRM NAME_____ PHONE_____

ADDRESS_____

CITY_____ STATE_____ ZIP_____

332

We're looking for a sharp operator to work in our photo lab. Must have 24 years' experience and not be afraid of the dark. For a clearer picture, call Randy Ivey at Metzdorf Advertising. 526-5361. (We're an equal opportunity employer.)

Magazine Ad:
"We're looking for a sharp operator..."
Art Director:
Charles Hively
Designer:
Charles Hively
Copywriter:
Stephen Heller
Design Firm:
Metzdorf Advertising Agency
Publisher:
Metzdorf Advertising Agency
Typographer:
Professional Typographers
Engraver:
San Jacinto Engraving

Newspaper Ad:
Profiles/The Girl In The
Black Helmet
Art Director:
Gene Federico
Designer:
Gene Federico
Copywriter:
Dick Lord
Agency:
Lord, Geller, Federico,
Einstein, Inc.
Client:
The New Yorker

PROFILES

THE GIRL IN THE BLACK HELMET

This was Louise Brooks. She made only twenty-four films, in a movie career that began in 1925 and ended, with enigmatic suddenness, in 1938. Two of them were masterpieces: "Pandora's Box" and its immediate successor, also directed by Pabst— "The Diary of a Lost Girl." Most, however, were assembly-line studio products. Yet around her, with a luxuriance that proliferates every year, a literature has grown up.

As an emblematic figure of the twenties, epitomizing the flappers, jazz babies, and dancing daughters of the boom years, Brooks has few rivals, living or dead. Moreover, she is unique among such figures in that her career took her to all the places—New York, London, Hollywood, Paris, and Berlin— where the action was at its height, where experiments in pleasure were conducted with the same zeal (and often by the same people) as experiments in the arts.

"Reminds me of the night when Buster Keaton drove me in his roadster out to Culver City, where he had a bungalow on the back lot of M-G-M. The walls of the living room were covered with great glass bookcases. Buster, who wasn't drunk, opened the door, turned on the lights, and picked up a baseball bat. Then, walking calmly round the room, he smashed every pane of glass in every bookcase."

"Here, inevitably, are Scott and Zelda. I met them in January, 1927, at the Ambassador Hotel in L.A. They were sitting close together on a sofa, like a comedy team, and the first thing that struck me was how *small* they were. I had come to see the genius writer, but what dominated the room was the blazing intelligence of Zelda's profile."

Of all the names that spilled out of Brooks's memories of America in the twenties, there was one for which she reserved a special veneration: that of Chaplin. "Do you know, I can't once remember him *still?* He was always standing up as he sat down, and going out as he came in. Except when he turned off the lights and went to sleep, without liquor or pills, like a child."

Despite the numerous men who have crossed the trajectory of her life, Brooks has pursued her own course. She has flown solo. The price to be paid for such individual autonomy is, inevitably, loneliness, and her loneliness is prefigured in one of the most penetrating comments she has ever committed to print: "The great art of films does not consist in descriptive movement of face and body, but in the movements of thought and soul transmitted in a kind of intense isolation."

From a Profile of Louise Brooks by Kenneth Tynan, appearing in this week's issue (June 11) of The New Yorker. Yes, The New Yorker.

Newspaper Ad:
Fortunoff on Fifth
Art Director:
Jim Clarke
Designer:
Jim Clarke
Photographer:
Klaus Lucka
Copywriter:
Richard Wagman
Agency:
Martin Landy Arlow
Client:
Fortunoff
Typographer:
Chelsea Typographers Corp.
Printer:
Potomac Graphic
Industries, Inc.

681 FIFTH AVENUE at 54th STREET: Monday-Saturday 10AM to 6:30PM, Thursday to 8:30PM, Sunday from Noon to 5PM. Call (212) 758-6660. Out of New York State call toll-free (800) 223-2326. Also in WESTBURY, L.I. on Old Country Road and PARAMUS, N.J. at Paramus Park Mall. We honor the American Express Card.

Look breathtaking in jewelry from the **Christian Dior** collection.

Breathless is Your Dior.

NAPIER IS SAVVIER.

Lariat, $15.

Napier® 530 Fifth Avenue, NY 10036. At fine stores everywhere

The VEILED REDS

Deep down inside all bright reds
are other reds longing to slink out.
They are muted, mysterious, worldly.
The reds of darkened corners
and mature experience.

For your eyes, your cheeks, your lips,
your nails, your libido.

And only from

'ULTIMA' II
CHARLES REVSON

Magazine Ad:
The Veiled Reds
Art Director:
Martin Stevens
Designers:
Martin Stevens,
John Abbate
Photographers:
Richard Avedon,
Phil Marco
Copywriter:
Rita Grisman
Agency:
Revlon Creative
Workshop, Inc.
Client:
Revlon, Inc.

What kind of blossoms have no stems, no leaves,
never fade, come in clear, fresh, romantic colors,
and look even more beautiful on your eyes,
your lips, your nails than in a bouquet?

BLOSSOMS
'ULTIMA' II
CHARLES REVSON

A celebration of colors for spring. In lipstick, lipgloss,
lip liner pencil, eye shadow, blush, all over face color, nail enamel

Magazine Ad:
Blossoms 'Ultima' II
Art Director:
Constance von Collande
Designers:
Constance von Collande,
John Abbate
Photographers:
Rebecca Blake,
Jerry Friedman
Copywriter:
Rita Grisman
Agency:
Revlon Creative
Workshop, Inc.
Client:
Revlon, Inc.

Magazine Ad:
"Fisher-Price knows that
the more huggable. . ."
Art Director:
Raphael Morales
Photographer:
David Langley
Copywriter:
Francesca Blumenthal
Design Firm:
Waring & LaRosa, Inc.
Client:
Fisher-Price Toys

Magazine Ad:
"Fisher-Price knows that
toddlers. . ."
Art Director:
Raphael Morales
Photographer:
David Langley
Copywriter:
Francesca Blumenthal
Design Firm:
Waring & LaRosa, Inc.
Client:
Fisher-Price Toys

Magazine Ad:
"Fisher-Price created this
not-so-typical
phonograph. . ."
Art Director:
Vince Salmieri
Photographer:
David Langley
Copywriter:
Liane Revzin
Design Firm:
Waring & LaRosa, Inc.
Client:
Fisher-Price Toys

Fisher-Price knows that the more huggable a toy is, the more washable it should be.

Somehow a soft, lovable toy gets lugged around everywhere. It shares the highchair and gets fed strained peas. It rides in the stroller and the car and the little red wagon. It topples into sandboxes and bathtubs and mudpuddles. And then, of course, your child insists on taking it to bed.

That's why all the toys on this page are made to go into the washing machine without a protest. Toys like our new Pillow Pals, two nursery-rhyme dolls that nestle into their own pillows at the end of the day. Or our new Puppy with his own soft pillowy Playhouse.

Every one of our squeezable toys is the kind that children find as inseparable as the fabled "blue blanket." And that's why Fisher-Price makes sure that every one comes out of the wash fresh, smiling and ready to love again.

Fisher-Price knows that toddlers have very short legs and a very big urge to go places.

So we designed three sturdy riding toys to take them there.

They are all perfectly balanced not to tip, because at first just getting on and off is a project. The next challenge is to get the legs going in the right direction. (Most beginners start by going backwards.) But soon, they not only go forward, they learn to steer, u-turn and stop on a dime.

There's storage space in all three toys and room for imagination, too. Our Riding Horse goes clippety-clop as he rolls merrily by. Our Creative Coaster brings along its own plastic blocks or other gear. And our Explorer makes a terrific revving-up sound.

Of course our riding toys are almost indestructible. Because they're going to ride fast and hard and long. They're going to ride like the wind.

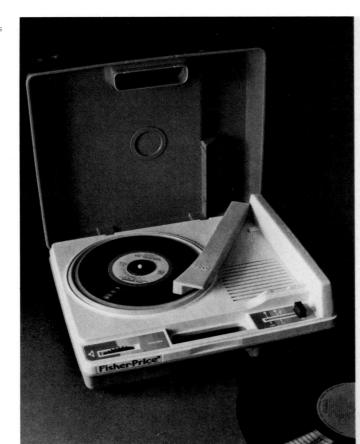

Fisher-Price created this not-so-typical phonograph to survive a typical childhood.

Fisher-Price knows that children begin to appreciate music at a very early age. Usually, a little before they fully appreciate how to handle delicate things like tone arms and fragile records.

That's why we designed our new phonograph with lots of features other record players don't offer. To assure that this phonograph can take the toughest treatment young music lovers can hand out and keep playing in fine tune year after year.

1. There's a real, replaceable diamond needle that lasts five times longer than a sapphire needle.

2. The needle cartridge actually retracts when the tone arm is forced down, to prevent deep scratches.

3. The tone arm is solidly constructed so it can be pulled and tugged and still work smoothly.

4. The detachable case cover is specially designed to gently guide the tone arm back in place even if the cover is slammed shut.

5. The phonograph's 4" speaker provides a nice clear sound. And there are just two simple controls for volume and record speed (33 and 45 rpm) plus a built-in storage space for the electrical cord.

So you can see, the Fisher-Price Phonograph is not a toy. It's a really dependable piece of audio equipment that's made especially for children. So you, and they, can relax and enjoy its wonderful sound for years to come. And that should be music to your ears.

Instant movie star.

We all tend to get a bit self-conscious when we get before a camera—especially a movie camera.

Yet, if the truth be told, we all secretly itch to see ourselves on the silver screen.

Maybe it's the effect of Hollywood, or maybe it's just human nature, but there it is. We wonder what we'd look like.

Take movies of any group of people, and show them the movies, and every one of them will look at himself, or herself, first.

"Oh, I look awful!"

"Gee, is that really me?"

"Suzy looks terrific, but my hair's a mess." (Translation: "Even with my messy hair, I look twice as good as Suzy.")

It's curious. You never get anyone saying, "I really look great." That would be immodest.

However, one thing becomes immediately apparent. Everyone *else* looks pretty much like you expected.

Because, unlike photographs, movies don't catch you in that 1/100 of a second when you blinked, or had an unfortunate expression on your face.

The movie camera gives you the opportunity to see yourself as others see you.

Polavision is Polaroid's name for instant movies.

They're actually easier to take than conventional photographs.

The film develops in the player automatically.

You just pop the Polavision cassette into the player, and you're ready to watch.

The first time you view the film after you shoot it, it takes 90 seconds to develop.

Every time after that, it takes only 8 seconds to come to life.

Over and over again, if you like.

There's no screen to put up and take down. No projector to thread and rewind.

It's so easy, your preschooler can do it.

When the film is over, the cassette pops up like a slice of

toast, and the player turns itself off automatically.

You don't even need to store the player. It's compact, and well designed, so you can leave it sitting out, plugged in, if you like.

So your kids can look at your movies (or their movies—it's that simple) whenever the mood strikes them.

And because it's not a big production to watch Polavision, you can see what your acting talent is like.

So don't be surprised if, after shooting a couple of movies, you stop thinking of yourself as a director.

And hand the camera to someone else, and start thinking of yourself as a star.

Polavision from Polaroid

"Polaroid" and "Polavision" © Polaroid Corp. 1978. Simulated picture.

Magazine Ad:
Instant Movie Star
Art Directors:
Robert Reitzfeld,
George White
Designer:
George White
Photographer:
Bill Stettner
Copywriter:
Dick Jackson
Design Firm:
Altschiller, Reitzfeld
& Jackson
Client:
Polaroid Corp.
Typographer:
T.G.I.
Printer:
Master Eagle Photo
Engraver

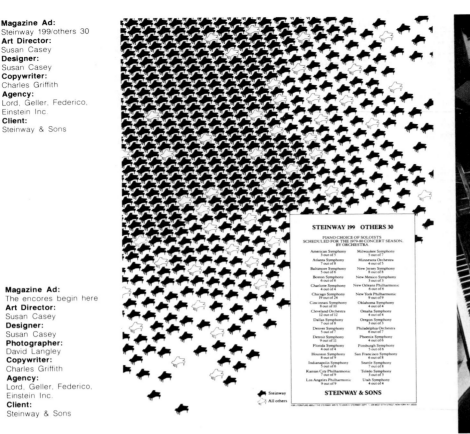

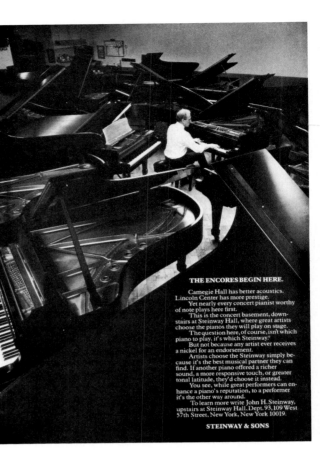

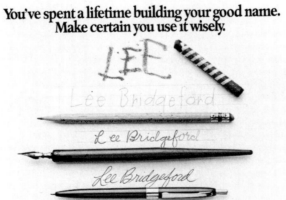

Magazine Ad:
Begin the eighties on top of the world!
Art Director:
Milton Glaser
Designer:
Karen Skelton
Artists:
Milton Glaser,
Karen Skelton,
George Leavitt
Copywriter:
Ron Holland
Design Firm:
Milton Glaser, Inc.
Client:
Windows on the World
Typographer:
Haber Typographers

Magazine Ad:
Sony Tape.
Full Color Sound.
Art Director:
Joe LaRosa
Artist:
R.O. Blechman
Copywriter:
Robert Oksner
Design Firm:
Waring & LaRosa, Inc.
Client:
Sony Corp. of America

SONY TAPE. FULL COLOR SOUND.

Sound has color. And Sony audio tape with Full Color
Sound reproduces every shade of color that's in the sound

itself. It can actually record more
sound than you can hear. Try it, and listen to all that color!

© 1979 Sony Industries, A Division of Sony Corp. of America. Sony is a trademark of Sony Corporation.

Sony Tape.
Full Color Sound.

Music is full of color. Incredibly beautiful color. Color that you can hear...and (if you close your eyes) color you can almost see. From the soft pastel tones of a Mozart to the blinding brilliant flashes of hard rock to the passionately vibrant blues of the Blues.

In fact, one of the most famous tenors in the world described a passage as "brown ...by brown I mean dark...rich and full."

Music does have color. Yet when most people listen to music they don't hear the full rich range of color the instruments are playing. They either hear music in black-and-white, or in a few washed-out colors.

That's a shame. Because they're missing the delicate shading, the elusive tints and tones, the infinite hues and variations of color that make music one of the most expressive, emotional and moving arts of all.

Music has color. All kinds of color. And that is why Sony is introducing audio tape with Full Color Sound.

Sony tape with Full Color Sound can actually record more sound than you can hear.

So that every tint and tone and shade and hue of color that's in the original music will be on the Sony tape. Every single nuance of color, not just the broad strokes.

Sony tape with Full Color Sound is truly different. Full Color Sound means that Sony tape has a greatly expanded dynamic range — probably more expanded than the tape you're using. This gives an extremely high output over the entire frequency range, plus a very high recording sensitivity.

There's even more to Sony tape with Full Color Sound, however. Sony has invented a new, exclusive SP mechanism for smoother running tape, plus a specially developed tape surface treatment that gives a mirror-smooth surface to greatly reduce distortion, hiss and other noise. Each type of tape also has its own exclusive binder formulation, that gives it extra durability.

Any way you look at it — or rather, listen to it, you'll find that Sony tape with Full Color Sound is nothing short of superb.

If you're not hearing the whole rainbow on your audio tape, try recording on Sony tape with Full Color Sound. Then you'll be hearing all the glorious full color that makes every kind of music, music.

© 1979 Sony Industries, A Division of Sony Corp. of America. Sony is a trademark of Sony Corporation.

Thelonious Bach

We play both sides

'G B H
Radio 89.7fm

FATS WAGNER

For people who want the best of both

WGBH RADIO 89.7 FM

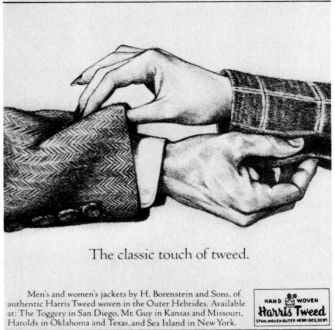

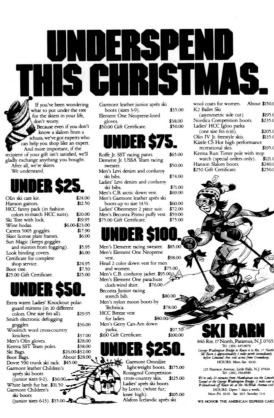

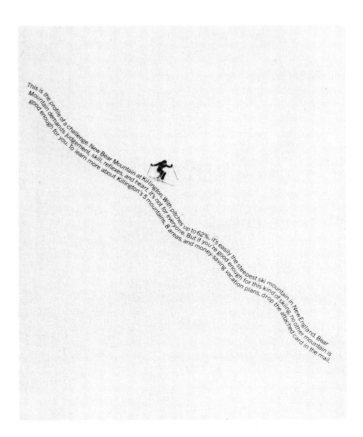

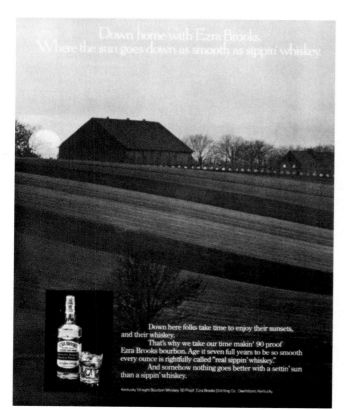

Down home with Ezra Brooks.
Where the sun goes down as smooth as sippin' whiskey.

Down here folks take time to enjoy their sunsets, and their whiskey.
That's why we take our time makin' 90 proof Ezra Brooks bourbon. Age it seven full years to be so smooth every ounce is rightfully called "real sippin' whiskey."
And somehow nothing goes better with a settin' sun than a sippin' whiskey.

Kentucky Straight Bourbon Whiskey 90 Proof. Ezra Brooks Distilling Co., Owensboro, Kentucky.

The evolution of the art of being a Gentleman.

16th Century/Sir Walter Raleigh
In Sir Walter's time, all it took was a few acts of chivalry to be considered a gentleman.

18th Century/Giovanni Casanova
Casanova became known as a gentleman through his devilish charm and savoir-faire.

19th Century/Beau Brummell
Brummell established his place as a gentleman with sophisticated taste in fashion.

Givenchy Gentleman.
The fragrance that separates the ordinary man from the gentleman.

These days, being a gentleman takes a different kind of style and finesse. So now the man of today can be a gentleman just by wearing Givenchy Gentleman.

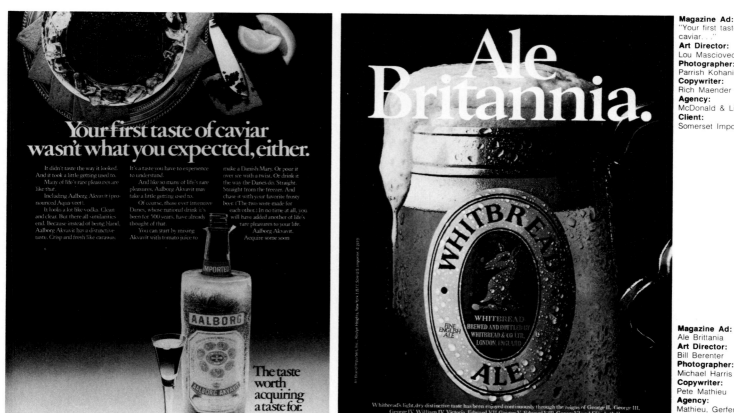

Your first taste of caviar wasn't what you expected, either.

It didn't taste the way it looked. And it took a little getting used to. Many of life's rare pleasures are like that.
Including Aalborg Akvavit (pronounced Aqua-veet).
It looks a lot like vodka. Clean and clear. But there all similarities end. Because instead of being bland, Aalborg Akvavit has a distinctive taste. Crisp and fresh like caraway.

It's a taste you have to experience to understand.
And like so many of life's rare pleasures, Aalborg Akvavit may take a little getting used to.
Of course, those ever inventive Danes, whose national drink it's been for 500 years, have already thought of that.
You can start by mixing Akvavit with tomato juice to

make a Danish Mary. Or pour it over ice with a twist. Or drink it the way the Danes do. Straight. Straight from the freezer. And chase it with your favorite frosty beer. (The two were made for each other.) In no time at all, you will have added another of life's rare pleasures to your life.
Aalborg Akvavit.
Acquire some soon.

The taste worth acquiring a taste for.

© 1979 Somerset Importers, Ltd. New York, N.Y., 90 Proof.

Ale Britannia.

Whitbread's light, dry distinctive taste has been enjoyed continuously through the reigns of George II, George III, George IV, William IV, Victoria, Edward VII, George V, Edward VIII, George VI and Elizabeth II.
Whitbread Ale from London's oldest independent brewery. The taste of the Empire since 1742.

A Conoco resin helped a customer become a success in the flea market.

A new flea collar is now doing well in the market.

But starting from scratch, the maker needed a resin that would be compatible with the collar's pesticides.

Testing of Conoco's 5465 PVC Resin showed a high compatibility.

Also, the resin ran well due to its superb flow properties, blistering was avoided, the reject rate was reduced 5-8%, and the buckle was easy to attach.

So another of our pet projects turned out to be a howling success.

And we can do the same for yours.

Already, we're in everything from sneakers to toys, carpet runners to wall coverings, power cables to appliance wire, and hundreds of other products.

So why not mail the coupon for technical data sheets on our line of resins and compounds? You'll be barking up the right tree.

Please send information on the materials checked below.
☐ PVC Resins ☐ PVC Powder Compounds ☐ Injection Molding Compounds
☐ Extrusion Compounds ☐ Wire and Cable Compounds ☐ Plasticizers

Name _____

Address _____ Phone _____

City _____ State _____ Zip _____

Company _____ Title _____

Application _____ MP

CONOCO CHEMICALS COMPANY, A DIVISION OF CONTINENTAL OIL COMPANY, P.O. BOX 2197, HOUSTON, TEXAS 77001

Magazine Ad:
"A Conoco resin helped a customer. . ."
Art Director:
Charles Hively
Designer:
Charles Hively
Photographer:
Carl Fischer
Copywriter:
Bob Miller
Design Firm:
Metzdorf Advertising Agency
Typographer:
Professional Typographers
Printer:
Haywood Graphics

How to put your foot down on a common problem.

R·Texas·S ROACHES

Try not to panic. Roaches are as common in Texas as long neck beers, pickup trucks and Arabian oil sheiks. And long after the above are all gone, Texas roaches will still be around.

If you want to help prevent roaches in your home or want to know how to best get rid of them, here are some helpful facts about these long-time Texans.

1) If you want to poison these critters, make sure a residual pesticide is used. A non-residual poison is not a good bet because it merely acts as a repellant. The poison loses its effectiveness soon after it is sprayed. With a residual poison, this doesn't happen.

2) To effectively control roaches, spray residual poison around all floor boards, in all cupboards. In fact, in just about every nook and cranny you can find. Obviously don't spray food or pet dishes, etc.

3) To dissuade roaches, keep your home as clean as possible. Don't leave unwrapped food laying around. That's Beluga caviar for a roach.

4) There are four different kinds of Texas roaches:
a. The German roach. Lives indoors, has black racing stripes and is about ½ inch long. In a single year a female can be responsible for 35,000 more roaches because of their 90-day life cycle.
b. American roach. This roach looks like a 1958 Buick. Very large and prefers to live outside. This is the roach that strikes fear in the hearts of most people when

spotted in the home, because of its large brown size.
c. Smokey Brown roach. Not quite as large as the American, but just as scary to the uninformed.
d. Oriental roach. This roach is only a problem in El Paso. Like the American and Smokey Brown prefers the great outdoors and should be treated where it's most likely to live. In flower beds, mulch and wood piles, anywhere it's dark, moist and reasonably creepy looking.

5) The Smokey Brown, German and Oriental roach live up to three years.

6) Roaches are super sensitive to light and heat. A roach can detect your presence in a room just by your body heat. This is why it's difficult to stomp them. They've got the jump on you even before you've spotted them.

7) Lastly, stomping a roach takes a great deal of practice. You need to be quick and wear the correct type of stomping gear. Lightweight leather shoes are highly recommended because roach bodies generally do not stick to leather.

For more information on roaches write:

The Texas Society for the Control of Roaches
2135 Bissonnet; Houston, Texas 77005

Keep in mind however, we're an informal, non-profit organization. We'll try to answer your roach questions as soon as we can. Please be patient. More pests we don't need.

Magazine Ad:
Texas Roaches
Art Director:
Yvonne Tocquigny
Designer:
Yvonne Tocquigny
Photographer:
James Stevens/
Flat Lizard Graphics
Copywriter:
Ed Kennard
Design Firm:
Winius-Brandon/
Texas, Inc.
Client:
Texas Society for the Control of Roaches
Typographer:
Typografiks
Printer:
San Jacinto Graphics Co.

Goodbye, bear.
Goodbye, bull.
Hello, squirrel.

Does "bear" or "bull" describe today's investment climate?

Or could it be a squirrel market? Squirrels don't hibernate. Nor do squirrels run in herds.

They gather and store their riches. Protect their accumulated wealth. And venture forth, with prudence and care, even on winter's coldest days.

At Drexel Burnham Lambert, we believe that astute investors behave similarly.

They're not bullish. Perhaps on certain stocks. But not about the entire market.

They're not bearish. Again, they may view some investments pessimistically. But they don't believe the sky is about to fall.

Drexel Burnham Lambert caters to such investors. An important distinction. For it's tougher to satisfy squirrels than it is to pander to a herd. And more demanding than waiting for sleeping bears to awake.

That's why we offer the prudent investor many meaningful advantages. Including full access to more than a

thousand investment professionals. Research hailed by customers and competitors alike. A truly international investment perspective. And a full range of investment products.

We'd like you to capitalize on these advantages. And with a single contact. For all our doors are open, all our capabilities are available, to any customer, without reservation.

You see, Drexel Burnham Lambert is a big international investment banker and broker. But not *too* big. We know we must help you realize your goals if we're to realize ours.

Drexel Burnham Lambert.

Whether the investment climate is winter-cold or summer-hot, you'll find we're a firm for all seasons.

Drexel Burnham Lambert
The professionals who care.

Magazine Ad:
Goodbye, bear.
Art Director:
Mark Hogan
Artist:
Stan Mack
Copywriter:
Jim Johnston
Agency:
Jim Johnston Advertising
Client:
Drexel Burnham
Lambert, Inc.

© Conoco Chemicals Company. A Division of Conoco Inc. Houston, Texas

How the human mind can expand the realm of possibility.

"No barriers, no masses of matter however enormous, can withstand the powers of the mind; the remotest corners yield to them; all things succumb; the very heaven itself is laid open." These words were written by a man named Marcus Manilius almost 2,000 years ago. Read them carefully. And remember them well.

For though these words carry the advantages of eloquence, they signify much more than the facility of a writer who has long since turned to dust.

These words express a truth that time cannot age or alter.

Because there is in all of us a need to understand that is immortal and insatiable. A need that makes the unknowable food for thought and the unheard-of music to our ears.

At Conoco Chemicals we are more than mindful of this need.

It is an intrinsic part of what we are and what we hope to be. For our need to know has compelled us to develop the kind of technology that will solve the problems we put to it.

The kind of technology that, when coupled with our supply self-sufficiency and financial strength, can breach the barrier between what is possible and what is not. The many advancements and refinements that we are presently responsible for are, we feel, both proof and promise.

Because the level of technology we have achieved is only the beginning of the kind of expertise that we are striving to attain. For Manilius was right. There are no real boundaries to the realm of possibility. There are only opportunities.

Opportunities that we intend to tirelessly pursue. Opportunities that we intend to share with you.

Conoco Chemicals

Magazine Ad:
"How the human mind can expand. . ."
Art Director:
Charles Hively
Designer:
Charles Hively
Artist:
Jean-Michel Folon
Copywriter:
Mary Langridge
Design Firm:
Metzdorf Advertising Agency
Client:
Conoco Chemicals Company
Typographer:
Professional Typographers
Engraver:
Pioneer Moss

In the beginning was the word.

Some of our best product ideas started out as a cry for help.

Customers with problems looking to us for answers At Inland Steel, we look at your problem as both a challenge and an opportunity.

Take our new heat-resistant Aluma-Ti, for instance.

Catalytic converters and inlet pipes have to stand up to intense heat and corrosion. It's a tough life for a converter, but not necessarily a short one. We developed super heat resistant Aluma-Ti steel to shrug off temperatures up to 1500° Fahrenheit.

Back in the thirties, we heard a cry for help to develop a steel that would machine better to keep pace with advancing industrial machining techniques. We answered by inventing Ledloy, and it became the premier leaded steel of its day. And today, Ledloy AX-Tellurium Bearing

Steel is the fastest free machining steel in the world.

Now while our booted feet manage to survive the salt on winter streets, it's hard on our automobiles' finish.

That's why Inland took the lead in commercially developing Zincrometal, the fastest-growing automobile corrosion protection around.

And now we've gone a step better and created Paint-Tite B.

With Paint-Tite B, today's answer to car corrosion problems, car panels get inside/out zinc alloy protection: superior rust resistance, weldability and exceptional paintability. Corrosion gets the cold shoulder.

Again, because we make coil coated steel, we've been asked to solve customer problems from priming to paint line clean-up and fume and residue pollution.

The answer? Inland Weldable Primers.

Instead of forming obstructive insulation, our primers conduct heat through the coating directly to your steel for welding. And, since you don't do the priming, you don't worry about plant pollution and clean-up.

The energy crisis has also provided a challenge.

With thirty-six electric motors in the average home, America's energy shortage is no small problem. So Inland R&D people, using a computer to find correlations between steel properties and motor designs, developed an advanced series of Lamination Steels that provide significantly better magnetic properties than competitive electric steels.

And, speaking of the energy shortage, we're helping American cars trim off excess weight.

Inland's emphasis on metallurgical technology created

light weight, highly-formable, high strength steels we call Hi-Form. Developed with the auto industry's concern for less weight, more mpg's in mind, Hi-Form steels are formable, weldable and paintable.

So you see, when American industry calls for help, somebody out there is listening.

We are.

Whether you have a problem right now or not, we figure you'll want to talk to a progressive, innovative steel company that really listens. Call your Inland Sales Representative or write: Inland Steel Company, 30 West Monroe Street, Chicago, Illinois 60603.

◆ **Inland Steel**

IT'S ABOUT TIME WE LEARNED HOW TO LISTEN.

There's a problem in this country that has cost American industry billions of dollars in losses.

As well as far greater human losses between man and woman. Parent and child. Country and country.

And that's the problem of people not knowing how to listen.

Most of us spend about half our waking hours listening.

Yet research studies show that we retain only 25% of what we listen to.

Which isn't surprising. Because listening is the one communication skill we're never really taught.

We're taught how to read, to write, to speak—but not to listen.

And listening <u>can</u> be taught.

In the few schools where listening programs have been adopted, listening comprehension among students has as much as doubled in just a few months.

And listening can also be taught in business.

Listening has been part of many Sperry training and development programs for years.

And we've recently set up expanded listening programs for Sperry employees worldwide. From sales representatives to computer engineers to the Chairman of the Board.

These programs are making us better at listening to each other.

And perhaps more important, making us even more aware of how essential good listening is. An awareness we can then bring to the people we do business with, as well as the people we live with.

The listening problem affects us all: Man and woman. Businessman and businessman. Even country and country.

We understand how important it is to listen.

Sperry is Sperry Univac computers, Sperry New Holland farm equipment, Sperry Vickers fluid power systems, and guidance and control equipment from Sperry division and Sperry Flight Systems.

How good a listener are you?
Write to Sperry, Dept. 4A, 1290 Avenue of the Americas, New York, New York 10019 for a listening quiz that's both fun and a little surprising.

Work your off.

Michael Salerno Exercise for Men & Women, 840 S. Robertson Blvd., 659-4061. By Appointment.

Magazine Ad:
Work your off.
Art Director:
Deborah Rodney
Photographer:
Bert Rhine
Copywriter:
Linda Chandler
Design Firm:
Deborah Rodney
Client:
Michael Salerno Exercise
Typographer:
Joe's Type Shop

MILLIONS OF MEN, WOMEN AND CHILDREN HAVE TRIED TO DESTROY THE TALON 42. AND FAILED.

Never has one zipper gone through so much in so many jeans. For over 20 years the Talon 42® metal zipper has been stretched, scrubbed, tumbled and trampled in more than 2½ billion jeans. And it still survived. Now, that's proven performance.

Which is why the Talon 42 zipper is the overwhelming choice of jeans manufacturers today.

So when you choose a jeans zipper, remember that millions of men, women and children have failed to destroy the Talon 42 metal zipper. You can turn their failure into your success.

Talon

Proven performance, not promise. That's what we're all about.

Talon **TEXTRON**
Talon Division of Textron Inc.

Newspaper Ad:
"Millions of men, women and children . . ."
Art Director:
Tom Wai-Shek
Designer:
Tom Wai-Shek
Artist:
Ray Domingo
Copywriter:
Alan Braunstein
Agency:
DKG Advertising, Inc.
Client:
Talon Division of Textron, Inc.

Magazine Ad:
Primavera Ristorante
Art Director:
Jennifer Clarke
Designer:
Jennifer Clarke
Artist:
Jennifer Clarke
Copywriter:
Jennifer Clarke
Design Firm:
Jennifer Clarke
Client:
Harley Baldwin
Typographer:
Jennifer Clarke
Printer:
Aspen Anytime Magazine

Primavera
RISTORANTE

HOMEMADE
PASTA
—serving LUNCH,
DINNER &
APRÈS MOVIE
Credit cards
accepted.
LOCATED in the
BRAND BUILDING,
Corner of HOPKINS
& GALENA.
925-6120

PRIMAVERA
RISTORANTE

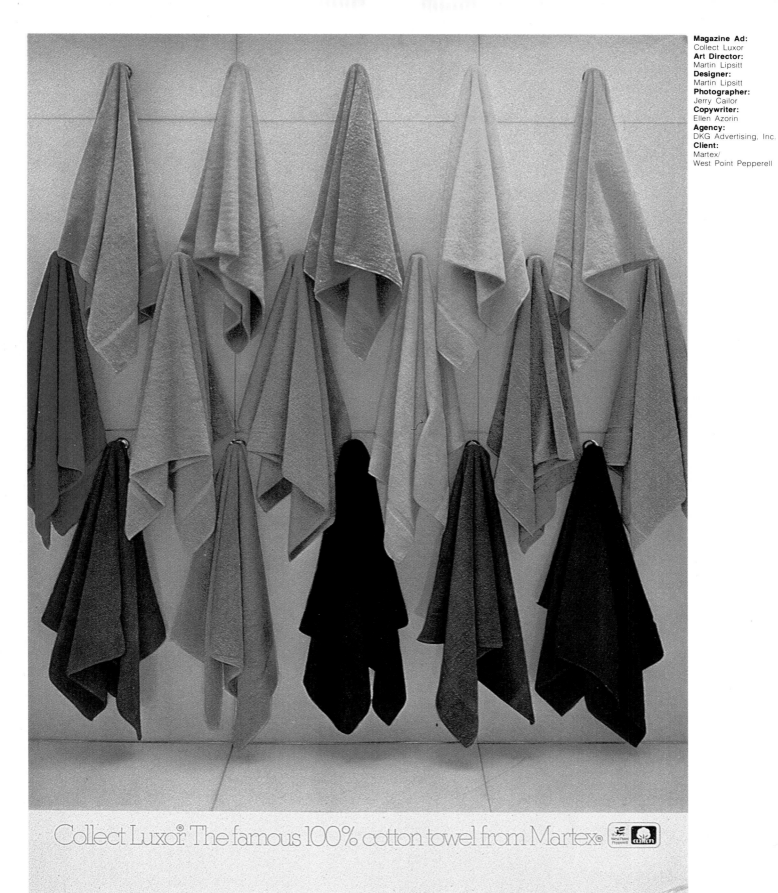

Collect Luxor® The famous 100% cotton towel from Martex®

Magazine Ad:
Collect Luxor
Art Director:
Martin Lipsitt
Designer:
Martin Lipsitt
Photographer:
Jerry Cailor
Copywriter:
Ellen Azorin
Agency:
DKG Advertising, Inc.
Client:
Martex/
West Point Pepperell

Magazine Ad:
"Playboy exposes the part of Burt Reynolds . . ."
Art Director:
Earl Cavanah
Copywriter:
Larry Cadman
Design Firm:
Scali, McCabe, Sloves, Inc.
Client:
Playboy Enterprises

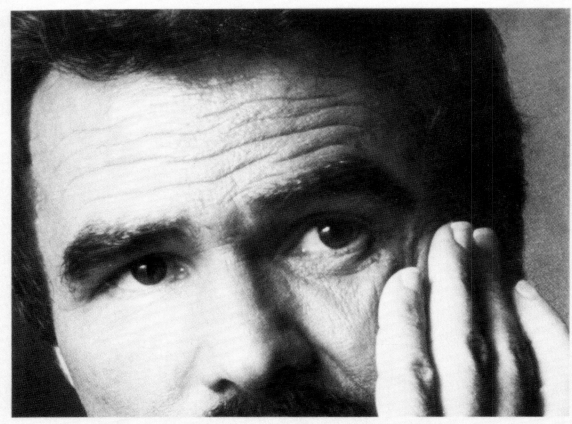

PLAYBOY EXPOSES THE PART OF BURT REYNOLDS COSMOPOLITAN IGNORED.

This month, Playboy induces Burt Reynolds to reveal his most interesting feature of all: his mind.

In a rare interview, America's #1 box office attraction—and Playboy's cover feature this month—talks candidly about acting, success, jealousy and the women in his life.

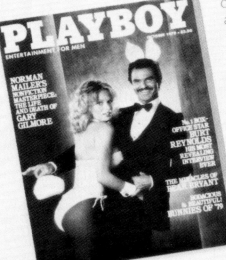

And Burt is just the beginning. This month's Playboy also features the first installment of a new non-fiction masterpiece by Norman Mailer. An article on Bear Bryant, college football's miracle worker. And a revealing look at some other winners: the Bunnies of '79 and the Playmates from 'Apocalypse Now.'

Pick up the October Playboy today. It's much too good to ignore.

THE OCTOBER PLAYBOY. AT NEWSSTANDS NOW.

20¼"

13"

Nothing is bigger than LIFE

Charles Rubens II, Advertising Sales Director. (212) JU 6-1212

For those unforgettable evenings...

CHANNEL
N°2

W G B H TV

Magazine Ad:
Nothing is bigger
than LIFE
Art Director:
Jim Adair
Designer:
Jim Adair
Artist:
Jim Adair
Copywriter:
Gilbert Lesser
Agency:
Geer Dubois Advertising
Client:
Life Magazine

Newspaper Ad:
Channel No. 2
Art Director:
Christopher Pullman
Designer:
Christopher Pullman
Photographer:
Tom Sumida
Copywriters:
Caroline Collins,
Christopher Pullman
Agency:
WGBH Educational
Foundation
Client:
WGBH
Typographer:
Letraset

Magazine Ad:
Sensation is Your Dior
Art Director:
Gene Federico
Designer:
Gene Federico
Photographer:
Chris von Wangenheim
Copywriter:
Gene Federico
Agency:
Lord, Geller, Federico,
Einstein, Inc.
Client:
Christian Dior

Sensation is Your Dior.

Look and feel sensational in hosiery from the **Christian Dior** legwear collection.

Newspaper Ad:
"Whether she's about to slide into a Santa Claus suit..."
Art Director:
Jeff McKay
Photographer:
Gosta Peterson
Copywriter:
Geraldine Stutz
Design Firm:
Henri Bendel
Advertising Dept.
Client:
Henri Bendel

Whether she's about to slide into a santa claus suit—or the prettiest christmas party dressing—she'll feel sensational with something silky against her skin/ bendel's lingerie shop is currently crammed with teddys and tap pants and camisoles and petticoats—in the most melting colours of satin, georgette, and crepe de chine/ so now's the time to ho-ho-ho your way to the home of the hottest underwear in town, on 5 at 10 west 57th

HENRI BENDEL

Magazine Ad:
"We love active sports..."
Art Director:
Richard Trask
Designer:
Richard Trask
Photographer:
Patrick DeMarchelier
Copywriter:
Richard Trask
Design Firm:
Don Wise & Co.
Client:
Personal Sportswear
Typographer:
Photolettering, Inc.
Printer:
Sterling Graphics

we love active sports....we could watch them all day!

PERSONAL PLAYERS

Presenting a premier collection of relaxed sportswear. Personal Sportswear 1437 Broadway 212-221-4248
A division of Leslie Fay Inc.

Our pie was a smashing success.

Our objective was to present you with the opportunity to tell us, good or bad, what you felt about our company and our products.

And, that's exactly what you did.

In our pie ad, we asked you not to hold back; that we'd take whatever you dished out.

The results: One pie in my face was worth more than 100,000 words from dealers, sales people and service stations all across the country.

Right now, I'm in the process of personally replying to each of the more than 600 responses we've received.

We did get a few "sour notes." Several of you complained about parts availability. Others felt our warranty service rates should be raised. A few of you asked that our reps be more responsive, or questioned our distribution channels.

While none of our "sour notes" represent universal, across-the-board problems, we are working on solving them all, and—where necessary—have already taken corrective action.

Most of the "sweet notes" we got praised Marantz stereo components for their overall quality, performance and design.

We have achieved the goal of our pie ad. We are now able to take your input and use it to improve our methods of serving you.

We intend to keep the communication lines open so that, if you ever have a problem, you can let us know about it right away. Even if you have to hit me with it.

Thanks, again, to all of you who cared enough to take the time to write. And, yes, that was me on the receiving end of that pie.

Fred Trahurshey

marantz.
Good for your system

DON'T TRUST YOUR OVEN!

The Perdue 'Oven Stuffer' Roaster with new Bird-Watcher thermometer always comes out perfectly—no matter how big a liar your oven is.

Oven temperatures can vary up to 75°F. colder or hotter than the temperatures people set them for. But even if your oven is that far off, it won't prevent you from enjoying the 'Oven Stuffer' Roaster at its delicious best. The built-in Bird-Watcher thermometer makes sure of that. When it pops, it's perfect. Which means that even though you may not be able to trust the people who made your oven—you can be sure if it's Perdue.

Too Bad You Weren't Invited.

AMERICAN BEER DRINKERS ARE NOW PROTECTED BY GERMAN LAW.

Anyone who drinks fine German beer in Germany is protected by a German law written way back in 1516. The 'Reinheitsgebot.' (Pronounced Rine-hites-ga-boat. Reproduced above.)

Actually, it's an Order of Purity. It dictates of what ingredients beer must be made. And how it must be brewed. And it practically guarantees that the beer drinker over there will get the taste he thirsts for when he orders beer.

When German beer is exported to America, however, sometimes Reinheitsgebot isn't followed at all.

Some exceptions are allowed.

Some artificial ingredients get added. Some shortcuts take place.

But not with Würzburger Hofbräu. Whether it's downed in Hamburg or Hartford, Würzburger is deliciously the same. Brewed in accordance with Reinheitsgebot. Of 100% prized natural ingredients 100% of the time.

And only Würzburger Hofbräu is shipped to the United States in enormous, air-tight, insulated barrels to keep it fresh and delicious.

(Würzburger is bottled after it gets here. And shortly before it gets to you.)

Which means, whether you savor German beer over here or over there, you can finally enjoy all the terrific taste you're entitled to under the Law.

Würzburger Hofbräu

IT TASTES AS GOOD HERE, AS IT DOES THERE.

WHEN YOU SERVE FINLANDIA VODKA, MAKE BETTER ICE.

There are few vodkas worthy of ice made with the finest natural water.

But after tasting Finlandia Vodka, you'll know why it's one that is.

People who experience the clean, icy character of Finlandia, consider it to be the finest vodka in the world.

One reason may be the water Finlandia is made with. Its 100% natural, drawn from a well beneath a 10,000-year-old glacial formation in Finland.

Which is why when serving Finlandia on ice, it would be a pity to undo in a second what it took nature 10,000 years to help create.

IMPORTED FINLANDIA. THE WORLD'S FINEST VODKA.

ANY BOURBON THAT CLAIMS TO BE THE WORLD'S BEST, BETTER HAVE THE PROOF.

Old Weller does. 107 proof, to be exact. Aged seven long years with the most loving care dedicated bourbon lovers could give it.

Old Weller The Original 107 Proof

We start with meticulously selected ingredients, including the Weller family secret "whisper of wheat." We seal it in barrels of handpicked white oak, charred on the inside to enhance the mellowing. We store it near a long row of windows at the top of the distillery, opening and closing the windows every morning and evening so the whiskey can breathe during the day without getting chilled at night. After seven years, it has become our pride and joy. This careful aging coupled with bottling at 107 proof produces a unique bourbon whiskey with a more sophisticated taste for the true bourbon connoisseur. High in proof, but incredibly smooth and mellow. As we like to say, "a great spirit, tamed but unbroken."

And since we consider what goes into a bottle of Weller 107 as good as gold, we actually spin a veil of 22-carat gold over the entire surface of each and every bottle.

Seek some Weller 107 out soon. It may be a bit hard to find, but then, the best things usually are.

Copyright ©1979 By W. L. Weller & Sons Distillery, Louisville, Kentucky. Kentucky Straight Bourbon Whiskey, 107 Proof

PHEASANT UNDER GLASS.

Fine feathery fowl gather on a feather-light plate, ringed in a glow of 24 karat gold. The coup de glass, wine while you dine. See how Mikasa innovates, tastefully co-ordinates crystal to plates.

THE BEST DRESSED TABLE WARES
MIKASA

The average set of fine china is used perhaps 100 times in a lifetime. That's a pity.

The world's best chili comes from your post office.

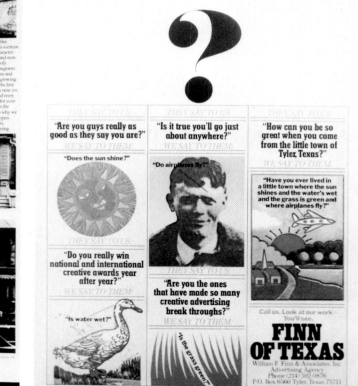

Patchwork solutions to facility management problems are really no solutions at all.

◡ **herman miller**

Magazine Ad:
Herman Miller
Art Director:
Ivan Chermayeff
Designers:
Steve Jenkins,
Ivan Chermayeff
Design Firm:
Chermayeff & Geismar
Assoc.
Client:
Herman Miller, Inc.

At Herman Miller, we concentrate on addressing the issues rather than merely treating the symptoms.

In the 1960's, while others were busy looking at ways to divide space in offices, we were asking questions about how workers work and managers manage. Which led to the Action Office* system, designed to support the way organizations really function, and to change as needs change.

And while others have been showcasing flashy new gadgetry, we've been developing

realistic new answers—and re-defining existing ones—to constantly improve the accommodation of today's work processes. Which has resulted in the kind of solutions your customers will appreciate both now and years from now.

It takes a clear corporate head and a steady grasp of the future to deal intelligently with dramatically changing work styles and management needs.

It takes the kind of responsible, research-based thinking Herman Miller provides best. A mentality that recognizes the value of a thoroughly satisfied customer. And knows how to keep that customer satisfied.

The next time you sit down to approach a project, look to the thinking beyond the hardware. Look to Herman Miller as your partner in the process.

Write for our booklet, *Your Partner in the Process*. Herman Miller Inc., Marketing Department, Zeeland, MI 49464.

Sales/education facilities in Atlanta, Boston, Chicago, Dallas, Detroit, Houston, Los Angeles, New York, San Francisco, Washington D.C., Amsterdam, Basel (Herman Miller AG), Brussels, London, Paris, Toronto and other key cities internationally.

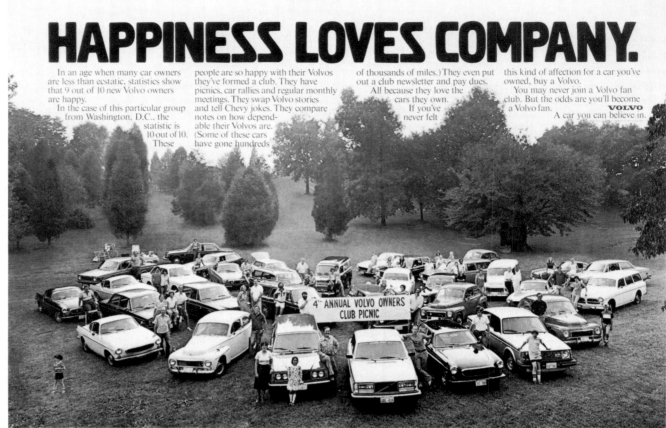

HAPPINESS LOVES COMPANY.

In an age when many car owners are less than ecstatic, statistics show that 9 out of 10 new Volvo owners are happy.

In the case of this particular group from Washington, D.C., the statistic is 10 out of 10. These people are so happy with their Volvos they've formed a club. They have picnics, car rallies and regular monthly meetings. They swap Volvo stories and tell Chevy jokes. They compare notes on how dependable their Volvos are. (Some of these cars have gone hundreds of thousands of miles.) They even put out a club newsletter and pay dues.

All because they love the cars they own.

If you've never felt this kind of affection for a car you've owned, buy a Volvo.

You may never join a Volvo fan club. But the odds are you'll become a Volvo fan.

VOLVO
A car you can believe in.

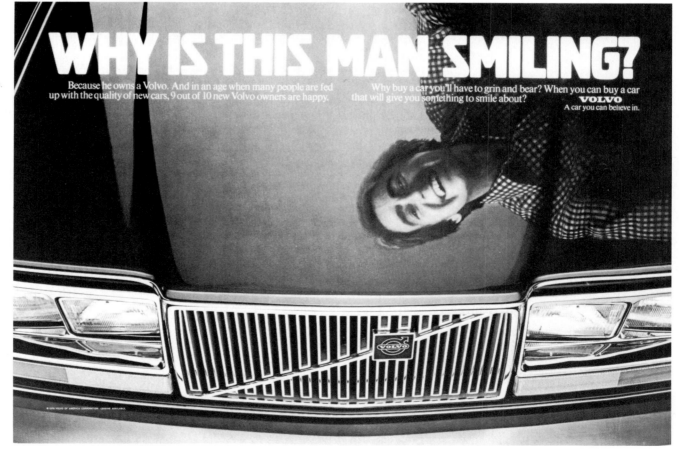

WHY IS THIS MAN SMILING?

Because he owns a Volvo. And in an age when many people are fed up with the quality of new cars, 9 out of 10 new Volvo owners are happy.

Why buy a car you'll have to grin and bear? When you can buy a car that will give you something to smile about?

VOLVO
A car you can believe in.

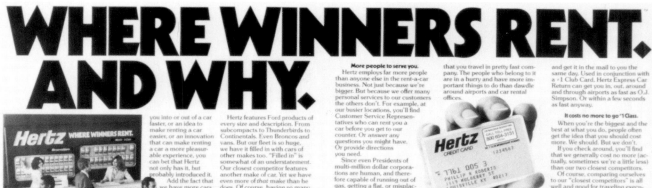

WHERE WINNERS RENT. AND WHY.

Winners have always rented from Hertz.

Forty-three years ago, Franklin Delano Roosevelt used a fleet of Hertz cars to carry his election campaign across the country. And won.

If you had aspirations to the highest office in the land, wouldn't you go with #1?

Winners just naturally go with winners. That's why so many people at the heads of their fields today rent from Hertz. The Presidents of over 80% of the top 500 companies in America rent from Hertz. As do many of the most important people in show business, sports, fashion and the arts.

Those who don't, probably don't, simply because they ride in limousines.

Nobody does it better than Hertz.

Hertz came up with the idea of renting cars in 1918. And we've been winning at it ever since.

If there's a service that can get you into or out of a car faster, or an idea to make renting a car easier, or an innovation that can make renting a car a more pleasurable experience, you can bet that Hertz not only has it, but probably introduced it.

Add the fact that we have more cars, more locations and more people to serve you than anybody else, and the thought of renting from anybody else becomes unthinkable.

The largest fleet of cars in the world.

You only rent one car at a time. So is this really important? It's important.

Hertz has over 240,000 cars and trucks around the world. So if you want a certain kind of car in a particular place at the appropriate time, you do what winners do. Take the odds.

Hertz features Ford products of every size and description. From subcompacts to Thunderbirds to Continentals. Even Broncos and vans. But our fleet is so huge, we have it filled in with cars of other makes too. "Filled in" is somewhat of an understatement. Our closest competitor features another make of car. Yet we have even more of that make than he does. Of course, having so many cars requires a sophisticated maintenance program to keep them all in perfect running condition.

This is another reason winners rent from Hertz. We don't put them into losers.

Wherever you are, we are.

Winners get around. Which is one of the main reasons they come to Hertz in the first place.

With over 4,000 locations around the world, it's hard to find a place where you won't find Hertz. This means you can go practically anywhere and pick up and drop off your car where it's convenient for you. Which is eminently more sensible than picking up and dropping off cars where it's only convenient for car rental companies.

More people to serve you.

Hertz employs far more people than anyone else in the rent-a-car business. Not just because we're bigger. But because we offer many personal services to our customers the others don't. For example, at our busier locations, you'll find Customer Service Representatives who can rent you a car before you get to our counter. Or answer any questions you might have. Or provide directions you need.

Since even Presidents of multi-million dollar corporations are human, and therefore capable of running out of gas, getting a flat, or misplacing their car keys, Hertz provides 24-hour-a-day Emergency Road Service. Services like this require a lot of people. And Hertz has them. But we're not out to impress you with numbers. The pride of Hertz isn't the size of the work force, it's the caliber of it.

One recurring theme in the mail we get from our customers is how nice and helpful Hertz people are. "How do you train them to be that way?," we're often asked. Well we've found that you can't train anyone to be nice or helpful. So we just hire the nicest people we can find and do everything possible to insure that they stay that way.

Today, Hertz wouldn't be the place where winners rent, if it wasn't also the place where winners worked.

Winners belong to an exclusive club.

Carrying a Hertz #1 Club Card offers you the world's fastest way to rent a car. It also tells other people that you travel in pretty fast company. The people who belong to it are in a hurry and have more important things to do than dawdle around airports and car rental offices.

If you rent a car more than two or three times a year, it could be the most worthwhile club you've ever joined.

Membership costs nothing. The advantage to you is that we keep all the information we need about you on file. So your rental agreement is filled out, ready and waiting, when you arrive at the counter. There's no waiting for a computer to slowly poke out all the details. You just show your credit card, your license, sign and go.

Hertz Express Car Return.

This is another time-saving service invented by Hertz. If you're a charge customer, you just drop your rental agreement in the Express Return box. We compute your statement and get it in the mail to you the same day. Used in conjunction with a #1 Club Card, Hertz Express Car Return can get you in, out, around and through airports as fast as O.J. Simpson. Or within a few seconds as fast anyway.

It costs no more to go #1 Class.

When you're the biggest and the best at what you do, people often get the idea that you should cost more. We should. But we don't.

If you check around, you'll find that we generally cost no more (actually, sometimes we're a little less) than our two closest competitors.

Of course, comparing ourselves to our "closest competitors" is all well and good for traveling executives whose companies are picking up the tab anyway.

But what can we offer someone who just wants to take the family on vacation and save some money? A lot. In fact, our weekly "Touring" rates and weekend "Take-Off Rates" are competitive with all but the most cut-rate operations.

Not bad when you consider that you also get to take advantage of all the resources and services Hertz offers the President of the company you work for. Right down to being chauffeured to your car in a luxurious bus instead of a dinky little van.

After all, you only get one vacation a year. Why travel like a loser?

WHERE WINNERS RENT.

Magazine Ad:
Where the winners rent. And why.
Art Directors:
Bob Wilvers, Norm Siegel
Photographer:
Alan Dolgins
Copywriter:
Ed McCabe
Design Firm:
Scali, McCabe, Sloves, Inc.
Client:
Hertz Corp.

The environment people work in should be designed around the work they do.

Imagine an office environment that takes its cues from the tasks people perform. That is infinitely adjustable, allowing swift, cost-effective response to changing needs.

Imagine, too, an advanced systems knowledge base, developed over years of research and refined in experience. An intelligence that ensures effective facility planning and management—before, during and after your move.

The Action Office system by Herman Miller. It's more than a place to work. It's a way to work better.

Send for our booklet, A Sensible Approach to Facilities. Herman Miller Inc., Marketing Department, Zeeland, MI 49464.

herman miller

Magazine Ad:
Herman Miller
Art Director:
Ivan Chermayeff
Designers:
Steve Jenkins,
Ivan Chermayeff
Design Firm:
Chermayeff & Geismar Assoc.
Client:
Herman Miller, Inc.

Magazine Ad:
"How I bought a
Volvo wagon. . ."
Art Director:
Jim Perretti
Photographer:
Phil Mazzurco
Copywriter:
Larry Cadman
Design Firm:
Scali, McCabe, Sloves, Inc.
Client:
Volvo of America Corp.

"HOW I BOUGHT A VOLVO WAGON AND LOST 1,000 POUNDS OF UGLY FAT."

By Pat Fellman, as told to Volvo.

"You wouldn't know it to look at me now, but I used to have a wagon that weighed two tons and felt a block long.

I thought that was the price you had to pay if you were a wife with kids, dogs and groceries to haul around.

One day, my oldest daughter, who had become very energy conscious, said, 'Mom, what are you driving that big thing for? Why don't you get something smaller?'

Then and there, I decided to lick this weight problem of mine.

First, I looked at the little station wagons. They felt tinny and unsafe. And they didn't hold much of anything.

Then I looked at the Volvo wagon. What a shock! It had almost as much room in back as the monster I'd been driving. Yet when I drove it, it handled more like my husband's sports car. It felt safe, solid, maneuverable. It was easy to park. And I could look over the steering wheel instead of through it.

Somehow, since buying that Volvo wagon, I feel more liberated."

Statistics show that 9 out of 10 people who have bought new Volvos are happy.

Why not follow the Volvo weight reduction plan yourself?

You have everything to gain.

VOLVO
A car you can believe in.

© 1978 VOLVO OF AMERICA CORPORATION LEASING AVAILABLE

"Before, I used to have to wrestle with a beached whale. No wonder I felt tired all the time."

"This is me after losing half a ton. I feel like a new woman."

Gaviscon. For the heartburn that hits a man when he's down.

It's 3 a.m. and you've got a 4-alarm fire. Acid indigestion. Searing heartburn that won't let you sleep.

Looks like that take-out pizza's about to take its toll.

Unless you use Gaviscon antacid.

Gaviscon is specially formulated to stop painful heartburn—even the kind that hits you at night.

Its unique formula goes to work fast and keeps on working so you can fall asleep.

And because you may run across another pepperoni pizza from time to time, Gaviscon, taken as directed, is safe whenever heartburn strikes.

So, try Gaviscon. Get the fast, lasting relief that helps keep a good man down.

It works lying down.

Read and follow label directions.

Magazine Ad:
Gaviscon. For the heartburn that hurts. . .
Art Director:
Artie Megibben
Designer:
Artie Megibben
Photographer:
Marty Evans
Copywriter:
Sheila Moore
Design Firm:
Tracy-Locke Advertising
Client:
Marion Labs
Typographer:
JCS/Graphic Typography
Printer:
Kiefer/Nolde

Magazine Ad:
"You don't have to own..."
Art Director:
Lyle Metzdorf
Designer:
Lyle Metzdorf
Photographer:
Bill Wolfhagen
Copywriter:
Lyle Metzdorf
Design Firm:
Metzdorf Advertising Agency
Client:
Conoco Chemicals Company
Typographer:
Professional Typographers
Printer:
Haywood Graphics

You don't have to own an economy car to get good gas economy.

It's not just what you drive, but how you drive it.

As a rule, small cars get better gas mileage than big ones. But no matter what size car you drive, chances are, it's not operating at peak efficiency.

A tune-up can improve mileage 10%.

If your car has fouled spark plugs, poor timing or clogged oil and air filters, you could be cutting your mileage by as much as 10%.

Properly inflated radial tires can increase mileage 4%.

Another thing that hurts fuel economy is under-inflated tires. A set of radial tires, properly inflated, can increase mileage up to 4%.

Poor driving habits drive gas economy out the window.

Prolonged engine warm-ups, jackrabbit starts, riding the brake and fast stops all cost you gasoline. So does extra weight in your trunk. (Remove your golf clubs, tire chains or whatever, until you need them.)

At 50 mph you can get 20% better mileage.

To save gasoline, drive at slower, constant speeds, avoid traffic congestion, combine trips and observe the speed limits.

It's a proven fact that you can get 20% better mileage driving at 50 mph than you can at 70 mph.

SPEED LIMIT 55

I care about your business.

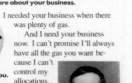

I needed your business when there was plenty of gas.

And I need your business now. I can't promise I'll always have all the gas you want because I can't control my allocations.

My promise to you.

But I can promise I'll do everything possible to help you through the gas shortage.

Why do I care?

Because you're more than just customers to me.

We're friends and neighbors.

Jobber name and company.

conoco

SAMPLE AD. NOT FOR REPRODUCTION.

Magazine Ad:
"The American farmer..."
Art Director:
Lyle Metzdorf
Designer:
Lyle Metzdorf
Photographer:
Bill Wolfhagen
Copywriter:
Lyle Metzdorf
Design Firm:
Metzdorf Advertising Agency
Client:
Conoco Chemicals Company
Typographer:
Professional Typographics
Printer:
Haywood Graphics

The American farmer needs more horsepower than this.

In the 1940's it was common to see a farmer working his land with a team of horses.

But times have changed.

Technology put the horse out to pasture and turned farming into America's biggest business.

Today our farmers are the most productive in the world.

They grow enough food for every man, woman and child in the U.S.—plus millions of people in foreign countries.

In addition, America earned $18,323,000,000 last year from exporting agricultural products.

But our farmers couldn't be this productive without sophisticated machinery and petroleum products to keep farms running.

A shortage of diesel fuel during the critical time of planting or harvesting could mean lost crops.

The end result? Millions of hungry people.

This country can't afford to let that happen.

We need farm products to keep America strong.

That's why our farmers can count on me to help them through the oil shortage.

I care about the American farmer. And America.

My promise to you.

conoco

SAMPLE AD. NOT FOR REPRODUCTION.

HOW TO DRIVE A CADILLAC WITHOUT GAS.

Lease a Diesel Cadillac from Highams, and forget about gasoline worries and conventional tune-ups. The diesel needs neither, and it provides significantly better mileage than a comparable gasoline engine.

See the Diesel Cadillac now, available in all body styles for sale or lease at Highams, the dealership that's been providing Houstonians with luxury automobiles for nearly thirty years.

Highams
Cadillac • Rolls-Royce

QUIETLY DOING THINGS VERY WELL.

Loop 610 at South Post Oak, Houston, Texas, (713) 623-2050.

Magazine Ad:
How to Drive a Cadillac Without Gas.
Art Director:
Janet K. Young
Designer:
Janet K. Young
Copywriters:
Ed Kennard, Greg Bolton, Chuck Adams
Design Firm:
Winius-Brandon/ Texas, Inc.
Client:
Highams Cadillac/ Rolls Royce
Typographer:
Typografiks
Printer:
San Jacinto Graphics Co.

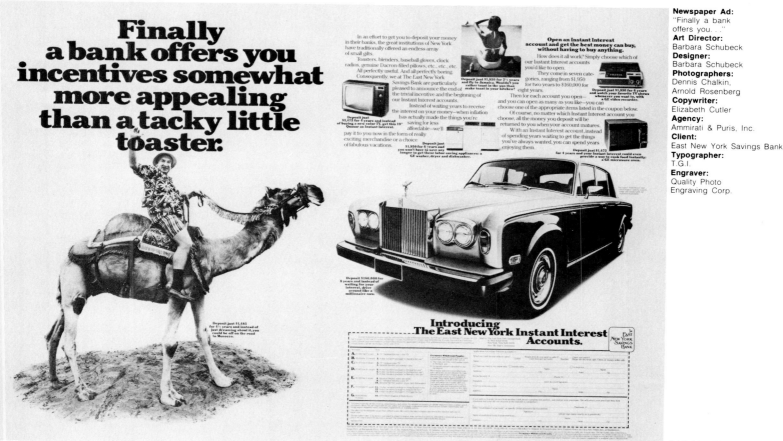

Newspaper Ad:
"Finally a bank offers you..."
Art Director:
Barbara Schubeck
Designer:
Barbara Schubeck
Photographers:
Dennis Chalkin, Arnold Rosenberg
Copywriter:
Elizabeth Cutler
Agency:
Ammirati & Puris, Inc.
Client:
East New York Savings Bank
Typographer:
T.G.I.
Engraver:
Quality Photo Engraving Corp.

The Book Show

To be eligible, books must have been designed and published in the United States or Canada. Of the 760 books submitted in seven categories, the juries selected 16 General Trade books, 25 Special Trade books, 12 Paperback designs, and one Limited Edition-Private Press book. The Textbooks jury chose 14 books, and the judges of Juvenile Books gave 35 awards.

Chairman

Tom Suzuki
Art director for Time-Life Books, Tom Suzuki studied at the California Institute of Art (formerly Chouinard Art Institute) and began his professional career with the *Pasadena Independent Star News.* He has been a designer with Pacific Press, art director for General Dynamics/Astronautics and for Image Art Studio in San Diego, and an independent designer of children's furniture. He was a partner in Chapman, McQuiston, Suzuki, and Wright, and later formed Suzuki and Wright before becoming director of design and vice-president of CRM Books. He then became director of design at Clareville Publishing Ltd., before joining Time-Life Books.

Jury
Special Trade, General Trade, and Paperbacks

Philip Grushkin
Book designer, calligrapher, educator, and consultant on design and production to book publishers, Philip Grushkin was formerly art director and vice-president of Harry N. Abrams. He studied at Cooper Union and subsequently taught there, as well as at NYU, Radcliffe, and Columbia University's School of Library Science. He served as a cartographer with the Office of Strategic Services during World War II.

James N. Miho
James N. Miho has served as design consultant for Champion Papers, Champion International Corporation, since 1965 and is design consultant to the National Air and Space Museum of The Smithsonian Institution. As an art director for N.W. Ayer & Son, his accounts included Container Corporation of America and DeBeers Diamonds, and while vice-president and creative director for Needham Harper & Steers, Inc., his accounts included Atlantic Richfield Co. and Xerox. He has also designed for the Royal Danish Consulate and Marimekko Oy of Finland. His work has been published worldwide, and he has had a one-man show in Tokyo, Japan. Miho's work is included in the permanent collection of The Museum of Modern Art.

Herbert Quarmby
A senior designer at Time-Life Books, Herbert Quarmby graduated from Cooper Union and began his professional career as a studio and advertising designer, before joining Time-Life in 1963 as a promotion designer. He has been with Time-Life Books since 1968.

Neil R. Shakery
A partner in the New York and San Francisco firm of Jonson, Pedersen, Hinrichs & Shakery Inc., which specializes in corporate, promotional, and editorial design, Neil Shakery graduated from The Ontario College of Art in Toronto. He began his professional career at the National Film Board of Canada in Montreal, went to work in London with International Industrial Designers, and then returned to Toronto with Art Associates Ltd. He has been assistant art director of *MacLeans* magazine, associate art director of the *Canadian* magazine and *Look*, and art director of *Saturday Review of the Arts* and *Psychology Today.* He has supervised textbook design for Harcourt Brace Jovanovich and designed the book *Between Friends,* the official gift from Canada to the United States for the Bicentennial.

Albert Squillace
Designer, consultant, and photographer Albert Squillace was art director of the publishing house Ridge Press for 25 years. He is the art director and photographer of the Teatro del Rinascimento, a nonprofit theater and center for Italian-American culture. He also designs house organs, promotional campaigns, and annual reports.

Limited Editions and Private Press Books

Bert Clarke
President and co-founder with David Way of Clarke & Way, The Thistle Press, Bert Clarke has been director of design and typography at A. Colish, Inc. since 1970. A graduate of Johns Hopkins University, he took a fling at songwriting in Tin Pan Alley and then began his design and printing career at the Garamond Press in Baltimore. After serving in the U.S. Coast Guard in World War II, he came to New York to work with The Limited Editions Club.

Marshall Lee
Head of the New York book packaging firm Balance House Ltd., in partnership with book designer, art director, and wife Kay Lee, Marshall Lee has been vice-president of design and production at Harry N. Abrams and has developed illustrated books for Milan's Fratelli Fabbri Editore. He graduated from Pratt Institute and began his publishing career as an illustrator. He headed the design department at H. Wolff Book Manufacturing Co., taught at New York University for 15 years, and is author of *Bookmaking.*

Juvenile Books

Riki Levinson
Art director and designer of children's books for E.P. Dutton, Riki Levinson graduated from the Cooper Union School of Art and then opened her own studio, where she primarily designed book jackets for 25 years. In 1970, she became design/production director of Western Publishing Company's Education Division and joined Dutton in 1972. She has taught at Parsons School of Design/Evening and at the City University of New York.

Charles Mikolaycak
Book designer and illustrator, Charles Mikolaycak graduated from Pratt Institute and began his professional career with the Du Crot Studio in Hamburg. He was designer/picture editor with Time-Life Books from 1963 to 1976. He has taught at Syracuse University and is co-author, illustrator, and designer of *The Boy Who Tried to Cheat Death.* He has illustrated and designed over 30 books for children.

Atha Tehon
Art director of books for young readers at The Dial Press, Atha Tehon graduated from the University of Illinois and did graduate work at the Pennsylvania Academy of Fine Arts and the University of Pennsylvania. She was previously art director of children's books at Alfred A. Knopf.

Textbooks

Suzanne G. Bennett
Art director of the Textbook Department at Academic Press, Suzanne Bennett graduated from Rollins College and studied at Parsons School of Design, the School of Visual Arts, and New York University. She designed books for Abelard-Schuman, R.R. Bowker, and John Wiley & Sons before joining Academic Press. She also taught editorial design at Pratt Institute for three years.

Marilyn Marcus
Art director of the College Department at Harcourt Brace Jovanovich, Marilyn Marcus graduated from Cooper Union Art School and Yale Art School. She began her book design career at Rinehart & Co. and joined Harcourt Brace two years later. She also designs seriographs.

Daniel Earl Thaxton
Art director of the College Division at Houghton Mifflin Company since 1976, Daniel Thaxton graduated from Denison University and did graduate work at Ohio University, majoring in printmaking. He has designed and illustrated books since 1969.

Review

Colophons and deckle edges, sensitive typography and strong black ink, handmade paper and marbled end-papers, binding imprints and spine stamping–these are the elements of traditional book design. They evoke a reverence for one of Western civilization's oldest continuous traditions–for 550 years–the art of making books. Yet during the 1970s, this tradition has been in a state of revolution.

The technological advances available to book design and production in the last decade have been enormous: electronics and automation, offset printing and web presses, perfect binding, laser scanners for four-color separations, microprocessors for computer graphics and typesetting. Process color is the most flamboyant demonstration of this phenomenon. Ten years ago, color was an occasional option. It has only recently become a primary vehicle of graphic design.

During the course of this revolution, there has also been a marked change in the relationship of book design to the book publishing industry. Foresighted members of the publishing community established the AIGA Book Show in 1929 for the purpose of bringing an awareness of the value of good design and production to the publication of books. Marshall Lee, a judge in this year's exhibition, stated that despite these initial efforts by the AIGA, when he first entered the book field in 1947, "the prevailing attitude toward the design of books was zero." Books were produced by "manufacturing men" who would send books to printers where, for the most part, they were produced according to formula. At one time, good printers were often good designers. When mechanization was introduced, printers hired designers whose services were offered to interested publishers. "I can't think of one company that had an art director. There were a handful that had designers: Knopf, Doubleday, Henry Holt, and Oxford University Press come to mind. In those days, if you went to a publisher for freelance design work, you saw the manufacturing man. If he had an aesthetic sense, it was accidental. Practically none of the people who were producing books had any art background. Essentially, this is what the AIGA was set up to change, and in my time this has happened. We now have art directors and professional designers doing a very high percentage of the books produced."

Despite the possibilities offered by new technologies, this year's jury commented on the conservative nature of book design: "There are traditions which a designer must understand before rejecting them. To be naive about the traditions is to design a bad book." At the same time, the jury felt that there is a great deal of repetitious design in book publishing, that styles do not change very fast. One reason cited was that "many young designers go into better-paying fields where graphic design is accepted more readily; book publishing lags behind."

Another more potent reason commonly stated for lack of change is that the publishing industry traditionally brings a low return on its investment in the production of hardcover, general trade books. Publishers see design refinements as expensive–though a good designer can design an interesting book for the same amount of money as something ordinary. It is, as Marshall Lee put it, "a matter of attitude."

The General Trade, Special Trade, and Paperbacks jury this year found an image of conservatism based upon financial conditions. Vanguard design was missing. Paperbacks showed more experimentation than the other two categories, presumably because their designers do not have to observe traditional forms.

While the jurors unanimously agreed that the technology of offset printing today (and the sharpness of laser scanners in reproducing images) is amazing, numerous books were seen that had good design and good concepts, but were judged to be poorly reproduced. Several books were praised: *The Catalogue of the Hans Syz Collection* of porcelain for its careful use of rules and its delicate use of typography; *Twelve Centuries of Book Bindings* for its excellent typography; and *The Architect's Eye* for its beautiful production and the fact that it "took chances." In general, however, the books of high design quality were traditional–not modern, experimental innovations.

The Limited Editions and Fine Press Books jury noted that books judged in this category would have to stand on their merits, which were not the same as those produced under the constraints of commercial publishing, and that awards would be made for "work whose design is a whole, a unit." The elements considered to make up this totality included: conception, design, execution, production, care, consistency, imagination, and quality. Ultimately, it was the "care for the individual parts of the book and the consistent appropriateness and sophisticated composition of all those parts" that made the whole.

After all their deliberations about near misses, only one volume met the judges' criteria of being "coherent"–*The Rowfant Manuscripts,* which, though questioned for recalling the 1920s idiom of Bruce Rogers, was referred to as "flawless . . . an expert combination of book design, typography, and manufacture."

The Textbooks jury raised issues that were close to the heart of graphic design. At odds, again, were good design versus function or good readability. It was noted that textbooks require large formats, lots of white space, fresh illustrations, color, and punch in design. It was thought that classically designed textbooks were often perceived by students as intimidating and hard to read. And the objective of good textbook design is to invite students to read.

The consensus of the jury was that textbooks shouldn't be dull, but that they ought to be simple. "Students should not have to be confronted with decoding design, as well as the new information they are trying to learn." In fact, they can more easily learn complicated material with the help of a skilled designer. Overall, the level of submission was good and, according to the jury, getting better. Many submissions were considered handsome but not exciting, yet only a few were not of interest to the judges.

A judge in Juvenile Books stated that good books in this category "are designed for reading *and* seeing, and I hope that never stops." The visual aspect is extremely important and the jury noted that the overall quality of illustrations in the books submitted was excellent. They commented on several illustrators whose work they had not seen before. They were also encouraged by the intelligent use of photographic illustrations. But in general, they noted that a key element missing from the character of the books was fun and humor.

In the Land of Small Dragons was discussed because the designer had alternated black and white with color without a jarring change of tonality and because the type was nicely leaded and placed on the page.

In the category of books for older children, the longer texts were found to be well designed, inviting, consistent, and showed a great deal of attention to detail that was gratifying.

Book Title:
The Architect's Eye
Authors:
Deborah Nevins,
Robert A.M. Stern
Art Director:
R.D. Scudellari
Designer:
R.D. Scudellari
Illustrators:
Various
Publisher:
Pantheon Books
Typographers:
The Clarinda Co.,
TGC
Printer:
Rae Publishing Co., Inc.
Production Manager:
Constance Mellon
Paper:
Quintessence 100#
Binder:
Publishers Book Bindery
Inc.
Jacket Designer:
R.D. Scudellari
Jacket Artist:
Michael Graves

Book Title:
Johnson Burgee/Architecture
Author:
Nory Miller
Art Director:
R.D. Scudellari
Designer:
R.D. Scudellari
Photographer:
Richard Payne
Publisher:
Random House, Inc.
Typographer:
Images
Printer:
Amilcare Pizzi, S.p.A.
Production Manager:
Peter Mollman
Paper:
Coated Gloss 100#
Binder:
Amilcare Pizzi, S.p.A.
Jacket Designer:
R.D. Scudellari
Photographer:
Richard Payne

CONTENTS

WATSON-GUPTILL PUBLICATIONS, 1515 Broadway, New York, N.Y. 10036

HALE
COYLE

ALBINUS ON ANATOMY

(spine) ALBINUS ON ANATOMY

ALBINUS ON ANATOMY

BY ROBERT BEVERLY HALE AND TERENCE COYLE

WATSON GUPTILL

The Great 18th Century Classic on Anatomy Adapted for the Contemporary Artist

Book Title:
Albinus on Anatomy
Authors:
Robert Beverly Hale,
Terence Coyle
Art Director:
Robert Fillie
Designer:
Robert Fillie
Illustrators:
Bernard Siegfried Albinus,
Terence Coyle
Publisher:
Watson-Guptill Publications
Typographer:
Lexigraphics, Inc.
Printer:
Halliday Lithograph Corp.
Production Manager:
Hector Campbell
Paper:
Patina 80#
Binder:
Halliday Lithograph Corp.
Jacket Designer:
Robert Fillie
Jacket Illustrator:
Bernard Siegfried Albinus

THE FOURTH ORDER OF MUSCLES, BACK VIEW

1. Rectus capitis posterior minor
2. Rectus capitis posterior major
3. Obliquus capitis inferior
4. Spine of axis (Second cervical vertebra)
5. Middle scalene
6. Multifidus
7. Spine of scapula
8. Subscapularis
9. Humerus
10. Supinator brevis
11. Radius
12. Ulna
13. Adductor pollicis, transverse head
14. Flexor pollicis brevis
15. Pronator quadratus
16. Ilium of pelvis
17. Iliacus
18. Great trochanter of femur
19. Ischial tuberosity
20. Adductor magnus
21. Outer epicondyle of femur
22. Head of fibula
23. Tibialis posterior
24. Peroneus brevis
25. Outer malleolus of fibula
26. Inner malleolus of tibia
27. Inner condyle of tibia
28. Inner epicondyle of femur
29. Obliquus capitis superior
30. Intercostal muscles
31. Semispinalis capitis
32. Semispinalis cervicis
33. Semispinalis dorsi
34. Levatores costarum (Elevators of ribs)

50 ALBINUS ON ANATOMY

THE BONES AND MUSCLES OF THE BODY 51

Book Title:
Wayne County:
The Aesthetic Heritage
of a Rural Area
Author:
Stephen W. Jacobs
Art Director:
Martin S. Moskof
Designer:
Martin S. Moskof
Photographer:
David Plowden
Publisher:
Publishing Center for
Cultural Resources for
Wayne County Historical
Society
Typographer:
Rockland Typographic
Service
Printers:
Lucas Litho, Inc.,
Philips Offset Co., Inc.
Production Manager:
Bruce R. McPhearson
Paper:
Astrolith 70#
Binder:
Lucas Litho, Inc.
Jacket Designers:
Martin S. Moskof,
M.J. Gladstone
Jacket Photographer:
David Plowden

A Catalog for the Environment

Wayne County:
The Aesthetic Heritage
of a Rural Area
by Stephen W. Jacobs
with photographs by David Plowden

Sponsored by the New York State Council on the Arts in a series on Architecture Worth Saving in New York State

Coal
Coal elevator, Ontario

In Ontario, a small community in the southeast corner of the township of the same name, there is a small warehouse area on Railroad Street. Here the New York Central line is a mile north of the old Ridge Road, which runs through the heart of town. Between the siding and the road is an elephantine structure: four silos under a rectangular roof. High, square bases support the cylinders, their cement finish spalling off to reveal rubble masonry beneath. The barrel-like silos are three stories high, each made of vertical staves bound with nearly two dozen closely spaced wires. The hoop fastenings are set diagonals, producing spiral patterns as they move upwards. The simple hip roof barely covers its fat columnar supports, and is crowned by a long, narrow, gabled structure sheathed with flush vertical boarding. Three parallel wires reach to the insulators along a small panel in the narrow end. Below, a conveyor in a wooden chute rises at a steep angle from a pit beside the track. On the long side is a wider opening, big enough for a coal truck to back into. Above, rudimentary diagonal bracing attempts to counter the inward tilt of the wood cylinders. It is supported on the inside corners of the bases, to avoid interfering with the pair of hoppers with folding chutes on either side.

1976 Notation: In March of 1975 the four silos were demolished to make room for expansion by Agway.

Coal and lumber
Sexton Coal and Lumber Yard, Palmyra

A wide doorway offers a glimpse of the inner court of a canal-side wholesale facility. The lumber and coal yard north of Canal Street in Palmyra consists of a series of low sheds surrounding a higher L-shaped building, the whole forming small courts. The effect is informal and irregular, but the spatial sequence, with a succession of light and dark areas surrounded by a variety of unpainted barnlike structures, is like that of Oriental palaces. The north-south wing of the largest unit divides the space seen here from less regular ones to the east. The west end of the canal-side wing of the high building has fieldstone walls. Colorful glaciated stones, larger and more irregular than oval cobbles, give it a tweedy texture. Roughly dressed squarish stones serve as quoins, but the narrow window has a cut stone lintel. In the distance is a storage building, whose cast block piers support brackets and beams which, in turn, carry a low second floor with clapboard sheathing and composition roofing. The dark, rectangular voids under it are echoed by the openings in the larger structure. The main building is of mill construction, capable of supporting heavy loads. Plank floors on thick beams rest on massive square posts. Fire doors were installed to block off the archways between the stone and wood portions, and the masonry unit is further protected by metal ceilings. The two bays of the wooden structure nearest the canal appear to be newer than those to the south. Perhaps they were rebuilt when the gently pitched roof that covers both wings of the L was installed.

Franklin Lakey, who bought local produce for shipment on the canal, began business here in the 1830s. The large, stone-ended main building had an elevator tower at the waterside and was folded, by a narrow mortise along the ridge to the broader section of the top floor, at the Canal Street end. For half a century after the builder's death in 1875, "Lakey's Malthouse" could be read on the square cupola atop the Canal Street facade. In the 1880s Pliny I. Sexton purchased the property, and maintained a coalyard there for more than forty years.

Grain
Newark Grain Company, Newark

These four utilitarian structures on Sodus Road in Newark are so placed and shaped as to form a remarkably architectural scene, rather like a stage setting. Morning light brings out the rhythmic triad of ventilatorlike towers set on the ridges of simple rectangular buildings. Makeshift extensions nearer the ground make for a counterbalancing horizontality, reinforced by a glimpse of the rolling countryside down the road. On the south is a long clapboard unit painted red. Below its two-step twice, an awning-like wooden shelter, broad enough to protect two wagons, is supported on angle bracing. Opposite are two stuccoed buildings, the closest is fertile, made of concrete block with small, nearly square windows set near the ground. Beyond it is a taller structure much like the apple driers built at the turn of the century.

AmericanGrilles

FRATTOLILLO & SALMIERI

Book Title:
American Grilles
Authors:
Rinaldo Frattolillo,
Steve Salmieri
Art Director:
Rinaldo Frattolillo
Designer:
Rinaldo Frattolillo
Photographer:
Steve Salmieri
Publisher:
Harcourt Brace Jovanovich,
Inc.
Printer:
Halliday Lithograph Corp.
Production Manager:
Raymond G. Ferguson
Paper:
Sterling Litho Gloss
Binder:
A. Horowitz & Sons
Jacket Designer:
Rinaldo Frattolillo
Jacket Photographer:
Steve Salmieri

Book Title:
One of a Kind
Recent Polaroid Color
Photography
Author:
Eugenia Parry Janis
Editor:
Belinda Rathbone
Designer:
Victor Cevoli
Photographers:
Various
Publisher:
David R. Godine
Typographer:
Typographic House
Printer:
Acme Printing Co.
Production Manager:
Alison Gustafson
Paper:
Cameo Dull 100#
Binder:
A. Horowitz & Son

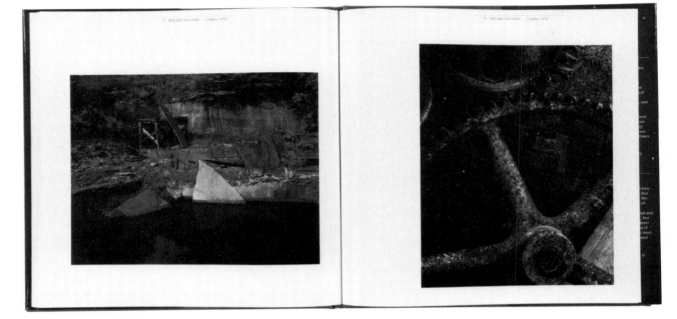

Book Title:
Click
Author:
Robin Forbes
Art Director:
Alan Benjamin
Designer:
Sylvia Frezzolini
Photographer:
Robin Forbes
Publisher:
Macmillan Co.
Typographer:
Set-Rite Typographers
Printer:
Halliday Lithograph Corp.
Production Manager:
Lottie Gooding
Paper:
Glatco Smooth 80#
Binder:
Economy Co.
Jacket Designer:
Sylvia Frezzolini
Photographer:
Robin Forbes

When you photograph,
think about light.

back light.

There is front light.

side light

and even speckled light.

Book Title:
Living Corals
Author:
Richard Chesher
Art Director:
Walter Eitel
Designer:
Douglas Faulkner
Photographer:
Douglas Faulkner
Publisher:
Clarkson N. Potter, Inc.
Publishers
Typographer:
Publishers Phototype Inc.
Printer:
Toppan Printing Co., Ltd.
Production Manager:
Walter Eitel
Paper:
Royal Art 100#
Binder:
Toppan Binderies
Jacket Designer:
Douglas Faulkner
Photographer:
Douglas Faulkner

Book Title:
Photography
Author:
Phil Davis
Art Directors:
David A. Corona,
Marilyn Phelps
Designer:
David A. Corona
Photographers:
Various
Publisher:
William C. Brown Company
Publishers
Typographer:
Typoservice Corp.
Printer:
William C. Brown Co.
Production Manager:
David A. Corona
Paper:
Sterling 70#
Binder:
William C. Brown Company
Publishers
Jacket Designer:
David A. Corona
Jacket Photographer:
James Ballard

Figure 9.6
a. Print solarization. First exposure slightly less than normal, flash exposure 1 second to dim room light.

b. First exposure 90% of normal, flash exposure about 2 seconds.

c. First exposure 75% of normal, flash exposure about 5 seconds.

images. The routine is simple—use a very high-contrast paper such as Brovira #6 and print in your usual way, underexposing the print slightly. Negatives of normal or low contrast are usually best, but high-contrast negatives will sometimes produce attractive effects. Develop the print in an ordinary MQ print developer (some other types will also work well), such as Dektol, diluted normally, until the image is visible but not fully formed. Flash the paper to white light (a 15-watt bulb, about 4 feet from the developer tray is probably adequate) for about ½ second and continue the development until the time is up or the image seems to have stabilized.

The quality of the final image is dependent on the amount of original print exposure, the time and extent of development before the flash exposure, the extent of the flash exposure; and, to some degree, the extent of development after the flash exposure. Low-contrast papers do not work well. The formation of the Mackie lines is facilitated if the developer is nearing exhaustion or if a little quantity of potassium bromide is added to the working solution (try about ½ gram per quart at first).

The process is made even easier and more predictable if the prints are developed in Solarol, a special product (Solarol Co., Box 1048, El Cerrito, Ca.) available in some camera stores. Solarol produces better contrast and allows better control than ordinary developers do. Follow the procedure outlined above, but increase the flash exposure to about 3 or 4 seconds for the first trial. Best results seem to be obtained if the print is developed about 40 seconds before the flash, and about 1 to 1½ minutes after the flash exposure. Agitation can be continuous and the developer should be used at at least 68°F to avoid possible streaking.

Screening

In the normal photographic process the image tones are *continuous* from black to white, through an infinite range of grays. When photographs are printed in magazines or newspapers, or, for that matter, when

Book Title:
Imogen Cunningham:
A Portrait
Author:
Judy Dater, in association
with The Imogen
Cunningham Trust
Designer:
Katy Homans
Photographers:
Imogen Cunningham,
Judy Dater
Publisher:
New York Graphic Society
Typographer:
Michael Bixler
Printer:
The Leether Press
Production Manager:
Nan Jernigan
Paper:
Karma 80#
Binder:
A. Horowitz & Son
Jacket Designer:
Katy Homans
Jacket Photographers:
Judy Dater,
Imogen Cunningham

Judy
Dater

Imogen Cunningham:
A PORTRAIT

Imogen Cunningham: A Portrait

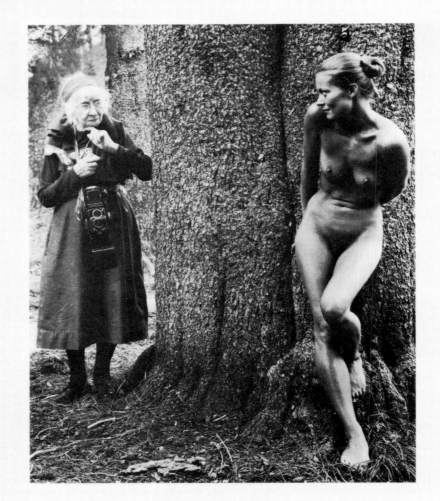

N Y
G S

by Judy Dater

Book Title:
Lisette Model
Author:
Bernice Abbott
Art Director:
Marvin Israel
Designer:
Marvin Israel
Photographer:
Lisette Model
Publisher:
Aperture
Typographer:
Scarlet Letters
Printer:
Edison Lithographing &
Printing Corp.
Production Manager:
Joel Friedlander
Paper:
Northwest Quintessance
Gloss 100#
Binder:
Publishers Book Bindery Co.
Jacket Designer:
Marvin Israel
Jacket Photographer:
Lisette Model

Book Title:
Intimate Landscapes:
Photographs by Eliot Porter
Author:
Weston J. Naef
Designer:
Eleanor Morris Caponigro
Photographer:
Eliot Porter
Publisher:
The Metropolitan Museum of
Art/E.P. Dutton
Typographer:
Mackenzie-Harris Corp.
Printer:
Acme Printing Corp.
Production Manager:
Hal Morgan, M.M.A.
Paper:
Northwest Quintessence text
dull 100#
Binder:
Publishers Book Bindery

Book Title:
Alaska
Authors:
Claus M. Naske,
William Hunt,
Lael Morgan
Art Director:
Nai Y. Chang
Designer:
Nai Y. Chang
Photographer:
Dennis Stock
Publisher:
Harry N. Abrams, Inc.
Typographer:
Zimmering and Zinn, Inc.
Printer:
Nissha Printing Co.
Production Manager:
Shun Yamamoto
Paper:
"Perfect" 190 g/m²
Binder:
Ohguchi Binding and
Printing Co.
Jacket Designer:
Nai Y. Chang
Jacket Photographer:
Dennis Stock

Book Title:
Yosemite and the
Range of Light
Author:
Ansel Adams
Designer:
Lance Hidy
Photographer:
Ansel Adams
Calligraphy:
Stephen Harvard
Publisher:
New York Graphic Society
Typographers:
Bob McCoy,
Cambridge Linoterm
Printer:
Pacific Lithograph
Production Manager:
Nan Jernigan
Paper:
Quintessence Gloss 100#
Binder:
A. Horowitz & Son
Jacket Designers:
Lance Hidy, Stephen
Harvard
Jacket Photographer:
Ansel Adams
Calligraphy:
Stephen Harvard

Book Title:
Helmut Newton Special
Collection 24 Photo Lithos
Art Director:
Bea Feitler
Designer:
Bea Feitler
Photographer:
Helmut Newton
Publisher:
Congreve Publishing Co.,
Inc.
Printer:
Rapoport Printing Corp.
Production Manager:
Karen Amiel
Binder:
Sendor Bindery
Jacket Designer:
Bea Feitler

Preceding Page

Fashion photograph. Paris, 1976.

Book Title:
Henri Cartier-Bresson
Photographer
Author:
Henri Cartier-Bresson
Art Directors:
Herb Lubalin Assoc.,
Robert Delpire
Designer:
Robert Delpire
Photographer:
Henri Cartier-Bresson
Publisher:
New York Graphic Society
Typographer:
Contempo-Type
Printer:
Thomas Todd Co.
Production Managers:
Paul Ickovic,
Nan Jernigan
Paper:
LOE Dull 100#
Binder:
A. Horowitz & Son
Jacket Designer:
Robert Delpire
Jacket Photographer:
Henri Cartier-Bresson

Book Title:
A Dance Autobiography
Author:
Natalia Makarova
Art Director:
R.D. Scudellari
Designer:
R.D. Scudellari
Photographer:
Dina Markarova and others
Publisher:
Alfred A. Knopf, Inc.
Typographers:
The Clarinda Co.,
TGC
Printers:
Rapoport Printing Corp.,
Halliday Lithograph Corp.
Production Manager:
Ellen McNeilly
Paper:
Paloma 70#
Binder:
The American Book-Stratford
Press
Jacket Designer:
R.D. Scudellari
Jacket Photographer:
Dina Makarova

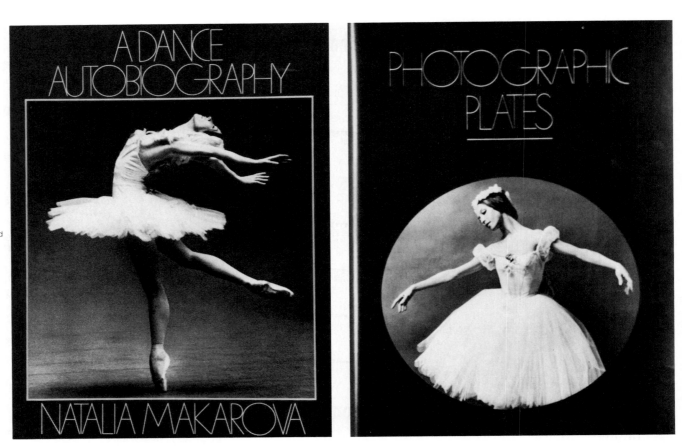

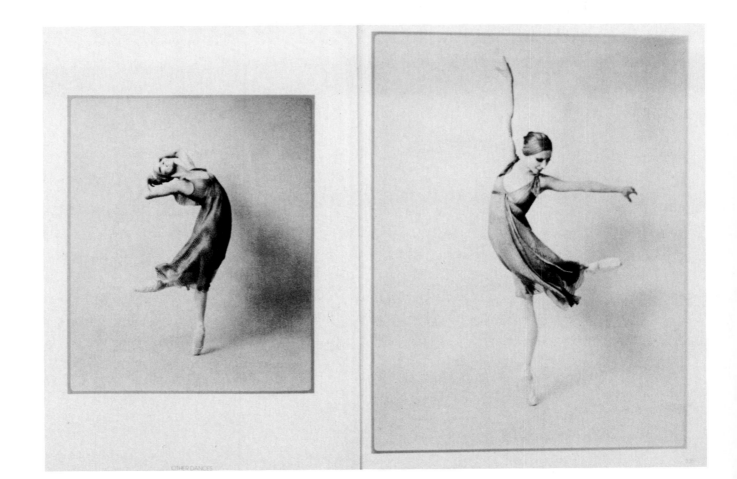

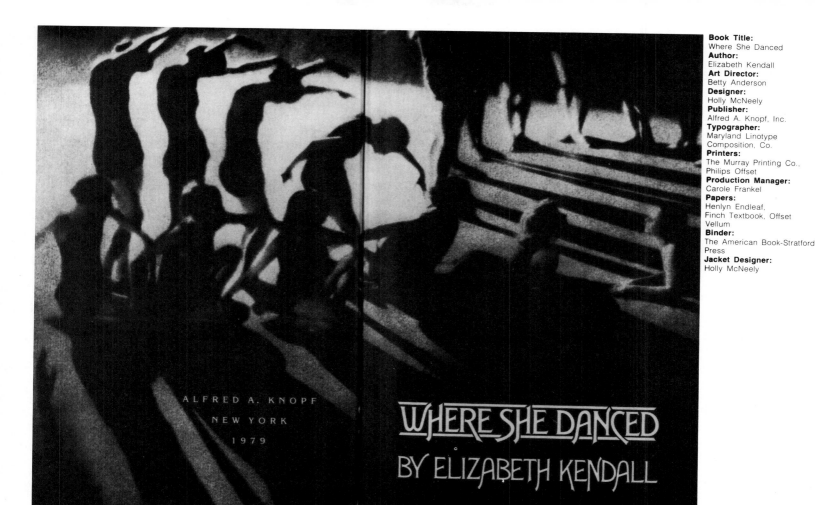

ALFRED A. KNOPF
NEW YORK
1979

WHERE SHE DANCED
BY ELIZABETH KENDALL

Book Title:
Where She Danced
Author:
Elizabeth Kendall
Art Director:
Betty Anderson
Designer:
Holly McNeely
Publisher:
Alfred A. Knopf, Inc.
Typographer:
Maryland Linotype
Composition, Co.
Printers:
The Murray Printing Co.,
Philips Offset
Production Manager:
Carole Frankel
Papers:
Henlyn Endleaf,
Finch Textbook, Offset
Vellum
Binder:
The American Book-Stratford
Press
Jacket Designer:
Holly McNeely

Book Title:
Dialogue with Photography
Authors:
Paul Hill, Thomas Cooper
Art Director:
Dorris Janowitz
Designer:
Cynthia Krupat
Publisher:
Farrar, Strauss and Giroux,
Inc.
Typographer:
Maryland Linotype
Composition Co., Inc.
Printer:
Vail-Ballou Press, Inc.
Production Manager:
Constance Fogler
Paper:
Perkins and Squier Regular
Offset 50#
Binder:
Vail-Ballou Press, Inc.
Jacket Designer:
Cynthia Krupat

Book Title:
Cober's Choice
Author:
Alan E. Cober
Art Director:
Riki Levinson
Designer:
Meri Shardin
Illustrator:
Meri Shardin
Illustrator:
Alan E. Cober
Letterer:
Alan E. Cober
Publisher:
E.P. Dutton
Typographers:
Boro Typographers, Inc.,
Royal Composing Room
Printers:
Halliday Lithograph Corp.,
Alithochrome Corp.
Production Managers:
Steven Konopka,
Jane Recca
Paper:
Lockhaven Offset MF Cream
70#
Binder:
Keenan Binder, Inc.
Jacket Designers:
Alan E. Cober,
Meri Shardin
Jacket Illustrator:
Alan E. Cober

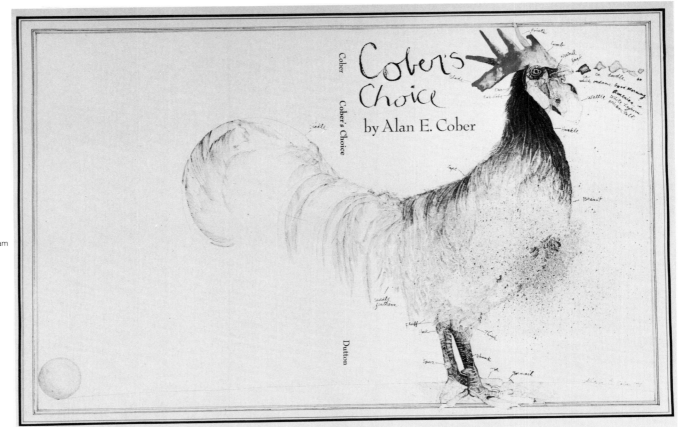

PHEASANT

Pheasants walk through my yard. Nine years ago I bought
a stuffed one to draw.

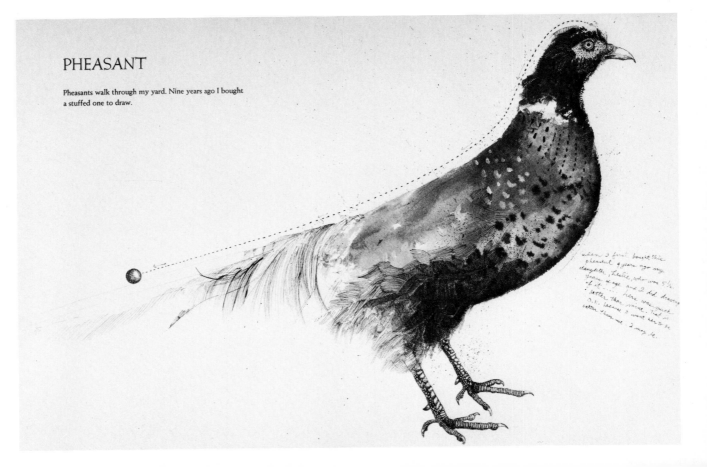

Book Title:
Feather Arts: Beauty, Wealth and Spirit from Five Continents
Author:
Phyllis Rabineau
Art Director:
Clifford Abrams
Designer:
Clifford Abrams
Photographer:
Ron Testa
Calligrapher:
Arthur Majeski
Publisher:
The Field Museum of Natural History
Typographer:
Design Typographers
Printer:
Argus Press
Production Manager:
Oscar Anderson
Paper:
Wedgewood Dull
Binder:
Frank's Bindery
Jacket Designer:
Clifford Abrams
Jacket:
Ron Testa

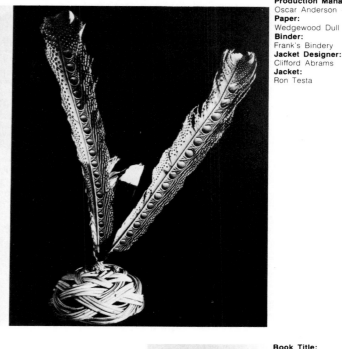

(left)
48. Rhinoceros hornbill
Borneo

(opposite)
49. Headhunter's cap
Dayak; Borneo
27.3
H 65 cm, D 29 cm.

(above)
50. Woodcarving of a hornbill for headhunting celebration
Dayak; Borneo
27.4
L 39 cm, H 32 cm.

feathers taken from hornbills (fig. 48) were associated with headhunters. They decorated the headhunter's war cap (fig. 49), and their images in wood were displayed at headhunting celebrations (fig. 50). Hornbills are shy creatures, living in remote forests where they are more easily heard than seen during flight the movement of air against their long tail feathers produces a loud roaring sound. These birds exhibit very distinctive behavior during nesting. While incubating her eggs, and for a short time after they hatch, the female hornbill is sealed inside a

hollow tree trunk by her mate, who feeds her through a tiny opening left in the mud enclosure.

These unusual aspects of hornbill behavior add to the bird's mystique, but do not explain why it is a symbol of headhunting. One highly speculative theory suggests that, at least in New Guinea, tribesmen identify mankind with the sugar palm, a tree whose sap is blood red. The tree's large fruit might therefore suggest the human head, and because the hornbill eats this fruit it, in turn, represents the headhunter.

The spiritual symbolism and use of feathers is a rich and varied topic that has only been briefly sampled here. However, just these few examples show the diversity of ideas the medium can convey, from blessings to warfare.

Book Title:
The Peregrine Falcon in Greenland: Observing an Endangered Species
Author:
James T. Harris
Art Director:
Edward D. King
Designer:
Edward D. King
Photographers:
David Clement,
James T. Harris,
M. Allan Jenkins,
William G. Mattox
Publisher:
University of Missouri Press
Typographer:
Heritage Printers, Inc.
Printer:
Thomson-Shore, Inc.
Production Manager:
Joy Endler-Flora
Paper:
Warren's Olde Style 60#
Binder:
Universal Bookbindery, Inc.
Jacket Designer:
Edward D. King
Jacket Illustrator:
Jerry Dadds, Eucalyptus Tree Studio, Inc.

Bill Burnham with rubber raft used for crossing river to Black Cliff in 1973.

Black Cliff.

The treaty between Denmark and the United States that provided for the air base at Søndrestrøm also stipulated that the Air Force would employ Danes for many jobs normally performed by airmen. Most of the Danes worked in Greenland for short periods of several years, at Søndrestrøm or the coastal towns, for their government exempted from taxes all money earned in a stay of at least two years, a sizable incentive as taxes normally consume half of a Danish citizen's income. Danes came for the two years, although they disliked winters and left their families behind. Some never visited the wilderness.

I met a man that evening who was not an unusual case. He had no time for the landscape because he worked sixty or seventy hours every week. He regarded his Greenland stay as two years wholly sacrificed so that he could buy his home in Copenhagen. Somehow he had already heard of Lieutenant Colonel Graham's expedition for birds. It was curious how the thousand residents of Søndrestrøm—Americans, Danes, but only several native Greenlanders—knew of everyone and talked of everyone. But more curious how many isolated themselves with overfull thoughts of home and hot Europe or New York, cut off from everything beyond the Søndrestrøm roads.

Mattox, Graham, and Burnham were not huddling in their tent by some nameless lake but strolled into the mess hall for supper. After our surprise at meeting, we fired questions at each other. They had just returned. They hadn't found any peregrines but did have news of a gyrfalcon pair. The adults were both white, and Bill had roped down to the eyrie ledge to find three eyasses. My friends hadn't covered as much ground as they had hoped. Although the cliffs they had seen were small, and thus not likely to be occupied by falcons, they heard about the peregrines on the Black Cliff with evident relief, because constantly as they walked and walked they had wondered whether many peregrines were still living in Greenland, or would we find only late, lingering pairs? Mattox told me that peregrines would not act with such aggressiveness as the ones at Black Cliff unless they guarded an eyrie.

And Dick Graham would have to leave Greenland immediately. At supper he was quiet, sad, and he looked worried also. In Colorado he kept twelve Spanish peregrines that he was trying to breed in captivity—these birds would be difficult to hold healthy in their cages, and I wondered if something had happened to them that Dick must leave. He hoped to return in two weeks. The next day the two Bills would begin to cover another section of tundra.

68

69

Book Title:
100 Artists, 100 Years
Author:
Katherine Kuh
Art Director:
Margaret A. Blasage
Designer:
Hayward Blake & Co.
Publisher:
The Art Institute of Chicago
Typographer:
King Typographers, Inc.
Printer:
Congress Printing Company
Production Manager:
Margaret A. Blasage
Paper:
Warren's Cameo Dull Enamel
Binder:
Zonne Bookbinding Co.

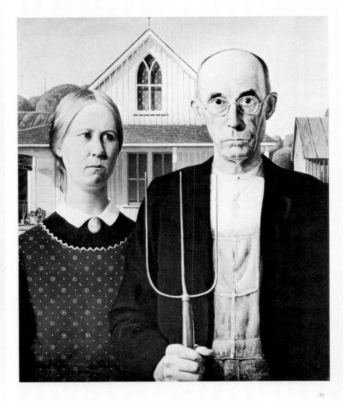

Pat Adams	George Cohen	Lester Johnson	Christina Ramberg
Calvin Albert	John Steuart Curry	Max Kahn	Daniel P. Ramirez
Ivan Albright	Nancy Davidson	Herbert Katzman	Seymour Rosofsky
Lennart Anderson	Arthur B. Davies	James Kearns	Barbara Rossi
Benny Andrews	Dominick Di Meo	Karl Knaths	Theodore Roszak
Rudolf Baranik	Richard Estes	Dennis Kowalski	Paul Sarkisian
George Gray Barnard	Edgar Ewing	Irving Kriesberg	William Schwartz
Robert Barnes	Sondra Freckelton	Ellen Lanyon	Diane Simpson
Don Baum	Frederick C. Frieseke	Richard Lippold	David Smyth
Jack Beal	Roland Ginzel	Anthony Martin	Nancy Spero
Rainey Bennett	Leon Golub	Robert Middaugh	Evelyn Statsinger
Thomas Hart Benton	Joseph Goto	Joan Mitchell	John Storrs
Vera Berdich	Red Grooms	Carl Morris	Lenore Tawney
Robert Bergman	Raoul Hague	Robert Natkin	Mark Tobey
Charles Biederman	Ted Halkin	Gladys Nilsson	Joyce Treiman
Aaron Bohrod	Philip Hanson	B. J. O. Nordfeldt	Charles Umlauf
Cameron Booth	Pop Hart	John W. Norton	Steven Urry
Ken Bowman	Gene Hedge	Jim Nutt	Vaclav Vytlacil
Roger Brown	John Henry	Georgia O'Keeffe	H. C. Westermann
George Buehr	Margo Hoff	Claes Oldenburg	Margaret Wharton
Cosmo Campoli	Linda Howard	Arthur Osver	Charles White
John Chamberlain	Richard Hunt	Ed Paschke	Karl Wirsum
Francis Chapin	Robert Indiana	Peter Passuntino	Emerson Woelffer
Alson Skinner Clark	Miyoko Ito	Irving Petlin	Grant Wood
Eleanor Coen	John C. Johansen	John Pittman	Ray Yoshida

Book Title:
Daniel Fowler of Amherst
Island 1810–1894
Author:
Frances K. Smith
Art Director:
Peter Dorn
Designer:
Peter Dorn
Illustrator:
Daniel Fowler
Publisher:
Agnes Etherington Art
Centre
Typographer:
Eastern Typesetting Co.
Printer:
Brown & Martin Ltd.
Production Manager:
Peter Dorn
Paper:
Rolland African Tan 140,
Kelmscott Matte 140
Binder:
Martin Bookbinding Ltd.
Jacket Designer:
Peter Dorn
Jacket Artist:
Daniel Fowler

Daniel Fowler
of Amherst Island
1810–1894

386

Book Title:
Patrick Henry Bruce,
American Modernist
Authors:
William C. Agee,
Barbara Rose
Art Director:
Patrick Cunningham
Designer:
Nora Sheehan
Publishers:
The Museum of Modern Art,
New York
The Museum of Fine Arts,
Houston
Typographer:
Boro Typographers, Inc.
Printer:
The Arts Publisher, Inc.
Production Manager:
Tim McDonough
Paper:
Warrens Lustro Offset
Enamel Gloss
Binder:
Sendor Bindery
Jacket Designer:
Nora Sheehan
Jacket Artist:
Patrick Henry Bruce

29. PEINTURE/NATURE MORTE [TRANSVERSE BEAMS]. c.1928
Oil and pencil on canvas, 32 x 51¼ in (81.3 x 130.2 cm)
Hirshhorn Museum and Sculpture Garden, Smithsonian Institution, Washington, D.C.
Cat. no. D23

30. PEINTURE/NATURE MORTE. c.1925-26 or c.1928
Oil and pencil on canvas, 35⅛ x 45¾ in (89.2 x 116.2 cm)
Hirshhorn Museum and Sculpture Garden, Smithsonian Institution, Washington, D.C.
Cat. no. D24

Book Title:
The Western Heritage
Authors:
Donald Kagan,
Steven Ozment,
Frank M. Turner
Art Directors:
A.H. McLeod,
Andrew P. Zutis
Designer:
Charles Farrell
Illustrators:
Various
Maps:
Theodore R. Miller
Publisher:
Macmillan Publishing Co.,
Inc.
Compositor:
York Graphic Services, Inc.
Printers:
Rand McNally & Co.,
Princeton Polychrome
Production Manager:
James T. Parker
Paper:
Mead Collier Matte
Thin, 50#
Binder:
Rand McNally & Co.
Jacket Designer:
Charles Farrell
Jacket Illustration:
Joseph Wright of Derby

Book Title:
Drawings and Digressions
by Larry Rivers
Authors:
Larry Rivers with
Carol Brightman
Art Director:
Michael Fragnito
Designer:
Hermann Strohbach
Artist:
Larry Rivers
Publisher:
Clarkson N. Potter, Inc.
Publishers
Typographer:
Publishers Phototype Inc.
Printer:
Toppan Printing Co.
Production Manager:
Elizabeth M. Ferranti
Paper:
Royal Cote 100#
Binder:
Toppan Binderies
Jacket Designer:
Hermann Strohbach
Jacket Illustrator:
Larry Rivers

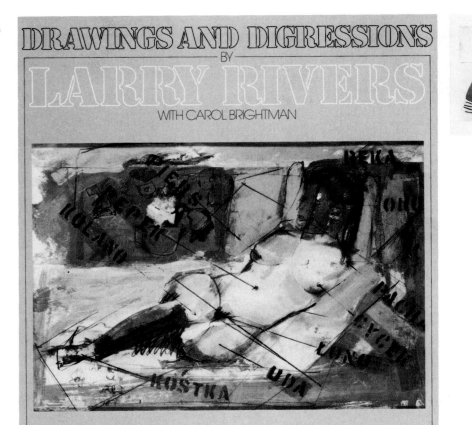

Book Title:
America Observed
Author:
Stephen Spender
Art Director:
Michael Fragnito
Designer:
Ladislav Svatos
Illustrator:
Paul Hogarth
Publisher:
Clarkson N. Potter, Inc.
Publishers
Typographer:
Publishers Phototype
Printer:
Lehigh-Steck-Warlick, Inc.
Production Manager:
Elizabeth Ferranti
Paper:
Beckett Opaque Traditional
White 80#
Binder:
A. Horowitz & Son
Jacket Designer:
Ladislav Svatos
Jacket Illustrator:
Paul Hogarth

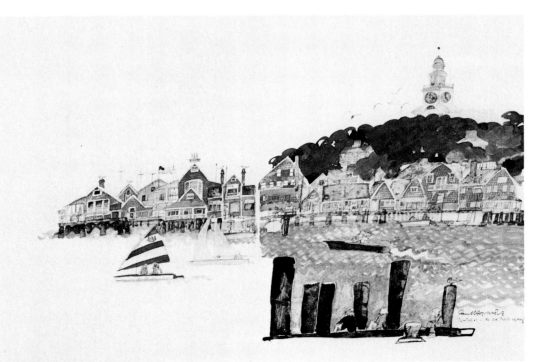

Book Title:
Misia
Authors:
Arthur Gold,
Robert Fizdale
Art Director:
Betty Anderson
Designer:
Holly McNeely
Photographers:
Various
Publisher:
Alfred A. Knopf, Inc.
Typographer:
The Maryland Linotype
Composition Co.
Printers:
Maple Press,
Alithochrome Corp.,
The Murray Printing Co.
Production Manager:
William F. Luckey
Paper:
S.D. Warren Eggshell Cream
60#
Binder:
Maple Press
Jacket Designer:
Gun Larson
Jacket Art Director:
Lidia Ferrara
Jacket Artist:
Henri de Toulouse-Lautrec

Book Title:
Luke Swank
Authors:
Various
Art Director:
Bennett Robinson
Designer:
Bennett Robinson
Photographer:
Luke Swank
Publisher:
Carnegie Institute,
Museum of Art
Typographer:
Davis & Warde
Printer:
Crafton Graphic Co., Inc.
Production Manager:
Robert M. Merkle
Papers:
Kromekote 10 pt.
Quintessence Dull Text 80#
Colophon Text 80#
Binder:
Sendor Bindery

Book Title:
Greek Vase-Painting in
Midwestern Collections
Author:
Warren G. Moon
Art Director:
Margaret A. Blasage
Designer:
Harvey Retzloff Design
Publisher:
The Art Institute of Chicago
Typographer:
Dumar Typsetting, Inc.
Printer:
Congress Printing Co.
Production Manager:
Margaret A. Blasage
Paper:
Warren's Cameo Dull Enamel
Binder:
Zonne Bookbinding Co.

Book Title:
Catalogue of the Hans Syz
Collection
Authors:
Hans Syz,
J. Jefferson Miller, II,
Rainer Ruckert
Art Director:
Stephen Kraft
Designer:
Natalie Bigelow Babson
Publisher:
Smithsonian Institution
Press
Typographer:
Monotype Composition Co.,
Inc.
Printer:
Chanticleer Press
Production Manager:
Lawrence J. Long
Paper:
Cameo Gloss 80#
Binder:
Japhet Printing Press Co.
Jacket Designer:
Natalie Bigelow Babson

Volume I

Catalogue of
The Hans Syz Collection

Meissen Porcelain and
Hausmalerei

Hans Syz
J. Jefferson Miller II
Rainer Rückert

Smithsonian Institution Press
Washington, D.C. 1979

Book Title:
Time Line of Culture in the Nile Valley and Its Relationship to Other World Cultures
Author:
Department of Egyptian Art, Metropolitan Museum of Art
Art Director:
Rudolph de Harak
Designer:
Rudolph de Harak & Associates, Inc.
Publisher:
The Metropolitan Museum of Art
Typographer:
Compo-set
Printer:
A. Mondadori
Binder:
A. Mondadori
Jacket Designer:
Rudolph de Harak

Book Title:
American Art Nouveau
Author:
Diane Chalmers Johnson
Art Director:
Nai Y. Chang
Designer:
Judith Michael
Publisher:
Harry N. Abrams, Inc.
Typographer:
Samhwa Printing Co., Ltd.
Printer:
Nissha Printing Co., Ltd.
Production Manager:
Shun Yamamoto
Paper:
Matte Coated, 157 Gram
Binder:
Taikansha Ltd.
Binding Art:
Redrawn by Joseph Argenziano
Jacket Designer:
Judith Michael
Jacket Photographers:
Scott Hyde,
Nai Y. Chang

TWELVE CENTURIES OF
BOOKBINDINGS: 400-1600

Book Title:
Twelve Centuries of Bookbindings: 400–1600
Author:
Paul Needham
Art Director:
Stephen Harvard
Designer:
Stephen Harvard
Photographer:
Charles Passela
Publisher:
The Pierpont Morgan Library
Typographer:
The Steinhour Press
Printer:
The Meriden Gravure Co.
Production Manager:
Stephen Harvard
Paper:
Mohawk Superfine
Binder:
Tapley-Rutter
Jacket Designer:
Stephen Harvard
Jacket Photographer:
Charles Passela

Book Title:
Broca's Brain
Author:
Carl Sagan
Art Director:
Bernie Klein
Designer:
J.K. Lambert
Publisher:
Random House, Inc.
Typographer:
The Haddon Craftsmen, Inc.
Printer:
R.R. Donnelley & Sons, Co.
Production Manager:
Ellen Leventhal
Paper:
S.D. Warren 55#
Binder:
R.R. Donnelley & Sons, Co.
Jacket Designer:
Robert Aulicino
Jacket Illustrator:
Jon Lomberg

Book Title:
The Genius
Author:
Gottfried Reinhardt
Art Director:
Betty Anderson
Designer:
Margaret M. Wagner
Ornament Rendering:
Anita Karl
Publisher:
Alfred A. Knopf, Inc.
Typographer:
Maryland Linotype
Composition Co., Inc.
Printer:
The Haddon Craftsmen, Inc.
Production Manager:
Carole Frankel
Papers:
S.D. Warren Offset,
Antique Finish/
Lustro Offset Enamel,
Dull Finish
Binder:
The Haddon Craftsmen, Inc.
Jacket Designer:
Lidia Ferrara

Book Title:
The Shtetl
Author:
Joachim Neugroschel
Art Director:
Lynn Hollyn
Designer:
Lynn Hollyn and Assoc.
Illustrator:
Muriel Nasser
Calligrapher:
Sol Novins
Publisher:
Richard Marek Publishers
Typographer:
Marvin Kommel Productions
Printer:
Westbrook Lithographers
Production Manager:
Ron Lief
Binder:
Economy Bookbinders, Inc.
Jacket Designer:
Lynn Hollyn
Jacket Illustrator:
Muriel Nasser
Jacket Calligrapher:
Sol Novins

Book Title:
The Sword of the Prophet
Author:
Robert Goldston
Art Director:
Atha Tehon
Designer:
Jane Byers Bierhorst
Publisher:
The Dial Press
Typographer:
The Maple-Vail Book
Manufacturing Co.
Printer:
The Maple-Vail Book
Manufacturing Co.
Production Manager:
Virginia R. Anson
Paper:
Sebago
Binder:
The Maple-Vail Book
Manufacturing Co.
Jacket Designer:
Holly McNeely
Jacket Illustrator:
Holly McNeely

THE HOUSE OF POWER

SAMI BINDARI

SEYMOUR SIMON
THE LONG VIEW
INTO SPACE

CROWN PUBLISHERS, INC. | NEW YORK

Book Title:
The House of Power
Author:
Sami Bindari
Art Director:
Daniel Earl Thaxton
Designer:
Daniel Earl Thaxton
Illustrator:
Daniel Earl Thaxton
Publisher:
Houghton Mifflin Co.
Typographer:
Black Dot Typographers
Cover Printer:
New England Book
Components
Book Printer:
Vail-Ballou Press
Production Manager:
Sylvia Mallory
Paper:
S.D. Warren Antique
Cream 55#,
Antique Cream 55#
Binder:
Vail-Ballou Press
Jacket Designer:
Daniel Earl Thaxton
Jacket Illustrator:
Daniel Earl Thaxton

This is a photograph of the Lagoon Nebula, which is in the constellation of Sagittarius.

Book Title:
The Long View into Space
Author:
Seymour Simon
Art Director:
Sylvia Frezzolini
Designer:
Sylvia Frezzolini
Photographers:
Various
Publisher:
Crown Publishers, Inc.
Typographer:
Set-Rite Typographers
Printer:
Halliday Lithograph Corp.
Production Manager:
Milton Wackerow
Paper:
Lustro Offset Enamel Dull
80#
Binder:
The Book Press
Jacket Designer:
Sylvia Frezzolini
Jacket Photographer:
Hale Observatories

Halloween Midnight temperature _____

Everybody's costumes

Who went trick-or-treating

The best treats were

The worst tricks were

We gave

as treats.

Homemade Halloween Poem

A memento of our day

110

111

Book Title:
Our Old Fashioned Country
Diary for 1980
Author:
Linda Campbell Franklin
Art Director:
Sonja Douglas
Designers:
Sonja Douglas,
Debi Bracken
Publisher:
Tree Communications, Inc.
Typographer:
David E. Seham Associates,
Inc.
Printer:
R.R. Donnelley & Sons, Co.
Production Manager:
Paul Levin
Paper:
Warren Olde Style 70#
Binder:
R.R. Donnelley & Sons Co.
Jacket Designer:
Sonja Douglas

Book Title:
Some of Us Survived
Author:
Kerop Bedoukian
Art Director:
Nanette Stevenson
Designer:
Kathleen Westray
Publisher:
Farrar, Straus and Giroux
Typographer:
American-Stratford Graphic
Services, Inc.
Printers:
Vail-Ballou Press, Inc.,
The Chaucer Press, Inc.
Production Manager:
Nanette Stevenson
Paper:
S.D. Warren Antique Cream
55#
Binder:
Vail-Ballou Press, Inc.
Jacket Designer:
Fred Marcellino

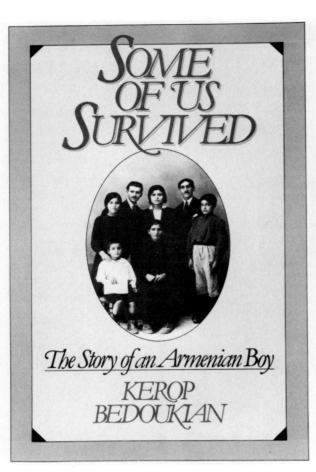

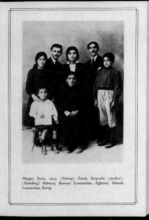

Book Title:
Separate from the World
Author:
Robert Minden
Editor:
Martha Langford
Art Director:
George Nitefor
Designer:
George Nitefor
Photographer:
Robert Minden
Publisher:
The National Film Board of
Canada
Typographers:
The Runge Press Ltd.
Printer:
Herzig Somerville Ltd.
Production Manager:
Martha Langford
Paper:
Cameo Dull 200M
Binder:
Holmes Bindery
Jacket Designer:
George Nitefor
Jacket Photographer:
Robert Minden

Book Title:
Introduction to Children's
Literature
Authors:
Joan I. Glazer,
Gurney Williams, III
Designer:
Jo Jones
Illustrator:
Joseph Gillians
Publisher:
McGraw-Hill Book Co.
Typographer:
Black Dot, Inc.
Printer and Binder:
Von Hoffmann Press, Ir
Production Manager:
Charles Hess
Paper:
Matte 50#
Cover Designer:
Jo Jones
Cover Illustrator:
Reynold Ruffins

CHAPTER
4

CONTEM-
PORARY
REALISM

FICTION OUT OF FACT

Book Title:
Max's Ride
Author:
Rosemary Wells
Art Director:
Atha Tehon
Designer:
Atha Tehon
Letterer:
Rosemary Wells
Publisher:
The Dial Press
Typographer:
Royal Composing Room
Printer:
The Collett Co.
Production Manager:
Sherri Johnson
Paper:
Solid Bleached
Sulphate, White
Binder:
The Collett Co.
Jacket Designer:
Atha Tehon
Jacket Letterer:
Rosemary Wells

Book Title:
Good-bye, Arnold!
Author:
P.K. Roche
Art Director:
Atha Tehon
Designer:
Denise Cronin Neary
Illustrator:
P.K. Roche
Publisher:
The Dial Press
Typographer:
Royal Composing Room
Printer:
Eastern Press, Inc.
Production Manager:
Virginia R. Anson
Paper:
Mohawk Vellum, Warm White
Binder:
Economy Bookbinding Corp.
Jacket Designer:
Denise Cronin Neary
Jacket Illustrator:
P.K. Roche

Book Title:
All in the Woodland Early
Author:
Jane Yolen
Art Directors:
Antler & Baldwin
Designer:
Jane Zalben
Illustrator:
Jane Zalben
Publisher:
William Collins Publishers, Inc.
Typographer:
Concept Typographic Services
Printer:
Federated Lithographers
Production Manager:
Dave Horowitz
Paper:
Patina 80#
Binder:
Book Press
Jacket Designer:
Jane Zalben
Jacket Illustrator:
Jane Zalben

I heard a loud QUAIL
As he took to his wings,
I saw a young RACCOON
And counted his rings,
 All in the woodland early.

And where are you going this morning in May?
"We're going a-hunting," was all they would say.

I saw a swift EAGLE,
A FOX in his lair,
I saw a fine GOOSE,
And I saw a young HARE,
 All in the woodland early.
And where are you going this morning in May?
"We're going a-hunting," was all they would say.

Book Title:
My Mother Sends Her
Wisdom
Author:
Louise McClenathan
Art Director:
Cynthia Basil
Designers:
Cynthia Basil,
Rosekrans Hoffman
Illustrator:
Rosekrans Hoffman
Publisher:
Morrow Junior Books,
William Morrow & Co.
Typographers:
Expertype, Inc.,
Franklin Photo
Lettering, Inc.
Printer:
Rae Publishing Co., Inc.
Production Manager:
Eugene Sanchez
Paper:
Monodnock Caress, Colonial
White Smooth, 80#
Binder:
Book Press
Jacket Designer:
Cynthia Basil
Jacket Illustrator:
Rosekrans Hoffman

Soon the forest path grew wider, and she could see spires
and roofs of the city houses through the trees. The streets
were narrow and crowded. Men pushed carts along, and
women cried their wares in the marketplace. "Come buy
from me, good bread, good fowl, good brooms today." Katya
stumbled along the cobblestones, wishing she were back in
the forest again. The city seemed noisy.

An old woman showed her the way to the moneylender's
house, which stood on a corner surrounded by a fence.

Book Title:
King Krakus and the Dragon
Author:
Janina Domanska
Art Director:
Ava Weiss
Illustrator:
Janina Domanska
Publisher:
Greenwillow Books
Printer:
Rae Publishing Co., Inc.
Production Manager:
Gene Sanchez
Paper:
Caress Vellum
Binder:
Book Press
Jacket Illustrator:
Janina Domanska

KING KRAKUS
AND THE DRAGON
JANINA DOMANSKA

t is you who must die!" King Krakus
cried out. And flourishing his sword,
he ran down the mountainside to fight the dragon.
But the dragon spouted a cloud of poisoned smoke,
and the brave king fell to the ground.

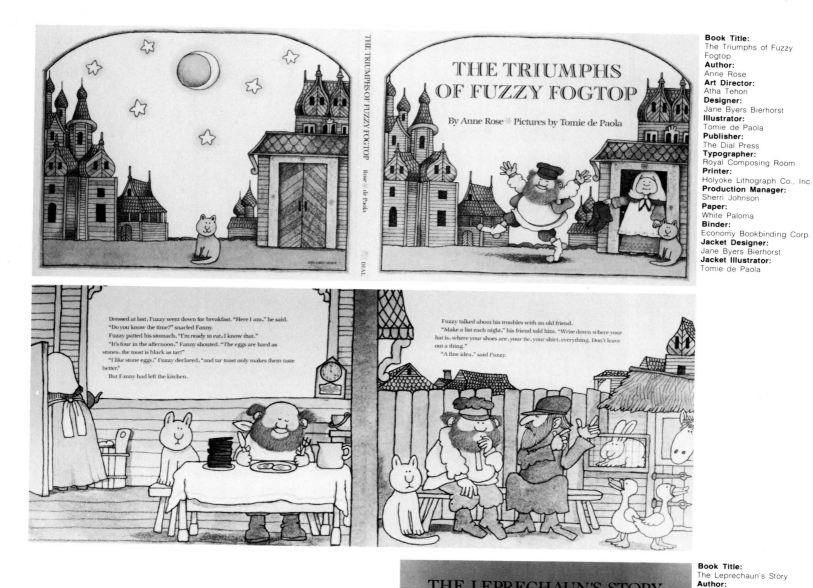

THE TRIUMPHS
OF FUZZY FOGTOP

By Anne Rose ✳ Pictures by Tomie de Paola

THE TRIUMPHS OF FUZZY FOGTOP

Rose ✳ de Paola

DIAL

Book Title:
The Triumphs of Fuzzy Fogtop
Author:
Anne Rose
Art Director:
Atha Tehon
Designer:
Jane Byers Bierhorst
Illustrator:
Tomie de Paola
Publisher:
The Dial Press
Typographer:
Royal Composing Room
Printer:
Holyoke Lithograph Co., Inc.
Production Manager:
Sherri Johnson
Paper:
White Paloma
Binder:
Economy Bookbinding Corp.
Jacket Designer:
Jane Byers Bierhorst
Jacket Illustrator:
Tomie de Paola

Dressed at last, Fuzzy went down for breakfast. "Here I am," he said.
"Do you know the time?" snarled Fanny.
Fuzzy patted his stomach. "I'm ready to eat, I know that."
"It's four in the afternoon," Fanny shouted. "The eggs are hard as stones, the toast is black as tar!"
"I like stone eggs," Fuzzy declared, "and tar toast only makes them taste better."
But Fanny had left the kitchen.

Fuzzy talked about his troubles with an old friend.
"Make a list each night," his friend told him. "Write down where your hat is, where your shoes are, your tie, your shirt, everything. Don't leave out a thing."
"A fine idea," said Fuzzy.

THE LEPRECHAUN'S STORY

by Richard Kennedy

illustrated by Marcia Sewall

Book Title:
The Leprechaun's Story
Author:
Richard Kennedy
Art Director:
Riki Levinson
Designer:
Patricia Lowy
Illustrator:
Marcia Sewall
Publisher:
E.P. Dutton
Typographer:
Cardinal Type Services, Inc.
Printer:
Rae Publishing Co., Inc.
Production Managers:
Steven Konopka
Jane Recca
Paper:
Finish Opaque Vellum 70#
Binder:
Keenan Binder, Inc.
Jacket Designer:
Patricia Lowy
Jacket Illustrator:
Marcia Sewall

Presently he was walking alongside a hedgerow, and he heard a soft humming from the other side. So with care not to make a sound, he parted the branches to see the matter of it. And right there was sitting a leprechaun busy at making a pair of small soft boots, for leprechauns are cobblers to fairies, as you might know.
"Arrah!" cries the tradesman with a great shout, jumping through the hedge. "There ye be, ye little imp, and my eyes are right on ye till ye take me to the gold treasure!"

Book Title:
Grandfather's Cake
Author:
David McPhail
Art Director:
Diana Hrisinko
Designer:
Diana Hrisinko
Illustrator:
David McPhail
Publisher:
Charles Scribner's Sons
Typographer:
Photo-Lettering, Inc.
Printer:
The Murray Printing Co.
Production Manager:
Martha Van de Water
Paper:
Alpine Vellum 80#
Binder:
A. Horowitz & Son
Jacket Designer:
Diana Hrisinko
Jacket Illustrator:
David McPhail

"Why don't you just take *yo'* hands off it!" said a deep voice that seemed to come from a stout beech tree standing just off the path.

The fox jumped back, terrified. "Who said that?" he squealed, not really wanting to know.

"*I said dat!*" roared a big black bear as he stepped out from behind the tree.

With one flick of his paw the huge bear snatched up the frightened fox and dangled him over the brook that tumbled along below the path.

"So long, Foxy," the bear chuckled, and he dropped the fox into the icy stream.

Book Title:
How I Hunted the Little Fellows
Author:
Boris Zhitkov
Translator:
Djemma Bider
Art Directors:
Donna Brooks,
Paul O. Zelinsky
Designer:
Paul O. Zelinsky
Illustrator:
Paul O. Zelinsky
Publisher:
Dodd, Mead, & Co., Inc.
Typographer:
American Book-Stratford Press
Printer:
Rae Publishing Co., Inc.
Production Manager:
Marion Hess
Paper:
P&S Offset A69
Binder:
Keenan Binders, Inc.
Jacket Designer:
Paul O. Zelinsky
Jacket Illustrator:
Paul O. Zelinsky

Somehow I stuck the deck in place, climbed on the table, and put the little steamship back on its shelf.

Everything was lost now!

I threw myself into bed and buried

myself under the covers. I heard a key in the door.

"Granny," I whispered under the blanket. "Granny, my dearest own Granny, what have I done!"

Book Title:
Pinkerton, Behave!
Author:
Steven Kellogg
Art Director:
Atha Tehon
Designer:
Jane Byers Bierhorst
Illustrator:
Steven Kellogg
Publisher:
The Dial Press
Typographer:
Royal Composing Room
Printer:
Holyoke Lithograph Co., Inc.
Production Manager:
Sherri Johnson
Paper:
Mohawk Vellum, Cream
White
Binder:
Economy Bookbinding Corp.
Jacket Designer:
Jane Byers Bierhorst
Jacket Illustrator:
Steven Kellogg

Book Title:
Thumbelina
Author:
Hans Christian Andersen
retold by Amy Ehrlich
Art Director:
Atha Tehon
Designer:
Jane Byers Bierhorst
Illustrator:
Susan Jeffers
Publisher:
The Dial Press
Typographer:
Royal Composing Room
Printer:
Holyoke Lithograph Co., Inc.
Production Manager:
Warren Wallerstein
Paper:
White Karma
Binder:
Economy Bookbinding Corp.
Jacket Designer:
Jane Byers Bierhorst
Jacket Illustrator:
Susan Jeffers

HANS CHRISTIAN ANDERSEN

Thumbelina

PICTURES BY Susan Jeffers

RETOLD BY AMY EHRLICH

Book Title:
If Wishes Were Horses and
Other Rhymes
Author:
Mother Goose
Art Director:
Riki Levinson
Designer:
Riki Levinson
Illustrator:
Susan Jeffers
Publisher:
E.P. Dutton
Typographer:
Boro Typographers, Inc.
Printers:
Lehigh Press, Inc.,
Philips Offset Co., Inc.
Production Managers:
David Zable,
Steven Konopka,
Jane Recca
Paper:
Mountie Matte 80#
Binder:
Book Press
Jacket Designers:
Susan Jeffers,
Riki Levinson
Jacket Illustrator:
Susan Jeffers

Ride a cock horse to Banbury Cross
To buy little Annie a galloping horse.

A TREEFUL OF PIGS

by Arnold Lobel · pictures by Anita Lobel

Book Title:
A Treeful of Pigs
Author:
Arnold Lobel
Art Director:
Ava Weiss
Illustrator:
Anita Lobel
Publisher:
Greenwillow Books
Printer:
Rae Publishing Co., Inc.
Production Manager:
Gene Sanchez
Paper:
Patina Matte
Binder:
Book Press
Jacket Illustrator:
Anita Lobel

The farmer's wife ran outside
and opened the cellar door.
All of the pigs came bouncing
out into the sunshine.

Book Title:
I Will Not Go to Market
Today
Author:
Harry Allard
Art Director:
Atha Tehon
Designer:
Atha Tehon
Illustrator:
James Marshall
Publisher:
The Dial Press
Typographer:
Royal Composing Room
Printer:
Eastern Press, Inc.
Production Manager:
Virginia R. Anson
Paper:
Mohawk Vellum, Warm White
Binder:
Economy Bookbinding Corp.
Jacket Designer:
Atha Tehon
Jacket Illustrator:
James Marshall

by HARRY ALLARD
Pictures by JAMES MARSHALL

Fenimore B. Buttercrunch looked out
the window. There was a blizzard raging.
"I cannot go to market today," he said.

Dreaming of jam, he warmed
his tootsies by the fire.

That night Fenimore B. Buttercrunch
went to bed early.
"I must get a good night's rest if I am to go
to market tomorrow," he said.

He peeked out the door the next morning.
The coast was clear.
"It's off to market today!" he sang.

And when Benjamin put Heek in bed between them, Brunus knew that he must do something.

Book Title:
Brunus and the New Bear
Author:
Ellen Stoll Walsh
Art Director:
Diana Klemin
Designer:
Marilyn Schulman
Illustrator:
Ellen Stoll Walsh
Publisher:
Doubleday & Co., Inc.
Typographer:
Intergraphic
Technology, Inc.
Printer:
Kingsport Press
Production Manager:
Marie Macfarlane
Paper:
Dull Coated 80#
Binder:
Kingsport Press
Jacket Designer:
Ellen Stoll Walsh
Jacket Illustrator:
Douglas Wink

Book Title:
Good Night to Annie
Author:
Eve Merriam
Art Director:
Lucy Bitzer
Designer:
Julie Quan
Illustrator:
John Wallner
Publisher:
Four Winds Press
Typographer:
Contempotype Inc.
Printer:
Pearl Pressman Liberty
Production Manager:
Doris Barrett
Paper:
Moistrite Matte
Binder:
Keenan Binders, Inc.
Jacket Designer:
Julie Quan
Jacket Illustrator:
John Wallner

Book Title:
The Nutcracker
Author:
E.T. Hoffman,
Adapted by Janet Schulman
Art Director:
Riki Levinson
Designer:
Riki Levinson
Illustrator:
Kay Chorao
Publisher:
E.P. Dutton
Typographers:
The American Book-Stratford
Press,
Capital-Crosby
Typographers, Inc.
Printers:
Halliday Lithograph Corp.
Philips Offset Co.
Production Managers:
Steven Konopka
Jane Recca
Paper:
Finish Opaque Vellum 70#
Binder:
Book Press
Jacket Designer:
Riki Levinson
Jacket Illustrator:
Kay Chorao

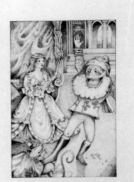

Book Title:
Dream Weaver
Author:
Jane Yolen
Art Directors:
Antler & Baldwin
Designer:
Sallie Baldwin
Illustrator:
Michael Hague
Publisher:
William Collins Publishers,
Inc.
Typographer:
Antler & Baldwin, Inc.
Printer:
Federated Lithographers
Printers, Inc.
Production Manager:
Dave Horowitz
Paper:
Patina 80#
Binder:
Book Press
Jacket Designer:
Sallie Baldwin
Jacket Illustrator:
Michael Hague

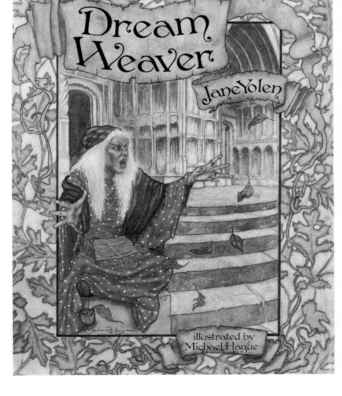

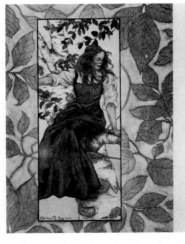

Book Title:
Bookshelf–Level A
Editors:
Connie Steensma Prins,
Doreen Nation Ziobro
Art Director:
Skip Sorvino
Designer:
Marijka Kostiw Yaworsky
Illustrator:
Elwood H. Smith
Publisher:
Scholastic Magazines Inc.
Typographer:
LCR Graphics, Inc.
Printer:
George Banta Co., Inc.
Production Manager:
Nancy DeWolfe Ragolia
Paper:
Baxter 45#
Binder:
George Banta Co. Inc.
Jacket Designer:
Marijka Kostiw Yaworsky
Jacket Illustrator:
Christine Bassery

Book Title:
Bookshelf–Level B
Editors:
Doreen Nation Ziobro,
Connie Steensma Prins
Art Director:
Skip Sorvino
Designer:
Marijka Kostiw Yaworsky
Illustrator:
Larry Ross
Publisher:
Scholastic Magazines Inc.
Typographer:
LCR Graphics, Inc.
Printer:
George Banta Co. Inc.
Production Manager:
Nancy DeWolfe Ragolia
Paper:
Baxter 45#
Binder:
George Banta Co. Inc.
Jacket Designer:
Marijka Kostiw Yaworsky
Jacket Illustrator:
Christine Bassery

Book Title:
In the Land of Small Dragon
Author:
Told by Dang Manh Kha to
Ann Nolan Clark
Art Director:
Barbara G. Hennessy
Designer:
Barbara G. Hennessy
Illustrator:
Tony Chen
Publisher:
The Viking Press
Typographers:
American Book-Stratford
Press,
Haber Typographers
Printer:
A. Hoen & Co. Inc.
Production Manager:
Jane Rafal
Paper:
Mead Matte 80#
Binder:
A. Horowitz & Son
Jacket Designer:
Barbara G. Hennessy
Jacket Illustrator:
Tony Chen

Book Title:
The Treasure
Author:
Uri Shulevitz
Art Director:
Nanette Stevenson
Illustrator:
Uri Shulevitz
Publisher:
Farrar, Strauss and Giroux,
Inc.
Typographer:
Arrow Typographers, Inc.
Printer:
Eastern Press, Inc.
Production Manager:
Nanette Stevenson
Paper:
S.D. Warren
Patina Coated Matte 80#
Binder:
A. Horowitz & Sons
Jacket Illustrator:
Uri Shulevitz

He walked through forests.

Now and then, someone gave him a ride, but most
of the way he walked.

Tonweya and the Eagles
and Other Lakota Indian Tales
retold by ROSEBUD YELLOW ROBE
pictures by Jerry Pinkney

Yellow Robe | TONWEYA AND THE EAGLES

DIAL

Book Title:
Tonweya and the Eagles
Author:
Rosebud Yellow Robe
Art Director:
Atha Tehon
Designer:
Atha Tehon
Illustrator:
Jerry Pinkney
Publisher:
The Dial Press
Typographer:
A. Colish, Inc.
Printer:
The Maple-Vail Book
Manufacturing Co.
Production Manager:
Sherri Johnson
Paper:
Mohawk Vellum Cream White
Binder:
The Maple-Vail Book
Manufacturing Co.
Jacket Designer:
Atha Tehon
Jacket Illustrator:
Jerry Pinkney

sound of steps pursuing me. By good fortune I found my horse. The rope about his head had caught in some bushes and held him fast. I mounted, and still shivering with fear, started in the direction of High Peak where I knew the rest of the party would be waiting for me. All day I traveled and all day I heard those footsteps behind me. Finally I summoned all my courage and looked around. There some hundred feet behind me was a woman. A woman of my own band. A woman who I recalled had been among the missing after one of the battles with the Crow. I stopped. I turned toward her and she vanished into the air.

"My horse, now beyond my control from fear, started galloping with me and never slackened his pace until we were in sight of High Peak. The others were already there and much to my surprise asked me why I did not bring the woman who was following me into the camp. I looked to where they pointed and there she stood. She never moved. She gave no sound. Just stood there watching . . . watching. It was then I told them what had happened. They laughed and would not believe me.

"One of them started toward her to head her into camp and again she vanished. Fear broke out among us and it was then that Great Eagle, who was wise in many ways, spoke. 'You have no cause for fear,' said he. 'Had it been an

98

Book Title:
The Sacred Hoop
Author:
Bill Broder
Art Director:
James Robertson
Designers:
James Robertson,
Diana Fairbanks,
The Yolla Bolly Press
Publisher:
Sierra Club Books
Typographer:
Mackenzie-Harris Corp.
Printer:
The Murray Printing Co.
Production Manager:
Eileen Max
Paper:
Caress Text Smooth 70#
Binder:
The Murray Printing Co.
Jacket Designers:
James Robertson,
Diana Fairbanks

The
Sacred
Hoop

A cycle of earth tales

Bill Broder

Book Title:
The Sad Phoenician
Author:
Robert Kroetsch
Art Director:
Glenn Goluska
Designer:
Glenn Goluska
Publisher:
The Coach House Press
Typographer:
Mary Scally,
The Coach House Press
Printer:
John Ormsby, The Coach
House Press
Production Manager:
Stan Bevington
Paper:
Zephyr Antique Wove
Binder:
Martin Bookbinding

Portrait of Frederick Locker-Lampson by Kate Greenaway

THE ROWFANT
MANUSCRIPTS

by H. Jack Lang

with an introduction by Herman W. Liebert

THE ROWFANT CLUB ❦ CLEVELAND

Book Title:
The Rowfant Manuscripts
Author:
H. Jack Lang
Art Director:
Freeman Keith
Designer:
Freeman Keith
Publisher:
The Rowfant Club
Typographer:
The Stinehour Press
Printers:
The Stinehour Press,
The Meriden Gravure Co.
Production Manager:
Freeman Keith
Paper:
Mohawk Superfine Soft-
white, Eggshell Finish, sub
80
Binder:
The Stinehour Press

THE PLAN OF ST. GALL

A STUDY OF THE ARCHITECTURE & ECONOMY OF, &
LIFE IN A PARADIGMATIC CAROLINGIAN MONASTERY

BY

WALTER HORN AND ERNEST BORN

with a foreword by WOLFGANG BRAUNFELS, a translation into English
by CHARLES W. JONES of the DIRECTIVES of Adalhard, 753–826, the Ninth
Abbot of Corbie, and with a note by A. HUNTER DUPREE on the Significance
of the Plan of St. Gall to the History of Measurement

VOLUME I OF THREE VOLUMES

UNIVERSITY OF CALIFORNIA PRESS · BERKELEY · LOS ANGELES · LONDON

1979

The Plan of St. Gall VOLUME I

189.B

LONGITUDINAL SECTION
[after Conant, 1958, p. 280, fig. 72] 1:450

*The red overprinting supplied by the authors on
Lanfry's fine drawing indicates where certain scars
in the original masonry give evidence of a structural
feature now notched. This is by some interpreted as
a simple engaged column rising from floor to
clerestory wall-head level, by others as the seat of
abutment masonry of diaphragm arches. The
controversy requires thorough re-examination through
a masonry study made from scaffold giving access to
full height of nave wall.
As long as such a study is lacking, and until a
structural engineering analysis is made, Ernest Born
and I prefer to keep the controversy alive, Born
favoring the former and I the latter interpretation.
W.H.*

PLAN 1:600

JUMIÈGES, ABBEY CHURCH (1040–1067) 189.A

SEINE-INFÉRIEURE, FRANCE

*Masonry scars in its clerestory walls (189.C, 189.D) prove that the nave of this Early Romanesque church was spanned by diaphragm arches
rising from engaged columnar shafts attached to every second pier of the nave (begun not before 1052). The square schematism and system of
alternating supports of Jumièges clearly derive from Ottonian architecture (fig. 288).
Columnar shafts introducing modular division into the nave walls first appeared in the cathedrals of Orléans (990) and Tours (ca. 990–1002)
and gained a hold in Germany, after the principle had been established in Speyer I (1030–1061). Jumièges goes further than Speyer through
use of diaphragm arches that carry modular division of nave walls transversely across the space. Diaphragm arches had previously been used in
the abbey church of Nivelles (1000–1046) and the cathedral of Trier (1016–1047). After Jumièges (1052–1067) they are found in other
Norman churches: St. Vigor-de-Bayeux (ca. 1060), Cérizy-la-Forêt (ca. 1080), St. Gervaise-de-Falaise (ca. 1100–1123), and St. Georges-de-
Boscherville (after 1114). They become fashionable even in distant Italy: San Pier Scheraggio in Florence (ca. 1050–1086), Lomello (1060?)
and the magnificent San Miniato in Florence (ca. 1070–ca. 1150).
In all these churches the diaphragm arches were placed at intervals too large to allow vaulting between them. This step, the last in development
of the medieval bay system, was made in Speyer II (fig. 190).*

234

Book Title:
The Plan of St. Gall
Authors:
Walter Horn,
Ernest Born
Editor:
Lorna Price,
**Camera and Press
Supervision:**
Charles R. Wood
Designer:
Ernest Born
Publisher:
The University of California
Typographers:
William Clowes, Ltd.,
Geoffrey Armstrong
Printer:
Southeastern Printing Co.
Production Managers:
Conrad Mollath,
Czeslaw Jan Grycz
Paper:
Curtis "Colophon" sub 95
Binder:
Nicholstone Book
Bindery, Inc.

Book Title:
Design: Purpose, Form and
Meaning
Author:
John F. Pile
Art Director:
Mary Mendell
Designer:
Mary Mendell
Publisher:
The University of
Massachusetts Press
Typographer:
Eastern Typesetting Co.
Printer:
Murray Printing Company
Production Manager:
Mary Mendell
Paper:
Beckett Traditional Opaque
Binder:
Murray Printing Company
Jacket Designer:
Mary Mendell

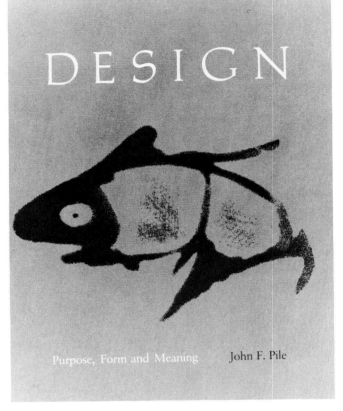

Book Title:
Design Basics
Author:
David A. Lauer
Art Director:
Karen Salsgiver
Designer:
Karen Salsgiver
Publisher:
Holt, Rinehart and Winston
Typographer:
York Graphic Services, Inc.
Printers:
Capital City Press,
Lehigh Press Lithographers
Paper:
Glatco 60#
Binder:
Capital City Press
Jacket Designer:
Karen Salsgiver
Jacket Artist:
Stuart Davis

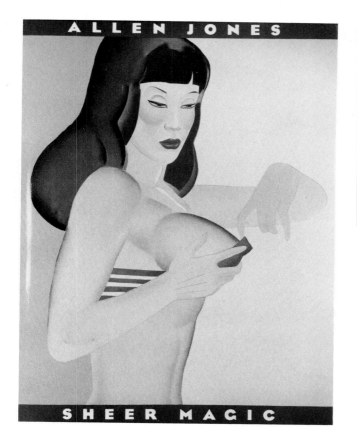

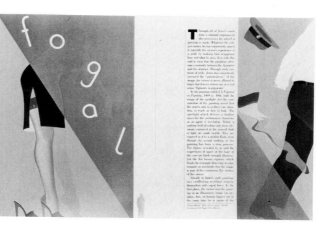

Book Title:
Sheer Magic
Author:
Allen Jones
Art Director:
Bea Feitler
Designer:
Bea Feitler
Illustrator:
Allen Jones
Publisher:
Congreve Publishing Co.,
Inc.
Printer:
Dai Nippon Printing Co., Ltd.
Production Manager:
Karen Amiel
Binder:
Sendor Bindery
Jacket Designer:
Bea Feitler
Jacket Artist:
Allen Jones

Book Title:
Attention to Detail
Author:
Herbert H. Wise
Art Director:
Joseph L. Santoro
Designer:
Joseph L. Santoro
Photographer:
David Frazier/
Studio Photography
Publisher:
Music Sales/
Quick Fox Inc.
Typographer:
Film Art Computer
Typography
Printer:
Dai Nippon Printing Co., Ltd.
Production Manager:
Music Sales/
Quick Fox Inc.
Paper:
Japanese
Binder:
Dai Nippon Printing Co., Ltd.
Jacket Designer:
Joseph L. Santoro
Jacket Photographer:
Herbert H. Wise

Book Title:
The Economy Today
Author:
Bradley R. Schiller
Art Director:
Meryl Levavi
Designers:
Betty Binns Graphics,
Martin Lubin
Illustrator:
Rino Dussi
Publisher:
Random House, Inc.
Typographer:
York Graphic Services, Inc.
Printer:
Rand McNally & Co.
Production Manager:
Della R. Mancuso
Paper:
Pentair Suede
Binder:
Rand McNally & Co.
Jacket Designers:
Betty Binns Graphics,
Martin Lubin
Jacket Photographer:
Genigraphics

Book Title:
Principles of Accounting
Authors:
Paul H. Walgenback,
Norman E. Dittrich,
Ernest I. Hanson
Art Director:
Geri Davis
Designer:
Geri Davis
Illustrators:
Evanell Towne,
Craig Fuller
Publisher:
Harcourt Brace Jovanovich,
Inc.
Typographer:
Allservice Phototypesetting
Printer:
The Murray Printing Co.
Production Manager:
Fran Wager
Paper:
New Era Matte 45#
Binder:
The Murray Printing Co.
Jacket Designer:
Geri Davis
Jacket Illustrator:
Craig Fuller

Book Title:
Holdup
Authors:
Emmett Williams,
Keith Godard
Art Director:
Keith Godard of Works
Designers:
Keith Godard of Works with
Emmett Williams
Photographer:
Keith Godard
Publisher:
Works Editions
Typographer:
Craftsman Type
Printer:
Eastern Press
Production Manager:
Charles Gasperon
Paper:
Patina 80#
Binder:
Meuller Trade Bindery
Jacket Designer:
Keith Godard
Photographer:
Keith Godard

Book Title:
Behavior and Life: An
Introduction to Psychology
Author:
Frank J. Bruno
Art Director:
Rafael H. Hernandez
Designer:
Edward A. Butler
Publisher:
John Wiley & Sons, Inc.
Typographer:
Precision Type
Printer:
Kingsport Press
Cover Printer:
Lehigh Press
Production Manager:
Rosemary Hirsch
Paper:
Warren Matte 620 50#
Binder:
Kingsport Press
Cover Designer:
Rafael H. Hernandez

Book Title:
General Chemistry
Authors:
Ralph S. Becker,
Wayne E. Wentworth
Art Director:
Daniel Earl Thaxton
Designer:
Daniel Earl Thaxton
Illustrator:
Eric Hieber
Photographer:
Professor John B.
Vander Sande, MIT
Publisher:
Houghton Mifflin Co.
Compositor:
Book Composition Ty-
pothetae
Printer:
Murray Printing Co.
Production Manager:
Sylvia Mallory
Paper:
New Era Matte 45#
Binder:
The Murray Printing Co.
Jacket Designer:
Daniel Earl Thaxton
Jacket Photographer:
James Scherer

Book Title:
Energy Planning for
Buildings
Author:
Michael M. Sizemore, AIA
Designer:
Jeffry Corbin
Publisher:
The American Institute of
Architects
Typographer:
Type House
Printer:
The McKay Press
Production Manager:
Jeffry Corbin
Paper:
Sunray Opaque Vellum Dusk
Binder:
John H. Dekker & Sons
Jacket Designer:
Jeffry Corbin

Book Title:
The California Water Atlas
Project Director/Editor:
William L. Kahrl
Art Director:
Richard Kharibian
Designer:
Richard Kharibian
Illustrators:
William A. Bowen,
David L. Fuller,
Donald A. Ryan,
Judith Christner,
Mark E. Goldman
Photographers:
Various
Publishers:
The State of California/
William Kaufman, Inc.
Distributors
Typographers:
A&A Graphics,
ReederType,
Zip Printing
Printer:
George Rice & Sons
Production Manager:
David L. Fuller
Paper:
Vintage Velvet Book 100#
Binder:
Hiller Industries
Cover Designer:
Richard Kharibian

Natural Moisture Demand

Book Title:
Biological Science
Author:
William T. Keeton
Art Director:
Antonina Krass
Designer:
Antonina Krass
Illustrator:
Paula DiSanto Bensadoun
Photographer:
Clark Carroll
Publisher:
W.W. Norton & Co.
Typographer:
New England Typographic
Service, Inc.
Printer:
R.R. Donnelley & Sons, Inc.
Production Manager:
Roy Tedoff
Paper:
Laurel Text White 43#
Binder:
R.R. Donnelley & Sons, Inc.
Jacket Designer:
Antonina Krass
Jacket Artist:
Georgia O'Keefe

KNIGHTS OF THE AIR

Book Title:
Knights of the Air
Authors:
Ezra Bowen and the Editors
of Time-Life Books
Art Director:
Tom Suzuki
Designer:
Albert Sherman
Illustrators:
Frank Wootton,
John Batchelor
Publisher:
Time-Life Books Inc.
Typographer:
Typographics, Inc.
Printer:
Kingsport Press
Production Manager:
Douglas Graham
Paper:
Consolidated Frostbrite
Matte
Binder:
Kingsport Press

The Baron's triple-decker

Baron Manfred von Richthofen scored the final 21 of his 80 victories in Fokker Dr I triplanes, including the one shown here in cutaway. Introduced in late 1917, the Dr.I had not only three wings but a supplementary airfoil on the undercarriage. These features enabled the diminutive plane (length: 18 feet, 11 inches; wingspan: 23 feet, 7 inches) to outclimb and outturn almost any contemporary Allied aircraft. But the small engine, an Oberursel of only 110 horsepower, limited top speed to 103 miles per hour.

Nevertheless, in a dogfight a skilled aviator flying the agile triplane usually enjoyed the advantage. He could evade pursuit by turning tightly, and once on his quarry's tail, he could rarely be shaken off except by a high-speed dive. If the duel dipped to treetop level, an Allied pilot had only one course of escape: to zigzag away as fast as his plane would fly. Any attempt to turn or to climb merely closed the distance between him and the Fokker's guns.

The one tactic likely to defeat a Dr.I was to dive from above—the approach used by a Canadian pilot in the battle that cost Richthofen his life.

The control column of the Fokker Dr.I had convenient firing buttons for the machine guns—mounted directly in front of the cockpit—and a remote control for the throttle. But cockpit instruments were sparse. Besides fuel and oil gauges (not visible here), a pilot had only a tachometer and a compass to help fly the plane.

THROTTLE CONTROL COLUMN WING RIB WING SPAR

AILERON

OIL/FUEL TANK

ROTARY ENGINE

WING STRUT

MAGAZINE

RUDDER BAR

ELEVATOR RUDDER TAIL SKID

TACHOMETER COMPASS UNDERCARRIAGE AIRFOIL WING-TIP SKID

120

121

Book Title:
The Whalers
Authors:
A.B.C. Whipple and the
Editors of Time-Life Books
Art Director:
Tom Suzuki
Designer:
Herbert H. Quarmby
Illustrators:
Peter McGinn,
Jay H. Matternes,
Roy Andersen,
John Batchelor
Publisher:
Time-Life Books Inc.
Typographer:
Composition Systems, Inc.
Printer:
R.R. Donnelley & Sons
Production Manager:
Douglas Graham
Paper:
Boise Cascade Dependoweb
Binder:
R.R. Donnelley & Sons

THE WHALERS

The Audubon Society Field Guide to North American Reptiles & Amphibians

The Audubon Society Field Guide to North American Wildflowers *Eastern Region*

The Audubon Society Field Guide to North American Wildflowers *Western Region*

The Audubon Society Field Guide to North American Rocks and Minerals

Book Title:
The Audubon Society Field Guides to North America
Authors:
Charles W. Chesterman,
Richard Spellenberg,
William A. Niering,
Nancy C. Olmstead,
John L. Behler, and
F. Wayne King
Art Director/Designer:
Massimo Vignelli
Photographers:
Various
Publisher:
Alfred A. Knopf
Typographer:
Dix Typesetting Co., Inc.
Printer:
Amilcare Pizzi, S.p.A.
Production Managers:
Susan Woolhiser,
Helga Lose,
Dean Gibson, Ray Patient
Papers:
Gloss Code Stock 60#,
Bible Paper 30#
Binder:
Amilcare Pizzi, S.p.A.
Jacket Designer:
Massimo Vignelli
Jacket Photographers:
Studio Hartman,
M. Halberstadt,
Sally Myers,
Dale and Marian
Zimmerman,
C.W. Perkins, Ed Cooper,
Z. Leszcynski, K.H. Switak

White Simple-shaped Flowers

41 Apache Plume, 7', *w.* 1¼", *p. 721*

44 Water Buttercup, *aquatic*, *w.* ½", *p. 714*

42 Dwarf Bramble, *creeper*, *w.* ½", *p. 730*

45 Beach Strawberry, *creeper*, *w.* ¾", *p. 722*

43 Richardson's Geranium, 8–32", *w.* 1", *p. 528*

46 White Mountain Avens, *creeper*, *w.* 1", *p. 720*

Book Title:
Zabar's Deli Book
Authors:
Susan Katz with Murray
Klein, Saul Zabar,
Stanley Zabar
Art Director:
Seymour Chwast
Designer:
Push Pin Studios, Inc.
Illustrators:
Richard Mantel,
Seymour Chwast,
Haruo Miyauchi
Publisher:
Hawthorn Books
Typographer:
The Haddon Craftsmen, Inc.
Printer:
The Haddon Craftsmen, Inc.
Production Supervisor:
Terry Berkowitz
Paper:
Perkins and Squier 55#
Binder:
The Haddon Craftsmen, Inc.
Jacket Designer:
Seymour Chwast
Jacket Illustrator:
Seymour Chwast

Book Title:
American Images: New Work
by Twenty Contemporary
Photographers
Editor:
Renato Danese
Art Director:
Carl Zahn
Designer:
Carl Zahn
Photographers:
Various
Publisher:
McGraw-
Hill Book Co.
Typographer:
Typographic House
Printer:
Acme Printing Co.
Production Manager:
Joyce Kaplan
Paper:
Cameo Dull 100#
Binder:
A. Horowitz & Sons
Jacket Designer:
Carl Zahn
Jacket Photographers:
William Eggelston,
Joel Meyerowitz

Book Title:
Bioscope
Authors:
Thomas A. Easton,
Carl E. Rischer
Art Director:
Janet Bollow
Designer:
Janet Bollow
Illustrators:
Barbara Hack,
Heather Preston,
Judith McCarty,
Connie Warton,
Cyndi Clark
Publisher:
Mayfield Publishing Co.
Typographer:
Computer Typesetting
Services, Inc.
Printer:
The Haddon Craftsmen, Inc.
Production Manager:
Michelle Hogan
Paper:
Warren Patina 60#
Binder:
The Haddon Craftsmen, Inc.
Jacket Designer:
Janet Bollow
Photographer:
David Scharf

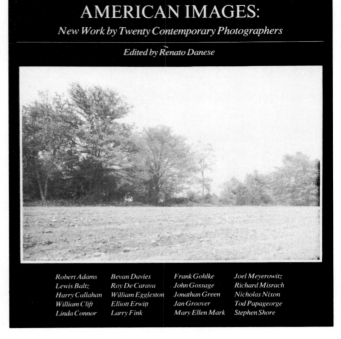

AMERICAN IMAGES:
New Work by Twenty Contemporary Photographers

Edited by Renato Danese

Robert Adams	*Bevan Davies*	*Frank Gohlke*	*Joel Meyerowitz*
Lewis Baltz	*Roy De Carava*	*John Gossage*	*Richard Misrach*
Harry Callahan	*William Eggleston*	*Jonathan Green*	*Nicholas Nixon*
William Clift	*Elliott Erwitt*	*Jan Groover*	*Tod Papageorge*
Linda Connor	*Larry Fink*	*Mary Ellen Mark*	*Stephen Shore*

BIOSCOPE

Alfredo Viazzi's Italian Cooking

MORE THAN 150 INSPIRED INTERPRETATIONS OF GREAT ITALIAN CUISINE

Designed and Illustrated by Milton Glaser

TORTELLINI IN BRODO
Tortellini in Broth

Tortellini in brodo is a soup served on holidays in Italian homes, but it is found daily on restaurant menus.

2 quarts chicken consommé (see p. 42)
2 packages tortellini (about 100 pieces), or homemade tortellini (see p. 70)
⅓ cup grated Parmesan cheese
Freshly ground black pepper

Bring consommé to a boil. Add tortellini and cook 5-6 minutes. If tortellini are homemade, cook for no more than 2 minutes.

Divide tortellini equally in individual bowls (approximately 17 per portion), and pour in broth. Serve with cheese and freshly ground pepper.

Serves 6.

STRACCIATELLA ALLA ROMANA
Roman Egg and Spinach Soup

3 eggs
½ cup grated Parmesan cheese
Salt and pepper
2 quarts beef or chicken consommé (see p. 42)
1½ pounds fresh, carefully washed leaf spinach (with tough stems discarded) or 1 package frozen leaf spinach, defrosted

Beat together the eggs and 1 tablespoon Parmesan cheese, and season with salt and pepper. Bring consommé to a boil. Add spinach and return to a boil. Fold in the egg mixture, making sure to blend well. As soon as eggs are cooked (1½ minutes), remove from heat. Serve with remaining cheese and freshly ground pepper.

Serves 6.

Book Title:
Alfredo Viazzi's Italian Cooking
Author:
Alfredo Viazzi
Art Director:
Milton Glaser
Designer:
Milton Glaser
Illustrator:
Milton Glaser
Publisher:
Random House, Inc.
Typographer:
Maryland Linotype Composition Co., Inc.
Production Manager:
Jan Tigner-McLaren
Printer:
R.R. Donnelley & Sons, Co.
Paper:
S.D. Warren
Binder:
R.R. Donnelley & Sons, Co.
Jacket Designer:
Milton Glaser
Jacket Illustrator:
Milton Glaser

Literary Architecture

Essays Toward a Tradition
WALTER PATER
GERARD MANLEY HOPKINS
MARCEL PROUST
HENRY JAMES

Ellen Eve Frank

THE STREET BOOK
An Encyclopedia of Manhattan's Street Names and Their Origins Henry Moscow

Book Title:
Literary Architecture
Author:
Ellen Eve Frank
Designer:
Wolfgang Lederer
Publisher:
The University of California Press
Typographer:
Dharma Press
Printer:
Carey Colorgraphics
Production Manager:
Czeslaw Jan Grycz
Paper:
Warren's Lustro Offset Enamel 70#
Binder:
Roswell Book Binding Co.
Jacket Designer:
Wolfgang Lederer
Jacket Letterer:
Wolfgang Lederer

Book Title:
The Street Book
Author:
Henry Moskow
Art Director:
Diana Graham
Designer:
Diana Graham
Photography:
Research Reports
Publisher:
Hagstrom Co., Inc.
Typographer:
Innovative Graphics Intl.
Printer:
Halliday Lithograph Corp.
Production Manager:
Tom Tracy
Paper:
Mead 80#/1st ed., Northwest Mounty 80#/2nd ed.
Binder:
Halliday Lithograph Corp.
Jacket Designer:
Diana Graham

Index

Book Show

Art Directors, Designers, Illustrators, Artists, Photographers, Authors, Editors, and Production Managers